Framing Attention

PARALLAX RE-VISIONS OF CULTURE
AND SOCIETY

Stephen G. Nichols, Gerald Prince, and Wendy Steiner,
SERIES EDITORS

Framing Attention

Windows on Modern German Culture

Lutz Koepnick

The Johns Hopkins University Press
Baltimore

This book was brought to publication with the generous
assistance of Washington University in St. Louis.

The Johns Hopkins University Press
2715 North Charles Street
Baltimore, Maryland 21218-4363
www.press.jhu.edu

Library of Congress Cataloging-in-Publication Data

Koepnick, Lutz P. (Lutz Peter)
 Framing attention : windows on modern German culture /
Lutz Koepnick.
 p. cm. — (Parallax, re-visions of culture and society
 Includes bibliographical references and index.
 ISBN 0-8018-8489-6 (hardcover : alk. paper)
 1. Windows in art. 2. Arts, German—19th century.
3. Arts, German—20th century. 4. Arts and society—
Germany—History—19th century. 5. Arts and society—
Germany—History—20th century. I. Title. II. Series: Parallax
(Baltimore, Md.)
 NX650.W57K64 2006
 700.943'0904—dc22 2006010570

A catalog record for this book is available from the
British Library.

Contents

Acknowledgments

Special thanks go to Nora Alter, Susan Bernofsky, Doerte Bischoff, Peter Chametzky, Sabine Eckmann, Geoff Eley, Amir Eshel, Angelica Fenner, Rolf Goebel, Patience Graybill, Julia Hell, Andrew Hewitt, Bernd Hüppauf, Christa Johnson, Laurie Johnson, Jennifer Kapczynski, Juliet Koss, Alice Kuzniar, Richard Langston, Patrizia McBride, Rick McCormick, Johannes von Moltke, Carl Niekerk, David Pan, Heike Polster, Sabine Rehorst, Eric Rentschler, Klaus Scherpe, Marc Silberman, Helmut Walser Smith, Scott Spector, Carsten Strathausen, Josef Thum, Nicholas Vazsonyi, Harald Weilnböck, Eric Weitz, Meike Werner, and Nele Willaert. Anne Fritz was of invaluable help in making it possible to illustrate this volume. I also would like to acknowledge Chris Bailes for preparing this book's index.

Preliminary versions of some portions of this book have previously appeared as articles. In all cases, however, earlier essays underwent significant rewriting and reconceptualization. For their kind permission to make selected use of published materials, I would like to acknowledge the *German Studies Review*, for "Redeeming History? Foster's Dome and the Political Imaginary of the Berlin Republic," 24.2 (2001): 303–323; Boydell and Brewer, Ltd., for "Stereoscopic Vision: Sight and Community in Wagner's *Die Meistersinger*," in *Wagner's Meistersinger: Performance, History, Representation,* ed. Nicholas Vazsonyi (Rochester: University of Rochester Press, 2003) 73–97; and Palgrave Macmillan, for "Windows 33/45: Nazi Politics and the Cult of Stardom," in *Fascism and Neofascism: Critical Writings on the Radical Right in Europe,* ed. Eric Weitz and Angelica Fenner (New York: Palgrave, 2004) 43–66.

Several institutions have contributed to this project. Grants from the American Council of Learned Societies and the Alexander Humboldt Foundation were essential to secure the time and space for the conceptualization of individual chapters and arguments. Washington University in St. Louis provided me with many additional resources to conduct research and carry out the writing. I owe particular gratitude to Edward Macias, dean of Arts and Sciences at Washington University, for offering financial support to illustrate this volume.

Acknowledgments

I am also grateful for having had the opportunity to present some of the ideas put forward in this book in various lectures. Drafts of different chapters were delivered at the University of Michigan, the University of Minnesota, New York University, Stanford University, Vanderbilt University, the University of Washington, and the University of Wisconsin.

Most of this book was written and rewritten during a sabbatical stay in Berlin. I am thankful to all those who turned this year into such a memorable, productive, and revitalizing one; and first and foremost, to Nicola and Kirstin, whose eagerness to explore distant realities during this time opened new windows for all of us.

Framing Attention

Introduction

Framing Attention

Windows are odd things. The longer we look through them, the more they confront us with metaphysical mysteries and epistemological conundrums. The more we think about their frames, the less sure we become about how we are able to see and perceive in the first place. Though windows come in all shapes and sizes, their shared function is that of providing, to put it simply, some kind of hole in some kind of wall. Windows connect dissimilar spaces: interior with exterior realms, private with public arenas, dim with luminous surroundings. They offer sites at which different symbolic or material orders can meet and engage in unpredictable transactions. Because windows pierce given architectural structures, they potentially unsettle our habit of seeing the world as one neatly divided into binary opposites. But no window can ever fulfill its task without also separating what it brings into contact. No hole can do without its wall. Whenever windows direct our senses to real or imaginary elsewheres, they simultaneously presuppose and reinscribe the very boundary they invite us to transcend. Whenever windows conjoin what is disparate or even incommensurable, their mere existence also divides the world into contrasting spheres.

It is for this reason that the role of windows in our lives is so much more difficult to understand than that of doors. A door's threshold marks a fixed and clearly defined point of separation. We can maneuver our bodies in either direction across a doorstep, we can kick doors in to enter a building or shut them for good to live somewhere else. Windows, by contrast, enable much more fluid and unstable relations. While a window's opening invites us to im-

merse ourselves in another world's allure, its frame at the same time reorders spatial arrangements and demarcates competing zones of distance and proximity. Doors leave us with little to wonder about: they situate us either on this or that side of a physical border, and with some effort, luck, or cunning we can exchange one place for the other. Windows do not accord us this kind of clarity. What makes them mysterious and often monstrous is that whenever we look at and through them, our senses and thoughts come to inhabit different worlds at once—worlds in whose horizons insides may well emerge as outsides and faraway places may be closer than our immediate surroundings.

"What we can see in the sunlight," Charles Baudelaire noted around 1860, "is always less interesting than what transpires behind the panes of a window. In that dark or luminous hole, life lives, life dreams, life suffers."[1] Baudelaire understood windows as screens of imaginary transport and creative displacement. Rather than merely putting a frame around extant realities, windows fuel the poet's fantasy and define the visible field as one of dazzling, mysterious, profound, and sinister meanings. They stimulate the mind's eye to make up stories and tell legends about the world. As importantly, they invite the observer to live, rejoice, and suffer in others—whether aware of being observed or not. Like poetry itself, a window establishes vital structures of empathy and identification, not because it depicts the real realistically but because it awakens the viewer's projective energies, our yearning to infuse visible objects with our own soul and corporeality. And similar to the author and reader of poetry, what matters most to the window-looker is not whether the world as he sees it in the window frame really exists but whether it helps him to feel inspired, enriched, and stimulated—whether it helps him to feel "that I am, and what I am."[2] Baudelaire's windows thus allegorize the very power of the aesthetic: its ability to puncture the hardened confines of everyday identities, its promise to disrupt automatic perceptions and standardized responses, its potential to open up dreamlike experiences of illumination and enrapture amid the regulated routines of modern industrial culture. Whatever separates viewer and viewed boosts the possibility of making intense experiences. It empowers the beholder's gaze to transgress the ordinary and wander off into uncharted territories.

Windows are odd things, then, because they don't really belong to the regular order of things. To be sure, similar to other objects in everyday life, windows appeal to our curiosity. They turn us into silent voyeurs, brazen exhibitionists—or both at once. What makes window frames fascinating is that they allow us to shun the messiness of existential involvements, expose us to

(or manipulate) other people's desires, filter out what we don't want to see, and intensify what we have fantasized about all along. But in all these cases, the window never simply represents or contains the real. Instead, by putting a frame around sight, the window produces the world as a site of noncontiguous visibility, of discontinuous to-be-looked-at-ness. Far from merely depicting the visible world, windows help define the very contours and extensions of the visible, its lateral dimensions, its spread and depth, its visual planes and volumes. No window, therefore, will leave untouched what is on either side of its frame. As they define the real as a realm of perceptible objects and intensities, windows at the same time elicit different habits of looking and perception. As they frame and reframe different perspectives onto the world, they also restructure the viewer's attention, regulate his or her perceptual distraction, or manage our desire simply to drift into the unknown and seemingly unfettered. Though we may often think of windows as mere tools of visual perception, as mere extensions of our bodies supporting our desire to see or to be seen, closer inspection tells us a different story. As we will see in the chapters to follow, what makes windows most dazzling and mysterious is their tendency, instead of merely facilitating our relation to the perceptual field, to turn our sensory perception into a prosthetic extension of the window's own ambiguous materiality. Windows not only shape how we see, know, and project ourselves into the world but also how we see our own seeing, probe our knowledge about the world, and question our modes of identification and imaginary dislocation. Windows not only frame our view, they (re)frame us as viewing subjects and open us up for the bliss—or terror—of sensual enchantment and aesthetic displacement in Baudelaire's sense.

In this, the role of windows is no different from the role of what we commonly consider under the concept of media, that is, technologies that communicate information and mediate between different nodes of meaning and agency. Windows are nothing other than media. They transmit or transpose perceptual data. They connect—intentionally or not—distinct senders and receivers. They construct and convey images of the real according to a certain code or program. Moreover, like any other media, windows have the ability to remediate the forms and contents of other media. They can display and appropriate the work of other media—their representational techniques, their formal codes, their social significance—in an attempt "to rival or refashion them."[3] Think only of the dubious pleasure of watching other people watching TV through their living room window. Or of observing from our office windows crowds of passersby as they silently listen to the music on their mp3

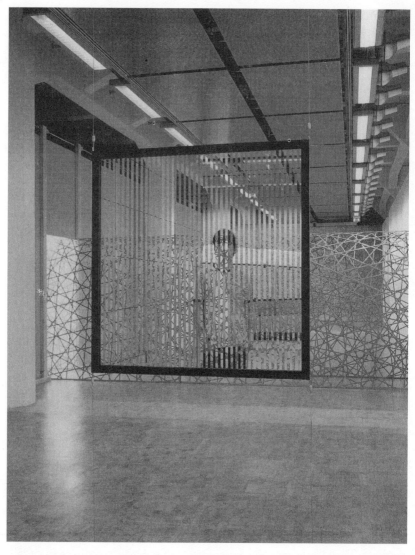

Olafur Eliasson, *Seeing Yourself Seeing* (2001). Photo: Franz Wamhof. Printed by permission of the artist.

players. What defines windows as media is not least their ability to offer a technology of perception that does not unfold in isolation from how other media communicate information and construct impressions of reality. And what makes them so dazzling and mysterious is that we tend to approach them at once as objects *and* as media, as material things *and* as vehicles of transport. Windows allow us to see and imagine how life lives, dreams, and suffers precisely because their frames and panes, by combining different ontological realities, never entirely recede from the picture. Windows fascinate not because we would ever perceive them as entirely transparent and invisible but on the contrary, because their ambiguous materiality cannot but foreground the very process of mediation and remediation and hence the very thrill of seeing the world converted into a still or moving image.

But to say that we approach windows like media is to say only half the truth. For there are many good reasons to invert this statement as well, to claim, with a certain universalism, that all media operate like windows of sorts. Media entertain sedentary viewers with the pleasure of motion and a more itinerant existence. Media supply our minds with prosthetic memories, records of real or imaginary pasts, and visions of unlived futures. Media carry us out of our habitual spaces and allow us to witness the grandeur of a unique voice, the intensity of an artwork, or the exemplariness of a personal biography. Media transport different views to us across dominant demarcations of public and private, rich and poor, male and female, right and left, and so on. Media permit us to see, hear, feel, remember, and envision what is not immediately around and present to us. Whether they involve acoustical, visual, written, or tactile properties, the primary function of every medium is to mediate what is present with what absent, to engage its users in a volatile dialectic of proximity and distance to play out a to and fro between the physical and the noncorporeal and thus to bring into view what initially seems to evade our perception. Media open up perspectives onto the world—visual, acoustical, and beyond. Media expose us to the world's view as well, be it for reasons of simple entertainment, economic penetration, or political control—or all at once. In spite of all the differences in how and why certain media link different horizons of perception, experience, and symbolization, what they all share is their role of interfacing noncontinuous or noncontiguous realities. What they all share is the way in which they are designed to open windows in some way onto that which is not directly present or at hand and, in doing so, not simply expand the dimensions of what we consider the real but reframe our attention and refocus our topographical orientation. All media operate like windows

because, far from merely providing innocent visual, acoustical, or linguistic images of the world, they restructure how we perceive this world in the first place and how we see our own seeing and may account for our own processes of perception—just as windows do.

Windows, today, are ubiquitous. Scarcely can we enter new or familiar spaces without directly encountering some mechanism of fenestral mediation: ambient television screens inundating us with the latest news or images of commercial products, computer monitors guiding us through the networked topographies of our global age, hidden loudspeakers enveloping us with acoustical wallpapers, handheld PDAs and cell phones linking us to faraway places anywhere and anytime. To live in front, behind, and surrounded by windows of all sorts has become our fate, that which makes humans today simultaneously human and posthuman—so much so, in fact, that we find ourselves ever less often at a conventional window frame, peeking—like Baudelaire—at urban panoramas outside or candlelit scenarios inside.

In this book, I recall a number of different episodes from the curious success story of the window since the mid–nineteenth century, its path from "mere" architectural device to—by dint of the ruthless ingenuity of some computer engineers—essential point of entry for our daily journeys into cyberspace. As we pay heed to certain fenestral innovations over the course of the past one hundred fifty years—from the breakdown of linear perspective and the redefinition of the proscenium stage to the attractions of early cinema screens, of subway windows, of political photography, of postwar television, and of the computer—*Framing Attention* explores how new types of windows transformed former boundaries between public and private, past and present, here and there, and in so doing established new modes of perception, belonging, and identity. To avoid any possible misunderstanding from the outset, let it be said clearly already here that this book is not designed—like many other are—to tell a teleological and triumphalist prehistory of the computer's graphical interface. Though by no means written in a spirit of humanist technophobia, the readings of this book also provide no reason to think of today's computing experts as incarnations of Hegel's world spirit, as ingenious minds in whose work the dynamic moments of earlier historical developments achieve conclusive meaning and realization. We learn from our own present to understand the failures and promises of our past; it would be foolish indeed not to look at our past to probe the achievements and fiascos of today.

A window's geometrical form, at certain times, may help us order and comprehend the complexities of human life; at other times, it may activate the

powers of the imagination and plunge us into the deepest mysteries. As membranes between dissimilar spaces, windows can enable us to re-dress our selves and reconfigure collective identities, but as sites of transformation and transience they can also produce rampant anxieties and cause people to reinforce past notions of what it means to be at home. In correspondence to the way in which this book considers the experience of contingency as the defining feature of modernity, the story of fenestral modernization as told here is one of contingent and often multivalent meanings and responses as well, one whose jagged course may not amount to what we would normally call a story or narrative. Not all is well about how modern media of reproduction, transmission, and dissemination both incorporated and displaced Baudelaire's windowpane, and the task of this book is to contemplate both the costs *and* blessings of how different windows in modern society have ever more hastily sought to multiply our frames of perception and unfix our locations in space and time.

Windows onto the World

In 1435, Leon Battista Alberti famously defined a painted image as an "open window" through which we look at the visible world.[4] What Alberti considered a picture categorically separated the space of the viewer or painter from that of the viewed, but precisely in doing so, it allowed for a seemingly objective and undistorted representation of the visual field. Alberti's metaphor of the window defined our view of space as strictly perspectival, yet it did so not in order to promote a triumph of untamed subjectivism but, on the contrary, to align individual acts of looking and representation with the seemingly universal and hence impersonal principles of Euclidian geometry. Pictures, for Alberti, were windows momentarily interrupting the flow of rays between a beholder's eyes and the object of his gaze, and what one could see on their framed surface visualized a standardized system of lateral lines, vertical planes, receding orthogonals, and vanishing points. Though Fillippo Brunelleschi and others had developed similar ideas in the preceding years and decades, the novelty of Alberti's 1435 system was not simply that it conceived of the visual field strictly in terms of a geometrical cone or pyramid but that it considered the surface of a painting as a lateral plane located somewhere in between this pyramid's apex and base. Alberti was the first to define images as interposing grids able to organize the contingencies of the visible world within a meaningful structure of measured planes, lines, foreshortenings, and vantage points.

As is well known, Alberti's window metaphor prepared the way for the revo-

lutionary breakthrough of linear and artificial perspective during the Italian Renaissance. Though Renaissance theorists and artists developed more than one notion of linear perspective, its general concept quickly came to conquer Western and non-Western image production in the name of objectivism, rationality, and scientific abstraction. And though we can find pockets of resistance against its growing hegemony in Baroque art and seventeenth-century Dutch painting,[5] the principles of artificial perspective were soon to be seen as an accurate template of how our eyes and brains perceive the world. As W. J. T. Mitchell notes, the effect of Alberti's invention was "nothing less than to convince an entire civilization that it possessed an infallible method of representation, a system for the automatic and mechanical production of truths about the material and mental worlds," the best index of its success being the extent to which artificial perspective denied its own constructedness and presented itself as a natural record of the visible world.[6]

Leonardo da Vinci famously extended Alberti's groundbreaking notion by suggesting that "perspective is nothing else than seeing a place behind a pane of glass, quite transparent, on the surface of which the objects behind the glass are to be drawn. These can be traced in pyramids to the point in the eye, and these pyramids are intersected by the glass plane."[7] Whether we call perspective—with Erwin Panofsky—a "symbolic form"[8] or—with Marshall McLuhan and other later theorists—simply a "medium,"[9] the decisive aspect of how Renaissance artists and theoreticians legitimated their new practice was to emphasize their technique's constitutive transparency and invisibility. For them, the geometric laws of perspective were able to record accurate representations of space because—following the window metaphor—they provided a see-through schema of looking at the world. In order to present things the way our eyes see them, good pictures favored product over process. They privileged the singular and seemingly effortless instant of representing petrified time over the durational temporality and labor of capturing phenomena in flux. The painter's principle task was to conceal his technique and thus erase the viewer's awareness of the very materiality of the picture plane. No line or brush stroke could claim a life of its own other than enabling allegedly natural and undistorted acts of perception. In this way, the early modern mathematization of space, which allowed the modern subject to view and control space from a single, monocular, detached, and seemingly disembodied vantage point, went hand in hand with an understanding of images as erasive media of representation.[10] What qualified images to present objective records of how our eyes see was the extent to which they succeeded in effacing their own status as

Albrecht Dürer, *Man Drawing a Reclining Woman* (1538). Courtesy of the Department of Special Collections, General Library System, University of Wisconsin–Madison.

media. And what allowed them to achieve impressions of order, control, and immediacy was their paradoxical ability to construct the act of viewing as one categorically removed from the vicissitudes of time and space, as one able to project itself into the world precisely because it was placed outside the contingencies of duration and the opaque unpredictability of the human body.

Good media, so the bottom line of Alberti's and da Vinci's defining use of the window metaphor, are not only self-effacing media, they also purify the visual field from the untidy temporality and corporeality of the beholder. Good media grant realistic perceptions and illusionary representations of the world because they situate the viewer as a disembodied observer outside of the space of the observed. Albrecht Dürer's perspective machine of 1514, as well as his famous drawing of a contemporary perspector drawing an image of a reclining female nude, illustrate the extent to which Renaissance culture considered disembodied sight not as a strategy of disempowering the observer but on the contrary, as a mechanism of endowing the viewer with sovereign power over the visual field. His eye arrested by a vertical stick, Dürer's draftsman scrutinizes his model through the lattice of an observational window, his hand simply copying the "image" that he sees through the windowpane onto a piece of paper marked with a matching grid. The draftsman's gaze and body are shown as serenely unaffected by the object of his look. Stick and window-grid define his space as one devoid of the messy vagaries of desire, as one in which scientific objectivity also manifests itself in radical isolation from the permutations of the natural world as they exist outside of the room's two windows. As facilitated by the window's frame and grid, geometrical perspective here not only

produces what seems to be a methodical and hence accurate representation of the world, it also defines the observer as a rational, scientific, attentive, and hence more-human-than-human soul whose vision approximates how God himself would contemplate the ephemeral spectacle of human existence.

We can barely underestimate the importance of Alberti's thoughts on windows, images, and perspective for the development of post-Renaissance codes of seeing and realistic illusion. Alberti's model of the window energized a culture already prone to privileging vision as the most trustworthy source of truth and knowledge as much as it helped buttress, from the seventeenth century onward, the invention of the modern subject as a Cartesian ego eager to disregard its senses in order to contemplate, map, and control space from the detached vantage point of modern rationalism. What is of no less importance, however, is how the early modern conception of images as transparent media in turn affected our very notion of the window itself. In post-Renaissance painting, for instance, the motif of the window was a stock element used to separate places of contemplation, of detached introspection, of protective domesticity, and later of romantic longing from the exterior world's hustle and bustle, its sensual lures, its impermanence, its lack of order and control.[11] Similarly, in narrative fiction windows often came to serve as textual devices aimed not only at framing suspense and producing mystery but also at separating the very space of writing—the interiority of the writer's creative mind and the sovereignty of his or her imagination—from the exteriority of the real: a more or less transparent margin of experience at once protecting the aesthetic subject against the pandemonium of existential relations and animating its desire to project structure, meaning, and narrative order into the world.[12]

Framing Attention recalls a series of snapshots from the complex story of how, beginning in the first decades of the nineteenth century, windows came to lose their alleged power to project geometrical perspective into space. Romantic genre painting around 1810 and fictional texts such as E. T. A. Hoffmann's 1822 "My Cousin's Corner Window" still employed windows as mechanisms reliably framing the world and defining the viewer as a sovereign onlooker. This book, by contrast, focuses on how, at some point in the 1830s and 1840s, windows started to forfeit their material and metaphorical credibility as media able to produce objective truth and timeless knowledge, to separate the intimate and the public, to emancipate observers from seeing their own seeing as part of the visual field, and in this way to define the viewer as a rational soul whose senses would not affect, or be affected by, the very objects of his or her look. As we will see in each chapter of this study, this process was far from unified

and linear. It triggered all kinds of polemical responses and hostile counteractions. But what will be in the center of this book is how certain media and their users, rather than simply denying the loss of stable perspectives on the real, actively embraced the modern window's reconfiguration of sight, no matter if they did so in the hope of intensifying or containing the sudden contingency of vision, of further decentering or of reinscribing former certainties. Though the rule of linear perspective may have not been as dominant prior to the nineteenth century as some of its theorists have suggested, this book chronicles its simultaneous demise and reinvention in the wake of the development of new windows and frames of image production since the emergence of industrial culture. How, so the first set of questions pursued in this book, did fenestral innovations such as the photographic image and the proscenium stage, the film screen and the television tube, the modernist architect's panorama pane and the subway's moving, albeit dark, window glass, usher their users beyond the dominance of Alberti's grid, situate the viewing subject as an embodied observer within the transitory temporality of the visual field, and hence draw their awareness to their media's own nontransparent materiality? And to what end and extent did, so my second set of questions, these inventions and their users, rather than advocating the pleasures of the new, seek to reframe the modern destabilization of sight so as to redeem the older window's promise of naturalistic illusion and scopic sovereignty, to maintain spatial boundaries and mental maps, and in so doing render frames and windows of perception transparent once again?

The Dialectics of Attention

There is clearly more than one way to account for the disintegration of stable viewing positions and perceptual reliability in modern culture, and *Framing Attention* will draw on a variety of sources in order to map out this process. Walter Benjamin's seminal argument about the industrialization of perception provides one important theoretical tributary for this study. Following the work of Georg Simmel, Benjamin argued that the rise of the modern resulted from two distinct influences. On the one hand, the unprecedented and potentially traumatic acceleration of life led to a concomitant mobilization of sensory perception. Urban traffic, factory halls, department stores, increasing communication speeds, and new modes of travel, as they emerged in the middle of the nineteenth century, confronted the subject with discontinuous visual stimulations and shock-like impressions, causing bourgeois city dwellers as

much as proletarian machine workers to raise their level of consciousness as a defense against this barrage of fragmented stimuli. Modern seeing and perception, according to Benjamin, are inherently nervous and distracted. The viewing subjects of industrial modernity register discontinuous impulses as isolated perceptual events, which they no longer are able to synthesize into meaningful experiences across time.

On the other hand, the advent of modern technologies of reproduction—of media to inscribe, archive, and disseminate traces of human presence—dislodged former frames of spatial reference and temporal linearity. Photography, phonography, telephony, and finally film: all do more than cater to the modern subject's at once heightened and fundamentally distracted forms of attention, they emancipate people and things from the strictures of time and place, displace traditional hierarchies of proximity and distance, and hence destroy premodern modes of sensory perception. In Benjamin's understanding, the rule of modern media overthrows the possibility of contemplative reverence for the uniqueness of certain things. In the age of film, that most advanced window of reproduction during Benjamin's own lifetime, to be able to switch one's attention instantly from here to there, from now to then, becomes the norm, such that no frame of reference can pretend to validate timeless maps and sovereign perspectives. Modernity, for Benjamin, is a non-place, designed for and inhabited by endlessly mobile and distracted viewing subjects, but far from mourning the loss of solid orientations, Benjamin wants us to understand the modern's drive toward ceaseless temporal and spatial displacement as a source of liberation, as an opportunity to invent new postbourgeois collectivities: "Our taverns and our metropolitan streets, our offices and furnished rooms, our railroad stations and our factories appeared to have us locked up hopelessly. Then came the film and burst this prison-world asunder by the dynamite of the tenth of a second, so that now, in the midst of its far-flung ruins and debris, we calmly and adventurously go traveling."[13]

The second important tributary informing this study is more recent work done on the physiology of perception of the nineteenth century and its shifting conceptualizations during the twentieth century, by Jonathan Crary and Mary Ann Doane, among others.[14] Though Crary's Foucauldian premise is not without its problems, it is one of the merits of his research to have rediscovered a body of scientific writing in nineteenth-century culture according to which vision no longer was seen as disembodied, monocular, and atemporal but as active, subjective, and inextricably bound to the transient temporality of the observer's body. Manifested in the work of (mostly German) poets, phi-

losophers, and scientists such as Johann Wolfgang Goethe, Arthur Schopen-
hauer, Johannes Müller, and Hermann von Helmholtz, nineteenth-century
thought on vision departed from what Crary calls the camera obscura model,
that is, the early modern conception of sight that—in analogy to Alberti's win-
dow—situated the observer as a privatized, albeit sovereign, individual whose
acts of vision were in no way related to his existence as a sensory being. Yet in
defining vision as a process actively lodged in the corporeality of the observer,
modern culture at the same time produced a body ridden with fundamental
anxieties, a body taught not to trust its own senses and therefore confronted
with a new language of perceptual failure, imperfection, and insufficiency.[15]
If we want to examine the modernization of sight since the mid–nineteenth
century, we also need to focus on the psychological pressures caused by the rise
of subjective and embodied vision. And even though the proliferation of new
media such as photography and, later, cinema came to play a key role in the de-
stabilization of the Renaissance model of vision, we cannot ignore the fact that
these very media were often introduced and used as prosthetic contraptions
compensating for the very flaws of corporealized vision, as improved windows
of representation providing bodies prone to error with superior frames of spa-
tial perception and with reliable archives of the past.

The central feature of modernity and modernization, as I understand them
in this study, is an unprecedented increase in and struggle with experiences of
contingency. What I mean by contingency is the modern's drive toward on-
going change and self-redress, its uncoupling of the present from the past, its
stress on historical transformation and malleability, its privileging of chance
and opportunity over destiny and fate. Contingency is both a product of and
a point of resistance against increased rationalization and secularization. It
seems to offer the subject a liberation from the burdens of tradition, a life
of splendid immediacy, mutability, and multiplicity. As Doane writes, "Time
becomes heterogeneous and unpredictable and harbors the possibility of per-
petual newness, difference, the marks of modernity itself. Accident and chance
become productive."[16] But the triumphs of contingency and chance also pro-
duced unprecedented fears over entropy, arbitrariness, and meaningless, ne-
cessitating the individual to find ways to preclude experiences of perceptual
disintegration vis-à-vis the multitude of possible distractions. Two basic, and
dialectically related, responses seemed possible to handle this perceptual crisis.
Either the subject engaged in a willful and dramatic sharpening of attention
with the goal of achieving eternal presentness. In order to maintain perceptual
synthesis and not be overwhelmed by contingent stimuli, the individual had

to learn how to isolate certain elements in the sensory field at the expense of others but also how to switch discontinuously from one impression to another. Or the modern viewing subject, fatigued by the challenges of maintaining an ordered and meaningful world, could seek to evacuate presence altogether, forfeit heightened alertness, and slide into a seemingly unproductive, albeit not necessarily unpleasurable, state of drift, understood here—per Leo Charney—as "an ungovernable, mercurial activity that takes empty presence for granted while maneuvering within and around it."[17]

This leads me to the third stream of thought feeding into this book's account of perceptual transformations in modernity, namely the notion that the rise of the modern, at least in its Western variation, went hand in hand with a massive expansion of spectacular elements in processes of social integration and political legitimation. Though modernist art actively explored anti-figurative and iconoclastic methods of representation, industrial modernity cannot be contemplated without its gradual transformation into a full-blown society of the spectacle, a society systematically enlisting the modern observer's perceptual mobility, distraction, and embodiment in order to remake the glue of human relationships. Spectacular capitalism, on the one hand, had little tolerance for distant and disembodied onlookers. It exchanged panoptic corner lookouts for dazzling display windows, thereby situating the perceiving subject amid—not in objectifying and hence unaffected distance to—the spreading circuits of commodity exchange. As importantly, however, the spectacle on the other hand also served as a mechanism containing possible anxieties about the mutability of meaning and identity in modern society. Its role was to contain disquiet about the anarchic noise of the real and redefine a shared sense of stability and orientation amid the frenzy of progress. Though it capitalized on the modern viewing subject's distraction, the spectacle promised to sooth the agonizing dialectic of attention and distraction that haunted the subject with an ongoing sense of crisis.

Taken together, then, the function of the modern spectacle was far more complicated than simply the conversion of a nation of Cartesian souls into a unified mass of sentient consumers. Instead, what I understand here as the spectacle of modern life inaugurated a new method of breaking certain bonds of solidarity so as to redefine modern communities as aggregates of highly individualized and isolated entities. The spectacle unified the separate as separate, it simultaneously entertained and placated the viewer's senses with compelling simulations of meaningful collectivity. But rather than merely describing a society in which omnipotent culture industries privileged sight over other

modes of perception, the spectacle redefined the entirety of social relationships in terms of the inherent logic of framed images, whether still or moving. As a system producing distracted and lonely crowds, the spectacle simultaneously animated and undermined the subject's desire to become part of a larger picture. What captured and distracted people's sense perception was not only a world filled with an abundance of radiant commodities but also one that itself was about to become a commodity and allowed the individual to see nothing but objects of consumption, including itself. As Guy Debord has famously written, "The Spectacle is *capital* accumulated to the point where it becomes image."[18]

The following chapters aim at recalling how modern media and their users negotiated the volatile force field of perceptual distraction, attention, drift, and spectacle as it emerged in the nineteenth century. Their focus is on how new windows of representation energized, but often also recontained, the experience of modernity as a state of increasing contingency and flux. One of my central premises in this endeavor is that the digital windows of our own present, even though they might have the potential to undo some of the notions of selfhood, subjectivity, and identity essential to earlier theories of perceptual modernization, continue to confront—and overwhelm—us with the modern problem of attention. Even though computer users today invent images of themselves, fashion performative subjectivities outside former oppositions of activity/passivity, and participate in a radical decentralization of the production and consumption of cultural material,[19] we still live in a universe largely defined by how modern industrial and consumer societies sought to engineer people's distraction and direct their attention. It is by exploring our perceptual past that *Framing Attention* hopes to learn more about the framing of our seeing in the present, and it is by engaging with the spectacles of our own present that this study intends to reframe how people saw and theorized their seeing in the past.

Cultures of the Interface

"Whoever leads a solitary life and yet now and then wants to attach himself somewhere," Franz Kafka noted in a little vignette, "will not be able to manage for long without a window looking on to the street."[20] At first, Kafka's observation merely seems to continue an established tradition according to which the window figures as a site of both loneliness and longing: a frame at once manifesting our existential isolation and mobilizing our hope to transcend our fate,

a conduit of imaginary transport and self-transformation, a means of reconnecting the viewer's mind and emotions to some kind of imagined community "out there." But the true import (and modernity) of Kafka's vignette lies in his peculiar understanding of the word "attach." For to attach or re-attach the window-user to the world of the street, for Kafka, does not simply imply an act of spiritual, psychological, or emotional self-transcendence—or our desire thereof. On the contrary, what Kafka means when speaking of attachment is a process of displacement in which the window immerses the observer somatically into the fleeting movements of the street. Kafka's window, far from merely appealing to what is abstract and distanciating about our sense of sight, transforms vision into something that affects our entire body, that can be physically felt, and that has the ability to set into motion even the most sedentary viewer. While some might use the window in order to pursue the voyeuristic pleasure of distant observation, the window's most salient function is to dynamize the place of viewing by situating the viewer as a sentient being in the commotion of the street. Its most relevant function is to enable empathetic forms of looking, allow us to experience ourselves and our bodies as others, and precisely in this way prepare the ground for our reentry into society. Even when, as Kafka's text concludes, our window-user "is in the mood of not desiring anything and only goes to his window sill a tired man, with eyes turning from his public to heaven and back again, not wanting to look out and having thrown his head up a little, even then the horses below will draw him down into their trains of wagons and tumult, and so at last into the human harmony."[21]

The English noun *window,* or *windowe* as it was called in Middle English, derives from the Old Norse *vindauga,* a compound fusing *vindr* for wind and *auga* for eye and thereby defining windows as openings for the simultaneous admission of air and light. What the etymology of *window,* in its mingling of tactile and visual dimensions, in fact denotes is a perforation appealing to multiple registers of sensory perception at once—a site of synaesthetic experience at which the boundaries between our faculties of sight and touch are fluid. Though we have come to think of industrial modernity as an age largely privileging the eye over other organs of perception, Kafka's hope for (re)attachment recalls the window's early meanings. Ignoring for a moment that the German *Fenster*—an heir to the Latin *fenestra*—follows a different etymology, the window of Kafka's text describes an opening that can help sight bring viewers literally in touch with each other and produce bodily responses to the movements of objects across the visual field. Like the Old Norse "wind-eye," Kafka's window provides a site not simply of bi-directional transaction but also of sensory

and synaesthetic immersion, one where you can see with the entirety of your body, and one where your body turns into an eye at once taking in the world and delivering us to the world's unstable spaces and temporalities.

In recalling the window's past, Kafka's text returned his readers to the present and future. For how can we think of Kafka's street window and his desire for sentient attachment and immersion without thinking of what the new window of film during Kafka's own lifetime did to how people looked at and responded to the sight of moving images. In 1934, Erwin Panofsky described the effect of cinema on the observer as a dynamization of space and a spatialization of time. In a movie theater, Panofsky wrote, "the spectator occupies a fixed seat, but only physically, not as the subject of aesthetic experience. Aesthetically, he is in permanent motion as his eye identifies itself with the lens of the camera, which permanently shifts in distance and direction. And as movable as the spectator is, as movable is, for the same reason, the space presented to him. Not only bodies move in space, but space itself does, approaching, receding, turning, dissolving and recrystallizing as it appears through the controlled locomotion and focusing of the camera and through the cutting and editing of the various shots."[22] Kafka's look through his apartment window is that of a moviegoer in disguise. Though his body might be safely installed behind the window frame, his senses are all in motion, attracted by and immersed in the movements that take place in front of his eyes. What Kafka's observer experiences is a potent dynamization of space in whose wake acts of observation lose any sense of Albertinian distance and purifying abstraction. Rather than endow the viewer with fantasies of scopic sovereignty and god-like control, Kafka's (cinematic) window defines the moving world beyond the frame as a prosthetic extension of the viewer's body as much as it situates the observer as this tumultuous world's prosthesis. To use contemporary parlance, in recalling the synaesthetic past of window-gazing for the age of cinematic sight, what Kafka does is to envision the window as an interface, a device not merely framing and ordering our view of the world but also allowing for reciprocal sensory contact between the human body and a world of unsteady representations. What Kafka does is to define the modern window as an intermediary in whose frame bodies, machines, and nonhuman objects can meet and establish sensory attachments and transformative relationships—relationships at once virtual *and* immersive, contingent *and* transitory, mobile *and* mobilizing, perceptive *and* projective, private *and* public.[23]

Had Kafka lived to our age of digital networking, he would no doubt have found himself wondering about the way computer screens have today taken

on the legacy of what he experienced in face of the street window. And notwithstanding his known aversion to the dislocating speed of modern means of communication,[24] Kafka would have certainly noticed that our understanding of the computer screen as a window is by no means as unified and monolithic as some of its industrial developers (and academic advertisers) would like to suggest. Because our own daily experience of windowed graphical interfaces energizes much of what will be said in the following chapters, it is warranted at this point to outline the two most influential paradigms of the human-computer interface. Though conceptualized by computer scientists primarily in the early second half of the twentieth century, these two paradigms continue to inform how we approach and can think through the multiplication of window frames and interfaces after the digital revolutions of the 1990s, this latest modernization of the Old Norse wind-eye.

Pressed by industry concerns and consumer demands for user-friendliness, we have come to think of the computer interface mostly as a screen or virtual space allowing for either disembodied but interactive or vivid but passive forms of human-machine transactions. Interfaces work best—allow for the highest degree of haptic immersion—a common assumption runs, if they either render themselves entirely invisible or mimic older, familiar work or entertainment environments and thus become almost imperceptible, the desktop icon here being the perhaps best known example. In a 1965 essay on the future of computer displays, Ivan E. Sutherland resorted to nothing other than Alberti's window metaphor to describe this dream of total interface transparency: "One must look at a display screen as a window through which one beholds a virtual world. The challenge to computer graphics is to make the picture in the window look real, sound real, and the objects act real."[25] For Sutherland, the inventor of "Sketchpad," the first graphical user interface, computers were meant to communicate directly to their users' senses by drawing attention not to themselves but solely to the image space they were designed to summon. In Sutherland's perspective, simulation of the real rather than mere illusion, sensory immersion rather than mere representation defined the royal road to making our use of the computer's artificial intelligence most effective. In his 1970 book *Expanded Cinema,* Gene Youngblood took up Sutherland's ideas for the purpose of envisioning new osmotic relationships between viewers and cinematic images. Youngblood's expanded cinema was to transport thoughts, emotions, and intensities without intermediary codes, signs, or processes of communication; it was meant to access the viewer's brain directly so as to create simulations of the real with no visible outside. Like Sutherland's visionary

window, Youngblood's futuristic cinema was to yield experiences of total immanence and enable a seamless incorporation of the viewer into the computer's image space. Independent of what they presented to the viewer, the interfaces of both Sutherland and Youngblood not only aimed at communicating messages without grammar and codes, they also sought to revolutionize the structure of aesthetic experience itself. The ultimate computer, Youngblood concluded, "will be the sublime aesthetic device: a parapsychological instrument for the direct projection of thoughts and emotions."[26]

Sutherland and Youngblood envisioned interfaces as surfaces, places, or spaces of contact between computers and human users with the primary purpose of either making users believe that whatever they did to affect visual representations on screen also moved some kind of real entity or allowing virtual worlds to achieve unmediated effects on the user's perception. Both conceptions envisioned the ultimate interface as a self-effacing conduit that, by collapsing any sense of difference and alterity, enabled spontaneous and hence very efficient contact between human and computer. In both conceptions, users could relate to or immerse themselves into the world of machines without knowing anything about their formal operations. Interfaces promised to operate best whenever they stimulated acts of mystical communion between the user's and the machine's bodies (and souls).

Though this model of the interface has profoundly informed the itineraries of computer scientists ever since, it was certainly not the only model developed in the early days of interface design to envisage the way in which future users should relate to the computer's window on images, sounds, data, and memories. Consider the pathbreaking work and visions of Douglas Engelbart, pursued with a small team of highly talented researchers at the Stanford Research Institute in the early 1960s. Though essential for the later development of the mouse, the windowed user interface, and the hypertext format, Engelbart's initial research at SRI ran counter to the mandates of user-friendliness and sensory immersion. Instead, his vision for the future of personal computing was guided by concepts such as coevolution and coadaptation, that is, the idea that technological improvements would transform the user's capabilities to think, feel, and manage complexity; that the development of new computing systems would go hand in hand with the augmentation of new forms of human intelligence and gesture; and that hardware and software designers, by inventing new forms of artificial intelligence, would also reinvent the human user rather than merely cater to presumed needs and existing forms of cognition and sensory self-expression. According to Thierry Bardini, "Engelbart's work was based on

the premise that computers would be able to perform as powerful prostheses, coevolving with their users to enable new modes of creative thought, communication, and collaboration providing they could be made to manipulate the symbols that human beings manipulate. The core of this anticipated coevolution was based on the notion of bootstrapping, considered as a coadaptive learning experience in which ease of use was not among the principal design criteria."[27]

Unlike Sutherland and Youngblood, Engelbart did not envision the computer's screen as a device empowering the untrained to manipulate data or experience sensory stimulations in more efficient ways. On the contrary, for Engelbart the user was supposed to employ future computing technologies in order to develop new ways of thinking and of exploring his or her own bodily identity. Whereas Sutherland's work sought to situate the computer as a popular and intuitively commensurable window of communication, Engelbart's research was driven by Enlightenment notions of individual learning, growth, and change. Rather than absorb the viewer through self-effacing operations, the interface in Engelbart's work was considered as a representational window with which software and hardware designers were trying to construct the shape of future users, and future users were invited to test and improve these constructions like actors playing roles in a stage play. What Engelbart considered the interface represented the designer's efforts to coevolve technology and the human subject. It was not meant to provide mystical experiences of total reciprocity between humans and machines but on the contrary, to represent a tangible third space of symbolic and physical transactions different from both the space of the user and that of the computer. Whereas Sutherland and Youngblood sought to define computers and users as the respective other's unmediated extension, Engelbart conceived of the interface as a site where users could become other without losing a sense for what made them different from the machine. Opposed to dominant templates of user-friendliness, Engelbart envisioned the interface as an artificial limb, bridging but never closing the gap between the organic and the artificial—a performative space in whose window ongoing acts of negotiation provided the condition for the possibility of insight and self-transformation.

This is not the place to engage in a long discussion about how computer engineers, since the 1960s, have sought to convert Sutherland's and Engelbart's visions into effective hardware configurations. Nor can I provide an overview here of how software developments since the early 1980s have relied heavily on the window metaphor to redefine the computer screen's space of representation

and immersion, and of how the model of the windowed graphical interface has come to reshape all kinds of other domains of communication, including the display of news items on conventional television programs with the help of multiple insert screens, data tickers, and hyperlinks. Let it be noted, though, that in our daily interactions with computer screens, we often find ourselves vacillating between competing conceptions of the interface. While individual software programs capture our senses with ever more detailed simulated environments, such that we, like Benjamin's moviegoer, feel that we can indeed enter the screen and go calmly and adventurously traveling, the multiplicity of open windows across the space of our screen cannot but draw our awareness to the very framing of the virtual. While each window on our desktop asks us to attach ourselves—like Kafka's onlooker—to a distinct world of simulated immersion, no single window can by itself completely dominate our perception and identification. Windowed interfaces, as they now govern the look of our computer screen, treat "a page as a collection of different but equally important blocks of data such as text, images, and graphic elements."[28] In this, they dramatize the dynamization of space and the spatialization of time that Panofsky saw as the essence of cinematic representation, but they also open up new territories in which modernist principles of montage and popular standards of visceral identification begin to coexist in uncontested simultaneity.

Sutherland wanted the screen to vanish from our awareness so as to enable the most effective manipulation of data, whereas Engelbart wanted us to witness the frame of representation—the interface—for the sake of actively negotiating new boundaries between body and machine. We must think of today's window users as beings curiously able to do both at once: establish empathetic relationships to the world of representation and approach this world with a quasi-Brechtian attitude of self-reflexivity and distanciation. Like channel zappers, today's window users tend to inhabit multiple universes of symbolization at once. Surrounded by ubiquitous human-computer interfaces, we have learned how to live parallel lives, to shift our attention fluidly among vastly different sites of attraction, to experience space and time as inextricable hybrids, and, often, to find no essential difference between understanding the screen as our body's extension and experiencing our own senses as a machine's prosthetic limb.

Windows on Modern Germany

This book recalls how various window configurations in modern German culture anticipated our experience of the windowed computer interface, much

as it seeks to remind the reader of alternative concepts of the modern window. In order not to build up false expectations, however, let me emphasize at this point that here there is nothing particularly "German" about windows and what I understand here as their modernization since the mid–nineteenth century. The German territories became centers of glass-making after the disintegration of the Roman Empire—and hence a good location to refine the essential ingredient of the premodern window—but similar hubs of glass-production existed in northern France and England.[29] Expressionist and later Bauhaus architects toyed with new concepts of the house as a framing device, but modernist visions of the house as a mobile viewing machine emerged with equal force in other national contexts as well. Though somewhat ahead of the game in the earliest stages of research, the inauguration of German television significantly lagged behind this electronic window's advent in other Western cultures. And in spite of the fact that German engineers and inventors may have played a considerable role in the development of photographic reproduction, motion photography, and the public projection of moving images, there is little reason to consider their story a peculiarly German one. To paraphrase Lemony Snicket, if you are interested in a story about the "exciting and memorable" adventures of the German window, with plenty of happy and heroic happenings in the beginning, middle, and end, you would probably be better off reading some other book—one still to be written.[30] Whether you see this as unfortunate or not, there is in fact no such thing as a peculiar German window, no German *Sonderweg* of fenestral innovation to tell, and for this reason I do not hesitate to focus on a series of figures in this book—Hugo Münsterberg (chapter 3), Nam June Paik (chapter 6), Sir Norman Foster (chapter 7)—whose work helped shape the German window landscape but who weren't themselves Germans at all or resided abroad.

And yet, this book's choice of German culture as a setting for the modernization of the window is far from arbitrary. Rather, this choice is meant both to counteract a certain lacuna and prejudice in German studies and to draw attention to the rich tradition of German critical thought on perception, vision, and aesthetics as a useful source to illuminate our own digital era. German culture studies has often located the most galvanizing resources of modern German identity in linguistic and acoustical properties. Whether the focus has been on the tessitura of the German language, the literary ruminations of high-brow novelists, or the sounds of prodigious German composers, a long tradition of writing on modern German culture has considered textual and musical materials as the principal avenues to the nation and its historical

transformations. This writing at the same time echoed negative judgments about the power of images and visual perception that were shaped not least of all by the eighteenth-century Enlightenment. As both Martin Jay and Barbara Stafford have argued, the German variant of Enlightenment reason emphatically denigrated the consumption of images from the vista of a semi-official hermeneutic of the interpretive word.[31] Images were not only seen as merely ornamental, as sources of deception and blindness, in constant need of textual interpretation and control, they were also excluded from what was supposed to fuel the project of bourgeois emancipation and political reform. In the wake of this Enlightenment critique, visual experience throughout the past two centuries has routinely been theorized as hazardous to democratic will-formation, progressive change, and individual self-determination. Because visuality—so the argument runs—undercuts rational debate and conceptual understanding, because it thwarts any successful articulation of private concerns in the public realm, and because it facilitates a dangerous colonization of individual pleasures and emotions through the agents of power and commodification—because of all this, the history of sight in modern Germany has mostly been seen as a history hostile to the emergence of a liberal, democratic, and diverse body politic.

There are surely good reasons to question the role of vision in processes of political legitimation. As we will see in chapter 5, for instance, the National Socialist regime relied heavily on sight, mechanical images, and spectacular self-representation in order to pursue its heinous agendas. But universalizing critiques of all public visuality as anti-rationalist and potentially fascist level all historical nuances. They also fail to consider the often peculiar and unpredictable ways in which historically situated viewers see, appropriate, or ignore images and frames circulated from "above." The following chapters draw a more complex picture of how shifting notions of sight have been implicated in larger political struggles. Their point is not only to address historical abuses of the visual field in modern Germany, abuses that would add grist to the mills of iconophobic stances, but also to investigate the potential virtues of framed views and visual perceptions as ways of communicating experience across dominant divisions of public and private. Instead of demonizing the visual, this study hopes to sharpen our awareness for the many ways that new frames of looking transformed social practices and changed how people conceived of themselves and the world around them. Though we will encounter many an attempt to naturalize and hence dehistoricize the mediated character of modern vision, one of the primary purposes of the following study is to re-

store the historical index of certain fenestral innovations: to reconstruct how various discourses in Germany tried to refute or make sense of certain technologies of seeing and how, in doing so, these discourses turned technological innovations into engines of the historical process. For this reason, it is no coincidence that we will repeatedly return to what I consider a new window's originary moment, its moment of technological and discursive crystallization, for it is the moment when we experience new media as still new that some of its most essential promises and threats, utopian appeals and causes for anxiety, can be most clearly perceived.

What makes the history of "enframed" viewing in modern Germany interesting and paradigmatic is not that German scientists, engineers, and inventors designed certain prostheses of sight long before anyone else. They simply didn't. Instead, what makes this history interesting is that the technologization of sight unfolded in an extraordinarily rich discursive context, one in which scientists and aestheticians, psychologists and physiologists, intellectuals and politicians, artists and patrons, entrepreneurs and consumers continually battled over the meaning of seeing and over the peculiar operations, ethics, and economics of visual attention in modern life. This book is partly about restoring the vivid historical milieu—the interplay of different technological inventions, everyday practices, political mandates, and critical discourses—in which the modernization of sight has taken place since the mid–nineteenth century, and we draw on witnesses as diverse as Johann Wolfgang Goethe, Arthur Schopenhauer, Johannes Müller, Hermann von Helmholtz, Robert Vischer, Richard Wagner, Konrad Fiedler, Heinrich Wölfflin, Hugo Münsterberg, Helmut Plessner, Ernst Jünger, Walter Benjamin, Albert Speer, Oskar Schlemmer, Theodor W. Adorno, and Günter Anders in order to map out the modern battles over fenestral looking and the framing of attention. Much can be learned from their accounts and arguments, I suggest, about our own cultures of the interface. The global hegemony of Microsoft's Windows operating system might be a peculiar product of postindustrial North America and its mobile alliances between local research cultures and flexible capitalist accumulation. But it is in the opulent body of work on the physiology, aesthetics, epistemology, anthropology, and politics of seeing, as produced during the past two hundred years in Germany, that we can find ample material to think through how we got to where we are today—and what we may have gained and lost along the way.

Framing Attention reconstructs this history in a series of often highly specific case studies. In chapter 1, I take a close look at Adolph Menzel's famous

painting *Balcony Room* (1845) in order to develop in further detail what I consider the notion of the modern window. Chapter 2 discusses the politics of Richard Wagner's theatrical innovations—his influential use of the theater's proscenium as a window of empathetic transport and transformative illusionism. The argument of this chapter draws on a critical investigation of the role of sight in *Die Meistersinger von Nürnberg*, particularly in its original staging in Munich in June 1868. The task of chapter 3 is to examine the way in which Emperor Wilhelm II embraced the new medium of film as a modality—a window—of imperial geopolitics around 1910, especially how cinema's dynamization of space provided new possibilities of providing political power with legitimacy. In chapter 4, I investigate how writers, poets, and intellectuals encountered Berlin's many new subway windows during the 1920s as peculiarly modern, albeit profoundly unsettling and potentially subversive, conduits for obscured views and obstructed exchanges. As it follows a diverse cast of characters into Berlin's underground, this chapter recalls a compelling alternative to the cult of distraction, velocity, spatial shrinkage, and temporal disruption often associated with both conventional railway transport and cinematic viewership. Chapter 5 examines the orchestration of sight and visibility during the Nazi era, paying special attention to how Adolf Hitler and his image designers used architectural window settings, the framing power of photography, and the seemingly frameless effects of his voice in order to fashion and refashion his public appearance. A 1963 Wuppertal exhibit of Korean-born video artist Nam June Paik is at the center of chapter 6. Its principle aim is to recall how in West Germany the advent of television's electronic window was welcomed and feared as a fundamental assault on the separation of public and private, exterior and interior spaces. And in chapter 7, the focus is on Sir Norman Foster's renovation of the Berlin Reichstag building. How, I ask, does Foster's glass dome on top of the building reframe the terms according to which postwar public discourse negotiated the relationship between symbolic politics and visual culture, between the burdens of the past and Germany's political responsibilities in an increasingly global present? And, further, how does Foster's enveloping window engage a gaze for which the presence of graphical computer interfaces has become a powerful "a priori" for how we look at windows in the first place?

Though all seven chapters proceed within different historical contexts, technological histories, and discursive orders, what they all share is, first, the understanding of visual modernization as a process that, far from simply leading to an autonomization of sight, lodged vision in the interiority of a corpo-

real, mobile, and essentially distracted viewer, stressed the spatial and temporal contingencies of individual acts of perception, and hence elevated the problem of attention to the hallmark of experience. The second common premise of the pages to follow is that whatever makes modern visual culture modern cannot be understood in isolation from the various techniques of power that have come to exploit, discipline, reframe, or recontain the aleatory practices of subjective and embodied viewing, techniques whose primary purpose was to present cultural effects as natural so as to regulate the transformative energies of subjective looking. It is one of the defining trademarks of modern visual culture, as I understand it here, that within its own rhetoric, representations, and modalities it often sought to disavow its constitutive multiplicity and contingency and make—in Hal Foster's words—"its many social visualities one essential vision, or to order them in a natural hierarchy of sight."[32] Though we cannot think of modern visual culture without thinking of all the machineries and discourses that mediated and decentered vision, by the same token we also cannot afford to ignore how these machineries and discourses often turned vision into something measurable and calculable and how, in so doing, they sought to homogenize the fractured field of modern visual perception. For every modernist attempt to position the individual as an active and autonomous producer of visual experience, there was a project, technique, or institution that made use of subjective vision in order to subject the individual to improved measures of power and control. To speak of the modernity of modern visual culture, then, does not only mean to speak of how the human eye encountered the accelerated temporalities and unfixed spaces of industrial life. It also means to test the different ways in which modern society implicated visual perception in a double history of subjectification and subjugation—a history that at once brought about distracted ways of seeing the world and sought to refocus the viewer's sight, attention, and experience of contingency. Any attempt to chronicle the modernization of sight since the nineteenth century, as I undertake it in this volume, must be prepared to write history in the plural: as an unfinished story of ongoing ambiguities, conflicts, and contestations.

It is now time to open the curtains and take a look at what was seen—and what remained from sight—in the many windows of modern German culture.

1 | *Menzel's Rear Window*

To be sure, what we see in this image is not a window in the strict sense but a set of French doors, propped open to allow light and air to enter a sparsely furnished interior. Both wings of the door are shrouded in white curtains. A gentle breeze has taken hold of one of the drapes, lifting it up slightly and blowing it smoothly into the room. The other curtain is held in place by a chair, which presses against the open door in such a way that we can see the shadow of the door's frame like a silhouette on a rear projection screen.

Note that even though everything we see in this image owes its existence to the aperture of these French doors, the painter systematically refrains from doing what innumerable other paintings preceding and succeeding this one have done, namely invite the viewer to gain some kind of perspective on the exterior world. At first one might want to fault the curtain fabric for this obstruction of our gaze, this affront to our curiosity. But once we realize the peculiar nature of the painter's point of view, we must concede that merely removing the drapes would be of no help in clearing a path for our gaze. In painting the French doors from the location suggested by the composition, at no point could the painter's aim have been to make us wander beyond the perimeters of the room, whether these two curtains accidentally blocked his own view in the process or not. His aim was not to frame exterior realities and contain them into a stable image within the image but to cause our view to roam around within the interior itself and capture different frames of reference without—as we shall see—finding anything to rest our eyes on. Rather than provide a compass for our perception, the open, albeit oblique, breach of the door further unsettles

whatever could anchor our own view. No matter how many times we come to look at this painting, our view will never feel entirely at home in it. Instead, we are condemned to drift through the painting similar to the way in which the breeze seems to puff the curtain at the door into ever-changing and amorphous shapes.

Nothing, then, might be more wrong than to call this image a window painting; nothing more thoughtless than to see it in conversation with other paintings that had flooded the art scene since around 1810 and had turned the dialectic of structured interior and open window into a staple of Romantic as much as Biedermeier art. Think of paintings as diverse as Georg Friedrich Kersting's *Reinhard's Study* (1811) and *Caspar David Friedrich in his Studio* (1812), Johann Erdmann Hummel's *The Chess Game* (1818/19) and *Berlin Drawing Room* (1820–25), Carl Gustav Carus's *Studio Window in the Moonlight* (1820) and *Balcony in Naples* (1828/30), Caspar David Friedrich's *Woman at the Window* (1822), and Ludwig W. Wittich's *Living Room in Jägerstraße 43* (1828). What makes it difficult to see the painting under consideration here as part of this tradition is not only the apparent absence of a human figure whose gaze—as a proxy of our own—would either stray through the window's frame into the distance far beyond or turn away from the opening toward intimate scenes of domestic life. As importantly, it is how the painter's peculiar choice of point of view privileges the fragmentary, fleeting, decentered, and unseen over a visual language of closure, stability, symmetry, and the obvious; how his sketch-like style displays the home as unsettled and unhomely rather than as a secure springboard for imaginary travel or a sedentary fortress of bourgeois interiority; and how his composition refuses to frame and focus our attention and thus produce clearly legible vistas—all this seems to situate this painting squarely outside the borders of German and European window painting as it preoccupied the artistic imagination in the first half of the nineteenth century.

And yet, I am tempted to call our painting—Adolf Menzel's *Balcony Room* of 1845—perhaps the most important window painting of German nineteenth-century art, not because it allows us to understand a historical template through innovative defiance, but on the contrary because it redefined the entire concept of the window and its role in art. Menzel's *Balcony Room* at once exposes and explores the fact that windows in German culture circa 1850 are no longer what they used to be; they can no longer serve as an experiential valve between private and public spaces, nor can their geometric makeup supply image makers as much as viewers with reliable codes of realism, truth, and

Adolph Menzel, *The Balcony Room* (1845). Oil on cardboard, 58 x 47 cm. Nationalgalerie, Staatliche Museen zu Berlin, Berlin, Germany. Photo: Bildarchiv Preussischer Kulturbesitz / Art Resource, NY.

authenticity. Rather than simply supersede or merely ignore an established artistic genre and concern, Menzel's oblique doors and curtains bear testimony to the advent of a new template of visual apperception, of framing the viewer's attention, in which all that once was solid about window frames now suddenly melts into the air—that is, billows in transient, contingent, and random movements like our left muslin curtain fluttering in the breeze.

Menzel painted *Balcony Room* at the age of thirty. The room was part of Menzel's third-floor Berlin apartment in Schöneberger Straße 18, which he occupied together with his mother and sister from 1845 to 1847. Berlin was booming at this time, its population having doubled since Menzel's birth, its residential quarters sprawling into the fields and sandy grounds around the city's erstwhile boundaries. Though Schöneberger Straße was soon to become an integral part of the metropolitan fabric, during Menzel's residency it was still located at the messy interface between the urban and the rural: a place neither here nor there, a site of ongoing transitions and instabilities, a location at which the natural and the industrial would be experienced in uncanny proximity. Other paintings by Menzel from this period such as *Rear Courtyard and House* (1844), *View over Anhalt Station by Moonlight* (1845–46), and *Berlin-Potsdam Railway* (1845–47) provide compelling impressions of what residents would have seen near their dwellings: hybrid spaces at once temporalized and fragmented by the vectors of technological progress, scenes of increasing ambiguity and abstraction which seemed to bar a resident's desire to establish bodily relations to his or her surroundings. At this early stage of his career, long before becoming a celebrated painter of Prussian history and glory, Menzel's art was clearly inspired from the urban periphery's anarchy and uncertainty. His work of the mid-1840s, including *Balcony Room,* may be seen as an effort to articulate experiences of alienation and isolation vis-à-vis the time's abundant signs of change and disintegration. As importantly, though, this work also developed compositional principles able to visualize how the abstract, ambiguous, and alienating aspects of industrialization affect the process of sensory perception and attention itself. Rather than turning its back to the modern, Menzel's work around 1845 immerses itself into it, detailing how situated bodies can register precisely that which seems to shatter the body's unity and situatedness.

Menzel's *Balcony Room* confronted the canon and contemporary practice of German art circa 1845 on a double front. On the one hand, in its rejection of narrative and its turn toward the private and ephemeral, Menzel's sketch deliberately worked against the continued privileging of history painting in

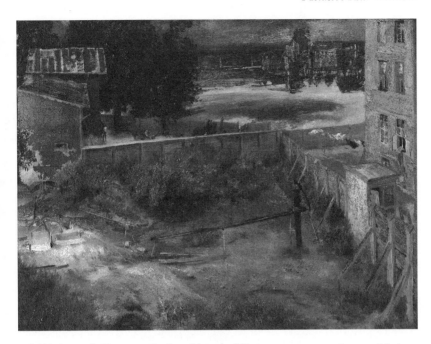

Adolph Menzel, *Tenement Backyard* (1844). Oil on canvas, 44.5 x 61.5 cm. Nationalgalerie, Staatliche Museen zu Berlin, Berlin, Germany. Photo: Bildarchiv Preussischer Kulturbesitz / Art Resource, NY.

mid–nineteenth-century Germany. Menzel's concern here is neither to venerate extraordinary historical events nor to display sweeping formal gestures emancipated from the vicissitudes of time but on the contrary, to capture the everyday in all its transience and render visible the temporality of representation itself. On the other hand, *Balcony Room* also had nothing in common with how leading architectural and landscape painters of Menzel's time such as Gärtner and Graeb glorified the city and its environs as spaces of visual comfort, order, and unquestionable belonging. What Menzel shows us is not the display value of bourgeois life and urban existence circa 1845 but rather how painting can come to display the visible in the first place, including that which exceeds the frames of the respectable—interior spaces in disarray, messy construction work in the backyard, the city's ambiguous night side.

By the time Hugo von Tschudi bought *Balcony Room* in 1903 for the Royal National Gallery and displayed the painting in the comprehensive retrospective of Menzel's work in Berlin in 1905, this dual confrontation had undergone

a radical change in meaning. Leading art critics such as Julius Meier-Graefe now not only celebrated *Balcony Room* as proto-impressionist and proto-modernist, they also saw good reasons for reconstructing Menzel's career as a declining path from daring genius to political compromise and formal stagnation. Though this revision of young Menzel's work aimed at challenging the painter's later obsession with depicting German history, Tschudi's and Meier-Graefe's interventions were clearly not free of patriotic interest and reverberation: "From this moment on, critical discourse constructed the dichotomy between Menzel 'the painter of Frederick the Great,' the history painter claimed by the Empire, and Menzel 'the Impressionist.' One could now argue that modernism, equated more often than not with French art, had legitimate beginnings in Berlin, and what is more, in the work of the Kaiser's most revered chronicler of the Prussian past."[1]

Much has been written in recent decades about the appropriation of *Balcony Room* for the construction of different narratives about Menzel's personal career and its relation to the political and national. It is therefore, perhaps, time to take a fresh look at the painting itself and emancipate *Balcony Room* from art historical debates about its canonicity and biographical significance. *Balcony Room* remains important, I argue in this chapter, neither because it opened an early window on German aesthetic modernism nor because it shut out spectacular views of heroic feats or bourgeois affluence, but rather because it redefined what may have counted as a window and as a representation of individual acts of attentive looking in the first place. It is on how *Balcony Room* modernized, not the history of German art but the notion of the window frame, of representation as a window onto the world, on how this painting offered a site to locate an effective reframing and industrialization of attention in the mid–nineteenth century that I center my focus in this first chapter.

Curtains/Veils

Adding a semilucent layer of white on top of a light gray background, Menzel used long vertical brushstrokes to visualize the curtain's apparent weightlessness. Though Menzel's brush work, here and elsewhere, is sketchlike in nature, we cannot avoid the impression of seeing in great detail every fold in the fabric as it is being conjured by the erratic energy of wind. Michael Fried has recently argued that the thematic of transfer and exchange between persons and things, bodies and objects, plays a fundamental role in Menzel's art throughout his career.[2] Whether it captures the sight of unmade beds or im-

posing uniforms, Menzel's art is one of mapping the traces of corporeal movements and positions. It reveals how human bodies animate their surroundings by imprinting themselves on the world of objects, and it urges the viewer to read the visible as a screen of subjective, bodily memory.

In *Balcony Room,* this constitutive thematic of the trace and the transfer is represented as a feature of the objective world itself, the billowing curtain providing a visible sign of the invisible, albeit animating, power of the breeze. Similar to the way in which a footprint in the sand indexes the former presence of moving body, so do the curtain's folds and bulges, their slight inward motion, embody that which we do not see here, namely the exterior world as it not simply intrudes on the private, but literally exhales life into it. Even though we might at first think that the curtains of Menzel's *Balcony Room* serve the purpose of shutting out the world, in truth their function is to render problematic, in fact render irrelevant, the very distinction between the interior and the exterior. An osmotic membrane much more than a partition, Menzel's curtains present the objective world as one inexorably permeated by subjectivity and bodily memory. Therefore, it would be foolish to think that one could keep the world beyond the perimeters of the home and succeed in defining secure spaces for our most intimate affairs. For the world is always already there, even if we refuse to see it. And even more strangely, we do not encounter this world as something categorically different from our bodies and sensations but something that belongs to our own body just as much as it imprints itself on and breathes life into our corporeal existence. Rather than veil the window and block our view, Menzel's muslin curtains embody that which seems to make sight and visibility here possible to begin with. It allegorizes the very process of vision as one no longer defined by the template of disembodied Renaissance perspective.

It is important to recall at this point that Leon Battista Alberti, when promoting the Renaissance notion of the picture as a window, urged painters to use the mechanical aid of a veil in order to establish a central viewpoint and order the visual field according to the principles of Euclidian geometry. Though Alberti remained principally unsure whether optical rays would go from the observer's eye to the object, or vice versa, his veil interposed an imaginary picture plane in between the apex and the base of what he called the visual pyramid, which in turn would allow perspectors to determine the positions of certain objects on their canvas. Let me quote Alberti's praise of the veil in full, not only because it helped define an influential model of understanding vision as a fixed window onto space, but also because Menzel's *Balcony Room* ceases

to endorse this conception of veil and window in the hopes of emancipating sight from the limitations of Albertinian perspective:

> I believe nothing more convenient can be found than the veil, which among my friends I call the intersection, and whose usage I was the first to discover. It is like this: a veil loosely woven of fine thread, dyed whatever color you please, divided up by thicker threads into as many parallel square sections as you like, and stretched on a frame. I set this up between the eye and object to be represented, so that the visual pyramid passes through the loose weave of the veil. This intersection of the veil has many advantages, first of all because it always presents the same surface unchanged, for once you have fixed the position of the outlines, you can immediately find the apex of the pyramid you started with, which is extremely difficult to do without the intersection. You know how impossible it is to paint something which does not continually present the same aspect. This is why people can copy paintings more easily than sculptures, as they always look the same. You also know that, if the distance and the position of the centric ray are changed, the thing seen appears to be altered. So the veil will give you the not inconsiderable advantage I have indicated. A further advantage is that the position of the outlines and the boundaries of the surface can easily be established accurately on the painting panel . . . you can situate precisely all the features on the panel or wall which you have similarly divided into appropriate parallels.[3]

Alberti presented his veil as a virtually foolproof method to organize multiple vanishing points and receding lines within one unified picture plane anchored in the viewer's eye-line. A material stand-in for what Alberti elsewhere called the "open window" of the picture, the veil helped map the real as a coherent system of orthogonals, base lines, and vanishing points. Though we may at first merely think of it in terms of a grid to be projected onto the world in front of our eyes, this veil energized codes of realism that were based on a categorical separation between the space of the viewer and the visual field. Whereas the latter was a space of material, manifold, and often messy facts, the former was one of purifying geometric construction and control. The veil's function was thus double in nature. First, it allowed the draftsman to withdraw himself from the world, disconnect the exteriority of the visual field from the presumed interiority of his own vision, and in this way define the observer's recording gaze as the gaze of an autonomous, sovereign, and free individual. To be on the perspector's side of the grid was to maintain a privileged position in which observation and control, individuation and authority joined into one mechanism. Second, the function of the veil was to define the position of the viewer

as one emancipated from the disorderly demands of the body and its unsteady temporalities. The veil was meant to liberate the act of seeing and painting from the contingencies of the observer's own physical and sensory experience. Its function was to bring time to a standstill, decontaminate perception from unwanted stimulation, and turn vision into a decorporealized relation to the world—all in the name of enabling the most accurate transposition of the visible from three to two dimensions. Alberti's veil allowed the subject to subject the exterior world to the authority of his vision by surrendering his own subjectivity to a pre-given, timeless, and idealized schema of ordering space.

Although he overestimates the hegemony of decorporealized vision in Western culture prior to the nineteenth century (I return to this at a later point in this chapter), Jonathan Crary has located a fundamental destabilization of this model of seeing—of that which Crary himself calls the camera obscura model—around 1830.[4] Whereas early modern sight had been separated from exterior space and the vicissitudes of sensory perception, numerous scientific, philosophical, technological, and social advances in the first decades of the nineteenth century triggered a revolutionary breakdown of Albertinian perspectivalism and older notions of a disembodied, monocular, and atemporal viewing subject. Neither Alberti's veil nor the camera obscura no longer seemed to provide adequate paradigms of understanding the process of vision. Firm distinctions between interiority and exteriority became problematic, and ever few spectators considered empty and immobile interior space as the sole precondition for knowing and representing the outer world.

The work of Arthur Schopenhauer (1788–1860), as it was published and refined in various cycles of productivity between 1819 and 1859, bears testimony to this new way of thinking vision beyond Alberti's veil and the paradigm of the camera obscura. But Schopenhauer's modernity resulted not only from his ruthless attempts to question the rigid separation of interior and exterior spaces of perception, it was also effected by his intricate combination of aesthetic and scientific lines of argumentation—the philosopher's openness toward the insights that the burgeoning disciplines of physiology, physics, and optics produced during his own lifetime. Contrary to earlier philosophical accounts, Schopenhauer neither considered the viewing subject as a passive receiver of sensations nor endorsed a model of vision eager to purify perception from the contingencies of the physical body. Neither an idealist nor an empiricist, Schopenhauer instead regarded the viewing subject as an active producer of sensations. Whereas both Alberti and Descartes wanted the observer to shut his physical eye to achieve ideal geometric vision, Schopenhauer closed his eye

and discovered that our bodies and brains see even when not looking at anything. Though Kant's work remained of prime importance for Schopenhauer's thinking throughout his career, insights such as these caused Schopenhauer to reinterpret Kantian philosophy in terms of modern physiology. As Crary has put it, "What Kant called the synthetic unity of apperception, Schopenhauer unhesitatingly identifies as the cerebrum of the human brain."[5] In this way, Schopenhauer not only overturned former distinctions between the interiority of perception and the exteriority of the perceived, he also posed the observer as a viewing subject inextricably bound to the messy temporalities of the human body: to desire, lack, reflex, delusion, growth, and death. For Schopenhauer's embodied observer, veils such as Alberti's were of little further use in organizing vision. They may have entertained illusions of scopic control, but they could no longer shroud what Alberti's veil had removed from sight: the constitutive opacity and temporality of every act of looking.

Schopenhauer had already left Berlin and moved on to Frankfurt by the time Menzel launched his own career as an illustrator in the second half of the 1830s. Given the delayed history of Schopenhauer's reception in Germany, it is quite unlikely that Menzel would have laid eyes on Schopenhauer's principal work, the two volumes of *The World as Will and Representation*, before very late in life. And yet, what I would like to suggest is that Menzel's *Balcony Room* in general, and the painting's curtains in particular, perform an understanding of seeing as embodied, temporal, and subjective analogous to the one envisioned in Schopenhauer's physio-philosophy. Menzel's curtains are like Schopenhauer's eyelids. Though closed, they do not keep the subject from operating as a site on which physiological sensations emerge and the formation of representation occurs. It is immediately obvious that, contrary to Alberti's suggestions, Menzel's curtains do not serve as a metaphor for the window that the art of painting once was supposed to open onto the world. As they flutter in the breeze, they provide everything but a solid and stable tool to map and order the world.

What is perhaps less obvious is that Menzel, though seemingly engaging the genre of interior painting, posits an interior space as a space of sensory perception and representation for which former boundaries between the interior and the exterior have lost their relevance. Note the two curved lines on the right curtain, the upper one a bit darker and thicker than the lower one, both however abruptly discontinued on the left by a billowing fold of the fabric. At first we might consider these two lines as a vague, albeit distorted, reminiscence of the grid that was woven into Alberti's veil. Or, perhaps more accurately, we

might want to see these shadows as an inversion of Alberti's grid, transforming the veil from a mechanism projecting grids onto the world into a screen onto which the exterior world now projects its own lines, shapes, and foreshortenings. But on closer inspection, neither of these readings seems to live up to what we really see here. For unlike Alberti's veil, Menzel's curtain is far from interposing an operative picture plane between the apex and the base of a visual field, whether we locate the apex of this field's cone on this or the other side of the open balcony door. And this is not least because Menzel's energetic brush strokes here tend to flatten our sense of spatial depth and thus entirely collapse whatever space might be left in between the fabric of the curtain and the actual lattice of the door. As a result, we come to see our two lines as imprints much more than as shadows cast across open space onto a screen. We perceive these lines as a result of direct touch rather than the projection of light rays. In this way, they leave us literally no room to think of the visual field as something whose elements could be subjected to Alberti's at once conical and grid-like perception. Rather than simultaneously open up, frame, and order an extended visual pyramid, Menzel's veil suspends the very idea of visual space as something necessarily having any physical extension independent of our own act of apperception. Whatever we see here might as well record the kind of optical sensations we apprehend when we close our eyes after looking—intently or not—at the world around us: a retinal afterimage indexing the observer's corporeal subjectivity rather than merely representing perceptions of the exterior world. Whatever we see when we look at these curtains might as well be a visualization—in Schopenhauer's terms—of occurrences within an observer's optical nerve and brain, occurrences that bear no direct correspondence to the world outside of the observer's sensory systems. Whereas Alberti's veil enabled the categorical separation of viewer and viewed, Menzel's curtains signify the extent to which the observer's body has become an integral part of the world to be observed or—even more radically—the extent to which the world we see belongs entirely to our bodies.

What makes *Balcony Room* modern, then, is not simply Menzel's concern with the fleetingness of a particular moment; it is not the proto-impressionistic visualization of the transitory itself. Instead, the painting's modernity lies in the fact that it seeks to picture the very process by which pictures come into being. Menzel's *Balcony Room* captures a new universe of subjective seeing in which the body of the observer produces phenomena that may not have any necessary correlates in the external world. To look at Menzel's room is to look directly into the painter's eye—and to realize that Alberti's notion of the veil

and open window loses its former meaning. Menzel's window does not provide a mechanism that, by separating interior and exterior spaces of perception, provides the precondition for ordering the visual field. Instead, it offers a site at which image makers can explore the constitutive opacity of visual perception and help us see our own seeing. What makes this window modern is that it invites us to see our own position within the representation as one energized by the contingencies of the physical body. It is the way in which Menzel's window details the physiological operations and social consequences of embodied vision that shall concern us in the remainder of this chapter.

Foreground

An artist whose hands were virtually unable to stop capturing daily impressions on paper, the ambidextrous Menzel was certainly one of the most gifted draftsmen of his time in Germany. Though his uncommon physical shortness in his more "private" work may often have caused rather low viewpoints and pictorial horizons, Menzel's drawings reveal an almost uncanny desire to make things speak to us by featuring them from striking angles and perspectives. In particular Menzel's countless sketchbook studies present an artist whose quest for realism and objectivity was inextricably wedded to his exploration of situated and subjective viewing. To know and represent the physical world most objectively, for Menzel, was to record the process of its subjective appropriation and inhabitation. The key to Menzel's realism is his use and exploration of perspective, and not—as many a contemporary realist would claim—the self-effacement or self-transcendence of subjective perception, the intentional erasure of all traces of intentionality.

And yet, as a closer look at the distribution of objects and organization of lines in space in *Balcony Room* will quickly lay bare, Menzel's understanding of perspective clearly differed from the codes developed by Renaissance theorists. Perspective in Menzel is both a process and a performance. Rather than anchor the visual field according to one unified and stable system of vanishing points, perspective here always manifests itself in the plural. It decenters our view, questions the primacy of the picture plane, and challenges the autarky of the painting's frame. Far from defining the picture as an open window onto the real, Menzel's use of perspective captures the hybrid coexistence of various points of view even in the most ordinary acts of perception. What perspective in Menzel reveals is the aggregate nature of seeing itself, the multiplicity of opaque windows and manifold frames that structure our perception even

before image makers seek to reconcile this heterogeneity of visual impressions with the compositional logic of their representation.

Let's take a look.

Menzel's viewpoint, if we reconstruct the vanishing lines suggested by the huge mahogany mirror on the right, must have been roughly at the height of the two grey wall lamps surrounding the mirror. Because Menzel's physical stature did not allow for such a relatively high viewpoint, the painter must have positioned himself on top of some kind of object to enable this vista. What is puzzling, though, is that other vanishing lines in the painting do not entirely conform to the ones indicated by the mirror and the two lamps. While mirror and light fixtures suggest the painter's eye point to be located about at the height of the darker grey patch on the wall, neither the molding of the ceiling nor the frame of the balcony door or the position of the red carpet on the left support this particular implied viewpoint. Add the fact that, given the angle at which we look at the mirror, it is virtually impossible to account for the position of the framed picture and the sofa reflected in this mirror; add how the billowing curtain draws our attention like a vortex to the invisible corner of the room; and add how the relative absence of furniture and objects on the left makes the entire image tilt to the right—and we cannot but come to the conclusion that *Balcony Room* presents the viewer not with one but with multiple planes and competing systems of foreshortening. What we see here does not represent one act of looking, it records and amalgamates a whole series of observations, each conforming to its own spatial coordinates, each resulting not from a simple readjustment of the observer's eyes but a repositioning of his entire body. Without moving one's entire head and eyes right and left, up and down, an occupant of this room situated at Menzel's suggested eye point could not have seen what Menzel allows us to see. A single unified prospect of space, as called for by Alberti's understanding of the picture as a window, is thus replaced by the co-presence of separate views across the surface of the painting. The representation of seamless perceptual synthesis makes way for the display of experiencing space as an aggregate of aspects, an assembly of distinct looks structured by the figure of addition rather than the one of fusion.

In *The Art of Describing,* Svetlana Alpers located a similar destabilization and deconstruction of Renaissance perspective as early as the seventeenth century. Rather than aligning their paintings with the demands of central perspective, Dutch painters of this time developed so-called distance point constructions as mechanisms to construct space as an aggregate of aspects. Unlike the Albertinian picture, distance point construction could do without the inter-

posing of a physically separate picture plane and central viewer along the cone of the visual field. Whereas for Alberti the operation of the eye itself was irrelevant for his construction of his painting as an open window, the northern draftsmen sought to represent space in analogy to how their eyes were moved by the objects in front of them. Distance point construction locates "the eye point not at a distance in front of the picture, but rather on the very picture surface itself, where it determines the horizontal line that marks the eye level of persons in the picture. The eye of the viewer (who in Alberti's construction is prior and external to the picture plane), and the single, central vanishing point to which it is related in distance and position, have their counterparts here *within* the picture."[6] Distance point construction, in other words, solely refers to the presence of people, perspectives, and objects in the picture itself. It is a function of the world seen rather than an expression of what a viewer considered external to the picture plane might do to the space in front of him. In the northern understanding of perspective, as Alpers argues, there is no framed window pane to look through. Whereas for Alberti the window of the picture was separate from the viewer, an object of the world to which we bring our eyes, in distance point construction the picture takes the place of the eye itself—and leaves the frame and the viewer's location rather undefined. Because the distance point method sought to record that which could be seen within the representation itself, because it allowed for the addition of numerous competing viewpoints, and because it privileged the authority of the seen rather than that of a disembodied observer and his ordering powers, in the northern method of representing space the eye and its movements over time became integral parts of the picture itself and depicted the world on the surface of the painting as an aggregate of sequential views: "The many eyes and many things viewed that make up such surfaces produce a syncopated effect. There is no way that we can stand back and take in a homogenous space."[7]

The compositional principles of Menzel's *Balcony Room* recall the aggregate space and syncopic effects of the Dutch distance point method. In both, the construction of space bears a critical temporal index; in both, one look cannot do justice to the heterogeneous processes of seeing depicted on the canvas itself; and in both, no implied window frame separates the viewer ontologically from the space of representation because both relocate the picture plane into the observer's eye itself. Was the arch-Prussian Menzel, then, a Dutch architectural draftsman in disguise?

There are good reasons not to overemphasize these homologies. For, though we may find it difficult to locate one exact eye point and hence one stable cen-

ter of looking in *Balcony Room,* Menzel's composition—in contrast to the Dutch distance point artists—did of course not aim at emulating the eye level of different persons within the picture to determine the painting's horizon line, only the artist's very own. And even though *Balcony Room* unmoors spatial representation from the primacy of the Albertinian picture plane, it does not simply record the world—like the Dutch draftsmen—as it would be seen by an observer whose physical body is part of the space viewed but rather presents the visible world as an integral part and product of the observer's body in the first place. *Balcony Room* might allow us to see and immerse ourselves in the temporality of Menzel's own seeing, but the mutual incorporation of eye and frame here causes the observer to partake of the uncanny experience of perceptual vertigo. Instead of merely mapping and thus inhabiting the world, like the Dutch, from various points within the representation, Menzel's *Balcony Room* draws our attention to the extent to which the deconstruction of Alberti's open window enables new relationships between the body and its surroundings—even as it pulls the rug from underneath our feet.

Let's take another look.

One of the most striking features of the organization of visual planes in *Balcony Room* is how Menzel's picture seems to start right in front of the beholder's feet, thus collapsing our own distance to the objects in the room in likeness to the collapse of space between the curtain and the right balcony door. Note the two shafts of light on the right and a number of briskly accented brush strokes on the left that direct our eye from different points in the lower quarter of the image across the floor all the way to the bottom of the painting. These light beams and brush strokes form a triangle whose implied convergence marks the physical position of the painter as one only minimally located outside of the frame. This triangle's effect on the viewer is twofold. On the one hand, it leads to a dramatic dynamization of the entire picture as it seizes our attention and leads our eye away from the various objects and their rather random distribution in the upper parts of the painting. Unable to rest our gaze on any detail in the first place, our view now literally drops toward and in fact through and beyond the frame of the image, where it will seek pause for a second before it dares reimmerse itself again into the painting's unsettling force field of lines, foreshortenings, and eye points. On the other hand, because Menzel's construction of the ground plane is an aggregate of various forward and downward perspectives, we cannot escape the dual impression that we strangely hover above the ground and that this ground seems to slide away from underneath our feet. The dazzling organization of planes and perspectives thus draws us

into the space of the picture as much as it almost violently shoves the picture through and down our eye. While the triangle on the floor at first seems to assign an unmistakable viewing position for us, it also and as unmistakably pulls this position away from us again, or pulls us away from it, only to leave our own physical relation to the world undefined. Rather than anchor our gaze in and vis-à-vis the painting, the dynamic planes of *Balcony Room* in the end suspend perceptual certainties and situate the viewer in a physical limbo.

Werner Busch has described this peculiar sense of dislocation as a product of Menzel's innovative integration of near and far vision.[8] Because our eye cannot see what is close and what is far simultaneously with equal clarity, classical theories of painting, in particular when addressing the practice of landscape painting, suggested various methods to solve the problem of representing the foreground. Whereas the middle- and background of a picture, a common principle holds, should be painted in front of the object and according to nature itself, the foreground should be filled in later, even if it means to take recourse to fictional and heterogeneous elements. Though the foreground was necessary to complete the composition and lead our eyes into the picture, it was considered mere staffage and was accepted as a product of the painter's free imagination. As the nineteenth century witnessed the emergence of the oil sketch as a "private" form of capturing one's surroundings, painters rendered the issue of the foreground problematic again and called for new solutions to incorporate the near and the far. In amalgamating differently tilted views onto the foreground while representing these multiple views in a deliberately unstructured and seemingly unfinished manner, Menzel's *Balcony Room* offered one response to the now open question of the near. Though aggregate and syncopic in nature, Menzel's foreground was neither fictional nor mere staffage but a dynamic part of the entire composition. Though we might experience the representation of this foreground as somewhat out of focus, it indexed a new kind of multifocality that must have been virtually illegible for contemporary viewers. That no one can or could ever see what *Balcony Room* invites us to see is the hallmark of Menzel's early modernism. The rebirth of the foreground through subjective vision, as staged in this painting, was inseparable from what constituted, according to contemporary codes of realism, a crude violation of natural sight and perspective. Embodied vision here was constituted not in opposition to but in close communication with and as an effect of certain techniques allowing us to track the workings of our eyes over time. Sight had to become prosthetic in order to be experienced as something that belongs to the contingencies of our body.

Hovering perspectives and asymmetrical visual planes, the attempt to question central perspective and temporalize pictorial space—all this, of course, can be found in the work of various nineteenth-century painters preceding Menzel, in particular Caspar David Friedrich, whose 1822 *Woman at the Window* many consider the most famous window painting of all time. As with Menzel, Friedrich's compositional method was often marked by a curious disjuncture between geometric principles and the psychology of seeing. In many of his landscape paintings, Friedrich chose extraordinary high viewpoints that resulted in a flattening of perspectival depth and—comparable to traditional Chinese landscape drawing—a conversion of orthogonal extensions into vertical surfaces. Instead of pulling the viewer into the landscape, Friedrich—like Menzel—tends to unsettle stable viewing positions, displacing us into a puzzling nowhere. These landscapes do not encode naturalistic representations of what was in front of the painter's eyes but conceptual records of inner visions. Like Menzel's private works of the mid-1840s, Friedrich's paintings were abstract and constructivist, a product of rigorous calculation much more than romantic affect. And yet, worlds seem to lie in between the phenomenological procedures and compositional practices of Friedrich and Menzel, including both masters' most famous window paintings. Pictorial space in Friedrich is often marked by strong contrasts not only between vertical and horizontal elements, but also between fore- and backgrounds. Though Friedrich's landscapes are inherently utopian and explore the "backside, the invisible side of physical space," his paintings rarely offer any transition whatsoever from what is near to what is far.[9] No mediation exists here between foregrounds and backgrounds, except—as in *Woman at the Window*—in the form of a figure that would simultaneously serve as the viewer's stand-in and partially block our view onto the exterior. Friedrich's foregrounds thus play the role of a mere stage, a frame enabling spiritual longings for the infinite, for that which transcends the mundane and ultimately redeems us from the strictures of time and place. If Friedrich manipulates central perspective and dislocates the viewer, he does so in order to invite us to sail off—like the mind of his woman watching the river boats pass—into some metaphysical beyond, or at least in order to articulate our despair about our inability to attain this beyond for some time to come.

Not so Menzel. Whereas Friedrich shows foreground and background as oppositional elements in the hope of emancipating vision from the physical body, Menzel collapses stable distinctions between the far and the near for the sake of emancipating the body from the metaphysics of seeing. In Friedrich, violations of linear perspective transform the canvas into a site of meditation,

Caspar David Friedrich, *Woman at the Window* (1822).
Oil on canvas, 44 × 37 cm. Nationalgalerie, Staatliche
Museen zu Berlin, Berlin, Germany. Photo: Bildarchiv
Preussischer Kulturbesitz / Art Resource, NY.

a material allegory for the immaterial. In Menzel's *Balcony Room,* by contrast,
the implied multiplicity of viewpoints addresses viewers for whom meditative
seeing has lost its promise and possibility. Friedrich stages subjective vision as
a mechanism to spiritualize and hence turn one's back to the physical world,
whereas Menzel embraces the subjective in order to explore the bodily rela-
tionships between viewers and the images they might perceive. If in Friedrich
the frame of both the window and the painting opens distant views onto that
which might succeed our existence in time and space, in Menzel the window
is that which immerses us into the very contingencies of being and the irrevo-
cable immanence of perception.

Woman at the Window is a painting about last things. So unremittingly does this painting's window divide interior and exterior spaces, fore- and background, the spiritual and the physical, that we must think that it knew of its own imminent historical demise. As if putting everything into one last heroic effort, *Woman at the Window* seeks to secure a space for acts of spiritual purification and self-transcendence as a bulwark against a future in which everything secure will wither away. Friedrich's window allowed its viewer to take one final breath before the storm of modernity would shatter its neat organization of space. With Menzel we find ourselves already in the midst of this storm. *Balcony Room* is not about last things. It is about beginnings, about the ceaseless creation of the world in the unstable window of the embodied eye.

Mirror

Only twenty-three years separate Friedrich's *Woman at the Window* and Menzel's *Balcony Room,* and yet what this brief span witnessed was nothing less than a principle makeover of how people recorded their seeing of the world and used technological aids in order to embalm fleeting impressions for future generations. It is well known that Menzel was greatly fascinated by the advent of photography in the late 1830s. He supported his brother to become a photographer and establish a studio in Berlin. Contemporaries of Menzel called the painter's style as one of "Daguerre-type realism" even before photography was able to capture singular moments in all their transitoriness.[10] And in the later stages of his career, Menzel was known to use photographs in order to add detail to the texture of his paintings.[11] But exactly how do paintings such as *Balcony Room* engage the coming of mechanical images and their putative syntax of intensified realism? What did photography do to "cause" painters such as Menzel to question the role of the window as a secure boundary between interior and exterior spaces? And how does the reframing of sight in *Balcony Room* affect our thinking about the early history of photography and its relations to the codes of representing space?

Almost all leading innovators of early camera and recording technology, as they tested their gadgets around 1840, captured images of street life as seen from the inside of a house or laboratory.[12] All early photography, as manifested in the work of inventors such as Niepce, Daguerre, Talbot, Bayard, Steinheil, and Natterer, was window photography. Allowing light to enter the engineer's work space, the window provided the conditions for the possibility of reproducing the visible world. Its frame and opening allegorized the very working

of the apparatus, the various ways in which these first inventors designed their lenses and shutters. As they located their cameras at the window sill, the pioneers of early photography not only captured their hope for mechanical reproduction to lead us from the familiar and protected to the new and unknown, they also documented photography's debt to the innovation of linear perspective in the fifteenth century, that is, to Alberti's understanding of the image as window onto the world. Wherever later practitioners may have driven the artistic and technological possibilities of their medium, the window pictures of its first users documented photography's encounter with the light of day, not as a revolutionary break with central perspective but its effective modernization, as it converted impressions of three dimensions into two. As they replaced Alberti's veil with a mechanical recording device, the cameras of these early innovators operated as tools to perfect perspective and its construction of ideal and monocular viewpoints. Photography, as Peter Galassi has put it, "was not a bastard left by science on the doorstep of art, but a legitimate child of the Western pictorial tradition."[13]

It has become commonplace to argue that the advent of photography around 1840 empowered painters to venture beyond the codes of mimetic realism and pictorial illusionism: their task and ambition became not to beat the camera at what it could do better anyway but to explore new spheres of representation and self-expression inaccessible to the camera's mechanical eye. What energized the birth and history of modern painting and visual culture, according to this understanding, is how it reacted to and compensated for the stunning achievements of nineteenth-century scientists and engineers. Because, the argument runs, the long exposure times of early photography necessitated subjects to remain motionless for extended periods of time, painters now showed a new interest in the fleeting and transitory. Because the photographic image arrested time and reified memory, painting began to expose the subjectivity of recollection and emphasized that we don't own the past like we own a thing. And inasmuch as photography simply reinscribed and perfected pictorial traditions developed during the Renaissance, nineteenth-century painters were urged to rethink perspective and, rather than construct through geometric principles three dimensions out of two, focus their—and our—attention on the constitutive flatness of the canvas.

It is certainly tempting to read *Balcony Room* in terms of this causal logic of reaction and compensation, on the argument that the syntax of Menzel's oil sketch answered the recent challenge of photography. The modernity of *Balcony Room,* then, would lie not only in how Menzel reckoned with the con-

Nicéphore Niepce, *View from the Window at Le Gras* (1826). Gernsheim Collection. Harry Ransom Humanities Research Center. The University of Texas at Austin. Photograph by Jack Ross, Ellen Rosenbery, Anthony Peres, J. Paul Getty Museum.

temporary emergence of eminently modern technologies of seeing and visual reproduction but in how his representation of window and room provided a negative to a positive, that is, how it sought to picture the world in determined opposition to the way in which contemporary cameras would or could do it. While such a reading might have much to offer, I would nevertheless like to pursue a much less trodden und ultimately contrary path, namely to argue that Menzel's painting frustrates our very attempt to understand images as being determined and caused by anything in the first place. What makes *Balcony Room* modern is that it redefines seeing as a window onto the world in whose frame traditional concepts of cause and effect have become irrelevant. What makes *Balcony Room* modern is that it pictures a world in which conflicting frames of reference dislodge our desire to narrate history as a story of linear determination and causal sequence.

Behold again the enormous mahogany mirror on the right. Though its lower right corner is partly obscured by the chair in the foreground, this mir-

ror begs for our attention and tends to attract our eye and curiosity away from the image of the billowing curtains.

Why?

The mirror shows the reflections of three objects located in the room, one of which is entirely visible in the rest of painting, one of which is partly visible, and, finally, one whose position is completely outside of the actual frame of the picture. First of all, what we see reflected in this mirror is the back of the second chair whose function it is to arrest the progress of the balcony door. Menzel situates its reflected shapes so closely to the contours of the other chair in the foreground that at first glance, we might overlook it entirely, and on second thought, might wonder if we are mistaken about what is actually being reflected here. Seen from a purely geometric standpoint, the angle and foreshortening of this first reflection does not really cohere with the implied viewpoint from which we see the mirror as a whole: the image in the mirror seems to run counter to the image of the mirror. The reflection of object two, the sofa situated on the left, amplifies this sense of disorientation. In the painting itself, Menzel indicates the sofa with an indistinct and hasty patch of olive color, leading much debate over the completeness or incompleteness of the oil sketch as a whole (to which I will return later). What we see in the mirror, on the other hand, is the corner of a plushy couch, its green and pink stripes adding importantly to the painting's general privileging of vertical lines, its arching back pleading for someone to sit down and fill the room's eerie void. Whether we consider the execution of *Balcony Room* formally complete or not, in according more detail and texture to the sofa's reflection than to the sofa itself, Menzel cannot but make us wonder whether the sofa's indefinite appearance needed a mirror image to achieve wholeness and completion, whether the real here is seen as nothing other but an effect of refraction, of the imaginary.

The reflection of object three, finally, takes up considerable space in the upper half of the mirror and is hence the first to catch our attention. We see the image of a black and white picture (a photograph?) showing a person in profile. The picture is surrounded by extensive beige matting and a simple golden frame, all of which are cut off by the left perimeter of the mirror. With no further clues given, we remain unable to infer the actual format and extension of the reflected image. What adds to our confusion is our inability to make the location of this image cohere with the reflection of the other objects in the mirror and their position in the room. As seen in the mirror, the image is located above the armrest of the sofa. As hung on the wall, the image should therefore at least partly reach into the visual field depicted in the painting it-

self. More precisely, in fact: exactly that which we do not see of this image in the mirror should be visible on the left side of Menzel's sketch. That it doesn't, doesn't merely—once again—reveal the simultaneous presence of incompatible viewpoints and perspectives in Menzel's *Balcony Room*. As importantly, it urges us to question the defining power and representational unity of the mirror itself and, by extension, the reliability of any framing of attention and perception. Unlike the function of many a mirror in early modern depictions of interiors—think of the famous round mirror in Jan van Eyck's *Arnolfi Wedding* (1434), think of the tilted mirror above the piano player in Jan Vermeer's *The Music Lesson* (ca. 1662–65)—Menzel's mirror does not display obscured aspects of the visual field or integrate elements of the off-frame space in order to achieve a greater sense of closure, wholeness, or totality. On the contrary, rather than unifying our perception of space, the frame of Menzel's mirror decenters spatial unity. Like Menzel's painting as whole, the mirror of *Balcony Room* provides a site and surface on which we witness an inconclusive and open-ended co-presence of multiple images and competing frames of reference. Instead of ordering the real and focusing our attention, Menzel's mirror frame urges us to learn the art of multifocal viewing, that is, not only to move our eye discontinuously and restlessly from one element to another but in so doing also to experience a complete destabilization of the idea and limit of the frame. In Menzel's world incessant acts of framing and reframing sight no longer offer any trustworthy compass to situate our bodies in space. Frames here do not provide exterior solutions or effective antidotes to the contingencies of perception; they are integral and unsettling moments of perception's very process. Menzel's frames and windows cause us to get irredeemably lost—not because we don't pay enough attention to our past and future tracks, but because incongruous sights and competing universes of representation galvanize our attention all at once.

Werner Hofmann understands the transition from monofocal to polyfocal painting as the hallmark of the modern.[14] Polyfocal art is essentially hybrid in nature: it allows for the mixture of different modes of style, expression, and realism within one larger frame of representation, it forces the viewer to refocus his gaze repeatedly while moving his eye across the surface of a particular image, and it situates dissimilar symbolic orders and ontological levels next to each other without aiming at formal coherence or unity. Polyfocality was a known practice already in the Middle Ages but was largely displaced by Renaissance art and its stress on monocular constructions of space. Though post-Renaissance art frequently challenged the monofocal implications of the

Renaissance model, it was not until the mid–nineteenth century that polyfocal modes of representation experienced a resurgence. This powerful return of the polyfocal resulted in large measure from aesthetic stalemates, tensions, and developments, but it also responded to the massive proliferation of various mechanical images and technologies of seeing since the early nineteenth century: the advent of contraptions such as the panorama, the diorama, the zoetrope, the phenakistiscope, and last but not least the daguerreotype and the photograph, all of which confronted the human eye with competing visualizations of time and space and interposed heterogeneous frames of pictorial reference into what once had been experienced as the unity of the visual field.

The disjunctive reflections we see in Menzel's mirror allegorize the polyfocal turn Menzel's 1845 *Balcony Room* seeks to perform as a whole. But to think of this turn as being "caused" and "determined" by the rapid multiplication of mechanical images and their fragmentation of the visual field around 1840 misses the full import of the polyfocal and its role in modern culture. That *Balcony Room* breaks with the mandates of Alberti's monocular window, that it stages polyfocal incoherence, simultaneity, and contradiction across the surface of one and the same canvas, is neither an effect of nor a direct answer to the rise of mechanical images or photography's spectral records of time. On the contrary, Menzel's mirror tells us that in a modern age of polyfocal looking nothing can ever be understood as being solely caused by anything else; everything must be seen as a potential site of messy multiplicity and overdetermination. Once a metaphor for rationalism at its best, the mirror—like the window—here no longer operates as a transparent tool of insight, knowledge, causal explanation, and geometric order. With its incomplete objects and incompatible perspectives, this mirror renders visible the very opacity of modern embodied and polyfocal seeing. What it reflects is the extent to which former paradigms of reflection and totalization have become problematic. What it reveals is that under the conditions of modern culture no act of reflection can be thought in isolation from untidy and open-ended processes of refraction.

Light/Color

Eager to overturn the rationalist empiricism of Sir Isaac Newton's *Opticks* (1704), Johann Wolfgang Goethe commenced his *Farbenlehre* of 1810 by asking the reader to perform a curious experiment. First Goethe wants us to transform a room into a camera obscura, a hole in the window's shutter serving as the aperture, one of the room's walls providing the screen. He instructs

us next to focus our eyes onto the circular image cast by exterior light sources onto the interior wall, our own body and eyes situated within the device itself. But rather than ask us to inspect the projected image in further detail, Goethe now instructs us to add yet another step to the experiment, namely to shut the window entirely, turn our attention to the darkest part of the room, and note the undulating play of colors that will now occur, seemingly in front of our eyes. Initially we will see a circular image floating right before us:

> The middle of the circle will appear bright, colourless, or somewhat yellow, but the border will appear red. After a time this red, increasing towards the centre, covers the whole circle, and at last the bright central point. No sooner however, is the whole circle red than the edge begins to be blue, and the blue gradually encroaches inwards on the red. When the whole is blue the edge becomes dark and colourless. The darker edge again slowly encroaches on the blue till the whole circle appears colourless.[15]

Goethe's experiment was a programmatic one. By making us turn off our camera obscura, his ambition was to explore forms of vision that had no direct correlative in the outside world. The floating colors and unsteady shapes we observe after we close the window, for Goethe, established that vision, rather than merely registering and reflecting the exterior world, actively belongs to the observer's physiological body. Much of what Goethe in his *Theory of Color* would go on to write about the nature of color perception, subjective vision, and the origins of afterimages certainly violated past and future standards of scientific inquiry and systematic analysis. But what is and remains important about Goethe's exploration of subjective vision, as Crary explains, is "the inseparability of two models usually presented as distinct and irreconcilable: a physiological observer who will be described in increasing detail by the empirical sciences in the nineteenth century, *and* an observer posited by various 'romanticisms' and early modernisms as the active, autonomous producer of his or her own visual experience."[16]

In the eyes of Goethe, our perception of color and light did not match earlier models of seeing as disembodied, passive, and exterior to the visual field. However, for Goethe, to understand the individual as an active producer of optical experience did not imply sacrificing notions of truth on the altar of radical solipsism or perceptual relativism. However ephemeral, the perception of color served Goethe as a site (and sight) at which to prove both the constitutive subjectivity of the real and the indisputable reality of the subjective. Goethe emancipated color from secure spatial referents not to plunge us into

absolute phenomenological isolation, but to show that we cannot talk about the real without talking about the subject. If defined in recognition of Goethe's thoughts on floating colors and impermanent images, any concept of realism in both the arts and the sciences had to account for the fact that the world belongs to the body as much as the body belongs to the world.

I return now to Menzel's *Balcony Room* and, more particularly, to one specific section of the painting that has concerned and bothered art historians ever since Menzel's work met the light of the larger public in the first decade of the twentieth century. I refer to the patch of light gray and white color on the wall, executed with confident and dynamic brushstrokes, yet strangely interrupted by a rectangular segment that cuts into and extends the wall's darker gray into this patch from the left. The effect of Menzel's brushwork here underscores the sketchlike character of the entire painting, whereas the rectangular insert gives the impression that Menzel either randomly broke off the process of work or simply saved some space for later additions such as another picture on the wall. At first enigmatic and unreadable, the patch has served as grist to the mills of those considering *Balcony Room,* in spite of the signature Menzel assertively placed in the right hand corner, as essentially unfinished.

What we are meant to see here, so much appears to be clear, is a patch of sunlight cast on the wall through the open door. The curved top of the patch, then, would correspond—with some expectable perspectival distortion—to the window's uppermost arc close to the ceiling. Additionally, it would suggest a relatively low position of the sun in the early morning or late afternoon, one that we will find difficult to reconcile with the crisp reflections of light and angular shadows that capture our attention on the apartment's floor. A more probable assumption, therefore, is to understand our patch not as a product of sun beams as they would directly hit the wall, but either as a highly diffuse reflection of day light as it enters and illuminates the room in general or as a result of an instance of refraction enabled through the open windowpane on the right. In either of these two more likely scenarios, what we seem to witness is a process of intricate mediation and transaction rather than direct impact and causation, of spatial and temporal displacement instead of unequivocal en-lighten-ment. Whatever we see on this wall has the status of an afterimage, an image that presents shapes and colors in the absence of unmediated stimulation and that reveals temporality and deferral as inevitable moments of sight and visual representation. Although there are good reasons to believe that Menzel's billowing curtains do not cover the entirety of the opening, Menzel's patch recalls the floating colors and unsteady shapes Goethe saw after

closing his shutters in order to study the optical experiences produced within and by the subject. Light and color, as in Goethe, are seen here without any necessary, unambiguous, or unmediated link to some empirical source. The seeming unreadability of Menzel's patch thus allegorizes the opacity of the modern observer itself. It provides an external representation of what Goethe called physiological color and vision, of how nineteenth-century discourse began to understand sensory perception as something unfolding over time even while cut off from external referents and direct causations. Reality, in Menzel's *Balcony Room,* is not that which seems to exist independent of the observer's perception. Real is that which emerges when we scrutinize our own process of perception, when we try to do the impossible, namely, see our own seeing as active and embodied producers of images. Instead of demonstrating the unfinished character of *Balcony Room,* Menzel's patch exposes to view the necessarily unfinished and open-ended nature of seeing itself, that we can never own what meets our perception, that we cannot stick optical experiences into our pocket and take them home like material objects purchased at the market.

What constitutes the modernity of Menzel's window painting, then, is that in questioning the correspondence of optical perception, it at the same time questions earlier notions of the subject as a sovereign and self-present master of his or her own life. Though Menzel's patch of color and light—like Goethe's closed shutter—draws our awareness to the active production of visual experience in the observer, we cannot think of this observer as one in full control over the mechanisms that produce impressions of the real. On the contrary. Sight here becomes unthinkable without the operations of a physiological body situated in space and time, but we should not think that we could have absolute authority over this body, nor that we can employ this body to claim authority over the visual field. The body of Menzel's modern observer is one that exceeds ideas of personal possession and sovereignty. Due to its inevitable temporality, contingency, and hence mortality, this body is that which we can never entirely master and dominate, and of which we therefore, all things told, will always remain mere custodians. Intractable to its own self, Menzel's modern observer is one who does not and can not demand pliability from others. Stranger to itself, the body of this observer renounces its will to rule over others, its will to order the manifold through assertive acts of looking. Rather than granting experiences of scopic power and self-presence, subjective and embodied vision in Menzel calls on us to recognize and learn how to live with our own limitations, our nonbeing. As it closes down possible views onto the street, Menzel's curtains encourage the modern observer to explore his or her own seeing and

precisely in this way acknowledge that—in Maurice Merleau-Ponty's words—"I borrow myself from others."[17]

This implicitly ethical nature of Menzel's concept of the modern window and observer adds importantly to what we have come to think about the modernization of sight beginning in the first half of the nineteenth century. For the notion of the window in Menzel's work seems to generate insights and experiences considerably different from those technologies of seeing that have been canonized by scholars as principal engines of visual modernization. I am thinking in particular here of the nineteenth-century panorama. Many today consider the panorama as the decisive springboard for the rise of scopic modernity. Its emphasis on illusionary virtualization, physical immersion, and mobile looking are recalled as one of the origins of modern vision. Let's have a closer look at how Menzel's window might change our thinking about this issue.

Deeply impressed after visiting one of the first panoramas on display in Germany, explorer and scientist Alexander von Humboldt wrote that this new 360-degree image medium could "almost substitute for traveling through different climes. The paintings on all sides evoke more than theatrical scenery is capable of because the spectator, captivated and transfixed as in a magic circle and removed from distracting reality, believes himself to be really surrounded by foreign nature."[18] The panorama, in Humboldt's view, provided an immersive interface enabling sensory journeys through space and time. It surrounded mobile and embodied viewers with seamless pictorial images to create the effect of actually being in and navigating faraway places or times. However, as best exemplified by Eduard Gaertner's 1834/36 panorama of Berlin, in which Humboldt himself plays an important role, we are wrong to assume that nineteenth-century panoramas necessarily relinquished older notions of spectatorial control and visual sovereignty. Solicited by no less than the king of Prussia, Friedrich Wilhelm III, Gaertner's panorama spread out the heart of Karl Friedrich Schinkel's Berlin for the visitor as observed from the viewing platform atop the Friedrichswerderscher Kirche.[19] The roof of the church occupies the entire foreground of all six panels of Gaertner's panorama; it is populated by various onlookers—including Humboldt and the artists—as they behold the city's monuments beneath their feet. Like Humboldt's own scientific efforts, Gaertner's panorama invited the spectator not only to observe the city from a privileged vantage point but to examine individual objects in all their totality.[20] Artist and scientist here joined their efforts in order to present the city as a meaningful unity, a coherent cosmos to be discerned in its spectacular totality by a distant and detached observer.

Eduard Gaertner, *Panorama of Berlin* (1834). Copyright: Haus Hohenzollern, SKH Georg Friedrich Prinz von Preussen (Foto: SPSG).

Though it effectively mobilized the viewer and thus participated in the modernization of sight in the early nineteenth century, Gaertner's spectacular panorama fortified long familiar viewing habits that Mary Pratt calls the "monarch-of-all-I-survey" position.[21] Well-known from colonial discourse, the "monarch-of-all-I-survey" gaze fuses the aesthetic experience of panoramic landscapes, as seen from an elevated point of view, with the act of imperial appropriation. Aesthetic pleasure, spatial ordering, impressions of self-presence, and the execution of power here become one and the same. Rather than displace this familiar rhetorical fusion, Gaertner's panorama reinvented it for the sake of entertaining his viewers with at once realistic and scientific observations of contemporary Berlin. It cast elevated perspectives onto the texture of the city, not only to strengthen the link between knowing and seeing but also to provide experiences of wholeness and totality that situated the observer as the master over the visual field. When seen in contrast to how Menzel's work positions us in front of his painting and appeals to our sensory perception, we cannot but come to the conclusion that Gaertner's viewers borrowed the world in order to imagine their own selves as sovereign and unblemished by the ineluctable marks of incompleteness, failure, contingency, and nonbeing. Though Gaertner's attempt to engineer privileged mobile vistas will return in many guises in the modern history of seeing, we should not think of it as the

only avenue toward the notion of the modern observer. In fact, as seen next to Menzel's window and its exploration of the contingency and intractability of perception, we might not want to consider Gaertner's imperial viewing apparatus in specific and the nineteenth-century panorama in general as very modern at all.

Chairs

Gaertner's panorama was designed for viewers eager to learn and enjoy a new art of seeing without giving up the principal stability of their viewing position, that is to say, clear separations between the interiority and exteriority of perception, between self and world. Their likes have been portrayed in literary figures such as the paralytic hero of E. T. A. Hoffmann's "The Cousin's Corner Window" (1822), who examines Berlin's urban crowds from the privileged and detached location of his apartment. In Walter Benjamin's famous words: "Hoffmann's cousin, looking out from his corner window, is immobilized as a paralytic; he would not be able to follow the crowd even if he were in the midst of it. His attitude toward the crowd is, rather, one of superiority, inspired as it is by the observation post at the window of an apartment building. From this vantage point he scrutinizes the throng; it is market day, and they all feel in their element. His opera glasses enable him to pick out individual genre scenes."[22] The cousin's art of seeing relies on his ability to utilize both his opera glasses and the window frame of his apartment as an Albertinian picture plane. The urban crowd outside might be in constant motion and deny its members any sense of overview, but as screened through the cousin's tools of detached imaging, the glasses and the corner window, the sight of the crowd becomes manageable, a source of aesthetic pleasure rather than a threat to the observer's desire for perceptual synthesis.

We find the likes of Gaertner's observer also in the construction of aesthetic subjectivity in the work of Sören Kierkegaard, the Danish philosopher who visited Berlin frequently between 1841 and 1845 and for whose thinking a popular gadget of the time—a small mirror installed at the window, enabling the dweller to scan his or her surroundings—became emblematic. Called a "*Reflexionsspiegel*" or "*Spion*," this window mirror helped project the exterior urban world into the secluded sphere of bourgeois domesticity. Its function was at once to subject the street to the perspective of the dwelling and define a precise border between the public and private. "He who looks into the reflection mirror," Theodor W. Adorno wrote in his 1933 treatise on the Danish

philosopher, "is the idle private person who is detached from the economic process of production. The reflection mirror establishes the absence of objects. What it brings into the apartment and sphere of private detachment is only the semblance of things."[23] A gadget to situate the individual as a sovereign observer of life, the window mirror ends up transforming this individual into a strangely disembodied and secret onlooker of his own existence. Window and mirror here energize a dialectic of thinking and living in whose wake the bourgeois subject in specific—and philosophy in general—turns into something profoundly spectral. Like Gaertner's viewers, Kierkegaard's subject hopes to appropriate and order the world in the medium of the sovereign look, but what it owns is merely a faint realm of appearances, a realm of ghosts and projections inviting deceptive acts of narcissistic identification and imaginary self-invention.

Menzel's window transports us into a realm in which the construction of the subject as an essentially protected, private, and sovereign observer of the exterior world is about to melt into the air. *Balcony Room* might show us the most worshipped space of bourgeois privacy and self-identity circa 1845, namely, the interior of a well-off household in which individuals can shed economic, social, or political concerns and constitute subjectivity as something seemingly emancipated from the vagaries of history and (extra-domestic) conflict. But in Menzel's perspective, this interior space—the core of bourgeois self-invention and identity—is a space of instability and uncertainty as well, a space of aleatoric adventure and perceptual ambivalence, of flux and multiplicity. No sovereign self inhabits Menzel's *Balcony Room,* not because the inscribed onlooker refuses to peek through the window out onto the street, but on the contrary because the street is always already in the house and the perceiving eye cannot but fail to establish detached perspectives onto the world. In Menzel's universe, unsettling and inconsistent afterimages are the very stuff perception is made of. Even when closing our windows, shutters, curtains, and eyelids, the world does not simply go away, for the image of this world belongs to our mortal body just as much as our eyes and bodies are physical extensions of it. Menzel's window is thus neither a tool subjecting the world to the gaze of a stable observer, nor does it define a limit between the interior and exterior, the private and the public. What makes this window modern is that, instead of catalyzing an unambiguous dialectic of inside and outside, it provides a site of bodily transactions at which experiences of scopic sovereignty and perceptual synthesis become elusive. The romantic conception of the window as a stable perimeter separating different ontological spaces and realms of cognition

makes way for a notion of the window as an interface whose fractured frames enable inherently messy, multiple, and multifocal experiences of immanence and immersion, that is, a mutual integration of viewer and image space. No longer empowering a gaze that hopes to possess the objects of the visual field like a booty, Menzel's new window thus also dispenses with the foundation of what Hoffmann's cousin understands as the art of seeing. It is not authoritative acts of framing and distanciation that decide what is aesthetic or not, but rather our willingness to explore and render visible the sensory perception of reality. Rather than reify the world and subject its objects to the power of a detached gaze, this new art of seeing exposes the extent to which our view even of highly protected and seemingly timeless spaces is essentially in flux, unstable, and inconsistent. Windows here no longer have the unquestionable power to order the manifold and reduce the complexity of the world. Far from offering unequivocal answers to the riddles of perception, they have become an integral part of the problem and adventure of seeing itself.

But we should not think that Menzel's emancipation of window and picture plane comes without any costs. Note the two chairs located in seemingly random positions close to the open balcony door, one used in order to hold the door open, the other one facing the viewer, yet situated at and in fact transgressing the very edge of the painting. Back to back, Menzel's chairs make a sad and deserted impression indeed. They resemble objects at a crime scene, tracing the ghostly presence of an absence. Given their solitary position, nothing is more difficult for us than imagining that these chairs could ever again serve their habitual function: to seat people, enable sedentary vistas on urban or domestic space, and allow dwellers to communicate within the protected walls of the interior. Nothing in Menzel's painting seems reminiscent of how contemporary ideologues such as Wilhelm Heinrich Riehl celebrated the bourgeois household as the age's material and moral center, as a site of ethical integrity, energizing prosperity, unhampered interaction, and meaningful universalism.[24] As it situates the subject as an active producer of visual perceptions, Menzel's new art of seeing seems to obliterate the communicative infrastructure of bourgeois domesticity, identity, and moralism. Contrary to what bourgeois thinkers during Menzel's times were eager to argue, restlessness and alienation here have deeply penetrated the domestic sphere; the sight of fragmentation, dispersal, and silence displaces Riehl's influential vision of the bourgeois "whole house." What makes Menzel's painting representative is nothing less than its denial of bourgeois universalism and representativeness. Whoever looks at and through Menzel's window will recognize that the advent

of subjective vision cannot be conceived in isolation of how the rise of modernity subjects the onlooker and his or her body to abstract and open-ended experiences of speechlessness and nonreciprocity. Menzel's modern onlooker is one for whom even the familiar is marked by profound strangeness. Nothing for him wants to add up to a whole anymore, including what we may witness within the frame of a work of art. Nothing gives us pause to rest and contemplate the meaning of things from an external position. Rather than permit sedentary experiences of totality and control, *Balcony Room* shows that the modern pleasures of subjective vision go hand in hand with the unsettling experience of dehumanization, just as much as the immanence of embodied perception cannot be separated from the perception of estrangement, physical or spiritual. The deserted or misplaced chair is a corollary of the modern, multifocal window. One cannot be thought without the other, one produces the other.

Both Alberti's conception of the image as an open window and the bourgeois cult of interiority and intimacy were based on the notion of the world as a stage that presented itself to and was framed by the onlooker's eye. Alberti's veil separated the spaces of the viewer and the viewed like a proscenium. It defined the subject as a detached observer whose categorical separation from the visual field provided the condition for the possibility of aesthetic experience and pleasure. Likewise, the bourgeois vision of the ideal house distinguished between the secluded sphere of the interior on the one hand, and on the other the zone of publicity and representativeness as it began already in the house's reception rooms and extended into the exterior world. To move from the domestic to the public was to become an actor entering the stage in order to perform his or her assigned role.[25] What we witness in Menzel's *Balcony Room,* by contrast, is how the advent of the modern window erodes the metaphorical conception of the world as a stage: neither art nor bourgeois life here appear able or willing to posit strict boundaries between different zones of experience in order to define their respective identities. As seen in face of and through Menzel's modern window of perception, the world becomes one in which we can no longer distinguish between stage and auditorium. Unable to focus our attention on any single detail, our eyes are pulled from one zone of representation to another; we drift among inconsistent views of the world without ever experiencing a sense of unity or wholeness. That Menzel's chairs remain empty is therefore all too logical. For how are we to decide whether we are viewers or viewed, audiences or actors, if Menzel's modern art of seeing centers its focuses on the dispersal of focus itself; if art here tries to see the contingencies of its

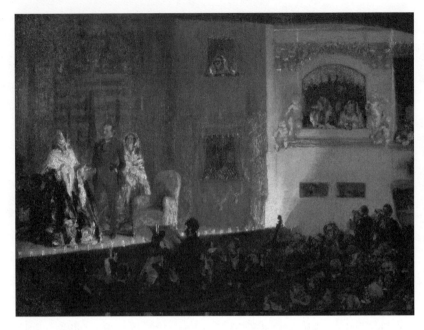

Adolph Menzel, *The Théâtre du Gymnase in Paris* (1856). Oil on canvas, 46 × 62 cm. Nationalgalerie, Staatliche Museen zu Berlin, Berlin, Germany. Photo: Bildar-chiv Preussischer Kulturbesitz / Art Resource, NY.

own seeing? How are we to locate the border between stage and auditorium if the beholder's eye itself actively produces visual impressions and the window's role is to simultaneously represent, reflect, and refract competing images of the world?

Nowhere perhaps does young Menzel's departure from the metaphor of the stage become clearer than in his paintings of theater life itself, in particular in his *Théâtre du Gymnase* of 1856. Though depicting a motif familiar from con-temporary French painting, Menzel's composition is highly unique in that it chooses a rather oblique point of view in order to depict stage and auditorium. Unlike the French masters, Menzel does not offer us one primary focus of ac-tion, nor does his painting elaborate a dramatic contrast between the onstage action and the audience's reception. Instead, as Michael Fried has written, in Menzel's painting "the viewer's attention is forcibly divided between the ac-tors on the stage to the left, the occupants of the various boxes across the hall, and the orchestra and audience, toward the right-hand edge of the latter of which two men attract attention by standing up and holding opera glasses to

their eyes."[26] Like *Balcony Room*, Menzel's later *Théatre du Gymnase* defines the viewer as a drifter. Unable to find any single area of attention, our eyes wander across the surface of the painting in search for something to hold on to. They find themselves drawn to the patches of warmer color and light (the creamy white on the right; the warm red in the middle) much more so than trying to distinguish the different spaces of theatrical communication. As a result, the painting not only comes to blur the boundary between stage and auditorium, thus violating nineteenth-century codes of theatrical illusionism and identification, it also identifies the depicted audience not as a collective of engrossed spectators but as a multitude of private onlookers, each characterized by essentially different practices of viewing. In the end, it appears as if the audience members here are as much on display as the professional actors, that the true drama does not unfold on stage but in the decentered and unsettled network of gazes and perspectives we observe in the painting itself, the sum total of which no longer adds up to a unified totality.

As it denies conventional distinctions between stage action and acts of reception, Menzel's oblique viewpoints in *Théatre du Gymnase* document the extent to which the role of spectacle in modern culture is less that of cultural homogenization than of social separation. Verso to the recto of subjective and embodied vision, spectacular culture as depicted in this painting pursues "the construction of conditions that individuate, immobilize, and separate subjects, even within a world in which mobility and circulation are ubiquitous."[27] The member of the crowd in the 1856 painting, like the inscribed viewing subject of *Balcony Room,* is an essentially lonely one. What awaits the individual beyond conventional codes of passive viewing and active performance, what lies ahead of the modern viewing subject once emancipated from monocular notions of representation as an open window is not an operative community of like-minded observers but a manifold crowd marked by experiences of atomization and isolation. How various initiatives in future decades employed different mechanisms of polyfocal vision in order to reverse, functionalize, or further promote such experiences of fragmentation; how they reframed the curious dialectic between the embodied observer and the rise of the modern spectacle in order to reconstruct the foundations of community; and how they identified the problem of attention as one of the principle problematics of modern industrial culture—it is to how Menzel's successors explored the diversified window cultures of modernity so as to fill the empty chairs of *Balcony Room* that we turn our focus in the following chapters.

2 Richard Wagner and the Framing of Modern Empathy

We have come to think of the bourgeois theater stage as a space separated from the audience by a proverbial fourth wall. Translated in 1760 into German by Gotthold Ephraim Lessing, Denis Diderot's seminal treatise *De la poésie dramatique* advised playwrights and actors to carry out their respective activities as if no audience were present in front of the stage. "Imagine a big wall at the outermost edge of the stage which is to set apart the parquet. Play as if the curtain had not been raised."[1] With the exception of some Romantic eccentrics eager to rupture the stage's autonomy a few decades later, German dramatists, stage directors, and actors readily followed Diderot's formula throughout the nineteenth century. Though German linguistic conventions turned Diderot's impenetrable stage wall into a "*Guckkastenbühne*" (peep-hole stage), nineteenth-century German staging practices relied greatly on Diderot's efforts to purchase realism and illusionism by radically segregating the different spaces of dramatic communication.[2] Theatrical plays best captured the viewers' minds and emotions, it was believed, if they presented themselves as self-enclosed universes. However ornate in design, the purpose of the theater's proscenium was not to connect stage and auditorium but to separate them; not actively to frame the viewer's viewing but rather to generate illusions of unseen and hence voyeuristic seeing. A synecdoche for Diderot's fourth wall, the frame of the proscenium came to present the world on stage as one emancipated from the strictures of framing. It granted naturalistic effects and viewer identification by disguising its own status as an interface, as a site of bi-directional communication.

Richard Wagner's musical theater, as it was envisioned in the composer's critical writings in the late 1840s and at its eventual institutional home in Bayreuth in 1876, has often been seen as the apex of this nineteenth-century history of illusionism. Conventional wisdom explains Wagner's desire to integrate poetry, music, and dance under the umbrella of one effective *Gesamtkunstwerk* as an attempt to perfect the bourgeois tradition of the fourth wall and thus produce peep-hole theater at its best. Wagner's theatrical initiatives, we are told, aimed at the creation of spectators affectively invested in the spectacle precisely because they were experiencing the action on stage as one wholly independent of the theater's mundane mechanisms of framing, staging, and reception. In trying to achieve this, Wagner's work in fact—one frequent conclusion has it—foreshadowed nothing less than the operations of twentieth-century mass culture, that is, the bliss of modern-day spectators gazing at the cinematic dream screen from the darkened womb of the auditorium.

This chapter confronts and complicates crucial aspects of this genealogy not only by conceptualizing the Wagnerian stage as a window of ambiguous attractions but by investigating the extent to which Wagner's theatrical initiatives illuminate post-Albertinian conceptions of the window as they took hold in the course of the nineteenth century. The task of the following pages is to locate the median position of Wagner's stage on a spectrum ranging from the bourgeois notion of peep-hole illusionism and perspectival space on one end and the double challenge to Diderot's fourth wall as it emerged around 1900 on the other. Though Wagner's theater was designed to engineer powerful illusions and emotional effects, it significantly modified how Diderot's followers defined the relationship of different theatrical spaces and their impact on the spectator. And even though Wagner's ambitions indeed prefigured central issues relevant for our understanding of both aesthetic modernism and twentieth-century industrial culture, we cannot reduce his theatrical interventions to a single dominant and coherent principle. Wagner's proscenium was a site of constitutive tensions and contradictions, a crossroads of conflicting aspirations indexing the historical ruptures of Wagner's own lifetime. Wagner's ambition, I suggest, was neither to separate the stage by means of a fourth wall nor to do away with whatever might disconnect actors and spectators. Torn between different conceptions of the stage and its relation to the audience, Wagner's theater instead envisioned the proscenium as an interactive membrane able to secure an equilibrium between the classical and the modern, between dissimilar aesthetic traditions and incompatible social visions. It is when considering Wagner's stage as a window frame, as a semi-transparent screen of different

attractions, that the composer's unresolved negotiations of past and present become clear.

A disappointed political revolutionary, Wagner imagined the ideal form of theatrical communication in 1850 as follows: "The spectator completely transports himself on to the stage by looking and hearing; the performer becomes an artist only by complete absorption into the audience; the audience, that representative of public life, disappears from the auditorium. . . . It lives and breathes now only in the work of art, which seems to it life itself, and on the stage, which seems to be the whole world."[3] Wagner's vision of future opera as a *Gesamtkunstwerk* aimed at a rebirth of Attic tragedy, not only in order to reunite the arts of music, dance, and poetry under the sign of the dramatic but to redeem the individual from what Wagner considered the impoverishment of modern sensory perception. An interactive portal linking actors and viewers across the boundaries of the stage, Wagner's "total work of art" was to liberate both artists and audiences from the modern rule of instrumental reason and the commodification of aesthetic pleasure. Though it reckoned with decentered, bifocal, subjective, and roaming viewing subjects à la Menzel, its project was to restore perceptual synthesis as much as to renew a charismatic sense of community, to rebuild aesthetic self-awareness and corporeal unity beyond the strategic realm of the everyday. According to Wagner's revolutionary visions circa 1850, the theater of the future should be a site neither of mere aesthetic self-expression nor of cultural consumption but rather a mechanism and medium of reciprocal transport. Its central task was to immerse willing audiences in other times and places, to bring spectators literally in touch with the world on stage as much as with each other, to train highly attentive forms of perception and self-projection, and to foster uninhibited emotional links among viewers, artists, and performers. Its central task was nothing less than to emancipate individuals from the strictures of their private existences, to provide an interface of individual self-transcendence and aesthetic self-transformation so as to recuperate the foundations of meaningful communality.

In the mid-1850s, Gottfried Semper—Wagner's brother in arms during the Dresden uprising in 1849—sought to convert Wagner's vision into an architectural design when he projected a stage setting for the Nibelung Festival of 1865 in the Munich Glass Palace. In accord with Wagner's own desire, Semper's theater was to abolish any possibility of representing hierarchy and social status in the auditorium. Like the Greek amphitheater, Semper's Wagnerian theater of the future consisted of tiers and platforms alone. No matter where the public was seated, the spatial arrangements of the auditorium and stage

were to provide what baroque loge theaters had suppressed: equality of vision and pleasure. And yet, in order to improve the theater's function as a funnel of transport and unhampered reception, Semper's design, rather than situating the orchestra as prominently as the other performers (like the Greek chorus), instead included a deep ditch in front of the stage, hiding the orchestra entirely from the audience's view. A "mystical abyss" in Wagner's own words, this chasm aimed at a bold combination of the antique practice of tiered viewing and the expectations of the bourgeois peep-hole stage. In keeping the mechanics of music production out of sight, the "mystical abyss" of the orchestra pit was to consolidate seemingly contradictory stances, namely Wagner's republican vision of theater as a space where audiences became a public entity with the voyeuristic desires that had energized the fourth wall tradition. As Beat Wyss has argued, in Semper's design the "antique *scenae frons* is broken by the *Guckkasten*-stage. The panels of the proscenium, doubled and graduated, condition the view of the spectator to a central perspective. Orchestra pit and *Guckkasten*-stage dedicate themselves to an illusionistic marriage of space and dramatic action, something for which the antique theater did not even strive."[4] Semper's design fused old and new in the hope of liberating the aesthetic from the dictates of bourgeois culture. In accord with Wagner's vision of 1850, Semper's blueprint revived the egalitarian ideals associated with the Greek *polis* by turning theater into a mechanism that could grant experiences of equal looking, unrestricted listening, and central perspective for all. Yet rather than entirely dislodging former codes of looking and identification, Wagner's reforms ended up reframing them in the name of the future. Unlike Menzel's early work, which redefined the window as a disjointed aperture enabling multiple sightlines, heterogeneous planes of composition, and aggregate temporal perceptions, Wagner and Semper's window-proscenium was to harmonize the fragmented by universalizing the particular, to unify the heterogeneous by reconciling the conflicting vectors of time and space.

The plan for the Munich Glass Palace was never realized, even though its architectural principles were to inform the later construction of Wagner's Festival Hall at Bayreuth. What the theater world of Munich during the 1860s witnessed instead of Semper's design was the opening of Wagner's *Die Meistersinger von Nürnberg* at the Königliche Hoftheater in June 1868. As staged at this venue, *Die Meistersinger*—in spite of its historical theme—helped showcase some of Wagner's most central concerns about the politics of modern culture and spectatorship. To be sure, the architectural layout of the Munich Hoftheater embodied everything that young Wagner and Semper had once

set out to overturn. Rather than enabling actors and audiences to absorb each other across the mystical window of the proscenium, this theater provided a space for the public to display hierarchy and represent social distinctions—a space not of redemptive transport and aesthetic democracy but of conspicuous consumption. And yet, I argue, the Munich production of *Die Meistersinger* nevertheless presented Wagner's music drama as a visionary opera deeply concerned with the vicissitudes of modern vision and fenestral spectatorship. Its mission was not only to reinvent the modern stage as a window of aesthetic transport but also to explore the prospects of empathetic viewing in an age of overwhelming modern distractions.

Hans Sachs's interpretation of Walther's song—"It sounded so old / and yet it was so new"—has often been seen as the key to understanding *Die Meistersinger*.[5] According to scholars such as Carl Dahlhaus, Wagner's *Meistersinger* relied on modern compositional practices in order to conjure the impression of older musical idioms.[6] For Theodor W. Adorno, Wagner's opera disguised reflection and technique as nature and spontaneity; it constituted itself as a "phantasmagoria," understood as the

> occultation of production by means of the outward appearance of the product. . . . In the absence of any glimpse of the underlying forces or conditions of its production, this outer appearance can lay claim to the status of being. Its perfection is at the same time the perfection of the illusion that the work of art is a reality *sui generis* that constitutes itself in the realm of the absolute without having to renounce its claim to image the world.[7]

This chapter examines what I understand as the phantasmagorias of vision and framed visibility in Wagner's *Meistersinger*. Though *Die Meistersinger* reckoned with the inevitable facts of modern embodied and subjective looking, and though its 1868 staging bore the mark of mid–nineteenth-century technologies of visual illusion and scopic entertainment, the opera hoped to engineer seeing as something untroubled by the historical process: a source of timeless meanings, pleasures, practices, and bonds. Similar to the way in which Wagner's larger theatrical politics set out to integrate the disparate traditions of antique theater and the modern peep-hole stage, so did the framing of sight and attention in *Die Meistersinger* acknowledge certain aspects of visual modernization while at the same time seeking to contain their unsettling effects—the lodging of vision in a body subjected to contingency, temporality, and error or the anxiety about one's relation to the external world—within the frame of a more stable model of vision. Whatever looked old in Wagner's *Meistersinger*

of 1868 was certainly quite new: the opera's image of the past was a product of the modern as much as it meant to offer an antidote to the present; the opera offered a window onto the past with the ambition to return the audience safely to the future.

Wagner's *Meistersinger*—like the reorganization of spectatorship at Bayreuth—indexes and engages fundamental changes of visual culture during the mid–nineteenth century. And yet we should be careful not to overlook certain differences between how Wagner's opera and how Wagner's Bayreuth project sought to modernize the stage and turn the proscenium into a window of future attractions. Though both sought to rattle at the foundation of the fourth wall and its dedication to Albertinian space, *Die Meistersinger* and the Bayreuth stage provided different versions of how to catalyze empathetic looking and sensual transport. Though both considered experiences of sensual absorption a key to aesthetic democracy, they came to represent different degrees of how to revise spectatorship, reorganize attention, and reinvent past and future. Rather than trace one coherent narrative about Wagner's restructuring of the fourth wall, this chapter therefore explores competing versions of Wagner's understanding of theater as a window onto the past and future, neither one of which is without its own internal ambivalences. The disparities between these versions matter, I argue, because they encapsulate nothing less than the later division of modern culture into opposing codes of active versus passive looking, of projective versus merely receptive spectatorship, of attentive astonishment versus voyeuristic consumption. I will develop the argument of this chapter in four steps. First I examine the significance of corporeal viewing for the narrative process of *Die Meistersinger* and relate it to contemporary debates about vision and the codes of realism. Second, I situate the framing of sight in Wagner's *Meistersinger* in emerging contemporary debates about empathetic, embodied forms of looking and their aesthetic dimensions. In the next section, I explore how the final scene of act 3 in particular and its 1868 staging take recourse to nineteenth-century modalities of seeing in order to facilitate the modern in its production of a dreamlike semblance of the past. And in the final step, I discuss the extent to which Wagner's framing of modern attention, spectatorship, and identification in *Die Meistersinger* and—differently—at Bayreuth, his various attempts to move with, beyond, or against the modern anticipate later developments in German history and culture.

Eyes Wide Shut

The work of Johannes Müller has often been identified as a pivotal moment in the modernization of sight during the nineteenth century. Müller's theory of specific sensory energies radically questioned our relation to the real. It claimed that our senses provide knowledge not of some external reality but solely of our nerve sensations: no sound without our organ of hearing; no color, light, or darkness without the physiological activities of our eyes. Situated in a finite body that could not trust its own senses, visual experience was thus uprooted from stable orders of referentiality. Sight could no longer be seen as a transparent window merely framing and ordering shared views of the real. Instead, it had to be considered a physiological activity producing the real in the first place. It was the research of Hermann von Helmholtz that during Wagner's life sought to contain the unsettling effects of Müller's physiological skepticism. Though Helmholtz acknowledged the importance of Müller's work and saw no reason to reject the facts of subjective and embodied vision, his research was eager to redevelop reliable codes for what could be taken for real. By elaborating "complex, though not necessarily mimetic, theories of relation between sensory images and the real," Helmholtz wanted to recharge sight with some sense of reliability and shared referentiality.[8] In his attempt to appease the modern subject's perceptual anxiety, Helmholtz's scientific explorations thus curiously echoed the way in which nineteenth-century modernization at large provided new visual experiences to gratify the modern subject and compensate for the potential flaws of subjective vision. Driven by a dramatic shift from the production to the provision of consumer goods, nineteenth-century capitalism witnessed an unprecedented surge of technological illusions and prosthetic vision machines. Industrially produced imageries and a myriad of scopic toys flooded the marketplace, invaded the arenas of everyday activity, and supplanted concrete experience with spectacular diversions. While everything solid seemed to melt into the air, this new culture of the spectacle—like Helmholtz's quest for reference and reliability—pacified anxieties about the subjectivization of vision as much as it promised to uphold increasingly spurious notions of community and social coherence. It simultaneously aroused and soothed minds, engineered and bonded emotions, proliferated new kinds of material objects and presented them as self-sustaining attractions.

Wagner's work from the 1850s onward, far from ignoring the optical, reflects and participates in this transformation of visual culture during the nineteenth

century. In particular *Die Meistersinger,* often simply seen as a tribute to the integrative power of song and music, served Wagner as an exemplary platform to address the ambivalent role of modern visibility, attention, and spectatorship. Much like Helmholtz's research on optics, Wagner's opera hoped to make modern sight manageable, that is, warrant its ability to provide a reliable sense of self, truth, and community. Instead of fueling the modern subject's angst about the contingencies of visual embodiment and subjectivization, Wagner's *Meistersinger* aspired to turn modern visual culture into a catalyst of social consensus, one that could give history the appearance of historical inevitability.[9] The opera hoped to overcome what Wagner considered the negative effects of modern distraction, to refocus the subject's attention by exploring immersive, haptic, and projective modes of modern seeing, and thus reconstruct the preconditions of what could unite people into a meaningful whole.

Notwithstanding a composer's intuitive affinity to sound and hearing, eyes in Wagner's dramatic and theoretical work designate the most fundamental site of human sensory perception and communication.[10] It is the eye, according to Wagner's anthropology, that allows the individual to distinguish between self and other, between what is similar and what is different. It is the modality of sight that in Wagner's larger socio-aesthetic program empowers the audience of public art to recognize itself in the aesthetic reflection provided on stage and thus sense their specific place within a specific human collective. Good sight in Wagner is focused, attentive, empathetic, and in harmonious touch with the body's other senses, and precisely because of this it can be linked to a corporeal experience of organic communality. It catalyzes unmediated reciprocity between those who are familiar and separates that which is foreign in nature. Distracted and merely strategic, bad sight, on the other hand, as we shall see, undermines communal identity because it either impairs the recognition of oneself in the other or fails to draw appropriate boundaries between dissimilar groups.

In Wagner's 1849 treatise *Das Kunstwerk der Zukunft* ("The Artwork of the Future"), the composer's doctrine of seeing finds expression as follows:

> The eye apprehends the *bodily form of man,* compares it with surrounding objects, and discriminates between it and them. The corporeal man and the spontaneous expression of physical anguish or physical well-being, called up by outward contact, appeal directly to the eye; while indirectly he imparts to it, by means of facial play and gesture, those emotions of the inner man which are not directly cognisable by the eye. Again, through the expression of the eye itself, which directly meets the eye of the beholder, man is able to impart to the latter not only the feelings of the heart, but even the character-

istic activity of the brain; and the more distinctly can the outer man express the inner, the higher does he show his rank as an artistic being.[11]

Sight's primary activity is to scan the environment and recognize physical signs of similarity and difference. In its aesthetically most portentous function, however, the eye transcends its merely receptive task, becomes an active organ of corporeal expression and projection, and establishes empathetic proximity between human beings. Alluding to the romantic conception of a return of the gaze, Wagner celebrates scopic reciprocity as a state of absolute presence and total transparency, a state in which one's feelings and thoughts can directly reach the heart of the other without requiring the alienating logic of linguistic mediation and conventionalized speech. At its best and aesthetically most relevant, then, vision in Wagner either collapses differences between like-minded souls into experiences of absolute sameness, self-recognition, and cohesion, or it reifies the appearance of the other into a manifestation of radical, incommensurable alterity.

Ideal forms of looking, then, simultaneously separate friend and foe and enable an empathetic beholding of oneself in the like-minded other. Good looking is active and projective. It prepares the individual for acts of self-transcendence and self-transformation; it enables the self to enter and establish bodily relations to the world, to touch upon and be touched by the world, and thereby to activate one's own emotions as much as one's surroundings. It therefore comes as no surprise that whoever falls in love in Wagner's music dramas falls in love at first—or, as I have argued elsewhere, at last[12]—sight. Love always enters the lives of Wagner's heroes in the form of a shock. It transpires as a rapture of visual recognition and empathetic transformation. The loving gaze, in which culminates Wagner's vision of unbridled transparency and reciprocity, suspends the ordinary continuum of time and discovers the absolute in a sudden moment of enchantment. The dashing hero Walther von Stolzing and the inexperienced maiden Eva Pogner, in the opening scene of *Die Meistersinger,* neatly illustrate Wagner's optics of instantaneous love. Affection here sets in as a silent drama of looking, of meeting the other's gaze and communicating passion through the enraptured eye. Wagner's demanding stage directions describe Walther and Eva's initial exchange of glances in the interior of St. Catherine's church as follows:

> Walther von Stolzing is standing at some distance away, leaning on the side of a column, his gaze fixed on Eva, who turns repeatedly around to him with mute gestures. . . . By means of a gesture, Walther puts a wistful question to

Eva. . . . Eva, by look and gesture, attempts to answer; but she drops her eyes again, ashamed. . . . Walther tenderly, then more urgently. . . . Eva: timidly repulsing Walther, but then quickly gazing soulfully at him. . . . Walther: enchanted; solemnest protestations; hope. . . . Eva: smiling happily; then, ashamed, lowering her eyes. . . . Walther, in extreme suspense, fixes his gaze on Eva. (13–15)

Whereas Wagner first envisions the initial encounter between Walther and Eva as one of inquisitive gestures *and* attentive glances, he quickly moves on to present their gazes as a tactile exchange, a corporeal gesture in and of themselves. It is the moment when the eye commands the ability simultaneously to behold and project affection, to see and to be seen, that true love comes into being. Understood as a corporeal window into mind and soul, the eye in this opening scene is by no means figured as merely passive or receptive, as an organ of disembodied speculation or pure knowledge. Instead, both Eva's and Walther's eyes communicate the body as a subject and object of desire. Sight in Wagner has erotic power, it literally brings people into touch, and it is the titillating sentience of seeing and being seen, the reciprocal sensation of empathetic vision, that causes Eva—cognizant of the customs of place—to withdraw her gaze well before any word between the new lovers has been spoken.

Walther's fervent gaze at Eva embodies an intimate mode of looking in which neither convention nor tradition seems to restrain the natural genius's emotional plenitude. Vision, for Walther, is beyond rules, norms, and frames. It transcends time and space, and it knows no limits to what can be shown or known. Yet as it transforms a public space (the church) into a highly private playground for the imagination, Walther's loving gaze—in spite of its aesthetic viability—is of little use as an operative blueprint for successful procedures of communal integration. It is instead in the figures of Beckmesser and Sachs that we can better understand how Wagner's *Meistersinger* probes different models of public vision and visibility and plays through their impact on the conditions, limits, and rule-bound forms of community. As we will see in a moment, at the core of this probing is the proposition that the visual and its framing is of critical importance for the translation of individual passion and madness into publicly communicable forms. Public festivals, in the perspective of *Die Meistersinger,* serve as simulacra of ritual sacrifice; they channel potentially destructive energy into social order and contain Walther's unbound and corporeal gaze within reliable and accessible frames of reciprocal seeing.[13]

Throughout the music drama, Beckmesser is typified by skewed forms of looking, by self-inflicted chiasmas bearing witness to the town clerk's greed,

egotism, and instrumental reason. Beckmesser wants to see too much, as it were. He hopes to enforce a spontaneous return of the gaze yet does not even dare to meet the other's look. Beckmesser's eyes are wide shut. Deeply distracted by Beckmesser's instrumental reason, they are unable to achieve empathetic reciprocity and hence restrict his access to true sensual transport and the aesthetic. His look is driven by calculating interest, only to be rewarded in the end for his manipulation of sight with public obscurity. During the song competition in act 3, for instance, Beckmesser's humiliating performance in no small measure stems from his failure to focus on Sachs's text. He secretly looks at the manuscript, "tries to read the paper; isn't able to" (241), and hence, in the judgment of the *Volk,* produces only nonsense. Likewise, at the end of act 2, Beckmesser fails to recognize what Sachs's apprentice David notices at first sight, namely that Beckmesser delivers his song to a stand-in, to Magdalena rather than Eva. Beckmesser's blindness in this scene triggers the violent turmoil that concludes act 2. Like bad singing, bad looking in *Die Meistersinger* leads to social disintegration; it undermines social well-being and promotes destructive outbreaks of rage and madness. It is therefore only fitting that Beckmesser, at the end of *Die Meistersinger,* must vanish into oblivion so that the fragmented community may live again. Redirecting the town community's latent violence, the festival on the open meadow sublimates the noisy blindness of the riot into a new order. Beckmesser is sacrificed, earmarked as the one who looks differently, so as to reinforce the boundaries of that which is familiar and communal.

Many commentators have pointed out that the cobbler-poet Sachs serves as a mediator between Walther's rule-defying romanticism and Beckmesser's manipulative, self-destructive formalism. Sachs represents a tradition of art that aspires to convert authentic inspiration into codifiable technique. Integrated into the circuits of the everyday, his preferred art "must constantly keep in touch with the natural spirit of the *Volk* or its 'free' individuals to avoid becoming overly artificial."[14] A similar point, I suggest, can be made with regard to Sachs's role in *Die Meistersinger*'s many dramas of looking. Sachs's gaze oscillates between the romantic bliss of private inspiration and the need for a public framing of communal cohesion. In the opening of act 3, we witness Sachs as a meditative reader situated in the midst of a prosaic environment, the workshop. In contrast to Beckmesser, Sachs's eyes are focused on the text. His view is not marred by greed and instrumental reason. The setting in fact is reminiscent of a genre painting, offering what Friedrich Schiller would call a "sentimental" restoration of bygone times.[15] As described in the stage direc-

tions, "Sachs is sitting in a large armchair at this window, through which the morning sun shines brightly on him; he has a large folio before him on his lap, and is absorbed in reading it" (175). Contemplative reading in this scene, far from arresting Sachs in passivity, endows the cobbler-poet with complete authority over the visual field. Sachs's contemplative posture coerces David, who has barely recovered from the previous night's turmoil, to assume a position of repentant submissiveness. Sachs's transfigured appearance as a romantic reader simultaneously attracts and rejects; it puts David in the role of the irreverent son whose foremost desire is to secure the paternal authority's forgiveness.

Sachs's figuration as both an absorbed and an absorbing reader sets the stage for his public celebration by the crowd in the last scene of act 3. Unlike Beckmesser, who is rejected by the assembled *Volk* as an unlikely suitor for Eva even prior to his song—"What? He? He's wooing? Doesn't seem like the right one!" (239)—Sachs enters the scene as a charismatic figure who compels and fascinates. Sachs is hailed triumphantly by the *Volk*. He is greeted as one who offers something for everyone and thus integrates the community across existing divisions of social status, age, and gender. Interestingly enough, Wagner's stage descriptions depict Sachs's spectacular entry as part of a larger "spectacle" (*Schauspiele*; 235), a theater within the theater. As importantly, it is through the medium of sight, not song or speech, that Sachs initially connects to the jubilant crowd gathered in front of the festival stage: "Sachs, who, motionless, has gazed above the crowd as if absent-minded, finally rests his gaze familiarly upon them, and begins with a voice affected by emotion, but quickly growing firmer" (235). One might suspect at first that Sachs's affable gaze at the crowd simply elevates Walther and Eva's earlier drama of reciprocal visuality to a public setting and that, therefore, Sachs's popularity relies on the fact that his eyes can meet the eyes of the *Volk* in a scene of mutual and spontaneous empathy. What is important to keep in mind, however, is that Sachs's look at the crowd emerges within an annual ritual that depends on identifiable sets of rules and staging principles. Rather than—like Walther—doing away with all rules, and rather than—like Beckmesser—manipulating given codes for a personal agenda, Sachs's amicable gaze at the *Volk* follows the customs of the festival in order to transcend them. What is staged and orchestrated must take the appearance of the natural and spontaneous, what is rule-bound and a product of technique must disguise premeditation and be tested in front of the crowd, so that communal traditions lose their stifling effects and open themselves up to continual renewal. Later, I will discuss in further detail how the festival scene of act 3, in its very framing of visual reciprocity and transparency,

expunges every trace of effort and willfulness, and how Sachs's appearance on the open meadow reflects the vicissitudes of political publicness in the middle of the nineteenth century. First, however, it is warranted to situate Wagner's framing and codification of empathetic vision within certain debates on the aesthetics of seeing and embodiment that fully emerged in the decades following the conception and premiere of *Die Meistersinger* while providing a context for and shedding light on the role of sight and fenestral mediation in Wagner's own thinking.

The Aesthetics of Empathy

As Jonathan Crary has argued in *Techniques of the Observer,* modern visual culture not only brought about a revolutionary breakdown of Albertinian perspectivalism as a code of realistic representation, As importantly, it also led to what Crary, taking Johannes Müller as his chief witness, understands as the autonomization of sight, a complete emancipation of vision from other modes of sensory perception, at once rendering the eye the primary organ of human experience and—due to its principle isolation—effectively subordinating it to new imperatives of power. The advent of modernity in the nineteenth century, in Crary's Foucauldian terms, not only fused visual subjectivization and subjugation into one single mechanism, it also promoted the separation of individual sensory systems—in particular the emancipation of sight from touch—as a means to control the modern individual: "The loss of touch as a conceptual component of vision meant the unloosening of the eye from the network of referentiality incarnated in tactility and in its subjective relation to perceived space. This autonomization of sight, occurring in many different domains, was a historical condition for the rebuilding of an observer fitted for the task of 'spectacular' consumption."[16]

As we have already seen, Crary's account is no doubt useful in recalling how nineteenth-century developments lodged vision in the temporalities of an embodied viewing subject. What seems questionable, though, is whether nineteenth-century thinkers exclusively experienced and described the modernization of sight in terms of a differentiation and autonomization of vision. For isn't there ample historical evidence that many a physiological, optical, philosophical, and aesthetic theorist in the nineteenth century, particularly its second half, viewed the modern reembodiment of sight as a necessary precondition for reconstituting the possibility of perceptual synthesis? Doesn't Crary ignore a whole range of other strains of modern thinking in which visual

embodiment enabled new form of empathetic perception, rather than merely resulting in an interlocked process of subjectivization and subjection, of rationalization and control? Doesn't Crary underestimate a peculiarly modern desire to explore the haptic and tactile dimensions of seeing and hence to explore how our eyes can literally bring different bodies in touch with each other?

Wagner's own writings on sight are certainly a good case in point. As we have already seen, Wagner—in line with many theorists of the modern—may have privileged the eye as the most powerful and discerning organ of human sense perception. But not only did Wagner's vision of future art entail the desire for integrating different sensory systems and thus permitting experiences of plenitude and wholeness, Wagner's understanding of human sight—whether alienated from other sensory functions or not—clearly acknowledged the eye as the aperture of an embodied subject, one whose acts of looking could never be entirely purified from the sense of touch. What makes Wagner's subject receptive for the task of art is—contrary to Crary's assumption—not the total autonomization and purification of sight but the way in which sight is situated in a perceiving body and thus allows viewers to establish new relationships between their bodies and the work of art. Wagner's hope for a modern aesthetics of embodiment in which theater could serve as a window of reciprocal transport and absorption, of projective seeing and aesthetic transformation, was clearly in tune with the collection of theories developed in late-nineteenth century Germany in perceptual psychology, art and architectural history, optics, and philosophy loosely labeled the empathy tradition. Empathy theory found perhaps its most succinct formulation between roughly 1873 and 1893 in the works of such figures as Robert Vischer, Konrad Fiedler, August Schmarsow, and Heinrich Wölfflin. Though this work succeeded most of Wagner's own writings on sight and rarely addressed Wagner's operas and theatrical reforms at all, German empathy theory remains useful in casting light on the enframing of embodied seeing, of the dialectic of seeing and touching, of framing and haptic immersion as played out in *Die Meistersinger* in its original staging.

While certainly aware of Müller's groundbreaking research in perceptual psychology, empathy theorists set out to theorize embodied responses to images, objects, and spatial environments and hence to think through the imbrication of our senses of sight and touch, the visual and the tactile. In his 1873 treatise "On the Optical Sense of Form," Robert Vischer described the viewer's active perceptual engagement with a work of art as such: "I entrust my individual life to the lifeless form, just as I . . . do with another living person. Only ostensibly do I remain the same although the object remains an other. I seem

merely to adapt and attach myself to it as one hand claps another, and yet I am mysteriously transplanted and magically transformed into this other."[17] German philosophy and aesthetic theory had used the term *empathy* (*Einfühlung*) since the late eighteenth century to describe affective relationships—centered around feelings such as pity, sympathy, or compassion—between non-identical particulars. What made late nineteenth-century discourse on empathy qualitatively new and different, however, was its dual emphasis on the projective abilities of seeing and on the subject's active encounter with the spatial forms of three-dimensional manifestations, architectural space in particular. Empathetic looking, for Vischer and others, infused the form of visible objects with our own bodily form and soul. It blurred the boundaries between the self and certain objects occupying the visual field, animated the latter and dissolved the hardened contours of the former, and in this way allowed spectators actively to transform into and become the other. Empathetic looking, according to its nineteenth-century theorists, turned spatial enclosures into a living space. It did not simply map preexisting forms and configurations but actively constructed and produced them in the first place.

This is not the place to discuss in detail how empathy theory sought to ground the aesthetic impulse in both the artist's and the viewer's experience of embodiment. Yet what is important for our context here is twofold. First, empathy theory, while considering sight the perhaps most important of our sensory systems, envisioned modern forms of looking that did not result in an autonomization and purification of visual perception. Empathy theorists may have developed complex theories of visibility, but they—like Wagner—considered the act of looking an inherently messy and necessarily hybrid form of sensory perception, one that could not do without the input of other senses. Witness Heinrich Wölfflin's contention in "Prolegomena to a Psychology of Architecture," published four years after Wagner's death in 1886: "Physical forms possess a character only because we ourselves possess a body. If we were purely visual beings, we would always be denied an aesthetic judgment of the physical world. But as human beings with a body that teaches us the nature of gravity, contraction, strength, and so on, we gather experience that enables us to identify with the conditions of other forms."[18] Sight, according to nineteenth-century empathy theorists, was far too important to us and our aesthetic impulse to be relegated to the eye alone. Once emancipated from other sensory systems, sight could only produce blindness about the world or about the viewer's body. To separate the optical from the tactile was to eliminate the ground for pleasure and aesthetic experience.

Second, in exploring the relationship between viewers and works of art as one of reciprocal projections and transformations, empathy theory played an important role in encoding modern spectatorship not as a passive process of mere consumption and identification but as an active perceptual engagement with the aesthetic object. Accordingly, the work of art at its best embodied the basic facts of human perception: that to see and perceive something as something does not simply mean to behold external realities but first of all to create and articulate the real as part of the realm of the visible. In the work of Konrad Fiedler, this emphasis on the principle activity of the embodied eye even led to a categorical demise of traditional concepts of aesthetic mimesis. Because, per Fiedler, the "separation of world and individual is only a deceptive illusion," naturalistic copies of the real in art—representations seemingly free of the perceiver's subjectivity and perceptual engagement—are simply impossible.[19] Reality is lodged in the subject and hence inextricably perspectival, yet we should not understand the fundamental perspectivalism of human existence as a loss and limitation but rather as the generative principle of the real, as the condition of the possibility of the world and its objects. A somewhat uneasy (albeit after visiting Bayreuth, exhilarated) Wagnerian,[20] Fiedler's hope for future art was not to mimic the real but to explore the perceptual processes that make aesthetic objects possible, investigate the complicated links between sight and touch in our constitution and experience of the visible, and in this way empower spectators to find the true artists in themselves.

Wagner's thinking on sight as much as the choreography of vision and the encoding of visibility in *Die Meistersinger* foreshadowed these two basic tenets of late nineteenth-century empathy theory. Like Vischer and his ilk, Wagner considered human sight a sensory system that, far from being restricted to the optical alone, endowed the modern subject—like the principal characters of *Die Meistersinger*—with feelings of sympathy, compassion, attentiveness, and emotional responsiveness, which enabled the subject to empathize him- or herself into the surrounding world. And as with Fiedler's theory of visibility, Wagner's *Meistersinger* was carried out in the name of encoding modern spectatorship as an active process of exchange, projection, and transformation, one that would turn viewers into artists articulating a world of the visible powerful enough not to mimic the real but to displace it altogether with a parallel reality. And yet Wagner's hopes for theater as a window fusing the viewers' vision and touch and in this way refocusing their attention did not protect his work from duplicating the very processes empathy was meant to overturn: the transformation of modern society into a culture of spectacle and consumption. On the

contrary. How Wagner's *Meistersinger* and its first production negotiated the double ambition of modern empathy theory *avant la lettre,* and how Wagner's later Bayreuth festival house, in seeking to continue this negotiation, produced its opposite, namely, disembodied, desubjectivized, and fundamentally immobilized spectators, shall concern us in the remainder of this chapter.

Engineering the Real

Wagner's *Meistersinger* premiered on June 21, 1868, in Munich. Most of the sets were designed by Angelo II Quaglio and Christian Jank with the notable exception of the final festival scene, devised by Heinrich Döll, the *Königliche Hoftheatermaler.* Wagner's expectations for the first staging of *Die Meistersinger* were more than demanding. Privileging spatial depth and three-dimensional configurations over painted backdrops and perspectivalist foreshortenings, Wagner required the majority of sets and buildings to be *"praktikabel."*[21] According to Wagner's requests, the Munich premiere was meant to reembody rather than merely represent historical Nuremberg, to cast an imagined past into tangible forms and invite projective forms of spectatorship. Rather than merely enabling passive acts of reception, the set design was to allow the viewer to entertain active bodily relationships to the events of stage, to enter and activate what otherwise would remain void of form, affect, and meaning. Moreover, instead of recycling props, sceneries, or costumes from existing opera productions, Wagner called for a completely new design, one that would set authoritative standards for any future realization of Wagner's music drama. Neither trouble nor cost were spared to put *Die Meistersinger* on Ludwig II's royal stage. The Munich magazine *Punsch* spoke mockingly, and in startlingly unaesthetic terms, of the premiere as an "action requiring colossal working capital."[22]

Döll's 1868 design for the open meadow was dominated by a majestic tree stretching its leafy branches from the left side of the set all the way into the right third of the upper part of the stage. Three wooden poles provided a visual counterpoint to the tree on the right edge of the design. They were decorated with flags, banners, insignias, and garlands, some of which were intertwined with the branches of the tree. The mastersingers' stage occupied the left foreground, while a number of food stalls and amusement stands inhabited the slightly tilted background. Painted with perspectival foreshortening, the river Pegnitz meandered through the far end of the stage, visually tying the three-dimensional set designs to the atmospheric backdrop, the painted skyline of

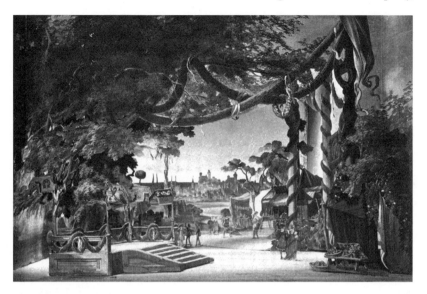

Heinrich Döll's 1869 set for Act III of *Die Meistersinger:* Meadow on the banks of the Pegnitz. Herrenchiemsee, König Ludwig II-Museum. Reprinted from Detta and Michael Petzet, *Die Richard Wagner-Bühne König Ludwigs II.* Munich: Prestel, 1970, p. 161, by permission of the Bayerische Verwaltung der staatlichen Schlösser, Gärten und Seen.

medieval Nuremberg. In Döll's design, the natural and the manmade thus appeared in prestabilized harmony. Tree and poles, garlands and branches merged into a virtual roof and frame in whose borders the mastersingers' procession could safely unfold. Döll's incorporation of tree and garland opened up a stage-like space within the stage on which nature was shown as architectural and architecture copied natural forms.

Contemporary reviewers of the Munich premiere praised Döll and Quaglio for their unprecedented combination of realism and illusionism. In the eyes of many reviewers, the set design offered a self-contained space of artifice and simulation powerful enough to trigger in the audience overwhelming experiences of empathetic transport and projective immersion. Praising the street set of act 2, the *Neue Berliner Musikzeitung* for instance wrote: "Here, one does not see any painted houses but rather complete cardboard buildings which imitate reality, as well as streets, plazas, and perspectives which create an almost perfect illusion."[23] In the view of Wagner's critics, the set designs succeeded in casting Nuremberg as second-degree nature, a virtual reality. They created

exhilarating illusions of spatial depth and corporeal movement, allowing the viewer to enter the space of representation and thus relate to the opera with their entire physical sensorium. According to the *Neue Zeitschrift für Musik,* the opera's course of visceral sensations culminated in the open meadow scene of act 3: "This colorful variety of poetry, sound, and scenery, this rapid series of gripping and surprising instrumental effects, these kaleidoscopic figments of the imagination, which barely allow eye and ear to come to their senses, must also convert the most stubborn opponents."[24] Wagner's critics commended act 3 of the Munich premiere in particular as offering a spectacular ride through space and time, as a captivating displacement of ordinary experience much closer to the logic of a Hollywood blockbuster than Wagner could have ever imagined. The sensuous appeal of the open meadow was enhanced by the fact that Wagner's score allowed for only thirty-seven bars of music, or roughly three minutes, to convert Sachs's house of act 3, scenes 1–4, into the festival plane. Döll's festival set had to be placed right behind Quaglio and Jank's workshop design, while a rather intricate horizontal and then vertical maneuver of the proscenium curtain—which in some sense anticipated the fade-in / fade-out of cinematic punctuation technique—was meant to transport the viewer smoothly from one locale to the next.

Die Meistersinger as film before film? As Hollywood made in Bavaria?

While there are, as we will see, good reasons indeed to probe how Wagner's initiatives foreshadowed different cinematic practices of the twentieth century, we should not overlook the extent to which the premiere of *Die Meistersinger* engaged modern technologies of seeing and illusionism that had already preoccupied Wagner's own contemporaries and that, at their worst, led to what Martin Jay has described as "a new form of visual pollution."[25] Think, for instance, of the stereoscope, one of those myriad of "-scopes" and "-ramas" that reorganized visual culture during Wagner's adult life and which, thanks to its equal bearing on the development of scientific discourse and popular consumption, was one of the most noteworthy visual gadgets of the 1850s and 1860s. Developed by Charles Wheatstone in 1838 and most comprehensively theorized by David Brewster in 1856, the stereoscope drew attention to the physiological basis for binocular disparity and the synthetic operations of subjective vision.[26] Allowing the observer to view flat images with a startling illusion of spatial depth and tangibility, the stereoscope offered new windows of representation that called into question the assumed congruence between the physical world and the mind's perception of it. While the "reality effect" in the stereoscopic experience was hailed as striking indeed, the device at the same

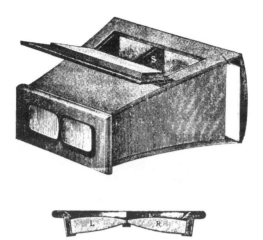

The ordinary stereoscope of Brewster. From Hermann von Helmholtz, *Popular Lectures on Scientific Subjects.* New York: D. Appleton, 1873, pp. 285, 286 (figs. 36, 37).

time helped discount epistemologies that defined the "real" without reference to the ever-shifting corporeal positions of the observer. Whatever people consumed as real, natural, unified, and secure from now on had to be understood in part as the work of rapid, subjective, and fundamentally unstable physiological operations.

So tantalizing were the impressions produced by the stereoscope that the instrument occupied a privileged place, not just in theoretical optics but in popular scientific discourse around 1860. In a number of well-noted public lectures, Hermann von Helmholtz in the late 1850s and 1860s explored the principles of stereoscopic vision in order to prove that all knowledge was gained through empirical experience rather than inborn ideas. Prompting in the viewer a process of false inductions, stereoscopic representations of real objects—according to Helmholtz—exemplified the rule for all illusions of sight, namely, that "we always believe that we see those objects which would, under conditions of normal vision, produce the retinal image of which we are actually conscious."[27] What makes the stereoscope special, however, is that it triggers illusionary perceptions that do not simply go away once we learn about the mechanisms which produce them in the first place. To illustrate this point, Helmholtz compared the apparition of the real in the stereoscopic

experience to the appearance of authenticity we accord to the performance of good stage actors. Stereoscopic seeing, like theatrical spectatorship, relies on adopted conventions according to which we see as nature what is a product of art, skillfulness, and technique. "We are all, so to speak, jugglers with the eyes," Helmholtz concluded, thereby suggesting that experience teaches us to understand how to render the theatrical and the illusory as real and to overlook the ineluctable incongruence of mind and matter.[28]

It is, I submit, precisely this paradoxical coupling of realism and spectacle, reference and theatricality, palpable experience and illusion, that the mid–nineteenth-century obsession with binocular vision shared with *Die Meistersinger*'s redefinition of theater as a window of embodied and empathetic spectatorship. In pointing out the similarities between the tropes that informed public debates about the stereoscope during the 1850s and 1860s and the staging and reception of Wagner's opera in 1868, my intention, however, is not to propose any deterministic relationship between these two; nor is it my ambition to encourage Wagner scholars to document whether or not the master spent his spare time peeping through stereoscopic lenses. Rather, my point is to show that the framing and codification of empathetic sight in *Die Meistersinger* was bound up with much more comprehensive ruptures in modern visual culture, ruptures that led to the reconfiguration of spatial perception, the breakdown of stable frames of reference, and the concomitant emergence of new realist codes of seeing.

In trying to reconstruct how stereoscopic images might have been perceived by mid–nineteenth-century spectators, Crary has argued that stereoscopic representations deranged conventional optical cues by presenting a multiplanic patchwork of intensities within a single image:

> Certain planes or surfaces, even though composed of indications of light or shade that normally designate volume, are perceived as flat; other planes that normally would be read as two-dimensional, such as a fence in the foreground, seem to occupy space aggressively. Thus stereoscopic relief or depth has no unifying logic or order. If perspective implied a homogenous and potentially metric space, the stereoscope discloses a fundamentally disunified and aggregate field of disjunct elements. Our eyes never traverse the image in a full apprehension of the three-dimensionality of the entire field, but in terms of a localized experience of separate areas.[29]

Stereoscopic images prompted the viewer's eye to follow a choppy path into the depths of the representation. They assembled local zones and receding

planes of three-dimensionality, aggregated discontinuous fields of clarity, and thus obstructed any perception of space as homogenous or coherent. As already discussed, Döll's stage design for the scene on the open meadow betrays some of the features typical for stereoscopic imagery and seeing. With its layered planes of action, its various areas of depth and flatness, and its pronounced modeling of the foreground, Döll's stage—prior to the entry of the mastersingers—suggests the multiplanic, aggregate space of stereoscopic representation. Decentering the homogenizing principles of monocular points of view, the amorphous deep-space of Döll's set design thereby closely followed Wagner's own intentions for the opening of act 3, scene 5:

> The Pegnitz River winds through the area: at the nearest point downstage, the narrow stream can be used [*praktikabel gehalten*]. Boats bearing colorful flags continually ferry the arriving, festively dressed burghers of the guild, with wives and children, across to the bank of the festival meadow. To the side, right, a raised platform, with benches and chairs on it, has been set up; it is already decorated with the banners of the guilds which have arrived; in due course, the banner-bearers of the still arriving guilds will put their banners up on the singers' platform so that at last it is completely enclosed on three sides. Tents with drinks and refreshments of all kinds border the remaining sides of the main downstage space. In front of the tents, things are going along already merrily: burghers, with wives, children and journeymen are sitting and reclining there. The apprentices of the Mastersingers, festively dressed, richly and charmingly adorned with flowers and ribbons, exercise in merry fashion the office of heralds and marshalls, with thin staves which are also decorated with flowers and ribbons. They receive those disembarking at the riverbank, organize the procession of the guilds and lead these to the singers' platform, in front of which, after the banner-bearers have planted the flags, the guild burghers and journeymen amuse themselves at will among the tents. At this moment, after the scene changes, the shoemakers will be received as planned at the riverbank and led downstage. (227–29)

Erratically jumping between different areas of action, Wagner's vivid stage descriptions envisioned a nonlinear dispersal of various activities across different zones and planes of representation. According to Wagner's ethnographic imagination, the *Volk* of Nuremberg was meant to enter scene 5 as an unstructured body, as engaged in a nonregulated multiplicity of enterprises, some of them ceremonial and festive, others simply amusement-centered and jocular. Döll's stage translated Wagner's description of (imaginary) local customs into a stunning architectural configuration whose violation of proper perspectival relations seemed to undo the borders between the illusionary and the real, be-

tween past and present. The set's disparate planes and perspectives invited the viewer's eye to follow a choppy path into the stage's depth. Far from coalescing all its elements into one homogeneous field of vision, Döll's stage prior to the beginning of the festival presented a conglomerate of separate and more or less disjunct areas of spatial coherence, a stereoscopic space *par excellence.* In doing so, the design—like stereoscopic sight—encoded the "real" as an aggregate of individual scenes and manifold surfaces, of sculptured depth and horizontal flatness. It moved vision beyond the codes of central perspective, redefined the proscenium as a window no longer governed by Albertinian geometry, and aimed at emancipating the stage from the conventions of peephole illusionism.

And yet, as if trying to appease possible anxiety about the unsettling modernization of vision on stage, the final scene of *Die Meistersinger* itself is eager to supplant this heterogeneity of the post-Albertinian window, recreate a shared frame of reference and hence provide safe ground for common acts of beholding the real. As we will see, after the arrival of the mastersingers on the open meadow, the actual narrative of *Die Meistersinger* aspires to nothing less than making the decentered space on stage cohere again and unify the discrete and fragmented into a meaningful whole. What violates the autarky of the frame and the shared linearity of perspective in the opera's final act is reframed and recontained within a stable window of reference in an effort to soothe the mind and warrant the bonds of community.

Good Looking?

Corrupt, self-absorbed, and decidedly non-empathetic forms of looking at the end of act 2 result in the disintegration of social harmony. Prioritizing private desire over the claims of community, Beckmesser is struck with symbolic blindness and unleashes what must remain hidden behind civilization's irenic façade: murderous antagonism.[30] The final scene on the open meadow, by contrast, serves the reconstruction of social cohesion and communal identity, the concealment of what can break society apart. It provides a spectacular framework in which, among others, acts of codified reciprocal visuality restore peace and order and at the same time remove from sight that which no longer is defined as belonging (Beckmesser). Once the crowds have entered the stage and gathered around the mastersingers' platform, once the crowds have recognized themselves enthusiastically in Walther's artistic performance on stage, little is left of the scene's initial impression of decentered multiplicity and

discontinuity. Stereoscopic depth and heterogeneity give way to a horizontal tableau of social reconciliation, a highly choreographed spectacle of sights and sounds. Though the festival stage on stage, in its stereoscopic construction, at first pointed toward theatrical traditions preceding the template of the fourth wall, in the end Wagner's opera seeks to synthesize these traditions with the practice of the peep-hole theater and its Albertinian codes of realism. Rather than entirely doing away with the perspectivalism of the fourth wall stage, Wagner hopes to offer central perspective for all in order to render empathy triumphant and secure the foundations of community.

Arthur Groos has demonstrated in great detail the extent to which Wagner's fair on the open meadow, far from recreating sixteenth-century processions, indexes the *mise en scène* of nineteenth-century festival culture and its attempt to establish a "secular liturgy for celebrating the *Volk.*"[31] Surely, Wagner's *Volk* in *Die Meistersinger* does not yet constitute a modern mass. Instead, it is figured as a self-conscious collective with a common will to action. However, what Wagner's *Volk* in the final scene of act 3 shares with the clientele of patriotic festivals around 1850 is both a vision of the nation as a sacred space and an emphatically middle-class orientation. Similar to historical celebrations during the mid–nineteenth century, the festival in *Die Meistersinger* is predominantly organized and consumed by bourgeois constituencies, by artisans, their families, apprentices, and journeymen. Wagner's festival meadow supplies the middle class with a site to celebrate itself, while any signs of monarchic leadership—in stark contrast, for instance, to Albert Lortzing's conservative reconstruction of Nuremberg in *Hans Sachs* (1840)—are conspicuously absent. Freely blending historical fact and historicist fiction, nostalgia and utopia, Wagner's festival, in particular by staging the aristocrat Walther's assimilation to popular taste, thus seems to consecrate the fact that an "aristocratic order has been replaced by a bourgeois artistic one."[32]

Given my foregoing discussion of the role of the visual in *Die Meistersinger,* Groos's remarks on the fusion of liberal and nationalistic elements, of political religion and public art, during the final scene of act 3 warrant further discussion. Let us first recall, however, that Wagner's central proposition in *Die Meistersinger* is that social cohesion depends on the community's ability to deter any rigid separation between art and politics, between master's song and the everyday. Neither the mastersingers' pedantic formalism nor Walther's genius for self-expressivity initially meet this demand. Cast into the role of the astute mediator between tradition and innovation, Sachs's purpose is neither to glorify nor to dismiss rule-bound behavior but rather to expose aesthetic codes

and practices to popular trials so as to probe their continued pertinence. The ritualistic festival on the open meadow serves precisely this purpose. If the *Volk* here assembles around its singers, it does so only to recode and authenticate whether or not public art still expresses its natural spirit, whether or not the masters' songs still have popular resonance and thus have the ability of bonding minds and emotions. Sachs therefore is not a liberal democrat tallying yeas and nays but a grassroots populist; his primary function is to ensure that cultural expressions continue to provide something for everyone and thereby elevate the particular to the organic whole of the community. Like Wagner's stage in general, Sachs's role on stage is that of an interface enabling a mutual integration of past, present, and future.

Because the aesthetic in *Die Meistersinger* is conceived as necessarily political, it is in terms of political models of visual representation that we must examine exactly how the festival of act 3 translates individual tastes and practices into representative and shared expressions of belonging. Wagner's framing of sight at the end of *Die Meistersinger* in fact draws on two different traditions of representativeness and public will-formation: one in which the visible merely caters to the passivity of individualized consumption, and one which considers sight and visibility as active processes of projection and community building. On the one hand, as a highly theatrical self-celebration of the bourgeoisie, the spectacle on the open meadow clearly recycles medieval and early modern understandings of representation in which public displays were meant to make the invisible visible and endow given authorities with "auratic" legitimation. Occupying a stage within the stage, the song contest identifies representative figures so as to indicate social status and reinforce existing social stratifications. As in feudal and absolutist models of representation, social cohesion in Wagner's Nuremberg depends on both the stage-managing of public appearance and the presence of people before whom power and status can be displayed; it requires a choreographed exhibition of political leadership that simultaneously produces and caters to essentially immobile and passive consumers.

On the other hand, Wagner's scene on the open meadow also alludes to Rousseau's idea of the festival as a nontheatrical site of total participation, pure presence, and unhampered transparency.[33] For Rousseau, outdoor festivals such as the wine harvest in his own *La nouvelle Héloise* permitted invigorating experiences of social communion in which the general will, as theoretically developed in *The Social Contract,* would come to the fore. On Wagner's open meadow, Rousseau's vision of reciprocity and plebescitarian immediacy plays a central role in reestablishing broken social bonds. "So lovely and dear,"

the *Volk* comments on Walther's prize song, "how distantly it hovers,/yet it is as if we're experiencing it with him!" (249). Walther's song not only reaches the heart of the spectator directly, but in driving art beyond mere representation it effaces the division of performer and viewer and unlocks a space of unmitigated immersion and total participation. Wagner's open meadow, in Jacques Derrida's words, "is the place where the spectator, presenting himself as spectacle, will no longer be either seer [*voyant*] or voyeur, will efface within himself the difference between the actor and the spectator, the represented and the representer, the object seen and the seeing object."[34] It therefore should come as no surprise that neither discussion nor vote is necessary to confirm Walther's triumph over Beckmesser. What in fact allows Walther to win the contest is nothing less than his ability to stimulate a direct communion of the souls. Endowing the body politic with the sensation of having but one interest and one will, Walther's victory requires no formal casting of votes precisely because his presentation overcomes the very need for settling public disputes by means of technical procedures. Walther revitalizes the community's power to express its will directly not through registering ballots and a bureaucratic apparatus but through empathetic acclamation—by inviting the audience to project itself and thus enter into the vibrant image of the crowd.

Rather than charting a transfigured or, as it were, misunderstood sixteenth century, this principal ambiguity of political visibility and publicness in Wagner's *Meistersinger* bears testimony to the vicissitudes of publicity between the mid–nineteenth-century decline of classical bourgeois culture and the late nineteenth-century arrival of postbourgeois mass culture. Jürgen Habermas, in his seminal account of the transformation of the bourgeois public sphere, discusses mid–nineteenth-century developments in terms of a refeudalization of the public sphere.[35] Inasmuch as the realm of cultural expressions became subsumed under the law of the market, Habermas's no doubt idealized culture-debating public of the eighteenth century was transformed into a culture-consuming public. Nonverbal communication took the place of reading and debate, discussion itself turned into a fetish, and prefabricated arguments and acclamatory settlements displaced the possibility of rational justification and decision-making. In this shifting climate of publicness, political institutions increasingly had to address their citizens like consumers. The political sphere and in particular the idea of the nation were converted into items of middle-class consumption, while public relations experts engineered forms of consent that had little in common with the unanimity resulting from time-consuming processes of critical discussion and deliberate persuasion.

Sachs's role on the stage of the open meadow is that of a modern publicity maker who is intimately familiar with the engineering of friendly dispositions. He organizes the audience's empathy for the sake of substituting formal debate with cultural consumption. Sachs succeeds not only in marketing the aura of representative figures as consumer goods but also—with the help of Walther's talents—in allowing the crowd to consume its own appearance, its semblance of organic communality, as the most thrilling of all sensations. The festival elevates the middle-class members of the crowd to the level of commodities. It creates a framework in which political leadership can present itself as an object of pure sensory amusement, a space in which audiences can consume the way in which political choreographies enable them to get in touch with each other. *Die Meistersinger* thus shrouds the refeudalization of bourgeois culture in Wagner's own times into a phantasmagoria of total participation and transparency. Rousseau's nontheatrical festival in Wagner takes the form of the theatrical itself; in Wagner's own words, it becomes a "spectacle of the people's jubilation" (*Schauspiele des Volksjubels*, 235). Yet as it supplants the negotiation of different opinions with an erasure of difference through argument-free acclamation, the spectacle's ultimate function is to produce a lonely crowd. Similar to the effects of spectacular capitalism in late nineteenth-century culture, Wagner's festival on the open meadow engineers a crowd unable to recognize symbolic materials and cultural differences as potential sources of emancipation, as in Guy Debord's formulation: "Spectators are linked only by a one-way relationship to the very center that maintains their isolation from one another. The spectacle thus unites what is separate, but it unites it only *in its separateness*."[36]

Beyond Wagner

By turning modern theater into a window onto the past and future, Wagner's ambition was to contain and unify seemingly opposing principles: the traditions of Attic publicness and of bourgeois spectatorship; the codes of feudal self-representation and of plebiscitarian immediacy; the understanding of seeing as either active and projective or passive and consumptive; the historical and the natural; the realist and the illusionist. A membrane allowing empathetic acts of transport between stage and auditorium, of fusing the visual and the haptic, Wagner's proscenium rattled at the foundation of the fourth wall—not in order to do away with it entirely but rather to reconcile it with other traditions structuring the viewer's attention and enabling the aesthetic.

Eager to soothe anxieties about the effects of embodied looking on the

modern subject, the staging of sight in the last act of *Die Meistersinger* thus reflected fundamental transformations of mid–nineteenth-century visual culture. Though Wagner initially conceived of empathetic looking as an antidote to the increasing fusion of commerce and culture during his own lifetime, in the final analysis *Die Meistersinger* simply adjusted empathy and subjective vision to the exigencies of the spectacle, the commercialization of the aesthetic, and the theatrical staging of the political. In this way, the opera's last act simultaneously indexed the decline of the classical bourgeois public sphere and previewed the refeudalization of political visibility in the age of the culture industry.

Wagner's Bayreuth festival house, as it opened its doors to the public in 1876, was to intensify the *Die Meistersinger*'s politics of spectatorship, at once consummating and subduing what in act 3 prefigured the spectacles of commercial culture. Seen in retrospect, the differences between the framing of vision in *Die Meistersinger* and the Bayreuth theater building, I suggest, correspond to those between early and classical cinema. Whereas the Munich audience was invited to experience Wagner's open meadow in 1868 as a kind of cinema of attractions—a showcase of sensuous astonishments privileging sheer acts of display and looking—the Bayreuth festival house was to provide the perfect framework to absorb the audience into the drama as it unfolded on stage and thus promote a seamless fusion of the performance's with the audience's temporality. Whereas in the 1868 production spectatorial pleasure depended in no small way upon the audience's awareness of the act of framing, the Bayreuth stage concealed Wagner's window of theatrical communication in the hopes of increasing its ability to solicit acts of empathetic looking and bonding. With its "mystical abyss" and its transformation of the auditorium into a black box, the tiered theater building at Bayreuth offered equal perspective and identification for all, independent of one's physical location in the auditorium, for the sake of perfecting the way in which audience members could leave their ordinary lives behind and enter—not as situated, but as universalized viewing subjects—the events on stage. In this, Wagner's festival stage prefigured the design of classical movie palaces—their production of self-effacing illusionism and of ever lonelier crowds. The Bayreuth public was to exist solely for the work of art on stage, undistracted by itself, the theater's own architectural detail, or the frame of the proscenium. So much so, that the building seemed to cancel the public as a corporeal fact: while the heat inside the auditorium became unbearable during performances, audience members could not even fulfill their most basic bodily needs during intermissions because the whole

Ground plan of Festspielhaus at Bayreuth (1876).
Reprinted by permission of MIT Press, Cam-
bridge, Mass.

edifice had not a single toilet. In order to render illusionism and empathetic
transport triumphant, Wagner's building extinguished the spectator's empiri-
cal being, at once exorcizing the theatrical fourth wall and forfeiting Wagner's
own original visions of sensual reeducation and synthesis. For the sake of total
theatrical experience and sensual redemption, Wagner's festival houses ended
up canceling the viewer's body and his or her senses. Unlike the festival stage
on the open meadow, the window of Wagner's Bayreuth proscenium was to
be entirely invisible. Like the codes of classical cinema, it sought at all costs to
impede "the public's self-awareness as a body gathered together to preside over
the trickery performed."[37]

Though the opera's open meadow was neither meant as a black box nor
intended to cancel the public's physical needs, *Die Meistersinger* nevertheless
anticipated essential implications of Wagner's Bayreuth stage. For both aimed

at redefining the aesthetic as an interface of empathetic absorption, sensory transport, and immersive self-transformation. And both, rather than mourning the disintegration of bourgeois models of critical publicness, banked on the power of spectacle to soothe anxieties about the modern and proffer increasingly spurious notions of organic communality. In its drive toward perfect illusionism and emotional identification, Wagner's work as a whole prefigured the operations of twentieth-century film and mass cultural entertainment. But must we therefore also conclude, as many have done, that Wagner's conception of modern theater as a window of empathetic transport provided a clear preview of fascist attractions and hence of what Walter Benjamin in 1935 identified as the essence of Nazi politics, namely the aestheticization of politics? Did Heinz Tietjen get it right when he produced the festival scene of act 3 in 1933 as a Nazi mass rally à la Riefenstahl, bringing no less than 800 performers on stage to deify modern power as a triumph of the will?[38]

It is only when we deny the constitutive tensions and historical ambivalences of Wagner's *Meistersinger* that we can answer these questions in the affirmative. However spectacular and phantasmagorical in nature, Wagner's opera in its 1868 production engaged its viewers in an intricate confrontation of the medieval and the modern. In turning theater into a window of projective seeing and immersive attention, *Die Meistersinger* aimed at the production of spectators able to negotiate conflicting temporalities and historical experiences; it reckoned with modern viewers at once exhilarated and anxious about the ramifications of embodied and decentered looking. Though Wagner's theatrical windows, in particular at Bayreuth, often sought to give history the semblance of historical inevitability, they never ceased to view aesthetic experience as a source of corporeal self-transcendence and self-transformation, of animating the individual member of the crowd to move beyond the present and become other. Both Tietjen and Riefenstahl, on the other hand, considered the crowd as deanimated material for an abstract, self-contained geometry of power, one in which reification became destiny and illusions of total presence obliterated all possible claims of past and future. Whereas the window of Wagner's stage was meant to escort individual and community into a different future, Tietjen's production offered a mere mirror image of present-day realities, presenting the ornamentalization of the masses as the *telos* of German history.

Benjamin's famous description of modern media politics and the Nazi spectacle offers further arguments why we should remain wary about seeing Wagner's window stage as a blueprint of Tietjen's Riefenstahlian Nuremberg:

Since the innovations of camera and recording equipment make it possible for the orator to become audible and visible to an unlimited number of persons, the presentation of the man of politics before camera and recording equipment becomes paramount. Parliaments, as much as theaters, are deserted. Radio and film not only affect the function of the professional actor but likewise the function of those who also exhibit themselves before this mechanical equipment, those who govern. Though their task may be different, the change affects equally the actor and the ruler. The trend is toward establishing controllable and transferable skills under certain social conditions. This results in a new selection, a selection before the equipment from which the star and the dictator emerge victorious.[39]

Benjamin .considered the relation of fascism to bourgeois society to be analogous to the relation between film and nineteenth-century theater.[40] This analogy proves instructive in pointing out critical differences between Wagner's framing of the crowd and that used by the Nazis. What remained ambivalent and tension-ridden in Wagner, an unabashedly eclectic reworking of different source materials, traditions, and historical references in the Third Reich's appropriation of *Die Meistersinger* became a phantasmagoria of unrestricted accessibility and self-contained presence.[41] Sachs and Walther may indeed foreshadow media stars of the twentieth century; their popularity on the open meadow may anticipate the illusive recreation of aura and authenticity through the film industry's star cult. But what we cannot find in the political actor Sachs is a camera-oriented dictator whose will is meant to triumph not simply over the masses but also over the modalities of postauratic representation. Whereas the Nazi spectacle—as we shall see in chapter 5—systematically exploited the means of industrial mass culture so as to manufacture a post-bourgeois community of the *Volk,* the politics of vision and visibility in *Die Meistersinger* remain inseparable from Wagner's uneasy association with nineteenth-century bourgeois culture and what we must understand as his theatrical view of politics.[42]

Wagner's mature musical style may have indeed, as Adorno has claimed, assimilated nineteenth-century high art to public taste at the expense of structural coherence, thereby anticipating the operations of the twentieth-century culture industry. Wagner's various efforts to redesign the proscenium into a window of projective seeing and spiritual self-transformation may have prefigured some of the codes and principles of cinematic spectatorship. But to think of all this as merely a preview of the Nazi spectacle would simply be foolish. It would not only erase our awareness of the historical index and specific-

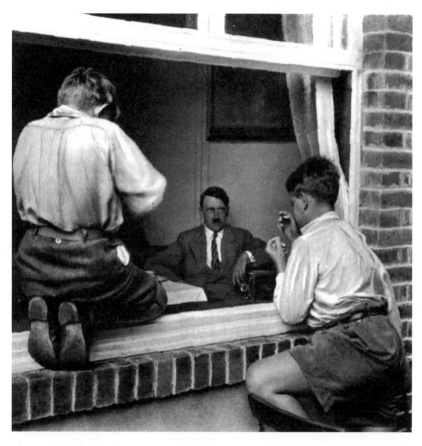

Photograph of Richard Wagner's grandsons looking at Adolf Hitler in Bayreuth, circa 1925. Printed by permission of Bayerische Staatsbibliothek, Munich, Germany.

ity of Wagner's theatrical reforms, it would also obscure the extent to which Wagner's unease about the classical proscenium and peep-hole stage opened the door for various twentieth-century avant-garde practices whose dismantling of the fourth wall was coupled to highly dissimilar political agendas. Wagner's thought and practice vacillated between competing models of seeing and spectatorship; he considered sight as either active and projective or passive and merely receptive. Yet precisely due to its indetermination, his work and his institutional initiatives carried out a dialectic that in the first decades of the twentieth century was to split modern culture into ever more hostile realms, hopes, and practices, causing both the modernist avant-garde and the

proponents of aesthetic politics, each in their own way, to formulate partial visions of total reform, synthesis, and redemption. Rather than presaging the full-fledged aestheticization of politics, Wagner's phantasmagorical framing of past, present, and future exhibited the dialectics of modern industrial culture, attention and spectatorship as something ambivalent—an ambivalence to which, as the next three chapters shall show, the windows of early cinematic entertainment, of modernist experimentation, and of Nazi media politics were to respond in very different ways.

3 | Early Cinema and the Windows of Empire

In 1916 German immigrant and Harvard professor Hugo Münsterberg asked the readers of his treatise *The Photoplay* to perform a brief thought experiment. Its purpose was to persuade highbrow intellectuals and academics to recognize the specificity of the filmic medium and its inherent artistic qualities. In the first decades of the twentieth century, many had argued that cinema at its best could never be more than canned theater. The screen's rectangle, for these critics, simulated the shape and appearance of a stage, yet due to its essential flatness it negated true perceptions of depth and thus denied any possibility of what had made the theater stage into a site of the aesthetic, namely, its ability to present human action in all its plasticity across the solid and continuous space of the visual field. Though a late convert to the pleasures of cinematic viewership, Münsterberg's ambition in suggesting his experiment was to turn such arguments upside down. For what Münsterberg proposed is that the film screen's evocation of spatial depth might come much closer to art's task of representing and transforming the real than the classical art form of theater itself and that cinema therefore is at least as aesthetic as the kind of art endorsed by highbrow academics up to Münsterberg's own present. Let us imagine, he wrote, that

> a large glass plate is put in the place of the curtain covering the whole stage. Now we see the stage through the glass; and if we look at it with one eye only it is evident that every single spot on the stage must throw its light to our eye by light rays which cross the glass plate at a particular point. For our seeing it would make no difference whether the stage is actually behind that

glass plate or whether all the light rays which pass through the plate come from the plate itself. If those rays with all their different shades of light and dark started from the surface of the glass plate, the effect on the one eye would necessarily be the same as if they originated at different distances behind the glass. This is exactly the case of the screen. If the pictures are well taken and the projection is sharp and we sit at the right distance from the picture, we must have the same impression as if we looked through a glass plate into a real space.[1]

Like many others before and after him, Münsterberg considered the cinematic screen a window onto the world whose material flatness does not inhibit the viewer from receiving captivating impressions of spatial depth and plastic movement. The screen's flatness is part of the objective technical arrangement of cinema, but for Münsterberg this flatness had nothing to do with how the viewing subject sees and perceives the world presented. As long as spectators take up proper positions in front of the screen, as long as their physical location in the auditorium allows them to identify with the camera's perspectival construction of space, their perception of what is behind the screen's imaginary glass plate is quite superior to how classical proscenium stages define the visual field. Whereas the space of the theater stage is broadest in the front and becomes ever narrower toward the background, the cinematic image—as conjured by the monocular eye of the camera—is narrowest in the foreground and opens up the greater the distance from the camera. Because the camera is merely the apex of a viewing angle that may include miles of open space in the background, cinematic images can thus direct the viewer's attention far more effectively than stage plays. For whoever in film comes toward the foreground gains much more importance in relation to his or her surroundings than he or she could achieve in the theater. And whoever moves away from the screen's imaginary window experiences a reduction in importance far more dramatic than he or she could on the stage.

To speak of cinema as canned theater, for Münsterberg, misses the point. The moving picture stage screen might be objectively flat, but in its function as a window onto the world it provides a means of representing space, of defining spatial relationships, and of guiding the viewer's perspective fundamentally different from those used in the classical theater stage. Cinema at its best, particularly when using techniques such as the close-up, offers something that lies completely beyond the possibilities of conventional stage productions: an embodiment of the very operations of our mind; an analogue, or model, of

how human perception maps the world and actively creates internal images of depth and movement.

Early writing on cinema frequently sought to locate the new medium's specificity in how its window of representation disrupted traditional experiences of linear time and helped orchestrate an unprecedented acceleration of human temporality. Film not only transplanted a new generation of stunned viewing subjects into imaginary elsewheres but also displaced the measured timetables of nineteenth-century life with the discontinuous itineraries of modernity. What was at stake in theorizing cinematic viewership, in other words, was to demonstrate the film screen's unique restructuring of human temporality, of how this new technology at once encoded and launched new experiences of contingency and ephemerality, how it reshaped the work of memory and the viewer's sense of presence, how it rationalized the inchoate realm of leisure time, and how it produced highly distracted spectators eager to fend off the shock of rapid image sequences through intensified, albeit mostly reactive, modes of looking. According to this dominant mode of modernist writing on film, then, the screen's window and its moving images allegorized nothing less than modernity itself, an age primarily understood as one that emancipated the present from the burdens of the past, and in doing so proffered to the subject a new sense of chance, change, mobility, and agency.

Münsterberg surely offered many keen insights about the emergence of cinematic time and its effects on the viewer's perception. But it was in what the windows of camera and screen may do to the appearance of external space that Münsterberg detected the new medium's most important cultural value and artistic mission. In Münsterberg's understanding, authentic art and the aesthetic come into being when subjects are able to experience things purely in themselves. Aesthetic objects are objects whose peculiar presentation allows viewers to isolate them from their surroundings and bring them before their mind as something devoid of external causes and effects. In Münsterberg's view, cinema excels at this particular experience of the aesthetic. For inasmuch as cinematic images picture space analogous to the internal operations of our mind, they allow us to experience the presented world as one freed from the weight of causality and determination. Offering a substitute for our own acts of perception and attention, the cinematic window immobilizes our bodies only to affect a stunning triumph of mind over matter. It thus permits us not only to "hurry on to ever new spots" or "to be at the same time in two or three places,"[2] but to enjoy the visible world as one charged with both enchanting

magic and stunning beauty: "Every dream becomes real, uncanny ghosts appear from nothing and disappear into nothing, mermaids swim through the waves, and little elves climb out of Easter lilies."[3]

Cinema, for Münsterberg, assumes the status of an independent and legitimate art form whenever it does not don its modernity in the cloak of older cultural forms but on the contrary actively seeks to employ the camera's peculiar view of physical space to emancipate the viewer from the imperatives of practical interest. Unlike the stratified auditorium and stage of the theater, the curious interplay of camera and screen enables central perspective for all, yet precisely in doing so it situates the viewer as one immersed in the spatial depth of the presented world even as he or she cannot take this depth for real. We may enjoy the moving images on screen, but we are also fully conscious that we can never own them. We surrender the autonomy of our sensory perception to the work of the camera, but only because we know that temporary losses of our selves—in Münsterberg's deeply idealistic view of culture—will make us into better citizens and human beings in the long run.

New and old thus strike a remarkable compromise in Münsterberg's thinking about how the cinematic window transforms the viewer's spatial coordinates. Rather than change the entire concept of art and its location in society, as Walter Benjamin would claim two decades later, the advent of cinema in Münsterberg's perspective has the ability to rearticulate the utopias of late eighteenth- and early nineteenth-century artists and philosophers—the Schillerian dream of aesthetic education—with the means of industrial society. According to Münsterberg, the screen's window can cultivate the viewer because it effectively separates its images from the domain of everyday existence, because it provides a self-sufficient space in which we are invited to become other, and because it liquefies the hardened structures that typify our lives outside the theater. If art's task is and has always been to overcome the given realities of the outer world, to adjust them to the forms of the human mind, and thus to foster a harmonious cooperation and meaningful totality of our sense perception, then we must recognize cinema indeed—so the upshot of Münsterberg's 1916 experiment—as one of the most powerful frames of aesthetic communication.

Münsterberg's view of cinema as a window on external objects as much as on the internal world of the mind shares many aspects with what we have come to know as apparatus theory in the course of the 1970s. Film screens and dark auditoriums, for Münsterberg, provided an unprecedented tool of cultural and emotional transport, carrying the viewer in no "more than one

sixteenth of a second . . . from one corner of the globe to the other, from a jubilant setting to a mourning scene."[4] Yet cinema's illusion of depth and movement at the same time threw into the relief the operation of the human mind itself, a process resulting from what Münsterberg—anticipating the work of later apparatus theorists—described as a curious transfer of control and activity from subject to machine, a subjugation of the subject's attention and desire to the apparatus. That most critics today recall Münsterberg's writing on early cinema, in spite of numerous later echoes, as a rather marginal contribution to the development of serious film theory has perhaps mostly to do with how this mandarin intellectual sought to combine his interest in the new medium's manipulation of attention with the aesthetic preferences and philosophical premises he inherited from nineteenth-century German culture. Though eager to legitimate film as a modern art form, in the eyes of the majority of later film theorists Münsterberg represents a curious leftover of the past frantically struggling to come to terms with a difficult present. His roots in German nineteenth-century thought—the aesthetic legacies of Weimar classicism and idealism; the work on spatial perception by empathy theorists such as Adolf von Hildebrand; the psychological research of Wilhelm Wundt—may not always have been fully recognized and understood. But it is Münsterberg's curious position as a relay station between bourgeois culture and modern industrial society and the way in which nineteenth-century tropes penetrate his academic prose that have kept and continue to keep Münsterberg from joining the pantheon of classical film critics.

One aim of this chapter is to take a new look at Münsterberg's work by exploring some of its so-called German origins in further detail. My argument is that neither Münsterberg's interest in the new medium, of film's reorganization of the perception of spatial depth and perspective, nor his desire to ennoble the cinematic window as a site of authentic art and aesthetic education came out of nowhere. On the contrary, Münsterberg's 1916 account merely epitomized a set of discourses and practices in late nineteenth- and early twentieth-century German culture for which the aesthetic value of mechanical and projected images primarily rested in their ability to reformulate the viewer's experience not of time but of space and central perspective. Yet, as I show, we would be wrong to understand this German privileging of cinematic space and perspective over cinematic time circa 1900 merely as an outcome of earlier aesthetic traditions and intellectual choices. What the following chapter suggests instead is that early German film culture's concern for the aesthetics of space—for how flat images and cinematic frames produce captivating impressions of depth and

thus open windows on the world—was deeply bound up with the geopolitical aspirations of the German empire after 1890, that is, the hope to reorganize the global map and legitimate German rule across ever larger territories. The argument of this chapter centers around two additional figures who, in spite of their difference in function, prominence, achievement, and personality, were equally important for the course of German film culture during its first decades: Ottomar Anschütz, whose interest in moving images prefigured the advent of cinema proper, and Emperor Wilhelm II, whose frequent presence on early film screens made him something akin to the first film star of German cinema.[5] As we will see, both Anschütz and Wilhelm II shared Münsterberg's curious location between tradition and modernity, between nineteenth-century aesthetic culture and the coming of modern industrial civilization. And both represent paradigmatic positions for which the art of framing moving images simultaneously energized and was energized by political exigencies. Anticipating Münsterberg's own infamous support of German politics during World War I, both Anschütz's and the emperor's use of moving images revealed crucial links between the imperial project of blessing the German nation with a proverbial place in the sun and the ability of cinematic windows to bless viewers with spectacles of light, motion, and spatial depth.

The biographical trajectory from Anschütz via Wilhelm II to Münsterberg is no doubt a discontinuous one. As I reconstruct it in the following pages, however, it shows the extent to which German discourses about cinema as a window on the world and the human mind cannot be seen in isolation from a complex and highly overdetermined aesthetico-political dynamic. While palpable illusions of spatial depths and images of imperial power were to define this window as a legitimate site of the aesthetic, the screen's reorganization of spatial experience at the same time would anchor the empire's quest for new and different territories in the perceptual systems of its people. While the geopolitics of empire helped to validate the new medium as a genuine art form and elevate it from mass-cultural vulgarity, the art of articulating space and movement within the new frame of the cinematic window helped legitimate the course of domestic and colonial power.

The Mobilization of Vision

On November 15, 1894, less than a year before the brothers Max and Emil Skladanowsky presented the first filmic images in Berlin's Wintergarten, Ottomar Anschütz made a desperate effort to rescue his financial fortunes. A

Anschütz-Schnellseher (speed-viewer), around
1890. Printed by permission of the Deutsches
Technikmuseum Berlin, Germany. Photo: Lutz
Koepnick.

highly proficient photographer of objects in motion since the early 1880s, Anschütz had tried for years to develop and market a viewing machine for the display of moving images, called the "*Schnellseher*" (speed-viewer). In all its different versions, Anschütz's speed-viewer essentially consisted of a wheel spinning
around twenty four photographic images captured with a chronophotographic
camera. A small window framed these images for the spectator. It was lit with
the help of a stroboscopic light bulb such that individual shots could produce
ever-recurring impressions of synthetic movement.

Although Anschütz had entered a cooperation with the emerging electricity
giant Siemens and Halske to mass-produce his invention and even export it to
the United States, the project quickly turned into a financial fiasco. To be sure,
historical documents provide ample evidence that Anschütz's contraption captivated the minds of thousands of his contemporaries. No matter whether
his speed-viewers displayed images of galloping horses, leaping gymnasts, or

parading troops, large numbers of viewers—for reasons I shall discuss in a moment—responded enthusiastically to what they saw in the window of the Anschütz apparatus. But the links connecting modern engineering, aesthetics, and economics, even in the booming entrepreneurial climate of the early 1890s, were more delicate than Anschütz had anticipated, and the cause for the failure of his venture was essentially twofold. On the one hand it can be attributed to Anschütz's perfectionism. Incessantly seeking to improve individual details of the apparatus, he consistently undermined smooth production and delivery schedules at the Siemens plant in Berlin. On the other hand, in spite of the considerable crowds willing to sink their coins into the machines' slots, the speed-viewer's principle of individualized spectatorship simply prohibited a cost-effective use of modern entertainment technologies. To fascinate viewers with wondrous machines and stunning images of movement was simply not enough to achieve a good return. What was needed to create and exploit profitable demand for moving images were technological and institutional solutions able to situate more than one viewer at a time in front of the machine's display window—a task involving a radical enlargement of Anschütz's initial display window and hence the development of new projection methods and collective viewing arrangements.

In late 1894 Anschütz, eager as ever to translate innovative engineering into astonishing entertainment, equipped himself with a newly developed Siemens contact light bulb, various circular sets of motion photographs exposed onto individual glass plates, and a novel projection apparatus intermittently powered by a Maltese Cross to turn the consumption of moving images into a profitable collective experience. The premiere on November 15 took place in the lecture hall of the post office in Berlin's Artilleriestraße. With the German Empire's Secretary of Culture von Gossler in attendance, the show presented five different series of images as well as two lectures spread out over a period of ninety minutes. Due to the premiere's overwhelming success, Anschütz's projection-based speed-viewers were soon used in a variety of German cities and venues, including the old Reichstag's assembly hall, which seated three hundred people in front of a huge screen measuring eighteen by twenty four feet, and Carl Heckel's Concert-Saal in Hamburg.

As if to draw special attention to the ability of the new apparatus to make images move, Anschütz's early programs regularly consisted of two parts. Whereas in the first part of the show audiences were invited to see still images of objects in motion, it was only in the second half of the evening that Anschütz's apparatus would bring images themselves to life. The attraction of

attending these shows thus lay as much in the consumption of life-size projections on screen as in observing the power of the apparatus to convert pictures of motion into motion pictures, of animating the enlarged window of representation itself. But even more important for our context here is that in both parts of the show Anschütz drew heavily on the focus of his career ever since the early 1880s: images of military exercises and parades that not only transported paying costumers to sites of national vigor and pride but also moved them with the apparatus's own essential features, namely the dynamic of ongoing movement and choreographed display.

A review of one of the first of these shows printed in the Berlin-based *Photographische Wochenblatt* neatly illustrates the extent to which the sight of moving troops simultaneously energized and allegorized the program's own astonishing move from still image to motion picture. The article reports that the first part of the show commenced with projected still images of Emperor Wilhelm I and his successors Friedrich III and Wilhelm II. Accompanied by the lecture of a retired army captain, the presentation continued with photographic images of maneuver scenes, introduced as a unique means of preparing soldiers and civilians for real battle situations. Skillfully chosen, the viewing angle of these images—according to our reviewer—appealed not only to the spectators' aesthetic pleasure but also to their moral attitude: "Because these images provided a spatially accurate representation of real war situations, one has the feeling that most of our battlefield images are merely conventional and do not offer accurate representations of real events, and that it is therefore urgently recommended that our battlefield painters study such photographic images of maneuvers in the future."[6] It was after proving the superiority of the photographic image as a tool that could map the real, elicit aesthetic delight, and strengthen military and civilian morale that the program, according to the reviewer's report, would finally switch to its second part, the long-awaited presentation of moving images. Once again, however, viewers were first presented with military motifs—the sight of soldiers riding their horses, military marches and parades, and shooting drills—before the program concluded with movement pictures of storks, deer, and other animals, all shown in strikingly realistic situations and activities even if their images had been taken at the Breslau (Wrocław) zoo.

Anschütz's show of 1894, though primarily designed to astonish the viewer with a miraculous new apparatus, in large measure relied on pictorial motifs and aesthetic arrangements that had played a pivotal role in Anschütz's work ever since the early 1880s. While the windows of image display and consump-

tion underwent fundamental changes, Anschütz's own artistic and political signatures did not: for him, to jump on the bandwagon of visual modernization did not mean reconstituting human perception, pleasure, memory, and knowledge in light of the new media's apparatical features, it meant improving the channels of transporting proven and hence timeless values. Three aspects of what I understand as Anschütz's conservative project of modernizing visual attention are particularly noteworthy here.

Firstly, in direct continuation of his work of the 1880s, Anschütz's 1894 presentation of motion images once again sought to outshine the two most renowned practitioners of chronophotography of the time, Étienne-Jules Marey and Eadweard Muybridge, by displaying photographic reproductions with superior contrast and an unsurpassed depth of focus. A trained physiologist, Marey's pioneering interest in chronophotography had been mostly scientific: to slice into the continuum of time to render movement and duration legible, to make the passing of time representable by capturing the motion of human bodies within the single frame of one and the same image. Muybridge's intention, on the other hand, had been to break up the continuum of certain movements so as to store discrete images of passing time in successive image series; he never really kept pace with technological developments of the 1880s in order to improve the quality of representation. Although Anschütz from the inception of his career as a chronophotographer—like Marey and Muybridge—had sought to transcend the temporal unity of the image frame as it had been institutionalized during the Renaissance, his primary interest in the medium was not a scientific or analytical one, nor was it driven by the mere dream of beating the passing of time at its own game. Instead, what energized Anschütz's work was his aspiration to map the origin of our sense of time as an effect of how bodies occupy and traverse different positions in space. Photographic images, for him, demonstrated the extent to which spatial movements produce time, and it was the task of refined camera arrangements and improved shutter mechanisms to document this process. As a result, Anschütz's photographic images featured a stunning choreography of space, sense of spatial depth, physical plasticity, and realistic concreteness that the majority of German reviewers found sorely missing in the photographic output of other contemporary photographers of time, Marey and Muybridge in particular. The 1894 show capitalized on Anschütz's well-known pursuit of deep focus and intricate spatial composition. Space here was not to be projected as a merely neutral container for the true and putatively more interesting dramas of time and movement. Instead, what was meant to make Anschütz's projected

images marketable was the attempt to subordinate the viewer's perception of time to his or her desire for illusive impressions of spatial depth and penetration with the screen—in spite of its material flatness—as a window onto deep space.

Second, in stark contrast to Marey and Muybridge's interest in capturing the ephemeral and producing pure records of contingent time, Anschütz's projected image series of 1894 stayed true to the same emphasis on narrative development and closure that had structured his photographic work all along. With its maximum of approximately twenty-five image slots, the ordinary wheel of an Anschütz speed-viewer allowed for a display time of about 1 to 1.5 seconds before any frame would repeat itself. Due to their brevity, the presentations of Anschütz's image sequences were experienced less as a tool of distraction and diversion than as a site at which the viewer had to concentrate his or her visual attention onto the window of representation at the expense of all other channels of perception. Whether based on principles of light projection or not, the technology's interface was seen as a vortex pulling the spectator's eye out of the manifold coordinates of everyday time and space. That Anschütz, in order to prolong the viewer's pleasure, kept his wheels spinning for several minutes at a time should therefore come as no surprise. What is surprising, though, is Anschütz's obsession with displaying motion in such a way that the end of each sequence of shots seamlessly returned the viewer to the beginning of the sequence. Unlike other chronophotographers of the time, Anschütz's desire in other words was not to provide analytical records of singular actions as they unfolded along an irreversible temporal axis but to forge individual time slices into rhythmical patterns and synthesize distinct images into archetypical representations. Without oversimplifying the matter much, we can therefore say that the windows of Anschütz's speed-viewers, including the projection-based version of 1894, privileged the display of circular over linear time, of aesthetic integration over analytical dissection, of ordering the ephemeral over recording the contingent, and of mythic repetition over progressive enlightenment. What made Anschütz's machines modern and marketable was their ability to enchant viewers with an eternal return of the new. Rather than provide indexical and hence scientific records of that which happens but cannot be recognized with our own bare eyes, the windows of the Anschütz speed-viewer invited the spectator to rest from the accelerated itineraries of modern time so as to contemplate the beautiful order of things.

Third, what is remarkable about Anschütz's show of 1894 is the extent to which he once again hinged his reputation as a photographer of motion onto

the representation of patriotic motifs, a choice whose true significance we would vastly underestimate if we simply considered it in terms of his images' content and not their form. Anschütz had shot many images of Wilhelm I in both public and private settings already in the early 1880s. But it was his photographs of troop parades and maneuver activities, often taken with the help of iron tripods mounted on elevated lightweight carts, that had made Anschütz famous during the early days of his career. In the course of the 1880s, the challenges of maneuver photography had caused Anschütz continually to improve his photographic techniques and technologies. His innovative development of dry plates, integrated rangefinders, and rapid shutter releases all had allowed Anschütz to take several shots in sequence, capture movement across space, and create a pool of negatives from which to expose only the most dramatic ones. The patriotic desire to document troop movements thus had led Anschütz to improve his photographic equipment, just as much as his modernization of the medium had essentially changed the image of the German army in the general public.

What critics had written about his earlier pictures of troops and crowds in motion—Anschütz's images "in spite of the speed of the object display general and even focus and show elaborate details even in the areas of darkest shadow"—certainly also held true for what could be seen during the 1894 presentation.[7] Shown at sizes that exceeded the possibilities of cinematic projection proper until around 1910, the stunning foci and superior gradients of Anschütz's image series of 1894 defined speed-viewer projection as an ideal medium to display and bond the viewer to the armed movement of the nation. To shoot sharp and detailed images of moving troops not only testified to the photographer's own mobility and flexibility—insofar as it presented the relationship between cameras and armed forces, between projectors and projectiles, between animated images and moving soldiers, as a symbiotic one, it also modernized the supposed object of the nation's pride and thus the image of the nation itself.

Anschütz's speed-view projector was well poised to profit from people's increasing hunger for moving images in the mid-1890s. That it failed in the end to produce stunning returns and was withdrawn from the market even prior to the advent of film in late 1895 resulted in part from the relative inflexibility of the technology: once spectators had witnessed their first show, Anschütz's window simply offered too little to draw audiences back for future screenings. But even though Anschütz's projection speed-viewer added yet another financial disaster to its inventor's biography and was thus easily displaced from memory

by the imminent arrival of cinema, we should not underestimate its cultural and political significance. A quickly forgotten technology of animating images and stirring attention, the windows of Anschütz's speed-viewer nevertheless provided compelling previews of coming attractions. In its effort simultaneously to mobilize vision and to move the nation, Anschütz's speed-viewer anticipated how German cinema in the course of its first decade would explore the new medium's peculiar aesthetics of space as well as its ambivalent position between narrative and display, in order to provide the empire with unprecedented forms of popular legitimation. Operating much more effectively and flexibly than Anschütz's unwieldy machines, early cinema fused what I have discussed above as the three interrelated aspects of Anschütz's windows of representation into the unity of one mechanism. How German films circa 1910, by framing the image of the emperor, at once sought to restructure and consolidate the modern experience of space, narrate a seemingly new story of colonial power and charismatic authority, and mobilize the viewer's vision for the cause of the nation—it is to these topics that we now turn our attention.

Framing Movement

European ideologies of colonialism in the late nineteenth and early twentieth centuries entertained highly ambivalent and often self-contradictory relationships to the figure of the nomad. Though imperial expansion justified itself through haughty concepts of geopolitical mobility, it found challenging counterimages in the practices of nomadism, the colonized and putatively uncivilized people's refusal to become sedentary. Imperialism presented sedentarization as the *telos* of western history and civilization, but in its grasp for new lands, peoples, and resources it of course itself unleashed new forms of nomadic motion and ongoing displacement. Struggles over the propriety of certain colonial appropriations thus became struggles over different interpretations and regimes of nomadism, of legitimate movement across space. In order to disavow its own inherently unsettled and unsettling nature, imperialism denigrated the nomadism of the colonized as either passive and degenerate or as aggressive and brutal in order to establish its own restless itineraries as something whose alliance with the forces of historical progress would provide self-sustaining legitimation. As John Noyes has argued, "If the history of the civilized West could be told as a process of sedentarization, then nomadism was either the barbaric roots out of which civilization had emerged, or else it occupied the geographical limits of the civilized world. The aggressive, ac-

tive nomad was relegated to prehistory, and the passive, primitive nomad was placed outside history."[8]

In the peculiar context of German imperialism, whose relatively "belated" institutional history closely coincided with the advent of cinema, the new window of cinematic representation played an important role in order to carry out this curious disavowal and transvaluation of the nomadic. The modernity of cinema, I argue, essentially helped to present imperialism's quest for new spaces as a quest linked to the forces both of historical progress and of sedentarization, thus camouflaging the extent to which the German Reich's geographical aspirations around 1900 unleashed their own and contradictory versions of nomadism. I don't mean to pursue this thesis, however, in the more trivial sense that German cameras and screens prior to World War I, in step with the contemporary practice of ethnographic shows, proliferated captivating images of the Reich's new colonies, their exotic populations, and the heroic deeds of colonial exploration and rule; or that the Deutsche Kolonialgesellschaft (DKG) took an active interest in the new medium of film around 1905 in order to shape the German public's view of colonial politics.[9] Instead, what I argue here is that German cinema in the years prior to World War I offered perspectives of the world that not only taught the viewer to perceive space as something to be inhabited by imperial power but also displayed legitimate power and rulership as something that would succeed in incessantly traversing, incorporating, and homogenizing seemingly disparate spaces. The window of the new medium became imperial not simply by inviting the viewer with exotic images to travel to the colonies but in a more profound sense by establishing effective relays between power, space, and perspective in the spectator's perception. As it synchronized the nervous nomadism of modern power with the sedentary pleasures of the viewer, cinema's role was to reframe the geopolitical aspirations of the empire as a biopolitical mission to emancipate the nomadic from its barbaric, prehistorical, and primitive roots. In this way, the modern projection of moving images for stationary audiences became deeply intertwined with the quest of imperial power to project itself across the map in the name of historical progress and modern civilization. One could not do without the other; in fact, one simultaneously presupposed and produced the other as a source for its own legitimation.

Though many scholars have described the Nazi government as the first regime in world history that performed politics for the eyes of film cameras, we should not underestimate the extent to which the copious presence of Wilhelm II on early German cinema screens already redefined modern politics

Maneuver (1911). Film still reprinted from Paul Klebinder, ed., *Der deutsche Kaiser im Film.* Berlin: Verlag Paul Klebinder, 1912.

as a struggle with and over the best use of modern media. And even though it has become a commonplace among scholars of German history to accredit the emperor's interest in film as merely another facet of his pathological narcissism, we do well to understand the many features recording Wilhelm II in public functions as part of a systematic effort to modernize the mechanisms of power and orchestrate political acquiescence with the most effective means available. To be sure, having been born with serious birth defects and having grown up within a thorny familial and generational dynamic, the notoriously edgy, restless, and nervous Wilhelm II may have had good reason to entertain omnipresent fantasies of personal grandeur and plenitude—whether it was by

seeing his own image proliferated across the mushrooming cinema screens of the nation or by pursuing his lifelong pet project, the formation of a strong navy able to match that of his royal British relatives and transport German might across the rapidly expanding map of geopolitical interest.[10] Navy and cinema, one in fact might argue in a Lacanian mode, were two sides of the same coin: they offered the emperor's unstable self a deceptive imaginary of unity and wholeness, of mobility and misrecognition.[11] But to understand Wilhelm II's spectacular media stardom merely as an expression of personal vanity and self-importance would blind us to the remarkable negotiation of old and new, the traditional and the modern, that was at the core of the last German emperor's so-called personal regime and obscure the fundamental transformations of German society after 1890 that enabled and necessitated new strategies to address the public, engineer political consent, and secure legitimate power.

Like Anschütz and Münsterberg, Wilhelm II was a man of the nineteenth century, someone deeply bonded to the social forms, structures, and rituals that preceded the rise of modern industrial culture. Yet nothing would be more wrong than to discount his intuitive interest in modern technology and science—whether it included his devotion to scientific research, his patronage of the first German automobile association (ADAC), or his concern for the best possible mechanical reproduction of his image—as a mere curiosity or a sign of ideological inconsistency. On the contrary. What attracted the emperor to modern technology, to the invention of cars, torpedo boats, and cinematic images, was their ability not to accelerate time and emancipate the present from the burdens of the past but to offer tools of transport able to produce impressions of homogeneous space and allow for a uniform inscription and territorialization of power. Recalling all the trouble involved in modernizing German sea power in the early phases of his reign, Wilhelm II described this geopolitical prospect of modern technology in his autobiography as follows: "The people woke up, began to have a thought for the value of the colonies (raw materials provided by ourselves without foreign middlemen!) and for commercial relations, and to feel interest in commerce, navigation, shipping, etc."[12] Far from hindering prospects of monarchical sovereignty, modern technology provided a promising frame to expand, intensify, and administer the nation's spatial relationships. Technological achievements were seen as windows whose function was to redefine the world as a space awaiting the imprint of imperial power and commercial initiative. Instead of blasting the old world and its modes of perception asunder, the window of modern technology—with cinema its most

emblematic representative—enlarged zones of interest and transport, enabled unmediated access to the nation's necessary resources, and helped frame their most effective exploitation.

Over and over gain, we see flickering images of Wilhelm II proudly riding his horse during parades, funeral ceremonies, and military exercises.[13] We see him displaying his imperial might when inaugurating new national monuments, celebrating patriotic holidays, or greeting foreign visitors. In many a newsreel or actuality film we witness Wilhelm II in more casual settings chasing deer, gunning down wildfowl, and chatting with hunting mates. A large number of short films record the many trips of this restless emperor, whether they involved official state visits to other European or non-European countries or his ritualistic "*Nordlandfahrten,*" yearly voyages on his personal yacht, called the *Hohenzollern,* to the Northern Atlantic. In the last years of his reign, we follow the emperor to the western front as he inspects his forces and tries to boost the troops' sinking morale. And finally, abundant filmic materials have been passed down tracking the emperor's exile in Holland, obsessively chopping down trees, cutting wood into small pieces, and handing out autographed postcards of himself to nostalgic visitors.

Wilhelm II initially showed little interest for the new medium during the first decade of its existence. He only learned to love its possibilities and pleasures after 1905 when the exhibition of films, gaining in length, quality, and formal variety, emancipated itself from its unsteady origins in variety shows and found its institutional home in the rapidly expanding context of urban movie theaters. The first documented film explicitly shot to present Wilhelm II to his German subjects was recorded in 1905 on the occasion of the crown prince's wedding by a Saarbrücken-based producer of actuality material. When court photographer Theodor Jürgensen in 1908–9 secretly filmed the emperor during one of his yacht vacations, Wilhelm II's final resistance against the new window of representation was entirely broken. Impressed by Jürgensen's presentation, the emperor in the enduring ten years of his reign willingly offered his form to the camera. That we rarely see Wilhelm II acknowledge the presence of the camera or gear certain activities directly to the implied viewer should come as no surprise. As if instinctively aware of the acting codes as they had developed around 1910 for narrative filmmaking,[14] the media emperor did everything he could not to disturb the audience's sense of immediacy and presence, that is, to situate the frame of the image as a realistic keyhole on the aura of power as it passed, affecting people's emotions. While the camera's conical and monocular construction of space helped Wilhelm II render

Wilhelm II, maneuver in Risa (1912). Film still reprinted from Paul Klebinder, ed., *Der deutsche Kaiser im Film.* Berlin: Verlag Paul Klebinder, 1912.

mostly invisible what he considered the traumatic deficiency of his own body, it could display the emperor's aura best when it obscured its own operations and tracked the emperor's movements invisibly across seemingly self-sufficient topographies of acclaim, astonishment, and assent. In order to present the extraordinariness of power on screen such that it could touch the viewer directly, Wilhelm II presented himself to the camera as if it provided a momentary frame around an ongoing reality, one in which camera and screen functioned like a window, opening one among many other views onto the world, and one which invited the viewer to enter the frame and enjoy its extraordinary meanings, motions, and pleasures. The German vernacular notion of *Kaiserwetter*

emerged precisely at this historical moment as a term not simply describing the rare experience of splendid sunshine during imperial parades in Germany but also the ideal conditions for the recording of photographic reproductions of the emperor. *Kaiserwetter* provided perfect surroundings for the production of moving images rich in detail, focus, and plasticity. It served as a vehicle to redefine politics as a spectacle of and for the camera, subjugating people's perception of nature to the demands of mechanical reproduction. Is it therefore cynical to suggest that the empire's proverbial search for colonial places "under the sun" was also a search for ideal cinematic lighting conditions, a search for the most effective window presenting the emperor's restlessness, mobility, and charisma as a cinematic astonishment of first rank?

In the wake of Tom Gunning's seminal work on exhibition practices and spectatorial pleasures during cinema's formative decades, film historians have come to distinguish between the early cinema of attractions and the emergence of a cinema of narrative integration beginning around 1907. Whereas the former primarily featured the extraordinary power of the apparatus to project moving images, was driven by exhibitionist impulses, and relied on the spectator's active and bodily presence in the auditorium, the latter subjected the various means of cinematic representation to the telling of a good story; it catered to the viewer's voyeuristic desires and in the long run centered the audience's attention entirely on the seemingly self-contained and progressive flow of narrative action on screen. The film career of Wilhelm II, the greatest celebrity of German film prior to World War I, exemplifies the extent to which we cannot think of these two modes of film production, exhibition, and consumption as mutually exclusive. On the contrary, one of the reasons for the emperor's popularity on screen was that his representation helped synthesize the spectacular and the narrative aspects of early filmmaking and thus offered a window whose principal role was to reconcile the viewer's exhibitionistic and voyeuristic desires. On the one hand, early films about the emperor privilege the continuity of a single viewpoint in an effort to display the emperor's charismatic appearance to the audience. Rather than articulating a story through varied shots, perspectives, and narrative strands, these films favor the integrity of the frame, the act of framing itself, in the hope of delivering the sight of their star to the audience's consuming glance and of demonstrating the stunning affinity between the emperor's spatial mobility and the projector's ability to make images move. On the other hand, however, the magnetism of these visual reports no doubt also resulted from the way in which they, due to their sheer accumulation over time, sought to tell a good story after all, a story not

only about how Wilhelm II navigated ever more territories to display charisma und homogenize diverse populations but also about how his charismatic body energized cameras and filmmakers to traverse the entire map in order to entertain the viewer at home and live up to the screen's promise of imaginary transport. It is in amalgamating the formal regimes of spectacle and narrative, of display and story, of attraction and identification, that the emperor's ubiquitous presence in the window frame of early cinema perhaps was at its most political. For what this presence achieved was to provide a spectacular narrative of power and geographical movement in which compelling images of political mobility at once animated and were animated by the sedentary pleasures of domestic audiences. What it achieved was to present the unsettling nomadism of modern geopolitics as part of an ongoing story of historical progress and sedentarization, and in so doing to supply turn-of-the-century imperialism with a compelling vocabulary of legitimation.

Mechanized Immortality

In 1913 representatives of the German film industry published a coffee table book in honor of the twenty-fifth anniversary of Wilhelm II's installation as emperor. Entitled *Der deutsche Kaiser im Film,* the book contained various essays and laudatory notes, poems, music notations, drawings, and abundant photographic reproductions. Though not all contributions addressed the emperor's importance for German cinema—some of the essays simply hailed film in general or celebrated the emperor's nautical skills—the majority of essays celebrated Wilhelm II as a man whose interest in cinema had logically resulted from his stalwart dedication to the joint causes of German culture, science, and progress. In his article *"Mechanisierte Unsterblichkeit"* (Mechanized Immortality), J. Landau presented film as a perfection of chronophotography and its ability not only to preserve singular moments in all their sensual detail but also to record without mediation the "life, movements, gestures, glances and expressions of great artists" such as Wilhelm II for the benefit of future generations.[15] Another essay, *"Hermelin und Lichtspielkunst"* (Ermine and the Art of Cinema), praised the emperor as "the most interesting personality that has ever been captured by the lens of a cinematographic camera."[16] Playing on the shared etymological roots of the Latinate terms for *objective* and *lens* in German ("Ganz objektiv ist nur das Objektiv!"), the essay continued to call cinema the most impartial chronicler of history—and, by extension, Wilhelm II its most worthy object. Already larger than life due to his personal cha-

risma, the emperor in the perspective of all of these contributions turned out to be the perfect subject, embodiment, and allegory of cinema's own ability to transcend the ordinariness of life and overcome the contingencies of human temporality. Cinema, in the eyes of the contributors, opened a window onto the extraordinariness of the emperor's public and private existence, just as the charismatic persona of Wilhelm II cast light on the extraordinary power of the apparatus, its ability to make images move, unify the conflicting demands of art, science, and the human senses, and prevail over the passing of time.

But the representatives of the German film industry had more concrete reasons to express their gratitude for the emperor's interest in film with their 1913 publication. After all, it was with Wilhelm II as its first full-fledged star image and flagship that German cinema had successfully entered the phase of commercial filmmaking as we essentially know it today, whereby the image of the emperor not only had served as an economically effective link between cinema's orientation toward spectacle and narrative respectively but also had helped to endow the disreputable pleasures of going to the movies with an aura of middle-class respectability. If modern industrial culture, as it emerged in the German empire in the course of the 1890s, was characterized by orchestrated efforts to provide something for everyone with one and the same streamlined product, then the screen image of Wilhelm II and his restless activities served as this new mass culture's preview of many coming attractions. Whenever it put a frame around the sight of the distracted emperor, the window of early German cinema offered a spectacular narrative of geopolitical mobility as much as it also relaxed the intelligentsia's anxieties about the new medium without frustrating the kind of pleasures that had fascinated film's earliest audiences. Wilhelm II's screen persona may have allowed German cinema to achieve what Münsterberg considered cinema's transition from outer to inner form, from mere technology to true aesthetic value. But in reconciling the spectacular and the narrative as much as the nomadic and the sedentary, his unique screen persona also authorized a much more mundane expansion of cinema itself across given barriers of class, status, and taste, an extension for whose economic implications the representatives of the industry had to be thankful indeed.

Cinema, Anton Kaes has argued (recalling the so-called *Kino-Debatte* in Germany circa 1910), "functioned as a kind of catalyst in the quarrel about the commodification of art."[17] In celebrating Wilhelm II as German cinema's foremost star sign, the film industry hoped to reverse the logic of this debate about the meaning and future location of aesthetic experience. Rather than

situate film as a medium whose commercial orientation could not but disfigure the authenticity of art and the political, industry representatives presented the emperor's charisma and geopolitical mobility as a legitimate incentive to create new markets and satisfy diverse aesthetic needs. The spectacular image and narrative of "Great Politics" was to authenticate the window of cinematic representation as a frame able to synthesize the seemingly conflicting mandates of art and the market.

Tales of Doubling

But then again, wasn't there something deeply troubling about the way that the window of cinematic entertainment transported images of the emperor to diverse audiences without being able to fully control their act of reception? Wasn't there something irreverent in multiplying the emperor's presence with the help of the cinematic apparatus, an act that could potentially subvert the very charisma it was to extend across ever extended spaces? Didn't the frame of the new medium, rather than effectively dispersing the emperor's aura, turn Wilhelm II into a ghost, an uncanny double, and thus deterritorialize and deface his authority?

This, at least, is what writer and future Hollywood exile Berthold Viertel wrote in 1910 while describing a state visit of Wilhelm II to Vienna, which included a joint visit to the movies with Austro-Hungarian Emperor Franz Joseph.[18] What both emperors saw on screen, Viertel reports with bewilderment, was of course nothing other than themselves, along with the loyal masses cheering at their appearance in and in front of the screen image. A Baudrillardian *avant la lettre,* Viertel experiences the mechanical multiplication of emperors and audiences as a baffling liquidation of the real, a simulacrum in which traditional boundaries between reality and its image, the real and its representation, cease to exist. When during the show the film happens to rip, the screen window's sudden blackness, rather than simply returning audience and intellectual safely to the real, causes Viertel to veer into deep epistemological speculation about the limits of political representation. "I am unable to get it out of my consciousness, this ghastly doubling of representation. The chosen One, whose task is to evidence a nation's existence simply by walking and talking and greeting, in fact by walking and talking and greeting as typically as possible—doubled?! Is it allowed to multiply grace in such a wicked way? Aren't two, no: four, kings too many for one and the same moment?"[19] Rather than frame and thus intensify the real, the window of cinematic rep-

resentation—in the perspective of Viertel—potentially effaces the operating principles of monarchical sovereignty: the charismatic here and now of the emperor's persona, the way in which the sanctity of his office is to be incarnated in the singular and extraordinary presence of his body. To double the real is to displace it altogether; it irrevocably ushers subject and society into a realm of the uncanny whose ghosts won't go away even if the apparatus does malfunction: "Where does representation begin, where does it end? And the folk, existing twice here, and therefore doubly happy, cheering about its own cheering, welcoming its own naive being as a folk in the mirror. Isn't that dangerous? Couldn't it terrify the people, as if they were seeing a specter?"[20]

To be sure, Viertel's comments about cinema as a machine producing too many bodies at once were written with satirical intentions. As if following Henri Bergson's contemporary study of laughter and the comic,[21] Viertel understands the doubling of the emperor's existence, as well as the emperor's and the audience's narcissistic responses to their own images, as compulsive expressions of mechanization and alienation whose unrecognized nature invite distant observers to free themselves cathartically via laughter from their own feelings of mechanized objectification. But Viertel's laughter invites what it derides to return through the back door. Though his essay mocks the doubling of imperial charisma and hence the emperor himself, it surreptitiously endorses cultural conditions that do not result in a putative liquidation of both the real and authentic representation. Viertel's unspoken, albeit very serious, hope in ridiculing the unholy alliance of emperor and cinema is to restore a state in which signs—be they visual, linguistic, or symbolic—mimetically represent the real rather than displace it with independent productions. His hope is to bring back former epistemological and perceptual certainties in whose context signs would not usurp their referent, images and frames would not supplant reality, and political charisma could articulate itself in a seemingly unmediated and emotionally effective manner.

One need not be a deconstructionist in order to see that Viertel's desired state of signifying the real and representing charisma never really existed, even long before the advent of cinema and its mass-cultural pleasures. What is anachronistic is not the figure of the emperor who embraces the window of cinematic representation to transport the charisma of power across the map. What is anachronistic is the figure of the modern critic who sets out to challenge the aestheticization of politics, yet ends up yearning for traditionalist views of art and culture in which the relation of signs and referents, images and bodies, realities and representations, rulers and people was allegedly un-

problematic. On the other hand, one does not need to be a clandestine monarchist or conservative to recognize that dedicated monarchists and conservatives circa 1910 often had much less of a problem with the multiplication of the ruler's body and charisma than the emperor's critics themselves. In a 1913 contribution to the journal *Grenzboten,* for instance, Albert Hellwig, after first detailing his overall discontent with the medium of film, did not hesitate to celebrate the pedagogical and propagandistic possibilities of cinema, the ability of the medium's window to transport viewers to the sites of "Great Politics" and disseminate patriotic values. Motion pictures, Hellwig marveled, empower millions of subjects to participate in patriotic celebrations without being physically there: "Even though cinematographic projection might only offer a pale reflection of reality, it serves as an excellent surrogate, one even the most daring dreams were unable to envision a few decades ago!"[22] To watch Wilhelm II on screen, for Hellwig and others, may have meant to get second-best, but it nevertheless allowed emperor and subject to express their patriotic feelings and experience what could effectively homogenize the nation. The cinematic window might lead to a profound deterritorialization of power and charisma. But in that it was able in turn to bring the world to the viewer as well, to entertain sedentary spectators with affective spectacles of movement, it could also enable a reterritorialization of power that far exceeded the reach of former mechanisms of political representation. It didn't take today's theorists of hyperreality and the simulacrum to realize the extent to which film screens can serve as interfaces for the redefinition of power as psychotechnology. In its pragmatic efforts to make modern achievements work for their own agenda, already staunch patriots of the Wilhelminian period were quite prepared to explore the ambiguous gray areas between signs and referents as a source of expanding the former frames of power and political self-presentation.

The Crisis of the Image

Turn-of-the-century German aesthetic culture has often been described as one primarily haunted by a crisis of the word, of signification. In the poetic, dramatic, and novelistic work of Hugo von Hofmannsthal, Stefan George, Robert Musil, and Rainer Maria Rilke, we witness a profound unease about the relationship between signs and referents, a desire to strip language entirely off its ordinary referential functions, to emphasize the pictorial and visual valence of written or spoken words, or to develop new structures of linguistic expressions able to name the innermost essence of individual things. What is

clear is that language, for these poets, seemed to have lost its ability to order and contain the world; language was experienced as being on the loose, no longer capable of safely linking intentions and meanings, mind and matter, perceptions and reality. Nowhere does this become more obvious than in the second paragraph of Rilke's modernist novel *Die Aufzeichnungen des Malte Laurids Brigge*, written in sporadic bursts of productivity between 1904 and 1910. In an entry dated September 11, Malte takes note of his fixation on sleeping in rooms with open windows in spite of the noises that rattle through the streets of nighttime Paris, his (and his author's) temporary place of residence:

> To think that I can't give up the habit of sleeping with the window open. Electric trolleys speed clattering through my room. Cars drive over me. A door slams. Somewhere a windowpane shatters on the pavement; I can hear its large fragments laugh and its small one giggle. Then suddenly a dull, muffled noise from the other direction, inside the house. Someone is walking up the stairs: is approaching, ceaselessly approaching: is there, is there for a long time, then passes on. And again the street. A girl screams, Ah tais-toi, je ne veux plus. The trolley races up excitedly, passes on over it, over everything. Someone calls out. People are running, catch up with each other. A dog barks. What a relief: a dog. Toward morning there is even a rooster crowing, and that is an infinite pleasure. Then suddenly I fall asleep.[23]

The passage describes an experience of ongoing shock and self-inflicted traumatization, of catastrophe as it were. With the windows of his room wide open toward the city, the perceiving subject is no longer able to distinguish between interior and exterior spaces, between reality, perception, and interpretation. Struck with understandable insomnia, Malte's mind seems to encompass the entirety of the street and its noises, much as the urban landscape seems to inhabit and traverse the innermost parts of his body; he is the street as much as the street is him. In this, Rilke's description of experiencing the open window of course brings to mind and fuses, on the one hand, the accounts of early film viewers afraid of being physically crushed by the approaching train on screen and, on the other hand, Münsterberg's view of film as an externalization of the operations of our mind. Rilke's Malte, we might conclude, is a film spectator in disguise, his simultaneous search for sleep and further distractions emblematic of the film viewer's desire to surrender his waking consciousness to the dream sleep of projected images.

And yet, while the quoted passage of *Malte Laurids Brigge* might secretly encode possible experiences of early film viewers, it also addresses issues that transcend the perceptual realities of cinematic viewership. Note that what

Malte experiences as a "screen" is not a physical object in front of his eyes but his mind's own internal window of perception endowing inanimate objects with human or mythical features. Note also that Malte's theater of the mind of course turns out to be anything but pleasurable or diverting, that it exhausts his attention to such a degree that even the relief of sleep approaches Malte—contrary to expectation—in form of shock, namely "suddenly." And note finally that Rilke's aim in this whole passage is less to emulate the operations of cinema with the help of literature but to offer a powerful allegory for the crisis of poetic language itself, its inability to structure perception, to separate between interior and exterior worlds, and reliably to signify and thus hold at bay extralinguistic events. What truly pounds and overwhelms Malte when trying to sleep with his windows wide open is not the noise of passing trams or breaking glass itself, that is, the contingency of the modern acoustic landscape as it impresses itself onto the subject's restless visual imagination. What really strikes and traumatizes Rilke's displaced hero is first and foremost the contingency of language, the menacing way in which words, rather than signifying external referents, have come to reference nothing but themselves.

Rilke's and the other poets' language crisis around 1900, famously encoded in Ludwig Wittgenstein's recommendation to remain silent about the most urgent matters of human existence, has come to occupy generations of literary historians in their efforts to isolate one of the major sources of twentieth-century aesthetic modernism.[24] This crisis was not so much a crisis of the word itself but a crisis of how to open up poetic language to the registers of visual perception; that the visual itself—the image, the experience of perspective, the articulation of time and memory within the frame of a picture—experienced a profound crisis in its own right circa 1900 has been left mostly out of sight. In his astute study of turn-of-the-century modernism and aestheticism, Carsten Strathausen has recently argued that our one-sided focus on the crisis of linguistic, not visual, representation may have been caused by the fact that modern image production and dissemination, whether or not its ontology puzzled authors such as Viertel, was destined to become a major site of twentieth-century entertainment and profit accumulation, whereas literary modernism was not.[25] To be sure, even prior to the advent of montage editing and narrative crosscutting, cinematic images formulated a powerful, albeit only partial, break with the Renaissance regime of central perspective and its privileging of a seemingly disembodied, objective, and divine point of view. No matter what apparatus theorists in the 1970s would write about the interpellative qualities of projection, the mere fact that projectors and screen windows

could call images to life, temporalize representation, and multiply the sight of the real made credulous and incredulous viewers wonder about the very status of the visual, its referentiality, its ability to move minds and matter to hitherto unknown places. It therefore does not seem an exaggeration to say that in their efforts to wed the ever more differentiated realms of modern science and art, the engineers of early cinema placed as much pressure on conventional ways of seeing and understanding visual images as poets such as Rilke placed on the habitual assumptions that words signify a pre-given extralinguistic reality and that early film projectors engaged an image-crisis just as much as aestheticist poets circa 1900 simultaneously suffered from and reveled in a fundamental crisis of language.

However, while Strathausen is certainly right to hold the mass-cultural success of cinema responsible for our collective forgetting that film, not just modern poetry, originated from a profound crisis of representation, this chapter suggests yet another reason for this critical blind spot. What caused historical spectators as much as later critics to disavow the way in which the advent of cinema in Germany simultaneously produced and answered to a peculiarly modern crisis of the image was the way that the restructuring of spatial perception on and in front of the cinematic window communicated with the German empire's efforts to renegotiate historical boundaries and penetrate into the depth of geopolitical space. Unlike aestheticist poetry and literature, whose hope to break all ties with the historical order of the day is well documented, the projection of moving images quickly came to be seen and embraced as something closely related to the spirit of the time. Cinema seemingly moved beyond the crisis of perception and representation that marked its birth not because it denied its own modernity but because by mobilizing pictures, camera, spectators, and emotions across space it was able to play into the hands of a politics of spatial expansion and mobilization whose stalwart rhetoric of resolution sought to crush whatever may have sounded like a modernist consciousness of doubt and crisis. Early cinema and imperial politics operated as the opposite sides of a coin. One did not cause the existence of the other, but each used the other in order to exorcise unsettling views of modern culture as traumatic and catastrophic—views that kept poets such as Rilke and their tormented, stupefied heroes from falling asleep.

Hugo Münsterberg, to return finally to our German-born Harvard professor with whom we started this voyage into the deep space of early German cinema, must have been quite receptive—consciously or not—to cinema's constitutive nexus between politics and perspective, mobilization and (e)motion, de- and

reterritorialization. Surely, Münsterberg's interest in film came relatively late in life; it is unlikely that he had many opportunities to watch visual reports glorifying Wilhelm II on Boston's cinema screens. At some point in 1914—when war in Europe left little time, space, and resources for domestic audiences to indulge in the pleasures of moving images—Münsterberg watched his first film ever, a fantasy flick directed by Herbert Brenon called *Neptune's Daughter*. As Münsterberg recalled in a biographical sketch in 1915, this first visit to the movies was epiphanic in nature, allowing the elitist German *Bildungsbürger* (educated citizen) to approach cinema no longer as a seriously bad object but as a source of both aesthetic pleasure and scientific insight: "Although I was always a passionate lover of the theater, I should have felt it as undignified for a Harvard Professor to attend a moving-picture show, just as I should not have gone to a vaudeville performance or to a museum of wax figures or to a phonograph concert. Last year, while I was traveling a thousand miles from Boston, I and a friend risked seeing *Neptune's Daughter*, and my conversion was rapid. I recognized at once that here marvelous possibilities were open, and I began to explore with eagerness the world which was new to me."[26] *Neptune's Daughter* was not destined to enter the ranks of outstanding American feature productions. However, in the remainder of his career Münsterberg would recall this feature time and time again to exemplify how the use of cinematographic means such as the closeup could emancipate the outer world from its normal weight, how a film's rhythm of cutting and editing could clothe impressions of the real "in the forms of our own consciousness",[27] and how cinema's peculiar organization of spatial and temporal relationships had the power to invite viewers to experience the world as something seemingly severed from the background of their practical interests. In Münsterberg's recollection, *Neptune's Daughter* assumed the status of a meta-film, a film allegorizing the operations and tasks of film itself, a feature evidencing the profoundly aesthetic and hence morally cultivating possibilities of the cinematic window.

By the time Münsterberg embarked on his mission to promote film to the pantheon of true art, the once highly esteemed professor of psychology had already lost much of his reputation among his colleagues and students at Harvard. As early as 1881, Münsterberg was already known as a vociferous German nationalist, glorifying—even before his academic training at Heidelberg with Wilhelm Wundt—authoritarian political structures and the role of German culture to educate society. After his move to Harvard in 1897 at age thirty-four, Münsterberg soon became an important spokesperson for German Americans, in particular those in favor of Wilhelminian authoritarianism while being con-

temptuous of the unsophisticated nature of American culture. All this did not help the mandarin intellectual Münsterberg to make many new friends among his colleagues at Harvard in spite of his high academic profile and productivity. With the outbreak of World War I and the war entry of the United States, however, Münsterberg's unyielding advocacy for things German became entirely tenuous. As if realizing that he had lost much of what once had energized his personal life and academic identity, Münsterberg at precisely this moment discovered what no one, including Münsterberg himself, would have considered likely or apposite: the seemingly undignified pleasures of going to the movies.

Neptune's Daughter over Goethe and Wilhelm II: Did the émigré Münsterberg, by endorsing film and concomitantly refocusing his academic attention, break with German nationalism and reconcile with the needs of wartime America? Did the Harvard professor, when going to the movies, seek to become "more American than the Americans" so as to overcome his own private as well as the inevitable public German catastrophe?

We do well at this point, I believe, not to jump to false conclusions. Surely what triggered Münsterberg's enthusiasm for the new medium—the mandarin intellectual's "conversion"—was not a newsreel feature inviting audiences to marvel at the German emperor's restless moves across the European map. After all, features such as the ones that captivated the mind of critics such as Hellwig or Viertel were simply not available to American audiences circa 1914. And yet, having Münsterberg's peculiar background and academic trajectory in mind, we cannot but wonder about the symptomatic value of what Münsterberg really saw when looking for the first time at and through the window of cinematic representation. Let's have a look at the fantastic plot of *Neptune's Daughter,* the object of Münsterberg's first cinematic pleasure, as summarized by Allan Langdale: "The daughter of King Neptune, a mermaid, travels to dry land to avenge the death of her sister who was accidentally killed by a fishing net cast by William, the King of the Terrestrial Kingdom. However, she falls in love with the very man whom she had come to avenge herself upon. Back in the watery world, aided by an army of mermaids, she does battle with the Witch of the Sea."[28] Shot on Bermuda and released on April 25, 1914, *Neptune's Daughter* drew the audience into a world of fantastic wonders that had been envisioned most compellingly, long before the advent of cinema, in the fairy tales of Hans Christian Andersen. Münsterberg was deeply familiar with this world; during his childhood he had loved to read stories such as *"Den lille Havfrue"* and also had sought to emulate the genre of the fantastic in his own writings when he

was a student. Half a lifetime later, during the screening of *Neptune's Daughter* in 1914, Münsterberg no doubt experienced the new medium as a frame catalyzing a curious return of the past, one that invited the embattled academic to transport his childhood fantasies to an obstinate present as much as it allowed him to reinterpret his own past in light of the unyielding demands of the day. As importantly, however, *Neptune's Daughter* must have engaged a viewer such as Münsterberg with images and themes deeply in accord with the ideological dynamic of Wilhelminian Germany. A tale about the epic struggle and final reconciliation between the forces of the land and those of the sea—mustn't this film have provided symbolic fodder for German nationalists obsessed with the buildup and integration of naval forces? By inviting viewers to travel back and forth between the dry and the watery territories, didn't the film also nurture powerful fantasies about a reorganization of the ordinary map, ask the viewer to step out of the bounds of the habitual structure of space and enter a new universe that could be reordered according to one's will and vision? Though much of this must remain speculation, in the end it does certainly not surprise that *Neptune's Daughter* struck a chord with the dislocated German nationalist Hugo Münsterberg. In the eyes of the chastised Harvard professor, *Neptune's Daughter* may have permitted both at once: to appease his contempt for things American and invigorate what had fueled this contempt in the first place. *Neptune's Daughter* allowed Münsterberg to become American by being German at heart. The film left him as a perfect double agent who could work on multiple fronts without anyone's knowledge—including perhaps his own.

Views of the ocean challenge our ordinary way of mapping our surroundings. In the absence of orienting human landmarks and natural signposts such as hills, valleys, or forests, the sight of the sea rebuffs our everyday strategies of framing space and locating our own position in relation to the observed world. Set off by the ocean adventure *Neptune's Daughter,* Münsterberg's 1914 conversion to film and American mass culture resembled a landlubber's first encounter with the seemingly frameless sight of the high seas, while his later film theory of 1916 served the purpose of finding his bearings amid the deep space of cinematic representation. Once more dislocating the already dislocated mandarin intellectual, *Neptune's Daughter* might also explain why Münsterberg, unlike contemporary philosophers such as Henri Bergson, in his analysis of the filmic medium primarily focused on film's spatial rather than temporal aspects. Whereas for Bergson, whose thoughts on cinema elaborated on the work of chronophotographers such as Étienne-Jules Marey, film was all about the dissection and rearticulation of our experience of time, memory, and

duration, for Münsterberg cinema's most salient features lay in the way that its window restructured our perspective on space, that film—like Anschütz's deep-focus photography, like Wilhelm II's screen presence, like Neptune's daughter traversing different territories—could direct the viewer's attention to discover and enter into new spatial configurations and make them their own. In Bergson's perspective, cinema allegorized the inevitable failure of the human mind ever to achieve self-presence; the medium's inherent temporality revealed the extent to which we, even outside of the cinema, "perceive only the past, the pure present being the invisible progress of the past gnawing into the future."[29] Münsterberg's theory of film was far from willing to follow Bergson's lead and see failure at work in the midst of people's most modern pleasures. Secretly born out of the spirit of Wilhelminian geo- and biopolitics, Münsterberg's thinking on film instead set out to understand how cinematic images could frame the seemingly frameless sight of the real, cast new perspectives onto unstructured realities, and thus situate cameras and viewers as daring seafarers eager to navigate the foreign and—in stark contrast to Malte's traumatic response to the open window in Paris—subject the incommensurable to their mind's will to form, coherence, and control.

It is because of his view of film as an external projection of the operations of the mind and of the cinematic image as a window onto the work of human perception and consciousness that we also find very little in Münsterberg's writing indicating concern over the epistemological crisis caused by mechanical images—moving or not—around 1900. Motion pictures, for Münsterberg, constituted a new art form, not because they provided a new means to represent the world mimetically but on the contrary because in emulating the work of human perception and the mind, they helped build a parallel universe in which the human mind could triumph over matter and seemingly disinterested pleasure displaced the stale routines of the everyday. In spite of his transatlantic relocation, Münsterberg always remained a Schillerian. Art, for him, became art by overcoming reality. Only when insisting on its principal autonomy from the order of the day, only when trying to offer nonmimetic simulations of the real was it able to appease viewer's conflicting drives, educate the masses through beauty and harmony, and thus improve society. What made art, including the new art form of film, political was its constitutive refusal to be overtly political. What made film a catalyst of aesthetic education was its ability to offer new windows of perception that could restructure the way we see, the way in which we see this seeing, and the way in which we see ourselves as part of a seeing collective in front of the screen. Motion pictures

dislodged some of the principles of Renaissance perspective and its codes of visual realism, but what counted for Münsterberg in the end was not the question of how mechanical images signify the real but how the window of cinema could project the involuntary operations of the human mind into and across physical space and thus enable sharable collective experiences.

Like the patriotic musings of Albert Hellwig, then, Münsterberg's writings on film were not haunted by basic doubts about the ontological or referential status of the cinematic image. To duplicate reality in the form of a cinematic representation did not really do anything to the integrity of the represented object, even though it might educate viewers to reconsider their own seeing and thus approach the world differently in the future. Whereas turn-of-the-century modernists despaired about how signs related to their referents, words to images, matter to mental representations, Münsterberg considered film a medium whose window of representation was able to displace such quarrels altogether simply because film's task was not to mimic but to simulate and displace the real in the first place. His work grafted nineteenth-century German aesthetic traditions onto the scenes of American mass culture in order to project a new way into the future, thereby using his own cultural displacement in order to displace his doubts about the epistemology and ontology of the mechanical image. In the end, the repressed returned to haunt Hugo Münsterberg like a monster. Legend has it that the Harvard psychology department had Münsterberg removed from its faculty photograph in order to distance itself from this academic double agent shortly after his death in 1916, using mechanical reproduction not only to displace the real but remake the collective memory of the past. Given his sense of cultural and political alienation at Harvard, Münsterberg was probably lucky enough to die before the American entry into World War I in 1917. But then again, wouldn't he have rejoiced to see German military authorities in 1917 establish a powerful film studio—the legendary UFA—in the hope of mobilizing people's perceptions for the cause of the German nation?

4 | *Underground Visions*

The window of the moving railway train has often been discussed as a site at which we can locate a paradigmatic modernization of visual perception. Nineteenth-century railway travel, it has been argued, helped industrialize the viewing subject, causing the observer to incorporate motion and speed into the very process of seeing. As perceived through the window of a train compartment, even seemingly pristine and timeless countrysides suddenly did not look the way they used to look. For aside from causing local administrations to standardize time for the sake of establishing reliable time tables,[1] nineteenth-century railway journeys fundamentally restructured the traveler's desire for voyeuristic pleasure and scopic control. The train's windows at once expanded and shrunk people's spatial horizons. They also led to a shocking disintegration of the visual field, asking travelers to learn how to establish new kinds of links between their sensory systems and their physical environments.

Adolph Menzel's 1892 gouache *Traveling through the Countryside* documents the extent to which this industrialization of sight affected individual practices of seeing as much as it reorganized the forms of social interaction. The travelers in Menzel's first-class compartment are portrayed as sleeping, leaning out of the compartment window, looking at passing scenery, reading, and conversing with each other. Although Menzel's point of view does not allow us to gaze at the countryside ourselves, his image emphasizes the way in which railway journeys produce a buzzing hunger for visual distractions. Visual prostheses such as binoculars and spectacles dominate the scene. Several passengers are shown looking intently at objects that remain outside of the gouache's frame, located

on either side of the compartment's rows of windows. Touristic voyeurism and restless intoxication here displace more contemplative modes of traveling. Unable to keep his eyes on his book, one passenger is shown speaking animatedly to a fellow traveler whose posture—seen from the rear only—suggests sleep rather than attentive listening. Not one person's gaze meets another person's gaze or establishes any sense of visual reciprocity. Menzel's compartment is clearly not a space for empathetic looking in the Wagnerian sense. Instead, the train's spectacle of motion, progress, and speed has entirely taken hold of this group of travelers, disintegrating unified sights as much as atomizing existing communities. Restlessly consuming fleeting sceneries, the traveler's thrill is shown in comical opposition to the compartment's sedate luxury. Only the uniformed ticket inspector in the background peeking into the car and the sleeping child in the middle of the image seem to evade the way in which the train's windows here reorganize people's attention. Menzel's principle of composition, by contrast, more or less compels the viewer to assume the traveler's nervous modes of visual perception. Overwhelmed by the relay of disconnected looks, the viewer cannot but fail to find something to relax his or her own act of looking. Each compositional element directs our gaze somewhere else—toward that which remains unseen yet spurs our curiosity. Thus decomposing space and defying any sense of visual closure, the frame of Menzel's *Traveling through the Countryside* ends up allegorizing the very industrialization of sight it represents. Though Menzel's painting seems to mock the passengers' edgy voyeurism, it frames its own pictorial space just as nineteenth-century railway windows at once displayed and produced passing landscapes for the traveler's eye. When looking at this image, we as viewers too are cut off from the possibility of immersive transport and empathetic identification.

Nineteenth-century railway travel, as depicted in Menzel's gouache of the early 1890s, fundamentally transformed the relationship between the passenger and the landscape. Train travelers no longer belonged to the spaces they traversed. They instead saw "the objects, landscapes, etc., through the apparatus which move[d] him/her through the world."[2] As they were thrust into a new universe of velocity and speed, railway travelers experienced a profound loss of depth perception. The train's mobility dissociated the viewing subject from the visual field while erasing any reliable distinction between visual foreground and background. The prominence of prosthetic viewing devices in Menzel's image—reading glasses, spectacles, and binoculars—might be seen as an expression of this disruption of spatial homogeneity and palpability. In the absence of fixed and stable points of observation, nineteenth-century rail-

Adolph Menzel, *Traveling through the Countryside* (1892). Private collection. Owner anonymous.

way passengers often encountered this process of visual abstraction as an acute despatialization of subjectivity itself. In his seminal study on train travel, Wolfgang Schivelbusch suggested the term *panoramic perception* to conceptualize this destabilization of subjective vision. For Schivelbusch, panoramic viewing emancipated the object of our look from the actual space of our looking. As importantly, however, panoramic perception reflected conditions of seeing that overwhelmed the viewer with discontinuous stimulations, leading to a temporary sharpening of our attention, yet also—unavoidably—to overexcitement, nervousness, fatigue, and psychic disintegration. Cited in Schivelbusch's study, an 1861 text by Benjamin Gastineau neatly summarizes this notion of the train as a viewing machine whose most stunning function was to display discontinuous sights for highly attentive, albeit essentially distracted, viewers: "Devouring distance at the rate of fifteen leagues an hour, the steam engine, that powerful stage manager, throws the switches, changes the décor, and shifts the point of view every moment; in quick succession it presents the aston-

ished traveler with happy scenes, sad scenes, burlesque interludes, brilliant fireworks, all visions that disappear as soon as they are seen."[3]

Descriptions such as Gastineau's have caused various scholars of modern visual culture to argue for a special affinity between the railroad and the emergence of cinema around 1900. Equipped with Benjaminian notions of visual shock and shock defense, they have come to discuss the railway window as a site of cinematic viewership and pleasure *avant la lettre*. Both railway and cinema invited their users to unprecedented experiences of spatial and temporal mobility. Both railway and cinema, in particular for the first generation of users, provided disjunct series of passing images to viewing subjects who were fundamentally dissociated from the actual space of the visible. And last but not least, in front of both the railway window and cinema's silver screen, modern society witnessed the rise of a new class of visual consumers willing to retrain their sensory apparatus, fend off shock impressions, and transform the potential trauma of discontinuous stimulation—the montage of transitory images—into a source of pleasure and identification. Because nineteenth-century railways themselves already operated like film projectors, the striking prominence of railway travel in early cinema should therefore come as no surprise. Whenever the pioneers of cinema featured rushing railways in their films, they honored the historical romance between trains and film projectors so as to propagate a powerful founding myth of modern visuality: the conception of modern sight based on the experience of speed, mobility, disruption, and shock. By showing steam engines and railway travelers on screen, early cinema hoped to bring the modernization of sight during the nineteenth century full circle. The image of steam engines, rather than merely foreshadowing the projector, now came to probe and allegorize the workings of cinema itself, understood as a modern regime of seeing and visual representation privileging distraction over contemplative attitudes, montage over organic representation, the temporal over the spatial.

There is clearly no reason to question this special kinship between the railway and the cinema, nor to renounce their joint role in modernizing vision, despatializing subjectivity, and producing a new mass of visual consumers since the second half of the nineteenth century. What I would like to challenge in this chapter, however, is the common idea that the speed of public mass transport and the windows of railway trains produced a unified regime of modern looking that knew of no alternative processes of visual modernization. Moviegoers even before the advent of cinema, Menzel's distracted travelers formed one subset of modern subjects whose sensory perception was reshaped

by the windows of moving railway cars—and, by extension, by the frames of cinematic projection. But the allegorical prominence of railway travel in early cinema around 1900 should not cause us to overlook the cultural dynamic of other means of modern transport whose emergence paralleled that of cinema. I am thinking in particular of the coming of the subway, whose dark window panes produced practices of seeing completely different from, but no less modern than, those conventionally associated with both the railway journey and the visit to the cinema. Underground transportation in Berlin witnessed a dramatic expansion during the Weimar Republic, the celebrated heyday of aesthetic experimentation, cinematic avant-gardism, and social mobility in early twentieth-century Germany. And it is in the course of these 1920s, as I shall argue, that various texts written on subways and their nontransparent windows not only probed scenes of modern looking uncoupled from notions such as speed, shock, voyeurism, heightened attention, and panoramic perception; they also cast the subway passengers' experience of obstructed and unsettled visuality into aesthetic forms substantially different from those found in the cinema and its disjunct series of images.

Consider the 1931 poem "The Dreamers in the Subway," by Joachim Ringel-natz (1883–1934), a Berlin-based cabaret artist and author of satirical verse:

> The dreamers in the subway
> Have fogged-up gazes.
> They dream their time, their fate,
> Subjected to both.
> Not one of them wants to see the other,
> Not one hears from the other,
> Not one wants to disturb any other in any way.
> They ride. And their thoughts turn,
> Thoughts turn, slowly, in circles,
> Don't get sore feet from walking.
> The dreamers in the subway,
> They have neither complaints nor delusions,
> For them there is not much to dream of
> Under the ground.
> They won't fail to reach their destination.[4]

Their eyes at once unable and unwilling to look at anything at all, Ringelnatz's subway travelers differ drastically from the distracted crowd that populated Menzel's nineteenth-century railway. Instead of sharpening the individual's visual attention, underground transport here ushers the subject into some kind

of surreal dream state that anaesthetizes perception, petrifies thought, and disables the possibility of communication. Unlike Menzel's train windows, which entertained the traveler with captivating spectacles of speed and progress, Ringelnatz's subway provides dull experiences of circularity, standstill, and boredom. In fact, because it offers travelers nothing to focus their gaze on at all, the subway here seems to displace the very condition of experience in the first place. Unable to distract themselves with anything, Ringelnatz's subway travelers—far from being exhilarated by the speed of modern mass transport—practice the art of cold conduct. They shut out the possibility of intimacy, no longer experiencing the difference between interior and exterior realities, between the mind and the material world, as one structured by possible tensions and sensory transactions. Ringelnatz's subway is a space devoid of transcendence, devoid of time and history, a space blurring the line between the real and the imaginary. However impoverished in nature, inner visions here turn into outward realities as much as physical spaces become landscapes of the mind. In this world of fogged-up seeing and preordained ennui, nothing can ever enter the traveler's visual field in form of a shock, nor will anything ever cause him or her to engage in panoramic acts of seeing. Instead of being physically dissociated from the visual field, the subway traveler is fully incorporated into the very apparatus of looking and modern mobility. Whereas in Menzel's gouache and Gastineau's text the windows of the train served as screens projecting montage-like sequences of the world, in Ringelnatz's poem the subway transforms the travelers themselves into ghostlike projections. Time here turns into space, yet space is no longer experienced as something contiguous and extended. You no doubt reach your destination, but, subjected to the dream-logic of the underground, you really don't know how you got there. In the excruciating absence of visual, acoustical, and haptic stimulations, even the poet's language starts to turn in circles. The dark windows of the underground suspend ordinary time, space, and perception, and in so doing they also suspend language's ability to communicate and arrange sounds and thoughts in linear orders. Underground space occasions the poet's words to stumble and repeat themselves, similar to the way that the subway causes the traveler's "thoughts turn, thoughts turn, slowly, in circles."

This chapter follows the tracks of Ringelnatz's subway travelers through the course of the 1920s, exploring their fogged-up gaze through, at, and away from Berlin's subway windows as an alternative site of modern looking. Mass transport in the underground created dystopian spaces and—to use Foucault's famous phrase—modern "heterotopias" where there is little to see and noth-

Route finder, early 1930s. Printed by permission of U-Bahn-Museum Berlin. Photo: Lutz Koepnick.

ing to focus your eye on.[5] It caused people not to dream of other worlds of light and distractions but to perceive their own existence as itinerant subway passengers as a dreamt one. Whether they looked at their own countenance in the subway window's dark mirror; whether they surreptitiously, albeit not voyeuristically, scanned the faces, bodies, clothes, expressions, and reading materials of their fellow travelers; or whether they simply stared straight ahead— subway travelers encountered the subway and its windows as a space of the uncanny, a space emancipated from the ever-accelerating modern drive toward visual distraction, shock, speed, and heightened attention above ground. The subway window, as I reconstruct its emblematic role in Weimar culture in the following pages, catalyzed a powerful return of the repressed. It is to be understood as the nightside of the modern spectacle, of panoramic looking and visual consumption, causing us to question the narrow understanding of modern visual culture in terms of the kinds of looks cast at railway windows and film screens. As this chapter follows the tracks of a number of Weimar writ-

ers, poets, and visual artists through the Berlin underground, it explores the fogged-up gaze of subway traveling as a compelling alternative to the modern cult of velocity, spatial shrinkage, and temporal disruption.

Cold Looking

Let's start our itinerary by taking a look at how people in the 1920s traversed the city's underground, and how the interior design of contemporary subway wagons regulated the passenger's physical movements and eye activity. After it was nearly brought to a complete shutdown in the aftermath of World War I, the Berlin subway experienced one of its most noteworthy phases of expansion between 1926 and 1930.[6] In 1930, the Berlin subway system was seventy-six kilometers long. It contained seventy-seven stations, offered five different lines connecting and encircling the city's diverse quarters, and transported more than 200 million passengers a year. In order to accommodate exploding passenger flow in the late 1920s, the length of many already existing stations was extended to 110 meters, permitting the use of eight-car trains at ninety-second intervals during the busiest hours of the day. The mid- to late 1920s also witnessed the introduction of the second generation of subway trains and wagons: on the one hand, in 1924, the proverbial "Tunnel Owl," named after its two oval-shaped front windows; and on the other the A-II car, whose exotic popular name—the "Amanullah Wagon"—honored the Emir of Afghanistan, Amanullah Khan, who had expressed his admiration for Berlin mass transportation during a state visit in early 1928. Both cars were to be entered through two sets of sliding doors and included up to eight windows on each side. Whereas during the first decades of the century passengers had the opportunity to chose from three distinct classes of transport, in 1927 they had to decide between first- and second-class only, the latter divided into smoking and nonsmoking sections. What all car types and classes of transportation shared, however, was a lateral arrangement of benches and seats, a system prevalent until today, allowing for maximum standing space in the wagon's center while at the same time asking passengers to face each other, turn to the side in order to communicate with fellow travelers, and either stare at or uneasily evade the image of their own reflection in the train window.

Public mass transport provides spaces of sudden encounters and unwanted mingling. Like Baudelaire's boulevards, it seems to encourage forms of contact and delight centered around the figure of catastrophe: whatever you see, hear, or smell may fascinate primarily because, in only a moment's time, it will

vanish forever. And yet, few documents of 1920s Berlin subway travel communicate any desire for experiencing the crowds in the underground as objects of enchantment and intoxication. On the contrary, in most of the accounts we hear of subway passengers eager to screen out accidental interactions and chance impressions, to draw firm lines between their own space and that of other people, to turn their gaze inward and fortify their hearts, minds, and eyes against the possibility of surprise, rapture, and transgression. In fact, no space within the accelerated landscape of the modern metropolis appears to be more hostile to the mysteries of non-intentional perception and unrestrained behavior than the subway. No place seems to regulate the forms of social exchange and, in so doing, quell the prospects of enchantment, astonishment, and shock more forcefully than the subway car's interior. Unlike Baudelaire's Paris boulevards, then, underground travel in the 1920s defined a space in which the physical alignment of bodies and perceptions corresponded to an utter disenchantment of the world, a visual field in which strategic rationality and calculating self-discipline radiated triumphant. In spite of the enormous flow of passengers, subway travel left chance no chance.

In a short newspaper article of July 1922 in *Berliner Tageblatt,* aptly entitled "Barriers," Berlin essayist Viktor Auburtin poignantly mocked the subway passengers' heightened need for demarcation, detachment, and distanciation. Traveling prior to the integration of second- and third-class compartments, Auburtin centers his focus on the startling physical proximity of both classes of transport within one and the same train. Separated by merely a door, passengers could easily traverse the existing division in order to find additional room. And yet, according to Auburtin, the subway's rigid codes of conduct excluded the possibility of spatial or social crossover. "The third class," Auburtin describes a typical experience, "is entirely empty; in the second class the gentlemen sit next to and are squeezed against each other, while the elegant ladies have to stand and squeeze as well. But no one of them comes across the idea of opening the door and entering the third class; no one would violate his role in such a fashion. The patricians would rather tolerate all kinds of torment than to be seen in the third class of the subway."[7] The subway car's interior served as a stage to display social status and perform different cultural identities. Though passengers might have been unable to see anything for and in front of themselves, one of the imperatives of subway travel in the 1920s was never to be seen as occupying the wrong stage, that is, never to violate one's presumed role and position by masquerading as other. Far from being chaotic and anarchistic, then, as many essayists tended to claim, Berlin traffic in the

underground followed narrowly defined scripts and conventions. Their func-
tion was to segregate members of different social strata as much as to separate
insiders from outsiders, locals from visitors. To beat chance at its own game
and secure a room of their own amid the crowd, passengers had to learn the
difficult art of being actor and audience at one and the same time. To evade
the unexpected and be left in peace, the subway traveler had to know how to
embrace the car as a sphere of impersonal and socially distant interaction, as
an all-inclusive stage of protective self-performance unlikely ever to generate
passionate audience responses, as a fleeting space of playacting devoid of any
sense of playfulness.

In his 1924 treatise *The Limits of Community*, sociologist and anthroplogist
Helmuth Plessner outlined a number of concepts useful both to theorize and
to historicize the subway traveler's codes of self-restraint and self-performance
in further detail.[8] Plessner in fact—I suggest—could as well have been writing
about the subway passenger's acts of cold distanciation, self-stylization, and
disenchantment when he developed his political anthropology in the first years
of the 1920s. According to Plessner, human psychology is inextricably caught
between conflicting drives, one toward being, reality, and identity and one
toward becoming and ongoing self-redress: "We want ourselves to be seen and
to have been seen as we are; and we want just as much to veil ourselves and
remain unknown, for behind every determination of our being lies dormant
the unspoken possibility of being different. Out of this ontological ambigu-
ity arises with iron necessity two fundamental forces of psychological life: the
impetus to disclosure—the need for validity; and the impetus to restraint—the
need for modesty."[9] Torn between our desire for visible form and our drive to
escape visibility, the human soul according to Plessner is constantly threatened
by the risk of ridicule, understood as the presentation of something contradic-
tory as if it were free of contradiction. The solution Plessner suggests in order
to overcome the predicaments of our soul is for the person to step out of the
communal sphere and take on the protection of an artificial mask. Learn how
to play, advises Plessner, learn how to interact with strangers under the sign
of game-like rules, and you will overcome the paradoxes of human existence.
Turn cold and shut out too much intimacy, draw definite lines between self
and other, forget nature and revel in the artificial, and you will be able to ap-
pear in front of others without being immobilized by the laws of appearance.
Ironic though it may seem, in Plessner's anthropology the privileged site at
which we can objectify ourselves and thus achieve reciprocal protection from
ourselves and each other is the public sphere. It is the stage of publicity and its

various mechanisms of coordinating social behavior that help us avoid ridicule and defeat the oppressive ambivalence of our soul. In particular in its modern, technologically mediated form, publicity enables the subject to enjoy the pleasure and power of being invisible while being looked at from all sides.

The patterns of behavior of subway passengers, as described for instance in Auburtin's 1922 article, provide prime exemplars for Plessner's anthropology. Not only do these passengers enter the subway car as a public stage of stylized self-realization and identity formation, they do so by actively shutting out the putative risks of intimacy, emotional authenticity, human reciprocity, and ridicule. Any attempt to ride the subway, for Auburtin and many other Weimar essayists, journalists, and poets, requires modern individuals to unrealize their soul, to embrace identity as a cold mask and strategic performance, to overcome unbearable physical proximity by bracing the self against chance and contingency. To ride the underground was to engage in game-like rules of conduct, not in order to enter a joyful celebration of communal life but on the contrary to prevail over the pressures of community and protect oneself from the effects of a highly mobile and modern society. Blind to the outside world, one of the principal functions of the subway's windows was to inspect the persuasiveness of one's own performance and self-realization as a distinct object of the other's gaze. Whenever travelers caught a glimpse of themselves in the frame of the window, their task was to test the compellingness of their own self-objectification, that is, the extent to which they succeeded in eliminating the portals of intimacy and community. In this way, the subway turned our conventional understanding of the window as a point of contact between the public and the private on its head. A site for the practice of cold conduct, the subway cars and windows of the Weimar period not only emancipated the bourgeois subject from the torments of the private and the intimate, they also taught a new art of self-objectifying looking in whose context the other's gaze served as the principal conduit to constituting one's own identity in society—and in whose domain to be seen publicly seemed to promise the curious and cold pleasure of remaining invisible.

When exploring a new underground line from Neukölln to Gesundbrunnen in April 1930, Siegfried Kracauer therefore had good reason to consider the Berlin subway one of the coldest places in town. For Kracauer, subway travel circa 1930 crisscrossed and interconnected the incommensurable. It transported workers effectively from proletarian neighborhoods to factories straight through the city's bourgeois heart of commerce. Thus upsetting former topographical orders and hierarchies, the subway in Kracauer's view also discarded

the remnants of nineteenth-century sensibilities and aesthetic sentiments. Tellingly, individual stations along this new route reminded Kracauer of "modern hospitals, with simple iron pillars, shiny wall tiles, plain signs and all kinds of light signals."[10] These stations were made for passengers eager to escape the desolate economic situation above ground, yet not in order to find a parallel world of marvelous dreams and mythological plenitude but to face the truth about the overall lack of fantasies of transcendence in contemporary culture. In Kracauer's perspective, the Berlin subway expansion of the late 1920s came to embody the cynical realism of a society that had run out of utopian energies and emotional depth. The underground's aloof modernity foreshadowed the end of the modern; its chilling objectivism symptomatically expressed the looming self-destruction of modernist culture: "The public, which is using this route, doesn't look as if it was able to entertain illusions and fantasies any longer. . . . Men with tool boxes, boys in leather jackets, women with bags and kids fill the seats and aisles. . . . If you get out somewhere during the ride and return to the light, you—contrary to Thousand and One Nights—do not move up into a world of dazzling castles but into torn-open landscapes of stone."[11]

In Kracauer's description, the new subway line between Neukölln und Gesundbrunnen manifested the sober spirit of New Objectivism as it had permeated many aspects of Weimar culture since the mid-1920s. Like the artworks associated with the movement of New Objectivity, Kracauer's underground denied any space for introspection, fantasy, and reflection. As it linked the incommensurable and solicited vacant gazes, it incorporated the emptied shells of bourgeois subjectivity into self-contained worlds of seamless, postbourgeois exteriority. People here performed their identities and engaged in game-like behavior, but no one could expect to discover anything behind their masks anymore. Passengers staged emotional restraint and probed the cold pleasure of self-objectification, but whatever they could see and witness here was everything they would ever get: a world of total disenchantment; a world free of mysteries, disparity, and hence the risk of ridicule; a world in which seeing became knowing in spite—yet perhaps even more precisely because—of the fact that there wasn't really anything worth knowing anymore.

Up and Down

The early history of the Berlin subway developed within a volatile force field of geological, technological, administrative, and aesthetic concerns. A city

proverbially situated on flat Prussian sand, Berlin's extremely high water table seemed to rule out the very possibility of constructing a solid underground system all the way through the late nineteenth century. It took the persistent ingenuity of engineers and entrepreneurs such as Werner von Siemens, of architects such as Swedish-born Alfred Elias Grenander, and of urban politicians such as Ernst Reuter to overcome the main obstacles to subway construction and thus accomplish what even a few years prior to the inception of construction work in 1896 appeared entirely impossible: to create a modern system of mass transportation able to evade traffic congestion above ground without inviting the risk of flooding even right below street level, to make use of modern building materials and efficient construction methods while at the same time accommodating the aesthetic tastes of the influential Berlin bourgeoisie, and, last but not least, to integrate the interests of socially diverse boroughs, sleepy suburbs, and mulish administrative units that deep into the Weimar era would often remain quite hostile to the concurrent self-invention of Berlin as a cosmopolitan center of first rank. Up to the final unification of competing transportation companies and construction holdings on June 4, 1929—the birthday of the BVG (Berliner Verkehr-Gesellschaft)—the construction and maintenance of urban railway lines in the larger Berlin area lacked any clear sense of direction and cohesion. It was marked by competing technological visions and solutions, diverse economic and political agendas, and conflicting cultural and aesthetic anxieties.

Due to the city's adverse geological conditions, late nineteenth-century visions for urban mass transport in Berlin initially favored the idea of elevated train tracks and overhead monorails. Numerous on-site experiments were carried out during the 1890s in order to test both the technological and aesthetic designs for above-surface constructions, designs which were then also included in certain sections of the first subway line, the "*Stammstrecke.*" Many a critic lamented the erection of elevated track segments as a devastating assault on Berlin street life and visuality. The sobriety of steel and iron posts was seen as antithetical to the splendor of residential façades. The presence of tracks, it was added, cast debilitating shadows onto the streets' vibrant movements, while the sight of passing cars in front of one's window obstructed entertaining perspectives onto the exterior world. Listen to one of the many voices arguing acerbically against elevated travel around 1900, that of theater critic and author Alfred Kerr: "Bülowstraße has changed. . . . What a bewildering sight: painted in red and grey, the iron frame of an elevated train track climbs upward with clumsy dreadfulness in-between the houses, in-between the small trees. Noth-

ing in the world looks more barbaric, disgusting, godforsaken, sillier, unfortunate, miserable, disgraceful, plucked, as if stepped on its tail."[12]

One of the perhaps most lasting imprints of the contested origins of Berlin subway history was the curious fact that various Berlin subway lines, in order to appease different constituencies, were designed to run above as much as below ground. As early as 1902, to take a ride on the Berlin subway was to experience dramatic alternations between elevated modes of travel along multi-story residences and extended expeditions through the city's underground, curiously located—in contrast to other metropolitan subway systems—right underneath the streets' pavement. Critics such as Kerr could not warm up to the sight of public mass transport because for them the realms of aesthetic culture and modern technology were mutually exclusive. What Kerr and other critics did not anticipate was the fact that within twenty years subway passengers themselves would learn how to consume transitions between above- and below-surface transportation along the Stammstrecke such as the one at Bülowstraße as nothing less than prime sites of aesthetic experience and spectacle. Whether subway cars plunged into the darkness of the tunnel or returned their riders back to daylight, numerous accounts of the 1920s describe the passage from one mode of travel to another as a feast for the senses and an intoxicating disruption of the routines of cold looking. Struck with sudden visual excitement and desire, subway riders would now find aesthetic value even in the most mundane and industrial urban settings: "Whenever the subway train leaves the tunnel after Leipziger Platz," Victor Auburtin wrote in the early 1920s, "I turn on my seat and watch the landscape through the window. This landscape, with its many railway cars and tracks is one of the most beautiful I know."[13]

The modern history of Berlin is full of voices lamenting the city's general absence of elevated vistas and breathtaking perspectives, caused by the region's topographical flatness as much as the historical problems of erecting tall architectural structures on the city's sandy ground. Eager to reinvent itself since the 1870s as the nation's commanding capital, what Berlin in the eyes of many critics lacked was a set of elevated vantage points. In 1910, Berlin essayist Karl Scheffler wrote: "What is entirely missing in order to animate the image of the city are the differences in altitude, the heights and low points, creating prospects and architectural structures and render the streets picturesque. One happens to breathe a sigh of relief whenever even a poor perspective will finally open up, along the canal or across one of the squares."[14] It is one of the great ironies of Berlin history that between 1902 and 1930 the first two major phases of subway construction ended up providing precisely what critics had so sorely

missed: viewing positions enabling the urban subject to render readable the increasingly congested, chaotic, unbound, and hence illegible text of metropolitan life. As they jerked subway riders briefly away from their habit of cold looking, the subway's gateways between surface travel and underground transport provided temporary windows onto Berlin able to stir the imagination. Yet in contrast to Scheffler's expectations, these windows offered everything but stationary and detached points of view. Instead, whenever it traversed the threshold between light and darkness, the subway offered sudden perspectives that were experienced at once as highly mobile and painstakingly temporary, that did not simply frame but also produced the city as a text and visual object in the first place, and that included the possibility of not offering any sight beyond the window pane at all, elevating affects by plunging riders into the underground. It is the much-commented presence of such transition experiences that infused the literary discourse on Berlin subway travel during the 1920s with an unusually high degree of self-reflexivity.[15] Again and again, it was in the portrait of the exceptional threshold event that the ordinary meanings and practices of subway travel crystallized most intensely; it was the account of the atypical that helped Berlin poets and essayists illuminate the way in which the subway established an alternate space of modern looking and visibility.

The Hell of Desire

What we see is next to nothing. A dark subway station faintly illuminated by a series of ceiling lights. One of Grenander's well-known tiled ticket offices in the foreground, its white display board forming the brightest spot in the entire image. A few passengers are waiting on both sides of the middle platform for their respective trains. Barely visible, they have something spectral about them, their contours blending into the platform's murky ground. Diffuse chiaroscuro effects take up some of the background. Their source, we can only surmise, are the beams of an incoming subway engine, refracted into an unruly play of light at the end of this tunnel segment. However weak and muted in nature, the beams' light suffices in order to render visible the frames of various billboards that are mounted on the tunnel's side walls. Strangely enough, wherever we are able to detect areas of reflecting light we cannot escape the impression that ceiling, walls, and floors are covered with a thin layer of water, as if rain—or groundwater—had somehow suffused the station at some point and enveloped its material structure in an unhealthy, albeit alluringly reflective, coat of dampness.

Sasha Stone, "Untergrundbahnhof Inselbrücke." Reprinted from *Berlin in Bildern* (1998) by permission of Gebr. Mann Verlag, Berlin, Germany.

The shot is taken from an elevated position, close to the ceiling. Though we may (rightly) assume that the photograph was taken from the staircase leading down to the platform, the shot's point of view—due to the darkness of the immediate foreground—strikes the viewer as oddly disembodied. We are at once invited to become part of this shadowy underground world—and aren't.

We seem to be at the point of entering the city's netherworld, yet we do so like ghosts from the past drifting through a long-forgotten dungeon.

What brings this spectral underground world—like the world of photography itself—into being is nothing other than the mysterious force of light. Light here does not simply make preexisting reality visible; on the contrary, it engenders the visible in the first place. Moreover, like the photographic image, the world of underground traffic as depicted here seems to suspend the modern perception of time as linear and progressive. Though trains project ever-new flickers of light onto the station's walls, what we see here is a self-contained universe in which the vectors of past, present, and future appear to collapse into one amorphous temporal horizon, a space unsettling modernity's belief in how future presents will necessarily erase the burdens of the past. Where do we come from? Who are we? Where are we going? Such questions of modernists like Gauguin remain without answers amid the station's ghostly darkness. What we see is a world at once driven by dynamic movements and appearing static, a world—like that of photography—mingling the dead and the living. That our photographer confidently ignores his time's language of photographic modernism; that he circumvents the cold and sober objectivism of *Neues Sehen*; that he stylizes his subject with filters in the dark room rather than endorsing photography as a means of analysis and documentation—all this seems only logical given that the underground, as we see it here, seems to question the themes that energized the forays of aesthetic modernism, namely the concept of teleological and progressive time. A world that in and of itself looks like a photograph renders the difference between old and new irrelevant. Contemporary avant-gardists may have thought of this image as an example of old-fashioned pictorialism and passé romanticism. In truth, however, our photograph records a process of perception in whose wake we can no longer meaningfully distinguish between what is old-fashioned and what is up to date, precisely because the modernist rhetoric of the new fails to address the meaning of too many dimensions of everyday life in modernity.

The image under discussion appeared in the very center of Kurt Tucholsky's 1929 *Deutschland, Deutschland über alles,* a collection of caustic aphorisms, bitter satires, revelatory newspaper clippings, and polemical images meant to challenge the antidemocratic legacies of Weimar politics.[16] The name of the photographer—Sasha Stone—remains unlisted. To the right of the image, we find a brief text, entitled "Subway," a meditation about the experience of traveling the Berlin underground and how it could be captured by photographic representations. In spite of their prominent positions, both image and text

stand in stark contrast to the rest of the book. For neither does this center-fold resort to the volume's prevalent tone of combativeness nor does it engage the disruptive principles of aesthetic montage used elsewhere in this book in order to articulate Tucholsky's leftist agenda. Though situated in the book's very middle, text and image instead first strike the reader as entirely atypical and apolitical: a moody reflection about metropolitan existence, a melancholy account about that which exceeds the struggles of the day, a dream-like encounter with the seemingly insignificant and forgotten, a gloomy quest for anomalous pockets of Romanticism amid the sober orders of the day. And yet, after more careful reflection, we come to the conclusion that in publishing image and text, Tucholsky sought to provide the reader with a reverse image of what defines the overall itinerary of *Deutschland, Deutschland über alles,* not in order to seek some kind of escapism but to put things into proper perspective by exploring their other, their night side. Tucholsky's odd reflections on subway travel are far from apolitical. Rather than skirt the inevitable fights about politics and representation above ground, this centerfold draws our attention to the city's political unconscious, understood as a dark continent of repressed longings that secretly energize the narratives and structures of political conflict above ground.

"It doesn't look like this at all—only the photographer ever sees it like this," Tucholsky resolutely begins his text.[17] As he continues, however, Tucholsky's assertive tone immediately surrenders to doubt, ambivalence, and indeterminacy. "It does look like this," he adds. And then again: "It doesn't." The reason for Tucholsky's indecisiveness lies in the fact that the photograph renders visible what under ordinary conditions eludes the passenger's perception. For the subway, Tucholsky explains, is something not meant to be seen. It impedes our very ability and desire to look, whether we stare at trains rushing into the station, rush through the crowd so as to catch a ride, talk to someone in order to bridge our boredom, or read ubiquitous ads with half-interested eyes. Offering spaces where urban subjects "see everything and nothing," the subway invites passengers to keep their eyes wide shut and perceive their own bodies as mere things among other things. By contrast, to take a photograph of and in the subway is to interrupt the rider's dreamless slumber and self-objectification. As it casts the unseen into an image, the photograph awakens to consciousness what usually remains below the threshold of our discerning awareness. Photographs capture the subway like passengers able to resist the underground's reification and automatization of sight. What the photograph does is to mimic the experience of a subway rider who understands how to en-

counter the underground—however briefly—as a landscape, a forest, a range of mountains: "You see the subway, and perhaps the whole huge city, the way the photographer saw it, only once. When you suddenly sense what it is you live inside. A landscape." Rather than anaesthetize the subject's perception, the underground here turns into a sensual space saturated with dark Romantic qualities. It makes the body tremble, infuses the passenger's veins with the smells and noises of the city, and converts feelings of alienation into ecstatic and synaesthetic sensations of belonging. What the photograph accomplishes is to capture the subway not as a space of dreamless numbness but as the site of a riveting return of the mythological and of the fantastic dreams encoded in our fairy tales. It documents a discontinuous state of reverie in which the black tunnel can become "a strange tube inhabited by giants."[18]

The subway in Tucholsky's short text is portrayed as a topography of the unconscious enabling the possibility of surrealist intoxication. Once you manage to see something here, you witness not the dazzle of Weimar surface culture[19] but the visible forms of desire and the unconscious, that is to say, a world in which distinctions between depth and surface, interiority and exteriority, intention and expression, no longer prevail. Like a surrealist artwork or film, Tucholsky's underground opens up a space of unforeseen encounters and random constellations. Its photographic reproduction does not simply represent a previously existing space but—precisely due to its stark realism and naturalness—actively creates an alternative reality, an imaginary as it presents itself to the dreamer's mind. Like the subway window itself, the photograph here operates like a mirror whose function is not to reflect what is but to provide an analogue of the self-contained form of our dreams.

Subway travel as surrealism with other means?

In 1924, the founding father of interwar surrealism, André Breton, took recourse in a curious hallucination of a man cut into two halves by a window to explain the relationship between unconscious thought and surrealist aesthetic practice. "Beyond the slightest shadow of a doubt," Breton wrote in the first *Manifesto of Surrealism,* "what I saw was the simple reconstruction in space of a man leaning out a window. But this window having shifted with the man, I realized that I was dealing with an image of a fairly rare sort, and all I could think of was to incorporate it into my material for poetic construction."[20] Initially, Breton's window hallucination was triggered by an inconspicuous verbal phrase that had occupied the poet's mind right before he was trying to go to sleep. In no time, however, the visual image unfastened a seemingly "interminable quarrel" of phrases.[21] This rage exceeded conventional fantasies

of artistic control and in so doing released unprecedented poetic energies from the unconscious.

Many members of the surrealist movement understood their aesthetic practice as an effort to tap the unstructured, formless, and primordial realm of the unconscious and play it out against the rational censors of our consciousness. Breton's window experience, however, points toward something more complex. It caused Breton to envision surrealist aesthetic practice as a method whose primary aim was not to celebrate the imaginary as a world entirely free of discourse and representation but to construct dream-like procedures that at once approximate the ways in which the unconscious articulates itself and reveal the extent to which this world is inextricably bound to existing language systems. Surrealism pursues aesthetic forms that, rather than representing anything, display the world as one in which the structures of the unconscious become identical with the structures of the visible. Surrealist art conjures a world that no longer knows of secrets and hidden symbolic meanings, a world in which the dreamlike completely rules over or envelops the real and quotidian. And yet, as Breton's window hallucination suggests, even our dreams are inherently structured by language. They must be understood as rhetorical figures, their collective imaginary deeply penetrated from the very beginning by the symbolic and discursive. Surrealist image production is therefore at its best whenever it, on the one hand, tries to find visual forms approximating the rhetorical structure of desire and, on the other hand, exposes the image and imaginary as a site of fateful misrecognition—a seductive illusion of wholeness and plenitude that can never be fully attained by the dreamer or the desiring subject.

Although Tucholsky had little in common with the surrealist avant-garde of his time, his image of the subway approximates the world of the unconscious that surrealism sought to cast into analogous aesthetic forms. The underground, as described by Tucholsky, confronts the passenger with a space of radical exteriorization. As long as you are willing or able to keep your eyes open, riding the subway turns out to be a surrealist activity *par excellence*. But as we catch a glimpse of our own reflection in the window of the subway car, what we experience is not a spectacle of self-identification and totality but one of misrecognition and continual displacement. Like Breton's image of a man cut into halves, subway windows, properly looked at, focus our attention on how the language of desire perpetually, albeit never successfully, seeks to overcome the individual's fundamental experience of loss and fragmentation. Haunting the tubes of the underground, Tucholsky's giants remind us of the

extent to which the subway not only figures as the modern city's unconscious but are also the site of a monstrous return of the repressed. One of the most significant reasons that subway riders feared and continue to fear nothing so much as to see their own reflection in the mirror of the window might therefore lie in the fact that they are trying to evade what surrealism brought into view: that neither the world of our dreams and unconscious nor the language of desire will ever succeed in providing durable experiences of plenitude, wholeness, presence, and self-fulfillment—that the giants are always after us. Like surrealist image-making in Breton's sense, the subway window provides a mirror whose ability to reflect, far from stimulating visions of future utopias, reveals the traumatic secrets of subjectivity and signification, enigmas so painful that they—as in the case of Tucholsky's *Deutschland, Deutschland über alles*—may even disturb the scrupulous rhetoric of political activism. All things told, the subway rider's bored, fogged-up, and absent gaze might embody nothing so much as a clever strategy to dodge surrealism's perhaps most enduring insight, namely that hell is right here, right now, and might last forever.

Windows of Consumption

Subway windows, then, confronted the viewer with irresolvable conflicts and unsettling ambivalences. Rather than luring travelers into distant realities, they trapped them in the real, a space of imaginary self-performance devoid of transcendence. And rather than appeal to their desire to become someone else, they revealed the deceptive origins and operations of desire itself—and hence had the power to make people desire the end of desire. Even though the subway window may have functioned as a mirror to ensure the efficacy of one's own self-production as a restrained subject of Weimar Berlin's cold modernity, at the same time this window also condemned the onlooker to suffer the heat of infernal punishments thanks to its power to expose the vanity of our desire to be someone in the first place. Unlike the experience of nineteenth-century train travel, subway windows were far from offering unequivocal visual pleasures and diversions. On the contrary, we do well to think of the subway window as a vertiginous screen that caused modern travelers temporarily to disavow their scopophilic drives altogether. For nothing they could see here would ever allow their eye to find rest or distraction, and whatever they did see was about to turn around on them and show its other, deeply troubling side.

Enter the potent alliance of underground architects and marketing specialists, eager to reanimate the traveler's dreamless stare with the glare of advertis-

ing signs and to distract the eye from the underground's perplexing absence of distractions. Due to the city's geological challenges, Berlin subway tunnels and stations had to be primarily located right underneath the streets' pavement. This severely restricted the possibilities of using underground stations as display cases for lavish architectural gestures and grandiose cultural self-representations, as in the case of the Paris Métro or the extravagant Moscow underground. The sobriety and aesthetic modesty of Alfred Grenander's predominantly functionalist stations was no coincidence. Sterile tiles instead of pompous stucco, low ceilings rather than sumptuous hallways dominated the design of the Berlin subway from its inception, even though Grenander's practice of color coding individual stations and entire lines added a unique feature to its look. In order to balance the Berlin subway's constitutive anti-aestheticism, station designers, city officials, and marketing agents from the very beginning of Berlin subway construction around 1900 actually explored the possibilities of using the underground as a space of colorful advertising and captivating commodity display. In the 1920s, the sight of rectangular billboards on the stations' bare side walls had become the norm. Their function was not only to open windows onto the dazzling world of commerce and consumption above ground but also to breathe life into the subdued world of the underground and add light to its perennial night. In the wake of the so-called *Plakatbewegung* (poster movement), which starting around 1896 had emphasized the artistic qualities of modern graphic design and advertising in Germany, meticulously spaced bands of billboards were turned into integral parts of each station's architectural makeup.[22] Like ambient television and ubiquitous computing today, the screen of the billboard structured the underground's inherent organization of space. In particular during the massive expansion phase of the late 1920s, the Berlin subway became a much-noted laboratory probing the compatibility—and mutual dependency—of advertising and architecture in the modern metropolis. An essential element of the station's wall itself, the frame of the billboard redirected the passenger's reserved, empty, and troubled stare to the dream world of capitalist consumption. It displaced the puzzling contradictions and anxieties experienced vis-à-vis the subway window with the promise of future plenitude and the modern consumer's agitated mobility. While waiting for the next train, travelers could temporarily forget about that which the subway car itself did not allow them to repress. Billboards provided interfaces not simply to the world of commerce but also to the passenger's seemingly lost ability to dream; they reintroduced fantasy to the harsh realities of industrial everyday life. They enticed the subway rider to desire desire again,

to hope for hope, and thus to find momentary—and commercially viable—relief from the bitter truths of the underground.

Grenander's billboards were designed to reenchant the disenchanted. In this respect, they resembled the role of the display window above ground, whose transparent glass panes and illuminated decorations garnered unprecedented attention during the Weimar era. As Janet Ward has written, "Alongside other strata of urban display . . . the *Schaufenster* was ideally situated as a powerful point of interconnection between product and potential buyer. Because it alone provided a literal link between the wares inside and the consumer outside, the display window of a department store (or of the first floor of an office block) became during the functionally obsessed mid-1920s the defining motif of an entire building: the expositional interface between inside and outside now commanded the logic of structure."[23] Insofar as it emancipated architectural forms from the excess of nineteenth-century ornamentation, the display window participated in a powerful rationalization of urban space. Many Weimar critics considered the sudden prominence of display windows and their electric lightning as the death knell of bourgeois culture, for both appeared to undercut the structuring binaries of nineteenth-century life—oppositions of inside and outside, of depth and surface, of what might see the light of the public and what should remain a secret—as much as they seemed to be in opposition to any desire for monumental self-representation.[24] And yet, the Weimar discourse on glass did not take long to develop its own hopes for a new and modernist language of the monumental, while the display window's role as a catalyst of architectural rationalization quickly fed into a new culture of re-enchantment and re-auratization. Weimar display windows filled the void left by the demise of bourgeois stuffiness and secrecy with the charm of the commodity and the promise of unbound mobility. Structural motif of urban architecture itself, the display window and its artificial illumination may have obliterated the sedentary aspects of late–nineteenth-century life, yet what they produced instead was the figure of the window shopper, of urban ramblers whose gait was guided by their eyes' desire, whose glance at passing windows resembled that of moviegoers consuming flickering images and whose pleasures increasingly lay not in having or touching objects of desire but simply in looking at them and in consuming their spectacular appeal, their synthetic aura.[25]

Though closely related to the display windows above ground, Grenander's subway billboards had little to offer in order to produce voyeuristic ramblers and cinematic forms of looking below the city's surface. No historical records

indicate that passengers were seen habitually strolling up and down the platforms in order to consume ads on display. Moreover, then and now, the gaze at the underground billboard, unlike the dreaming glance of the window shopper, is subject to violent, albeit much-anticipated, interruptions, because the very object of our waiting, the train, will finally obstruct our view of unbound consumption. Whereas the Weimar display window—like contemporary cinema screens—virtually transported the stroller into imaginary elsewheres of pleasure and plenitude, Grenander's billboards unsettled rather than fanned the individual's identification with the commodity. Instead of hailing the eternal recurrence of the new as the principal logic of commodity production, circulation, and consumption, the impermanent frame of the subway billboard, insofar as its vanishing from sight was experienced as an integral aspect of its existence, reminded the underground traveler of what most profoundly troubles the drive of modern societies toward spectacle: the figure of death. Electrically lit and carefully staged, display windows mimicked the effect of moving pictures in order to stir desire and promulgate the bliss of ceaseless consumption. Although they resembled monumental strips of film themselves, Grenander's subway billboards, by contrast, denied such animating pleasures. The spectacle here failed entirely to displace the incommensurable weight of human mortality. Desire instead remained melancholically framed, arrested, and scarred by its own futility. Grenander's billboards presented dead images of living things. They secretly reminded modern window shoppers of their own finitude, that is, the hubris of their desire to achieve fulfilling self-presence through consumption.

The reach of what Janet Ward has called Weimar surface culture, then, stopped short of the platforms and wagons of the Berlin subway. In the tunnels of the underground, the spectacle was no longer spectacular—if it had ever been; the modern did not necessarily and exclusively drive toward dazzling appearances and streamlined luminosity, and the visual codes of consumerism were clearly at odds with those forces that compelled celebrated flâneurs such as Walter Benjamin, Franz Hessel, and Siegfried Kracauer to stroll the avenues of the modern city. The windows of subway transport reminded the traveler of that which was buried behind Weimar's gleaming displays and surface values. Refracting the real, they confronted modern consumers with precisely what they were most eager to forget, repress, or toss out as unassimilable.

The Sound of Silence

Paris, September 1911. Though not a great fan of railway travel, Franz Kafka discovers unexpected pleasures when using the Paris Métro on a Sunday afternoon. In the absence of the rush hour's normal frenzy, Kafka realizes the extent to which even a noisy subway can open a space where strangers can enjoy silence, a sense of being next to but not together with others: "The Métro system does away with speech; you don't have to speak either when you pay or when you get in and out. Because it is so easy to understand, the Métro is a frail and hopeful stranger's best chance to think that he has quickly and correctly at the first attempt, penetrated the essence of Paris."[26]

Kafka's Métro makes strangers feel home because it sheds light on the inherent strangeness of all human existence. In contrast to the exoticist modern traveler, who travels abroad primarily to rejuvenate his or her sense of self, Kafka encounters the Paris subway as an alternate universe that reveals the alienated character of modern existence and, in so doing, eliminates the perpetual stranger's angst about being a stranger.[27] Rather than rejuvenate the self, the silence of subway travel illuminates what is strange and incommensurable about our modern sense of home. Liberated from language, the subway endows the traveler with the ability to explore the exotic qualities not of faraway countries but of what lies right beneath conventional notions of identity and subjectivity.

Kafka should have loved to ride the Berlin subway of the 1920s, for nothing must have been more difficult than to have a good conversation on its expanding lines. Ever-shifting noise levels and lateral seating arrangements forced passengers either to assume awkward body movements in order to address possible interlocutors or to behold of their own reflections in the opposing windows while speaking or listening. Both experiences encouraged forms of communication bordering the monological. Early subway riders had to learn how to talk without the reassuring force of direct eye contact in spite of the addressee's spatial proximity. From its very inception, subway language was one dominated by phatic speech acts, that is, linguistic phrases checking the proper workings and channels of communication itself.[28] It was one troubled by the possibility either that words may no longer arrive at the person spoken to or that we may catch sight of ourselves in the window as we drift through aimless and hence narcissistic soliloquies. Stripped down to linguistic essentials, operative subway language at heart has always included the toxic of antilanguage. It speaks in extremely short and curtailed sentences; it no longer ex-

pects or takes for granted meaningful responses; it disseminates words without knowing whether they really serve the intended purpose of communication. Kafka, therefore, had good reason to embrace speechlessness as the subway's most salient feature. Why talk in the first place if all talk here cannot but go astray? Why speak if every word and sound contains its own antithesis?

Unless, of course, one developed a new language whose grammar turned the perceptual templates of the underground into a source of effective self-expression and transmission itself. This, I suggest, was one of László Moholy-Nagy's intentions when drafting a unique film script—or "typophoto," in the artist's own lingo—in Berlin in 1921 and 1922, entitled "Dynamic of the Metropolis" and first published in the 1925 edition of *Painting, Photography, Film.*[29] Conceptually, Moholy-Nagy's work of the 1920s was dedicated to breaking away from the monofocal conventions of contemporary photography, its historical conformity with the rules of central perspective and temporal sequentiality. Photographic representation, according to Moholy-Nagy, should not mimic the putative laws or cultural formations of human vision, it should use the apparatical features of the camera, its ability to distort, foreshorten, and deform the visible field in order to supplement the work of the human eye and thereby produce unprecedented intellectual and affective experiences. Metropolitan life, for Moholy-Nagy, exposed the individual's perceptual organs to a hitherto unknown logic of simultaneity: multiple and unconnected things happen around us and enter our perception at one and the same time. Modern art's task, in turn, was to encode and enrich this experience of radical simultaneity, that is, to unfetter representation from the dominance of narrative teleology and temporal linearity. One of his proposals was to develop and make use of "cameras with systems of lenses and mirrors which can encompass the object from all sides at once."[30] Cameras such as these could capture multiple views of one and the same event; they would free artistic representation from the conventions and biological limitations of human looking. Their point, however, was not to improve what theorists and practitioners of cinema in the course of the 1920s hailed as the principles of montage aesthetic. The *telos* of Moholy-Nagy's visions was not to assemble ruptured impressions and shocklike visual fragments over time but on the contrary to spread out disparate visual elements within and across the frame of one and the same image. The split screens, windowed designs, and cluttered insert shots of our own contemporary cinema of simultaneity, not the shattered and disjunctive flow of Eisenstein's montage aesthetic, was the unspoken aim of Moholy-Nagy's initiatives. Neither the perceptual adjustments of train travelers nor those of urban

flâneurs served Moholy-Nagy as a model of representation and self-expression, but rather—I suggest—the fractured and unsteady gaze of the subway traveler, a gaze perceiving the world polyfocally through different frames of reference at once.

In his preface to the printed script of "Dynamic of the Metropolis"—the film itself was never shot—Moholy-Nagy presents his project as an assault on existing beliefs in temporal continuity and logical order: "Individual parts which do not 'logically' belong together are combined either optically, e.g., by interpenetration or by placing the individual images in horizontal or vertical strips (so as to make them similar to one another), by a diaphragm (e.g., by shutting off one image with an iris-diaphragm and bringing o the next from a similar iris-diaphragm) or by making otherwise different objects move in unison, or by associative connection."[31] The seven script pages that map out the project closely follow this intention. Black lines and edges divide each page into a multiplicity of smaller fields and disparate frames, filled with photographs, captions, individual words, signs and symbols, numbers, and typographical word poetry. The word *tempo* appears in one form or another on nearly every page, once for instance in a vertical arrangement, ripped asunder into "Tempo-o-po-o-o," and once as a product of a curious process of linguistic doubling or unfolding. The sheer shape and tangible materiality of word and letter here become tools of signification. Rather than arrange impressions, images, and scenes in a temporal sequence, Moholy-Nagy's use of iconic language—in unison with his use of multiple windows of attention on a single page—privileges synchronic over diachronic dimensions, simultaneity over linear progression, information density over sequential order. Language here assumes the task of relating events, neither in the conventional form of cause-and-effect chains nor the modernist one of shocking jump cuts and temporal ruptures but across noncontiguous fields and parallel frames of visibility.

Witness the grouping of images, signs, words, and inscriptions on page 3 of the script. The page is dissected into thirteen white rectangular panels of different sizes and shapes. Three of these windows are occupied by the word *tempo*; three others are completely blank. The uppermost field on the left presents an aerial photograph of a round square with eight streets opening into it, the caption on the top explaining what we see. In the stretched-out middle field, which divides the page into two unbalanced halves, we find a graphical image of a cogwheel next to a text describing urban traffic as a vertiginous dynamic: "The vehicles: electric trams, cars, lorries, bicycles, cabs, bus, cyklonette, motor-cycles travel in quick time from the central point outwards, then

all at once they change direction; they meet at the centre. The centre opens, they ALL sink deep, deep, deep."[32] Shot from a low angle, the photograph of a towering wireless mast attracts our attention in the leftmost window at the bottom, situated next to a field in which the image of a downward arrow asks the viewer for opposite eye movements. Texts of different size and typography occupy some of the remaining sub-frames. One instructs the cinematographer to tilt the camera swiftly toward the ground so as to create a visceral sense of plunging downwards. A second text describes the world beneath the trams, the underground of the sewers with dim light reflecting in the water. And in a third frame, we simply read: "Underground railway. Cables. Canals."

In this particular segment of Moholy-Nagy's film script, the subway operates like a giant vortex, consuming not only the tempo and perceptions of metropolitan street life but also the work of representation itself. Underground space-time, as depicted on this page, catalyzes an acute division and multiplication of the visual field; it stimulates an excess of vertical and horizontal framing that finds no parallel on any other page of the script. In Moholy-Nagy's realm of the subway, what we experience is a profound fracturing of the visible, a proliferation of competing windows of reference and perception that—note the empty panels on the lower third of the page—displace the frenzy of signs, activities, stimulations, and distractions above ground. And yet, though seemingly all movements presented on this page—transitions from light to dark, day to night, aerial mastery to subterranean enclosure—point toward the vortex of the subway, we should not think of this trajectory as one plotted along the lines of a teleological narrative. Nor are we justified to understand the story sketched out here merely as a narrative energized by modernist impulses to rupture the linear flow of time in the hope of shocking the viewer with sudden changes and hence—in Benjamin's famous words—turning modern art, as the Dadaists did, into an "instrument of ballistics."[33] To read this page like a cartoon or a conventional storyboard misses the point. What is challenging about Moholy-Nagy's script is that we are asked to look at various fields and frames of references at once, to refocus our eyes and minds constantly without finding any point of rest or closure, to immerse ourselves simultaneously into competing temporalities and parallel logics of communication. What, in other words, makes this page shocking is that it describes forms of experience for which the modernist category of shock—modernism's emphasis on radical suddenness and discontinuous temporal change—no longer seems of central importance.

Low aerial photograph over a square with

8

streets opening into it.

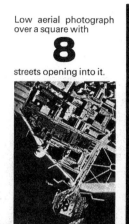

TEMPO-o-

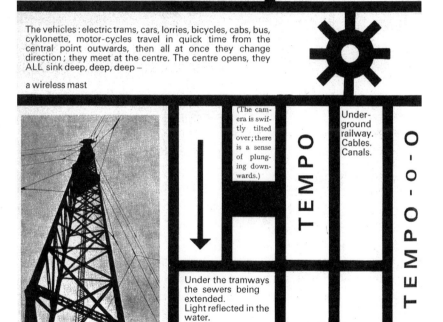

The vehicles : electric trams, cars, lorries, bicycles, cabs, bus, cyklonette, motor-cycles travel in quick time from the central point outwards, then all at once they change direction; they meet at the centre. The centre opens, they ALL sink deep, deep, deep –

a wireless mast

(The camera is swiftly tilted over; there is a sense of plunging downwards.)

Under-ground railway. Cables. Canals.

TEMPO

TEMPO-o-o

TEMPO

Under the tramways the sewers being extended. Light reflected in the water.

László Moholy-Nagy, *Dynamic of the Metropolis* (1921/22). © 2006 Artists Rights Society (ARS), New York / VG Bild-Kunst, Bonn.

Lev Manovich has suggested the terms *spatial narrative* and *spatial montage* in order to theorize the multiplicity of pictorial spaces and visual layers in Dziga Vertov's films of the 1920s as much as in computer art today. Manovich's terms prove useful also in understanding the compositional principles of Moholy-Nagy's film script. According to Manovich, in spatial narratives, different shots and discontinuous points of view are accessible to viewers at one and the same time; in spatial montage, the classical logic of temporal replacement and succession gives way to a logic of addition, supplementariness, and coexistence: "In spatial montage, nothing is potentially forgotten, nothing is erased. Just as we use computers to accumulate endless texts, messages, notes, and data, and just as a person, going through life, accumulates more and more memories, with the past slowly acquiring more weight than the future, spatial montage can accumulate events and images as it progresses through its narrative. In contrast to the cinema's screen, which primarily functions as a record of perception, here the computer screen functions as a record of memory."[34] Spatial narrative already played an important role in Giotto's frescos and in Bruegel's attempts at representing various micro-narratives within one and the same painting. It became marginalized, however, with the rise of the Enlightenment and the human sciences, on the one hand, and the industrialization of time during the nineteenth century, on the other. The institutionalization of narrative cinema in the first decades of the twentieth century was a major addition to the truncated understanding of narrative forms in primarily temporal and sequential terms. The dawn of digital culture in the last decades of the twentieth century, according to Manovich, has galvanized a powerful comeback of spatial narratives and the possibilities of spatial montage. It also allows us to reexperience and rethink the range of modern narrativity beyond, but also within, the cinema.

What we witness in Moholy-Nagy's film script of the early 1920s, I suggest, is the reinvention of spatial narrative and montage out of the spirit of subway travel. Boldly anticipating the windowed computer interface of our own times, "Dynamic of the Metropolis" adopts a polyfocal mode of representation whose daring hybridization of word and image seems ideally suited for subway passengers. Moholy-Nagy's new language is at once minimalist and multivalent; it makes room for experiences of radical simultaneity while at the same time liberating memory from the modernist obsession with time, progress, and the future. That Moholy-Nagy's film was never shot no doubt resulted from a shortage of funds (and experimental sensibilities) around 1922. Technological limitations clearly played a role as well, for Moholy-Nagy's script demanded

innovative methods of cinematic recording and exhibition in order to display the city as a site of unbound simultaneity. And yet, we would be wrong to consider Moholy-Nagy's project as untimely, as an oddball among the modernist initiatives of its time. To be sure, unlike many of his contemporary colleagues, Moholy-Nagy's script no longer sought to link the formal language and perceptual effects of twentieth-century cinema to what earlier generations of viewers had experienced when traveling by train through seemingly pristine countrysides. Though the perception of speed and the acceleration of visual perception in modernity remained essential to Moholy-Nagy's work, his aim was not to celebrate the curious romance between train windows and film projectors as a foundational myth of cinematic representation. Instead, Moholy-Nagy's project is about turning cinema into a training ground for those unwilling to accept the train traveler's panoramic, distracted, and despatialized mode of looking as the singular regime of modern visuality. "Dynamic of the Metropolis" embraces the subway's framing of sight so as to explore historical alternatives to the dominant narrative of visual modernization. In so doing, the script develops a language and grammar that could have helped contemporary subway passengers such as Tucholsky and Kafka to have a good conversation aboard after all.

Beyond the Uncanny?

In 1886, Austrian philosopher and psychologist Ernst Mach was struck by the strangeness of his own image as seen in the window of a bus. In his seminal essay "The Uncanny," Sigmund Freud recounted this episode in 1919 and added a version of his own:

> I was sitting alone in my *wagon-lit* compartment when a more than usually violent jolt of the train swung back the door of the adjoining washing cabinet, and an elderly gentleman in a dressing-gown and a traveling cap came in. I assumed that in leaving the washing-cabinet, which lay between the two compartments, he had taken the wrong direction and come into my own compartment by mistake. Jumping up with the intention of putting him right, I at once realized to my dismay that the intruder was nothing but my own reflection in the looking-glass on the open door. I can still recollect that I thoroughly disliked his appearance. Instead, therefore, of being frightened by our "doubles," both Mach and I simply failed to recognize them as such. Is it not possible, though, that our dislike of them was a vestigial trace of the archaic reaction which feels the "double" to be something uncanny?[35]

In Freud, uncanny experiences bring something to light that should have remained hidden. They reveal the extent to which our life is secretly structured by competing times and multiple temporalities, by repressed memories and desires that keep us from ever fully arriving in the present. For the bourgeois traveler Freud, safely situated in the cushy interior of a train car, the uncanny encounter with his own double comes in form of a sudden shock of recognition; the "archaic" shatters this private compartment like a rock unexpectedly smashing a window pane.

As they advanced to become one of the most effective components of metropolitan mass transit in the course of the 1920s, Berlin subway cars no longer granted what Freud experienced as his initial sense of comfort, privacy, and protection. Encounters with one's own reflection in the mirror of the compartment window or door, rather than triggering extraordinary jolts of (mis)recognition, instead became part of the order of the day. To take a ride on the subway was to situate oneself calmly and unromantically in the ubiquitous presence of the uncanny, that is to say, of that which denies the subject ever to achieve fulfilled self-presence in the first place. Subway windows displayed disparate temporal experiences—the archaic and the modern, the repressed and the obvious—within one and the same frame of perception, not as something pregnant with dialectical energies, but on the contrary as something confirming what modern urbanites know all along, namely, that they are far from being masters in their own houses.

Did subways, then, necessarily transport their users into realms not only beyond time and history but also beyond hope for transformative intervention? Did their windows, understood as screens featuring the simultaneous co-presence of the dissimilar, renounce people's desire to determine their own lives—to become autonomous subjects and accountable beings—altogether? Did underground travel, in rendering encounters with the uncanny as the norm of daily experience, dissolve the very possibility of both moral action and political agency? And did travelers, thus, when dully looking at the window's reflection, witness nothing other but the death of the Enlightenment and its various utopias of individual and collective emancipation?

We will certainly come to this conclusion if we read between the lines of Alfred Döblin's 1929 *Berlin Alexanderplatz,* a novel whose atmosphere and textual dynamic is unthinkable without the massive reconstruction of the subway station below Berlin's Alexanderplatz during the late 1920s.[36] To be sure, not once throughout the novel do we follow Döblin's hero, Franz Biberkopf, into the underground's darkness, let alone witness him riding a subway train so as

to follow his ill-fated pursuits. Though the pounding of subway construction permeates almost every page of *Berlin Alexanderplatz*—"Bang, bang the steam pile-driver hits on Alexanderplatz. Many people have time to watch how the pile-driver hits."—and though we often find Biberkopf maneuvering his path across and along torn up segments of the square, the novel situates the reader and its protagonist literally and metaphorically at the threshold of the underground.[37] And yet there are good reasons to think of Franz Biberkopf's dilemmas as dilemmas symptomatic for modern subway subjects experiencing the uncanny as the norm of urban existence. Biberkopf's inability to lead a good life, to manage his self-destructive desires and stay away from trouble, has less to do with the dynamic of his class position, his economic struggles, and his subsequent solitude than with the way in which the city's panoply of signs, texts, and visual allures—the experience of unbound simultaneity—produces a new kind of subject devoid of bourgeois categories of individual sovereignty and self-determination. Biberkopf doesn't speak for himself, he is being spoken. He doesn't cross the intersections of modern Berlin life, he himself serves as an intersection of incommensurable discourses and multiple experiences of modernization. Biberkopf's prosthetic arm at once allegorizes and masks the extent to which his entire body and identity are prostheses, that is to say, sites of physiological—albeit self-destructive—adaptation to the abstract rhythms, the floating symbolic order and imaginary, of the metropolis. A man haunted by the past, Biberkopf does not simply fail to structure his own present, he never arrives at its doors in the first place. Like subway passengers seeing their own reflection in the windows of the car, Biberkopf witnesses his own life as something strange, other, and uncanny. A postbourgeois subject *par excellence*, he is a testament to what happens if modern society runs out of emancipatory visions and transformative energies. Unable to achieve any sense of collective belonging or moral autonomy, Döblin's Biberkopf seems a perfect candidate to join the lonely crowds and disenchanted spectators crisscrossing Berlin's underground circa 1929. Like them, he encounters the city's accelerated dynamic as one without progress and direction while experiencing the temporality of his own life as one without narrative and selfhood, as one populated by the ghosts of archaic pasts who seem to crush all our hopes for a better, or at least different, future.

But then again, let us notice that in the critical imagination of the late Weimar Republic, it was not the itinerary of every unsettled postbourgeois subway traveler that was seen as a path to nowhere. In doing away with nineteenth-century concepts of sovereign individualism and self-identity, the un-

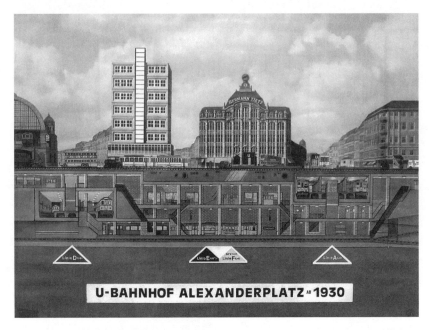

Cross Section of Alexanderplatz station, 1930. Printed by permission of U-Bahn-Museum Berlin, Germany. Photo: Lutz Koepnick.

canny and fractured space of the subway—for some—could just as well open a gate for new experiences of collectivity and solidarity. However odd they may seem at first, the famous last scenes of Slatan Dudow's 1932 film *Kuhle Wampe oder wem gehört die Welt* use first the lit interior of a Berlin rail car and then in the very last shot the dark tunnel of a local mass transport station in order to provide the viewer with a captivating preview of coming attractions: the triumphs of proletarian unity over bourgeois individualism and self-interest. And in 1935, Bertolt Brecht—who had played a significant role in the making of *Kuhle Wampe*—did not hesitate to hail the opening of Stalin's pet project, the Moscow underground, as a mass spectacle of socialist self-creation and self-representation. In Brecht's poem "Inbesitznahme der großen Metro durch die Moskauer Arbeiterschaft am 27. April 1935" (Appropriation of the great metro through the workers of Moscow on 27 April 1935), the operatic setting of the new Moscow subway becomes a site at which the proletarian masses can consume their own work as a nonalienated expression of unselfish collectivity, resting from all the work they have done and, as the putative subject-object of the historical project, seeing their own creation as something good. In the con-

text of what Brecht describes as an extravagant festival of collective self-constitution and self-mirroring, the aesthetic and the political join hand in hand. To see the product of collective work underground is not only to vindicate but to find pleasure in the demiurgic powers of socialist collectivity:

> Thousands were there, walking around
> To see the gigantic halls, and in the trains
> Immense masses drove by, the faces—
> Men, women and children, even old folks—
> Turned toward the stations, illuminated as if in the theater, for the stations
> Had all been built differently, from different stones
> In different architectural styles, even the light
> Came from ever-different sources. Whoever entered the cars
> Was pushed into the back of the merry crowd
> Since the front seats were the best to
> Take sight of the stations. At every station
> Children were lifted up. As often as possible
> Passengers dashed out and beheld
> With merry severity that which had been created.[38]

In Brecht's poem, of which this is only a short quotation, nothing is left of Ringelnatz's sarcasm, Tucholsky's urban melancholy, Moholy-Nagy's formalist sensibilities, and Döblin's covert moralism. Brecht's subway is no longer a space of bourgeois angst, self-estrangement, displacement, exile, and emotional fortification but one of postbourgeois elation and collective scopophilia. It is as exhilarated subway travelers that Brecht's Moscow masses constitute themselves as masses and shatter the windows of bourgeois individualism. Though the crowds experience the Moscow subway's grandiose halls and platforms as theatrical spaces of the first order, they know of no boundary between stage and auditorium, actor and spectator, image and reality. Unalienated producers of their own lives and times, Brecht's proletarian masses have moved beyond the frames of mediation that characterize bourgeois theater and culture, while the work of perception and the perception of work have become one and the same.

> Every face
> Was completely visible, for there was a lot of light from
> Lots of lamps, more than in any other railway I have seen.
> Even the tunnels were illuminated, no meter of work
> Was left in the dark.[39]

Brightly lit, Brecht's 1935 subway invites the crowds to revel in ecstatic feelings of self-presence and plenitude. No specters of the past here haunt the present

and future; proletarian solidarity has seemingly moved the individual through the uncanny beyond it. Amid all this illumination, Brecht's subway travelers no longer have to dream of the pleasures of dreaming. No one is caught with fogged-up eyes desiring the return of desire. And no one is troubled by the mysterious work of the unconscious, the repressed, the other.

We may be rightly suspicious about the ideological index of Brecht's vision. As importantly, though, we must question whether this utopian space of radical transparency, self-reflectiveness, and illumination, of unmediated and windowless self-presence, is worth living in the first place. For what is life without dreaming and desiring, without encountering the incommensurable and non-identical? How can we really exist under the sign of total visibility, surrounded solely by our own work and self-expression? How can we live without the underground's darkness?

Brecht's poem wants to bring paradise down to earth in the form of a luminary spectacle. Yet in thus celebrating the powers of presence and collective being, Brecht excises the memory of what continuously, and simultaneously, decenters and drives being forward in the first place: the nonbeing of death, the inevitability of ultimate failure. Celebrating proletarian solidarity as a triumph over the darkness of the uncanny, Brecht's text removes the possibility of death from the picture in order to entertain the poem's utopian fantasy. The certainty of death is what must remain outside of the crowd's frames of perception so as to warrant the dream of dreamless immediacy and liberate life from the frames of the bourgeois order. Ironically, then, death has to be left in the dark so that the community can live and enjoy its luminous being. It is to how Nazi Germany sought, in its own very different way, to remove the windows of bourgeois culture and wed fantasies of radical transparency and exposure, of frameless perception and immortal self-presence, to the agendas of totalitarian politics that we turn in the next chapter.

5 | *Windows 33/45*

In the early evening hours of January 30, 1933, Adolf Hitler appeared at the window of his new office to present himself to a chanting crowd gathered in front of the Berlin Chancellery at Wilhelmstraße 78. Located on the second floor, the chancellor's office had three windows, all overlooking Wilhelmplatz. It occupied a modern section of the Chancellery that had been completed only three years earlier under the direction of Eduard Jobst Siedler und Robert Kisch. The functionalism of Siedler and Kisch's annex had caused considerable outrage among those eager to preserve the neoclassicist milieu of Wilhelmplatz. For Hitler, however, during the first hours, days, and months of his chancellorship, the new annex produced concerns of a very different sort. Not only did it become usual for crowds to gather under the new German chancellor's office window, demanding to see the Führer and making it impossible for Hitler to work inside. The huge, albeit plain, windows of his office also turned out to be inappropriate for the purpose of staging Hitler's visual appearance. Siedler and Kisch's window design forced Hitler to assume awkward postures to enjoy public visibility. In fact, rather than displaying the Führer as a powerful attraction, the frame of the office window dwarfed the Führer's body and thereby undermined spectacular self-presentation. Hitler's first public appearance in the role as Reich chancellor thus offered a mixed blessing. "The window was really too inconvenient," Hitler remarked later to his master architect Albert Speer. "I could not be seen from all sides. After all, I could not very well lean out."[1]

A man of extreme obsessions and unsteady emotions, the new Reich chan-

cellor set out to have the problem fixed immediately. Because the old office windows, on the one hand, allowed for too much contact and transparency and hence undermined the Führer's desire for control and privacy, Hitler quickly moved his office to the back of the building. Rather than overlooking the noisy throngs at Wilhelmplatz, the windows of his new office now opened to the building's quiet garden. On the other hand, because Siedler and Kisch's design failed to display Hitler as an object of theatrical to-be-looked-at-ness, Hitler had Speer add a new "historic balcony" to the façade at Wilhelmplatz. Siedler protested this new addition, claiming that Speer's balcony would violate the building's aesthetic integrity. Hitler, however, resolutely dismissed these objections: "Siedler has spoiled the whole of Wilhelmplatz. Why, that building looks like the headquarters of a soap company, not the center of the Reich. What does he think? That I'll let him build the balcony too?"[2] When it came to matters of stage-managing the Führer's public appearance, no chances were to be taken. By 1935, Hitler had it both: a historic balcony, which instead of framing his appearance showcased the Führer as a sight of extraordinary meaning, and a secluded office, which allowed him to contemplate strategy and execute the mundane aspects of political leadership. Speer's later design for the New Reich Chancellery (which opened in January 1939) and the megalomaniac blueprints for the Chancellery of Germania (to be opened in 1950) fed even more Hitler's desire for separating the interior and exterior spaces of power. Both effectively secluded Hitler's office from the unruly commotion of Berlin street life, while both elevated the building's balcony to ever more majestic heights so as to increase the Führer's visibility when he would step outside and present himself like a modern media star to the gaze of the masses.

It is well known that windows have played important roles in democratic as well as nondemocratic politics in order to display power, legitimate authority, and broadcast political change. Think of the infamous Defenestration of Prague of May 23, 1618, symbolizing a political coup that helped trigger the Thirty Years' War in Europe. Think of German Social Democrat Philipp Scheidemann using a window of the Berlin Reichstag on November 9, 1918, as a setting to proclaim the first German Republic. Contrary to what we may expect at first, however, Hitler's relationship to windows was deeply ambivalent, to say the least. As a site of staging power, windows—in Hitler's understanding—limited perspective and excluded a multiplicity of possible viewing positions. Their frames drew too much awareness to themselves, thwarting any sense of immediacy and authenticity. They opened views on Hitler that exhibited the spectacle as spectacle and hence potentially undermined Hitler's

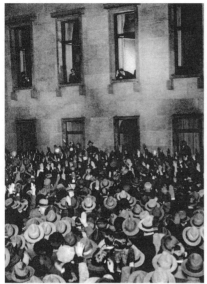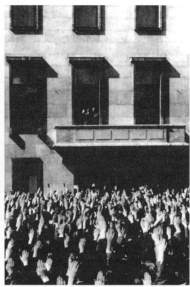

Hitler on the evening of January 30, 1933, at the window of the Reich Chancellery, and on Speer's historic balcony in 1935. Printed by permission of Sammlung Rudolf Herz, Munich, Germany (*left image*) and Bibliothek für Zeitgeschichte, Stuttgart, Germany (*right image*).

self-effacing myth as a charismatic leader. According to Hitler, window frames, rather than presenting him as a breathtaking attraction, catered to the masses' desire to get ahold of their new Führer in the form of an image—a desire that unwittingly consumed what it yearned for, namely the redemptive presence of distance and charisma. In privileging open balconies over framed windows as the most appropriate stages of Nazi leadership, Hitler hoped to show himself as a sight that exceeded the defining power of any ordinary frame, as a view whose aura captured minds and coordinated attention without the help of external framing devices, as a self-sufficient window that brought into view nothing but himself.

Nazi politics aspired to recenter a differentiated modern state and culturally diverse society by giving political operations the outlook of dynamic, heroic, and unified action. It relied on well-designed images of charismatic leadership and extraordinary willpower, on aesthetic identification and corporeal pleasure, in order to bond the body politic and remove any trace of otherness.[3] At once mad about and made by movies, Third Reich politics drew heavily on

the tools and cultural practices of industrial mass culture—photography, radio, and particularly film—in order to inflate leadership with a synthetic aura. This chapter recalls how Nazi film and photography showed Adolf Hitler at a variety of window settings so as to frame attention and refashion his public appearance. How did Nazi representations of Hitler at the window, I ask, organize political loyalty via the protocols of a modern consumer society? To what extent did Hitler, in presenting himself as a fenestral spectacle, emulate the codes of media stardom as developed in 1930s German sound cinema? And finally, to what extent was it possible under the conditions of Nazi culture to develop counter-images that contested the dominant framing of audiovisual attention, emphasized the mediated character of modern perception, and hence challenged the myth of authenticity so central to the cult of both Nazi power and film stardom?

"We want to see our Führer"

Hitler's ambivalence about window frames recalls what Wilhelminian critics—as we saw in chapter 3—had feared most about industrial mass culture: that the proliferation of two-dimensional images would inevitably flatten the ruler's aura. Given this unease, we cannot but be surprised to notice that window frames play such a prominent role in the opening sequence of the most notorious of all Nazi self-promotions, Leni Riefenstahl's 1935 *Triumph of the Will*. The first sequence of Riefenstahl's film not only—famously—opens with sublime views on Nuremberg as cast through the windshields of Hitler's airplane, but it also ends with Hitler confidently displaying himself at the window of his Nuremberg Hotel. Why did Riefenstahl decide to place multiple frames around the Führer's appearance? And why did Hitler, whose participation in the staging, shooting, and editing of the project is well documented, allow Riefenstahl to do what had caused him to reject Siedler and Kisch's Chancellery only a few months earlier, namely present power as a fenestral spectacle?

At first sight, one might be tempted to read the opening sequence of Riefenstahl's film simply as an attempt to reinscribe Christian symbolism with the help of mechanical reproduction. Whereas the airplane shots at the beginning introduce Hitler as the Messiah, whose divine gaze awakens the city to life and order, Riefenstahl's images of the hotel window recall the early Christian metaphor of the *fenestra caeli*, the "window of heaven" through which one could behold the light of the savior. And indeed, as shown from the ever-shifting

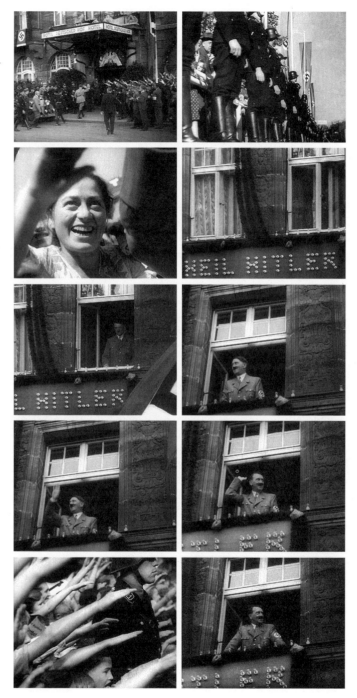

Leni Riefenstahl, *Triumph of the Will* (1935): Hitler at the window of his Nuremberg Hotel.

points of view and focal distances, the crowds outside of Hitler's hotel seem to hail the appearance of the Führer at the window as if expecting immediate entry into paradise—as if the Führer's divine presence could redeem them from the earthly burdens of history, mortality, and subjugation.

But let's be more precise, for much more is at stake in the first seven minutes of Riefenstahl's film. In his seminal essay on *Triumph of the Will*, Steve Neale has argued that the opening sequence is centrally concerned with the activity of looking itself, with defining a complex relay of looks and anchoring it in Hitler's presence (and occasional absence). According to Neale, the first sequence of *Triumph of the Will* aspires to ground the political relationship between Hitler and the crowd in an asymmetrical system of looking: "Hitler's status *in the film* derives from, and is motivated and signalled by, the fact that he is structured and marked as the privileged object of the gaze, that he himself is the ultimately significant spectacle—for the crowds *in* the film and for the spectators *of* the film."[4] We experience Hitler looking at city and people from above. We see ecstatic individuals looking at Hitler. We see Hitler seemingly directing the look of cats and even inanimate statues. We see his Mercedes passing through areas of light and shadow that seem to allegorize the work of cinematic recording and projection. Furthermore, our scopic drive is lured, entertained, and overwhelmed by the rhythm of Riefenstahl's editing, the dynamic way in which her film in this first sequence oscillates between closeups and long shots, point of view and reaction shots, images of movement and scenes of stasis, tableaux of looking and of display. Though clearly not designed as a narrative feature film, *Triumph of the Will* here seems to engage the viewer's attention according to the codes of classical narrative cinema. It inscribes the spectator as a looking subject in the diegesis itself—a diegesis that hinges on an energetic, "invisible," and carefully choreographed interplay of presence and absence, lack and fulfillment. And what we get at the end of this first sequence is the culminating view of Hitler at the hotel window, first looking to the right, then to the left. Acknowledging the look of the frenzied crowd. Returning the gaze, as it were. His arms outstretched, his face indicating a state near reverie itself. Finally, in the last shot of this sequence, according to Neale, Hitler in fact seems "to turn his head not in order to look at something specific, but in order that the gaze itself can be properly and fully looked at, undisturbed by any possibility of its being caught within a specific action or event, which would direct our attention and our gaze away, or absorb it into a function conflicting with the one that it in fact performs, soliciting the look of the spectating subject."[5]

Neale's discussion of how Riefenstahl installs spectacle and looking as central principles of the film's textual operations is incisive indeed. In line with most postwar scholarship, Neale understands the political aesthetic of Nazi Germany mostly in terms of a shrewd colonization of the visual; he conceptualizes Nazi film and visual culture as a laboratory of primal effects silencing spectators with spellbinding images. What Neale, however, seems to overlook—or shall I say over-hear?—is the peculiar role of sound in organizing the political as a homogeneous space of spectacle and mass consumption. I am not thinking so much of Herbert Windt's pseudo-Wagnerian soundtrack submerging the viewer in a flow of majestic melodies. Rather, what is more interesting is the diegetic inscription of sound at precisely the moment when Hitler is about to open the hotel's window and present himself to the masses. For the function of sound at this moment is nothing less than, by providing spatial depth, to expand the image from two to three dimensions, to convert—as it were—the window into a balcony and hence alleviate possible unease about the scene's setting.

As always in Riefenstahl's work, the sequencing of images and sounds is of extreme importance. We start with a low-angle medium long shot. It depicts Nazi soldiers in black uniform, neatly lined up. We cut to two consecutive long shots swerving over an ecstatic crowd first from the side and then from a more frontal perspective. Whereas in shot one Riefenstahl still offers us Windt's Wagnerian soundtrack, in shots two and three she changes to diegetic sound: a seemingly amorphous roar emanating from a multitude of voices. Next, we cut to two somewhat shaky medium shots of young male onlookers and then to a frontal closeup isolating a middle-aged woman's face from the crowd around her. It is precisely at this moment that the crowd's chaotic shouting unifies into an identifiable slogan: "We want to see our Führer." Next we cut to a long shot, marked according to the codes of classical narrative cinema as the woman's point of view. The camera smoothly veers over to a waving swastika flag in front of the hotel, briefly pauses on a sign installed underneath the window, and then focuses our attention onto the window itself as Hitler is about to open it. When Hitler finally appears, Riefenstahl quickly cuts back to the exuberant throng in front of the hotel. Now that the people's hopes and desires have been fulfilled, the crowd's voice disintegrates into a boisterous rave again. What we hear recalls nothing less than the auditory landscape of a soccer stadium or, for that matter, the sounds of movie fans celebrating their star on premiere night.

As with the image track, Riefenstahl's soundtrack at the end of the opening

sequence rhythmically progresses from far to near, from mass to individual, from the abstract to the particular, from the disembodied to the embodied—all to set the stage for Hitler's appearance. What remains fundamentally puzzling, though, is why Riefenstahl's camera so conspicuously displays the sign reading "Heil Hitler" under the hotel's window while we hear the crowd demanding the presence of the Führer. Made out of numerous electric bulbs, the writing on the sign clearly mimics light displays of the day. If this scene were shot at night, we would no doubt expect these two words to blink like a street ad for an urban cabaret show. Why, one cannot but wonder, do we hear *and* see the voice of the people when the camera shows us Hitler in the frame of the window? And doesn't this sign, in a way, recall a cue card whose presence should have been hidden in order to achieve the most sweeping impression of immediacy and spontaneity?

On the other hand, if the scene indeed mobilizes the codes of classical narrative cinema in order to display Hitler like a film star, why doesn't Hitler here do the kind of thing for which he was known best, namely to address the gathered masses as a skillful rhetorician? In classical cinema, the star's performance often interrupts narrative progress in favor of spectacular interludes whose purpose is to exhibit the star's peculiar features to the viewers' consuming perception. Whenever it functioned as a star vehicle, classical narrative cinema opened showcases in which the star could do his or her peculiar thing. Why, then, did Riefenstahl—whose impact on the general choreography of political rallies is well known—show us the passionate speaker Hitler as a silent consumer of the consumers' gazes? Why, in this first sequence, did she not allow any words to emanate from the frame, from the space of the hotel window?

Engineering Charisma

In order to answer these questions it is useful first to recall that Hitler started out his political career between 1919 and 1923 as a sly agitator whose primary tool and trademark was his voice, not his appearance. Eager to revive a nation that had lost face due to the Treaty of Versailles, the amateur artist and social dropout Hitler fashioned himself as the inner voice of the German conscience.[6] Hitler in fact employed his vocal abilities not only to stir emotions and capture minds but also to open a space of communal integration, of redemptive renewal. Acoustical properties—the rhythm of speech, the guttural registers of his vocal organ—were meant to carry individuals beyond themselves and fuse them with crowds of enchanted listeners. As the self-stylized

voice of the disenfranchised, Hitler at the same time largely rejected any attempt to circulate photographic portraits of him. According to Heinrich Hoffmann, later the official photographer of the Third Reich, in autumn of 1922 Hitler requested an enormous sum of money to have his picture taken and printed in national and international newspapers.[7] In May 1923, the magazine *Simplicissimus* published a satirical arrest warrant by Thomas Theodor Heine, asking "What does Hitler look like?" Heine's drawing presented a gallery of twelve widely different physiognomies, only to conclude that Hitler couldn't be depicted in the first place: "Hitler is not an individual. He is a condition. Only a futurist can represent him as an image."[8] Also in 1923, Hitler's movement distributed a postcard with the title "Hitler is Speaking!" which showed the interior of Circus Krone in Munich, dramatically lit and packed with hundreds of mostly male listeners directly facing the camera. Hitler's body, however, remains out of sight in this postcard, his voice ghostly present only in form of the inscription in the upper left corner and the devout faces of the crowd.

Hitler's image—according to the apparent rationale of Hitler's early campaign style—had to be protected from vulgar sight so as to warrant the Führer's most valuable property, the aura of his voice, understood as an acoustical window joining the masses and transporting them into the future. Hitler's early unease about the power of the visual, however, had nothing to do with some variant of iconophobia or fetishistic vocophilia, pathologies of the mind that have often been attributed to Hitler's personality and even to National Socialism in general. Instead, it simply reflected Hitler's strategic fear that photographic images, due to their base in mechanical reproduction and duplication, could dispel the magnetism he was eager to develop in his performances as a speaker. Although photographic images in later years would play an essential role in engineering the "Hitler myth," in the eyes of Hitler the "drummer"—the agitator of the early 1920s—circulating mass-produced images had the potential to thwart his self-invention as a charismatic leader and thus close, not open, the shutters toward the future.[9]

In his 1920 *Economy and Society,* Max Weber had defined charisma as a form of authority that would rely on the extraordinary, otherworldly, quasi-super-human qualities of the leader.[10] Charismatic leaders appeal to messianic expectations among their followers, and they defy any institutionalization of norms, legal precedents, and general procedures of decision-making. We do not need to think that Hitler read Weber's treatise, but it is Hitler's self-conception as a charismatic leader that explains much about his early evasion of visual media

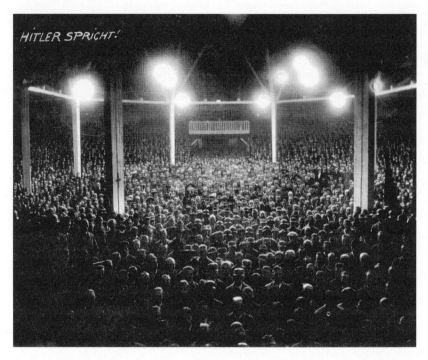

"Hitler is Speaking!" Propaganda postcard, photographed by Heinrich Hoffmann, 1923. Printed by permission of Sammlung Rudolf Herz, Munich, Germany.

and windows. Whether speaking without any technological aid in the early years, amplified through loudspeakers after 1926, or piped through the radio ever more profusely after 1930, Hitler exploited his voice in order to produce impressions of an extraordinary here and now, of an otherworldly intervention. Hitler's live sounds seemed to embody unbridled presence and authority. They accessed the deepest recesses of the listener's soul to shape emotions of charismatic redemption and new bonds of community. The photograph, by way of contrast, seemed to weaken Hitler's desire to establish new obligations. Photographs severed Hitler's image from his voice, his sights from his sounds. Unless they isolated him as a person of heroic vision and incessant resolution, they deflated the kind of otherworldly authority Hitler assumed when performing as a speaker in front of live audiences. Whereas the visible voice seemed to recuperate the virtues of the popular, of community and sensual immediacy, silent images were stained by the evils of modern mass culture, mechanical reproduction, and an abstract and alienated society.

In some sense, then, Hitler's early unease about photographic reproduction was fueled by the same impulse that caused him to disparage Siedler and Kisch's window design in 1933. Like the window of the Chancellery, photographic portraits put a limiting frame around his charismatic presence and thereby reduced his ability to control every aspect of his public reception. Photographic images, according to Susan Sontag, change according to the many contexts in which they can be seen, and "it is in this way that the presence and proliferation of all photographs contributes to the erosion of the very notion of meaning."[11] In the eyes of the early Hitler, the containment of the power of speech within the confines of a silent and still photograph enabled multiple and competing practices of reception and thereby undermined his ambition to reanchor the German nation in shared meanings and experiences. The frames of photographic images of Hitler as a speaker hid more from sight than they showed. The task of the visual, for the Hitler of the 1920s, was primarily to render his voice present and amplify the charisma of speech. Images somehow had to resound with his voice, had to carry acoustical properties, so as to avoid the ghostly and freakish and not deflate the Nazis' project of charismatic reawakening.

Hitler's early unease about photographic reproduction may surprise, given the extent to which we have come to think of Nazi rule after 1933 as the first full-fledged media dictatorship in world history. Nazi rule embraced modern technologies of dissemination and reproduction—radio, photography, and in particular film—in order to move the state beyond bourgeois-democratic codes of legality, morality, and political emancipation. Nazi Germany, in the realms of politics and entertainment, employed industrial mass culture so as to homogenize conflicting viewing positions and define people with different social, cultural, religious, and gender backgrounds as members of one and the same national audience. That Hitler in the 1930s, however, was ready to take the helm of such a highly modern media dictatorship had less to do with personal changes in strategy or attitude than with fundamental revolutions in the media landscape around 1930. In fact, Hitler's stance on the audiovisual, as compared to 1923, stayed very much the same. What changed instead between 1923 and 1933 was the technological world around Hitler: the kinds of interfaces that spread mediated images and sounds, transporting people's bodies to different spaces and times. What changed were the kinds of discourses that sought to define the proper relationship between the visual and the auditory, between body and voice, between the near and the far.

The crucial turning point for Nazi media politics was June 3, 1929, the day

the Gloria-Palast in Berlin showed the first film featuring synchronized sound in Germany. The coming of film sound, on the one hand, resulted in an unprecedented homogenization of former models of spectatorship as much as of the film industry's economic structure: "Silent film presentations had been notoriously variable. Works could be projected at different speeds, with operators advised in some manuals of their trade to vary the rhythm of projection within a given film. A single work could exist in different versions: black and white, or colored by one of several methods; long, short, or medium length; accompanied by a large orchestra using carefully planned cue sheets, or by a single drunken pianist."[12] Sound film streamlined the aleatory aspects of silent film presentation. It focused the viewer's perception onto the film itself and enforced spectatorial silence and passivity as middle-class standards of cultural respectability. Because sound film production required specialized equipment and vastly higher expenses, the coming of sound at the same time largely erased the possibility of a modernist counter-cinema of experimentation. Contrary to the silent era, individual artists could no longer afford to develop their projects in relative isolation and according to their personal visions.

On the other hand, the coming of synchronized sound allowed filmmakers to develop new ways of staging human bodies in diegetic space and of inscribing the audience's perspective in the film itself. Sound offered a new means of generating fantasies of wholeness and corporeal self-presence: "The addition of sound to cinema [introduced] the possibility of re-presenting a fuller (and organically unified) body, and of conforming the status of speech as an individual property right."[13] Once a number of technological difficulties had been overcome, sound became an important element to anchor the body in the space of the narrated world. It not only expanded a film's diegetic space and the camera's frame of perception, it also positioned the viewer as an "auditory subject" whose pleasure would be dedicated to illusions of oneness, of identity and meaning sustained by moving bodies situated in space.[14]

Nazi film officials and practitioners embraced synchronized sound as a highly welcome tool of fantasy production.[15] Although actual practice often contradicted theory, cinematic sound was seen as a viable means of disseminating the timbre of the German language and German musical traditions and, in doing so, to incorporate diverse viewers into the national community. But sound film, in the eyes of Nazi filmmakers and film theorists, not only increased cinema's mass-cultural reach and popularity. By fusing sight and sound, body and voice, music and dialogue, into dramatic unity, it also articulated within the bounds of industrial society Richard Wagner's idea of opera

as a *Gesamtkunstwerk*. No matter how modern and technological in origin, synchronized sound, in the perspective of Nazi film officials and practitioners, carried modern subjects beyond themselves and allowed them to recuperate the mythic. Like Wagner, Nazi filmmakers hoped to create audiovisual spectacles whose unified effects could forge contradictory experiences into fantasies of reconciliation. They endorsed synchronized sound around 1930 as a captivating window enabling empathetic identification and sensory immersion.

Which finally returns us to Riefenstahl's depiction of Hitler and the puzzling sign installed right underneath the window sill of his Nuremberg Hotel in 1934. Riefenstahl's window picture, I suggest, far from lacking control or being redundant or sloppy, presents a sophisticated attempt to re-auraticize film with the help of synchronized sound. In accord with the Wagnerian aspirations of Nazi film theory and practice, Riefenstahl here explores the possibilities of sound cinema in order to absorb the spectator into the film's image space and thus redefine mechanical reproduction as a site at which the Führer's charisma can come into being. As if trying to alleviate Hitler's earlier unease about the photographic image, the choreography of sights and sounds in Riefenstahl's window scene is intended to prove that industrial culture can transmit the extraordinariness of charismatic leadership after all. It seeks to produce its evidence through four different, albeit interrelated, strategies. First, Riefenstahl's film, with the help of an editing maneuver that recalls Eisenstein's principle of intellectual montage, transfigures Hitler's visual appearance as that of the voice of the people. The Führer doesn't do his thing here, namely speak, simply because Riefenstahl's shot identifies his body as already the incarnated voice of his subjects. Second, the window scene involves the viewer in an enchanting dialectic of the seen and the unseen, of the visual and the auditory, of onscreen and offscreen space. With the people's voice off-screen, Riefenstahl's window image dramatically expands the space in which cinema seeks to anchor its meanings and pleasures. It integrates diverse spaces into a higher synthesis, a cinema of total effects in which the whole counts more than whatever element we can see or hear in isolation. Third, in deliberately displaying the "Heil Hitler" sign underneath the hotel window, Riefenstahl's shot renders the sound of the crowd as image and thereby further resolves the kinds of concerns that once troubled Hitler. Rather than being singled out as a separated realm of representation, the visual here is shown as essentially driven by and connected to the verbal, as a register of perception and articulation grounded in the sonic. Fourth and finally, by framing Hitler as a living image within the film's frame itself, Riefenstahl's window sequence strives to emancipate the photographic

image from its precarious lack of inner movement, its unpredictable reception, and its potential erosion of meaning. The younger medium of film here, in Jay Bolter and Richard Gruisin's word, "remediates" the older medium of photography, not only to restore control over the process of reception, but to elevate both media to a higher level at which their sounds and images appear unmediated and industrial culture may thus produce auratic experiences and charismatic effects again.[16]

Speech as/into Image

It is useful at this point to compare Riefenstahl's framing of Hitler as the embodiment of the people's voice with the oratorical style and performance of Benito Mussolini. Like Hitler, Mussolini based his popularity on emotional appeals and direct communication. Though he considered prolix speeches as antithetical to fascist activism, his verbal presentations captured people's attention. More importantly, however, Mussolini used speeches in order to produce impressive imagery that could be circulated with the help of visual media: "His face was a spectacle in itself, appropriately coordinated with Mussolini's oratorical tone and body movements. His head leaned halfway back, his eyes almost out of their sockets, his chin and mouth forward, Mussolini underlined with his exaggerated facial expressions the word units he uttered. At the same time, by moving his head down and striking his classical posture of hands at the waist, waving his right hand with a rotary movement, Mussolini communicated hardness and firmness."[17] For Mussolini, speeches offered settings to increase and disseminate his charismatic sight. The primary task of his voice was to unfold the visual spectacle of his authority, which explains why Mussolini paid little attention to the propagandistic possibilities of radio.[18] Hitler, by way of contrast, understood public visibility as a medium to broadcast the magnetism of his voice. His sounds were inseparable from his image, which might explain why the Hitler regime in the second half of the 1930s did not pursue the development of German television because it shrunk sounds and images to an undesirable size.[19]

Riefenstahl's window scene staged Hitler's version of charismatic politics at its most effectual, defining sound film—a year prior to the experimental television broadcasts of 1936—as an audiovisual window projecting the Führer as an overwhelming presence. As importantly, however, Riefenstahl's window scene, in its peculiar integration of sound and image, of voice and body, of the written and the auditory, hoped to reinstate what neither photography

nor silent film in themselves, according to Hitler's early media politics, could accomplish. What triumphs here is not only the will of the Führer but also the Wagnerian medium of sound film over its technological predecessors. If mechanical reproduction before the advent of sound film seemed to dissolve charismatic presence, Riefenstahl's window sequence seeks to demonstrate that sound film is the most appropriate tool to restore phenomena of distance, no matter how close they are. Unlike photography, sound film frames and displays the Führer's body as unified, authentic, and self-present, even when we do not hear his most precious trademark, his voice. And unlike silent film, sound cinema allows for much more effective ways of framing and organizing the viewer's attention in the filmic text itself, of giving mediated effects the appearance of the elemental. In staging Hitler as a fenestral spectacle, Riefenstahl thus displays both Hitler and the medium film as spell-binding realities *sui generis*. The window scene engineers the phantasmagoric image of power as a self-contained and awe-inspiring being—as something that cannot be questioned; that emancipates the state from the modern heteronomy of economic, administrative, social, and cultural imperatives; that implements the autonomy of the political and thus fulfills the dreams of interwar intellectuals of the extreme right.

Star Gazing

Precisely by displaying Hitler in the frame of his Nuremberg Hotel, Riefenstahl achieved what Siedler and Kisch's window design failed to accomplish, namely to intensify Hitler's charismatic appearance in public. Unlike the architects of the Chancellery annex, Riefenstahl defined the window as a site of sacred revelation and mystical contact, a site at which Ernst Kantorowicz's famous distinction between the king's two bodies would collapse.[20] According to Kantorowicz, medieval and early-modern monarchy rested on the legal differentiation between the king's natural and hence mortal body and his mystical corpus, the body politic, which was not exposed to death. Individual rulers—so the tenor of absolutist monarchy—might die, but their sacred authority could not. In Riefenstahl's window picture, by contrast, the Führer's natural body and his body politic became one and the same. Riefenstahl presented Hitler *as* the voice of the people while at the same time anchoring the legitimacy of his regime in the aura of his corporeal presence. Riefenstahl's Hitler was the sacred essence of the new Germany. His natural body opened a window onto his body politic such that his political role could not be separated

from his extraordinary existence. No other natural body could ever substitute or succeed Hitler without damaging the national community.

It has become commonplace among scholars of Nazi culture to understand Riefenstahl's presentation of Hitler as one body, as The One's Body, in terms of how 1930s entertainment industries circulated charismatic star images. And indeed, throughout the 1930s the Nazi culture industry eagerly disseminated fan images and sounds of the Führer in private as much as public settings in order to build up the myth of Hitler as a man of resolution and compassion, of vision and strength, of common sense and extraordinariness, of sacrifice and indefatigable energy, of modern enthusiasm and traditionalist beliefs. Next to Riefenstahl's filmic presentation, Heinrich Hoffmann's photographic work played an essential role in molding Hitler into an iconic object of mass-cultural consumption. Hoffmann, whose photographic studio became a semi-industrial and monopolistic production site after 1933, had a symbiotic relationship to Hitler. His friendship with Hitler since the early 1920s allowed him to produce "Führer images" without bureaucratic arrangements or intricate formal preparations: "Hoffmann was intimately familiar with the peculiarities and insecurities of his model as well as his preferences for certain shots and motifs. He knew about the most advantageous shot angles and scenarios and he had internalized Hitler's visual imagination over the years."[21] Hoffmann's fan albums, such as *Deutschland erwacht* (1933). *Hitler wie ihn keiner kennt* (1932), *Jugend um Hitler* (1934), *Hitler in seinen Bergen* (1935), *Hitler abseits vom Alltag* (1937), *Hitler in seiner Heimat* (1938), and *Hitler baut Großdeutschland* (1938), reached printings of several hundred thousand. Like the star images of the classical Hollywood studio system, Hoffmann's Hitler embodied contradictory social values that in many senses were in crisis. Hitler's image brought with it the illusion of lived life that transcended notions of individuality as type or mere role play, and in doing so, like the Hollywood star performance in Richard Dyer's description, erased the "distinction between the actor's authenticity and the authentication of the character she or he is playing."[22]

It is certainly true that we cannot speak about National Socialism without speaking about how the Nazi state explored the whole spectrum of modern mass culture to captivate minds and bond emotions. Contrary to the regime's credo of political mobilization and coordination, the Third Reich was quite eager to offer middle-class diversions and Hollywood-style entertainments, including the promotion of ideology and political action as desirable consumer items.[23] And yet, in spite of the omnipresence of modern consumer practices in particular during the mid- and late 1930s, we would do well not to blur fun-

damental differences between the marketing of Coca-Cola, Mercedes Benz, or the sights and sounds of, say, UFA star Zarah Leander on the one hand, and the promotion and consumption of Hitler and his charisma on the other. While the regime was willing to make some allowance for the hedonistic fantasies and material pleasures associated with modern consumption-oriented societies, it clearly feared that consumption's appeal to the senses, in the arena of political representation, could become a source of unwanted individual self-redress and political nonconformity. Modern consumer culture might have been inevitable, but it needed to be framed by normative discourses and political interventions in order to secure its proper workings. It is in Riefenstahl's use of window settings, I suggest, that these striking ambivalences of Nazi consumer politics and its cult of stars become clearest.

In the mid-1930s, after a slump in box-office returns and popular appeal, the German film industry made a concerted effort to build up a Hollywood-like star system of its own. Nazi film stars such as Zarah Leander, Lilian Harvey, Willy Fritsch, Hans Albers, and Heinz Rühmann proved highly instrumental in transforming the products of Goebbels's film studios into mass-cultural product packages. Though influential Nazi film critics such as Oskar Kalbus and Fritz Hippler expressed some concern about the hedonistic attitudes associated with film stardom, Nazi film stars were essential in redefining film spectatorship in the middle-class terms of privatized consumption and individual self-formation.[24] Interwar ideologues of the extreme right may have rejected the individual's physical needs and desires, privileging sacrifice over the allure of happiness, discipline over spontaneity, sacrifice over individualism, the metallized over the impulsive body.[25] Nazi film star images, however, seemed to encourage fantasies of personal self-transformation and social mobility that, to some degree, challenged received notions of individual sovereignty, identity, and authority. They were designed to empower individual spectators to flirt with temporary losses and mimetic transgressions of their ordinary selves. Like the Hollywood star cult of the Depression era, the Nazi star system of the mid-1930s invited viewers to remake their own identities in likeness of the sights and sounds presented on screen. Rather than denying the spectator's body as a site of private pleasure and imaginary redress, the Nazi film industry also, to some extent, promoted—as Andrea Weiss has noted in a different context—"the idea that different roles and styles could be adopted by spectators as well as by actors and actresses, and could signal changeable personalities, multiple identities."[26]

Riefenstahl's *Triumph of the Will* swept through German cinemas shortly

before the film industry of the Third Reich launched broader efforts to emulate the Hollywood star system. As I have argued in the previous section, the window scene at the end of the first sequence in particular seemed to employ the codes of narrative cinema in order to define Hitler's relationship to the crowd on and in front of the screen as one similar to that of a film star to his fan community. It identified modern consumer practices as a highly effective, and perhaps inevitable, resource of modern political legitimation. And yet, are we really justified in understanding Riefenstahl's presentation of Hitler as a Hollywoodization of German politics? Did Riefenstahl really do to Hitler what Detlef Sierk did to Leander, Paul Martin to Harvey, Herbert Selpin to Albers, or E. W. Emo to Rühmann?

Riefenstahl's *Triumph of the Will* begins with a famous shot straight through the windshield of a Junkers Ju 52. We see parts of the engine in front of us, although the propeller's blades remain invisible due to their high speed of rotation. Like a film projector's Maltese Cross, the airplane's propeller makes its own work invisible. It fools the slowness of our visual perception, presenting as transparent and continuous what in fact is a sight marked by constant blind spots and discontinuities. But Riefenstahl doesn't give us much time to contemplate the curious affinities between projectors and propellers. For her opening shot veers immediately to the left to grant us a spectacular view of cloud formations as seen through and framed by the airplane's side window. The camera's ninety-degree pan is smooth and unobtrusive, yet it clearly communicates what any viewer accustomed to the codes of narrative cinema will identify as a sense of subjectivity. Riefenstahl's camera begins and authenticates its mission by assuming the perspective of the airplane's pilot. And as it will become clear only a few moments later, the pilot's gaze of course allegorizes the gaze of the Führer's himself, sublime and powerful enough to call Nuremberg to life and organize the movements, perceptions, and fates of its citizen into patterned forms. It is Hitler's gaze that secretly conjures and shapes all appearances, events, and meanings. It is the divine Führer who defines the terms of political and aesthetic representation. And it is Riefenstahl's camera that allows the viewer, for a brief moment, to see the world through Hitler's supernatural perspective, to bathe ourselves in his power and witness how the window of his eye orders the complexities of both nature and social life.

Riefenstahl's presentation of the Führer as aviator and vision machine harked back to Hitler's innovative use of airplanes during the 1932 election campaign: "Flying from city to city in a truncated campaign squeezed into less than a week to accommodate an Easter truce in politicking, Hitler was able to

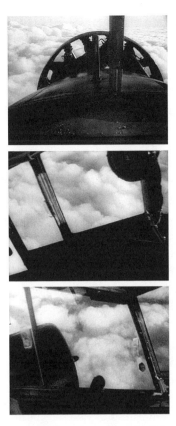

Leni Riefenstahl, *Triumph of the
Will* (1935). Opening shot.

hold twenty major speeches in different venues before huge audiences, total-
ing close to a million persons. It was a remarkable electioneering performance,
the like of which had never before been seen in Germany."[27] Hitler's *Deutsch-
landflüge* established the future dictator as a man of restless energy and em-
blematic modernity. The airplane enabled Hitler to meet his followers in their
own particular situations and localities, without employing the mediating role
of mechanical recording and copying. Mechanical reproduction, Walter Ben-
jamin wrote in 1935, "can put the copy of the original into situations which
would be out of reach for the original itself. . . . The cathedral leaves its locale
to be received in the studio of a lover of art; the choral production, performed
in an auditorium or in the open air, resounds in the drawing room."[28] Hitler's

airplane campaigns, by way of contrast, sought to beat the modern culture of the copy at its own game. It allowed the Führer to be seen and heard in places formerly out of reach, yet it did so without substituting a technical reproduction—a copy of Hitler's image—for the original—Hitler himself. Rather than simply replacing tradition, Hitler's *Deutschlandflüge* were meant to create sensory experiences of contact and community with the help of modern technology. Rather than undoing the past, Hitler's plane was supposed to reinvent it for the future.

As they invite the viewer to approach old Nuremberg through the eyes of aviator Hitler, the opening shots of *Triumph of the Will* reframe Nazi modernism with the means of film itself. Modern aviation, for Riefenstahl, is "television" in reverse. It might shrink the parameters of spatial and temporal experience, but it nevertheless enables charismatic impressions of presence and proximity, of authorship and authenticity. Allegory of Riefenstahl's own cinematic project, the windshields of Hitler's airplane produce the real as a sublime and self-contained attraction. Their purpose is not to picture or penetrate reality but to author the real like an awe-inspiring artwork. In doing so, Hitler's airplane seems to embody the opposite of everything that, in the eyes of Benjamin, qualified film and photography as tools of collective self-representation and proletarian emancipation. Instead of empowering the viewer to explore and reconfigure the visual field like a surgeon, Riefenstahl's airplane posits Hitler as a magician whose gaze conjures the tangible world for us from a distance. Instead of eliminating the auratic and its authority, Riefenstahl's window shot establishes and consecrates Hitler's power over the viewer's life and imagination. Nothing in what follows, asserts the first shot of *Triumph of the Will,* will be left to chance. Because in Riefenstahl's world the gaze of the Führer creates the very subjects that will later cast pleasurable looks at him, there is no space for coincidence or imprecision, no space for ambiguity or unwanted interpretation.

By anchoring the film in Hitler's godlike perception, Riefenstahl aspires to bind her images into one coherent statement, one that excludes the possibility of competing appropriations and completely controls the attention of the viewer. Though Riefenstahl indeed installs spectacle as the organizing principle of both its cinematic operations and its Nazi politics, her film clearly fears the capacity of images to unravel stable meanings. She frames Hitler's presence (as in the hotel window scene) as well as our own perception (as in the opening shots) not in order to incite visual pleasure and satisfy our scopic drive but in order to manage our experience, regulate interpretation, and dis-

cipline consumption. We may have come to understand *Triumph of the Will* as the Third Reich's most skillful attempt at fusing aesthetics and politics, at exploring modern visual culture in order to legitimate political authority. But as Riefenstahl's use of multiple framing devices indicates, in the final analysis the political aesthetics of Nazi Germany were marked by fundamental fears about the vagueness of the image and the vagaries of visual pleasure. In trying to make mechanical reproduction auratic again, filmmakers such as Riefenstahl not least hoped to circumscribe cinematic images and reorganize the visual in terms of the putative certainties of the verbal, of speech and propositional meaning. Images here were to become words through other means. They were designed to communicate unified messages and police the unpredictable power of visual consumption in and of themselves.

It is Riefenstahl's simultaneous inscription of Hitler as the originating subject *and* object of looking, as the unequivocal frame of all meaning and experience, that should caution us not to equate Nazi aesthetics with the movie industry's cult of stardom. The cult of Hollywood or Hollywood-like star images in the 1930s appealed to fantasies of individual self-transformation and social mobility. It essentially relied on the assumption that certain star images could be adopted by individual spectators and translated into a multiplicity of vernacular uses and meanings. Part of the rise of modern consumer practices, the cult of stardom promoted an ethos of individual self-formation and autonomy that challenged conventional markers of identity, social hierarchy, and privacy. While we should not falsely heroize this production of individuality and multiplicity *qua* consumption as automatically subversive—Adorno called it pseudo-individualization, the "halo of free choice" on the basis of standardization itself [29]—we should also not deny that the sheer quantity of consumer practices and sensual pleasures potentially disrupted naturalized norms of gender, class, ethnicity, and race. Hollywood stars produced effects close to drag: their cult of authenticity was so stylized and hyperbolical that it tended to debunk itself, encouraging the viewer and fan to perform a better job.

Riefenstahl's staging of Hitler, by contrast, does everything at its disposal in order to contain future uses and meanings *in the image itself.* The director's imagery not only sought to rouse powerful affects but at the same time to control all possible effects. Riefenstahl's windows are screens of calculated seduction. They overwhelmed the viewer's senses with excessive choreographies of sights and sound—not with the intention to encourage multiple uses and vernacular interpretations but to deny the individual body as a site of need, desire, and autonomous experience. Their proximity to modern consumer cul-

ture notwithstanding, Riefenstahl's images of Hitler reveal deep-seated fears about the utopian energies, materialist longings, and hedonistic pleasure of mass-cultural consumption. In fact, we might best understand these images as part of an orchestrated attempt to define a startling counter-measure to the movie industry's cult of stardom and privacy—one in which Führer and state emerged as superior moral entities that divorced economic activities from individual needs, desires, and pleasures and instead turned these activities into ethical enterprises. Like Hollywood mass culture, the spectacle of Hitler at the window provided imaginary solutions to real contradictions; it established powerful relays from the imaginary to the real.[30] Unlike Hollywood, however, the Hitler star cult could only allow for one object of desire, and it painstakingly restricted its everyday uses. Fans and consumers were to imitate the ethical state. They were not to mimic or performatively transform it but rather to disappear within it mimetically. We should therefore see Riefenstahl's window pictures of Hitler not simply as a contribution to the Nazi aestheticization of politics but as a foray into a totalitarian culture of *anaesthetics*. Privileging unified forms over messy appropriations, the windows Riefenstahl opened onto the body of Hitler denied the original meaning of aesthetics, namely the sensory experience and pleasure of perception. Although Riefenstahl's images appealed to people's emotions and sentiments, they ultimately strove to neutralize people's senses—to "knock them out."[31]

Panorama Windows

In his preface to Heinrich Hoffmann's coffee table book *Hitler wie ihn keiner kennt* (Hitler as no one knows him), Nazi youth leader Baldur von Schirach wrote: "To be popular means: to be photographed a lot. Adolf Hitler has always resisted becoming an object of photography. In particular twelve years ago, when his name emerged for the first time from the darkness of anonymity, he was a declared enemy of the camera. Back then, the whole world's illustrated press tried to obtain a picture of the Führer. Without success. In spite of all kinds of monetary offers, Hitler categorically refused to have his picture taken for the sake of reproduction."[32] According to Schirach, the Führer's early resistance to the camera resulted from his aversion to decadent capitalism. Reproduction, under the aegis of the Weimar Republic, was inseparable from reification and commodification, from that which drained meaning and charismatic renewal. Once in power, however, Hitler realized the ideological and moral possibilities of the photographic medium. The Nazi state emancipated

mechanical reproduction from its earlier complicity with commodity culture and thus allowed Hitler to use film and photography in order to disseminate his ideological convictions and moral missions, including—following Schirach—his personal dedication to vegetarianism, nonsmoking, and anti-alcoholism.

Considering the millions of Hitler fan pictures and coffee table books circulated throughout the 1930s and early 1940s, not much seems to have remained of Hitler's initial camera shyness. Contrary to the Führer's media politics of the 1920s, Hoffmann's und Riefenstahl's Hitler images of the 1930s presented the Führer as an exhibitionist of the first rank: a statesman whose excessive exhibition of ideological beliefs and moral values, from today's perspective, must be seen as a form of perversion. And yet, as if wanting to return to his early "darkness of anonymity," Hitler, in the course of his rule, became ever more eager to escape the media's windows of publicity. He withdrew from sight and reproduction. In particular in his remote Obersalzberg domicile, Hitler hoped to inhabit a space that seemed to shut out public visibility. The building promised to provide a site where one could look at things without being looked at by cameras, a site where Hitler could withdraw from his own role as a window connecting people and nation. And yet, in occupying this sanctuary, did Hitler really break away from the burdens of the camera? Did his resort, for Hitler, really restore a sense of privacy and interiority, untouched by the interfaces of modern reproduction?

In the summer of 1935, Hitler decided drastically to reshape his unassuming country house at the Obersalzberg into a more stately domicile, known as the Berghof.[33] Hitler's renovation plans resulted in what Obersalzberg locals must have experienced as a fundamental restructuring and modernization of their natural surroundings. In order to secure both the privacy and magic of Hitler's mountain, the Führer's acolytes not only had to confiscate forests and tear down existing farmhouses, they also had to construct new roads and promenades and to engineer a complex system of escape tunnels and underground shelters. According to Albert Speer's memories, Hitler himself designed the ground plans and cross sections for his new country residence—much to the dismay of the Third Reich's master architect:

> A huge picture window in the living room, famous for its size and the fact that it could be lowered, was Hitler's pride. It offered a view of the Untersberg, Berchtesgarden, and Salzburg. However, Hitler had been inspired to situate his garage underneath this window; when the wind was unfavorable, a strong smell of gasoline penetrated into the living room. All in all, this was

a ground plan that would have been graded D by any professor at an institute of technology. On the other hand, these very clumsinesses gave the Berghof a strongly personal note. The place was still geared to the simple activities of a former weekend cottage, merely expanded to vast proportions.[34]

Speer's disdain for the Berghof exposes some of the central elements of Hitler's interest in architecture and of Nazi aesthetics in general. Similar to what Nietzsche and Adorno considered to be Wagner's histrionics, namely the composer's desire to impress his audiences at all costs, Hitler's passion for built space privileged the stimulation of certain effects in the viewer over a building's structural integrity. Hitler deliberately designed the new Berghof as a mechanism to collect sublime visual sensations. An extravaganza of unique proportions, Hitler's panorama window was intended to open up monumental views of the surrounding landscape. In fact, Hitler conceived of this window as a self-effacing interface between exterior and interior spaces, between the landscapes of nature and those of civilization. House residents may have smelled the fumes of cars, but their visual perception was entertained with the illusion of dwelling in nature, of inhabiting a clearing within the surrounding forests and mountain landscape. Professional architects may have given Hitler a failing grade for his amateur structure, but the Berghof's structural failings were extraordinarily systematic. In so many ways, they resulted from Hitler's overriding ambition to disguise architecture as nature and spontaneity, to engineer a dreamlike semblance of natural authenticity. Valuating sight as the primary of all human senses, Hitler's Berghof was not meant to rest safely in its environment but to embody an organic extension of that very landscape in which it rested.

Speer's comments about the Berghof are intriguing and to the point. What they ignore, however, is the intrinsic modernity of Hitler's design, that is, the way in which his new Berghof accessed nature, not in strict opposition to urban culture and technological sophistication but in secret engagement with the modern, especially the modernity of twentieth-century mass media. Hitler's panorama window allowed residents and visitors to behold the surrounding landscape from the Berghof's most emblematic room: the Great Hall. It was here that Hitler welcomed his guests, took his meals, spent hours having conversations, and last but not least consumed the latest UFA and Hollywood products with his associates. At a right angle to the impressive picture window, a huge tapestry—showing three equestrians in a natural setting—concealed a private film screen. A large bronze bust of Richard Wagner, sculpted by Arno Breker, could be admired right underneath this screen. It rested on a massive

The panorama window in Hitler's Berghof. The tapestry on the left hides a film screen. Printed by permission of Bayerische Staatsbibliothek, Munich, Germany.

chest of drawers, containing built-in speakers. What is most striking, however, is the curious similitude between tapestry and picture window. Both could be removed to open up views on gripping attractions; both relied on advanced engineering in order to entertain the viewer with illusions of wholeness and utopian reconciliation; and both encouraged horizontal over vertical views, the screen at the classic aspect ratio of 4:3 and the picture window at the—shall we say, widescreen—ratio of roughly 2.1:1 (a little less than CinemaScope's 2.55:1). Whether we think that the window replicated the screen or that the screen copied the window, what is important to note is that Hitler's Great Hall at the Berghof was deliberately designed as a viewing machine, as a lens taking and projecting moving pictures. It was camera and screen at once, an architectural structure simultaneously able to frame natural settings as moving pictures and naturalize cultural products into elemental forces.

The curious modernism of Hitler's Berghof design—and its limitations—

become clearer when compared to the window designs of avant-garde architects such as Le Corbusier. Polemically privileging horizontal over vertical window perspectives, Le Corbusier in the course of the 1920s developed a number of residential projects whose primary function was to direct the resident's view to urban and natural landscapes. Operating like cameras, these houses were supposed to be mobile. They were designed like a "box in the air, pierced all around, without interruption," as the architect explained in 1930, and they could be moved to any place—to Paris or the Sahara Desert, to Biarritz or Argentina.[35] As viewing apparati to collect views, Le Corbusier's box houses were in some sense immaterial. According to Beatriz Colomina, these structures were "no more than a series of views choreographed by the visitor, the way a filmmaker effects the montage of a film. Significantly, Le Corbusier . . . represented some of his projects . . . in the form of a series of sketches grouped together and representing the perception of the house by a moving eye. As has been noted, these drawings suggest film storyboards, each of the images a still."[36] In Le Corbusier's designs of this period, the house's window collapsed the boundaries between interior and exterior, the public and the private. Rather than framing the resident's body or simply guiding the user's eye, Le Corbusier's windows became mechanical substitutes for the resident's body—interfaces charged with transformative powers.

Like Le Corbusier, Hitler intended his expanded Berghof as a viewing machine framing the landscape and screening magnificent horizontal views. His new domicile was drawn with a moving picture, a film-like impression, in mind; it was designed as a frame for that impression, one that converted mere acts of looking into sublime experiences of seeing. Unlike Le Corbusier, however, Hitler was of course not concerned with building a house that could be moved to other places. Considered an organic extension of nature, the Berghof instead was to root its inhabitants firmly in the ground, in nature's clearing. For Hitler, the Berghof provided a space of calm and seclusion, a space where he could at once relax from and gear up for his public appearances. A site to reground and reframe himself, not one of dispersion, commotion, and contingency. Rather than encouraging the viewer to become a film editor whose task was to splice different viewing angles into one montage construct, Hitler's house favored the autarky of the frame and the stability of uncut spatial perspectives. Whereas Le Corbusier's house urged its residents to synthesize individual frames and create their own narratives of movement, Hitler's panorama window unified different perspectives and unfettered visual perception from the viewer's narrative drive.

The panorama window in Hitler's Berghof at the end of the war. Printed by permission of Bayerische Staatsbibliothek, Munich, Germany.

In spite of such differences, however, it is important to point out here that Hitler's Berghof window, far from allowing the dictator to escape the burdens of modern publicity, presented surrounding space in direct engagement with the omnipresence of mass media in twentieth-century culture. It incorporated the inevitable presence of modern media in order to conjure impressions of privacy and the elemental. Industrialized perception here situated architecture as a symbiotic expansion of sublime landscapes. It engineered reciprocal relations between the spaces of nature and those of civilization, between the archaic and the historical. Rather than shutting out the modern altogether, Hitler's Berghof played an essential role in evidencing the Nazis' desire not only to remake people's attention with modern means but also to establish Hitler's rule over the whole array of modern media.

Reframing the Nazi Spectacle

Umberto Eco has famously defined fascism as a form of fuzzy totalitarianism, "a collage of different philosophical and political ideas, a beehive of contradictions."[37] According to Eco, both Italian fascism and German National Socialism were characterized by a structured confusion. They served as eclectic screens for highly diverse and often incompatible agendas, desires, and resentments. What in fact made fascism fascist was its ability to mesh dissimilar interests and tropes—machismo, cult of heroism, glorification of struggle, vitalism, xenophobia—into an integrationist all-purpose ideology, one that seemed to provide everyone with something while at the same time drawing clear boundaries between friend and foe. Translating Eco's insights into the vocabulary of our explorations here, we might say that fascism represented a self-effacing window that gave heterogeneous experiences the appearance of unified action and in whose frame temporal and spatial discontinuities gave way to the integrated image of linear time and homogenous space. While Nazi ultranationalism and palingenetic populism may indeed look fuzzy from today's perspective, the Nazis' successes rested not least of all on their abilities to order and organize people's attention, to refocus their awareness, and in this way to order the messiness of modern life within reliable frames of perception.[38]

Perhaps it is for this precise reason that German visual artists who were unable or unwilling to escape Hitler Germany often resorted to window motifs in order to allegorize their sense of ideological and existential estrangement. Think, for instance, of Paul Weber's 1943 *Das Gerücht,* Anton Räderscheidt's 1943 *Der Gefangene,* Carl Hofer's 1945 *Alarm,* and Otto Pankok's 1945 *Das Judenhaus.* In these counter-images, the window motif served as a symbolic tool to engage with the Nazis' framing of perception, fantasy, desire, and technology from within. In many cases, such images helped both explore and destabilize not reality itself but reality as the Nazis wanted its subjects to see it, the Nazi methods of lending fuzzy experiences the appearance of unity, coherence, and continuity.

The most famous of all window painters during the Hitler period was former Bauhaus member Oskar Schlemmer. Stripped of his official positions in the early years of the Nazi regime, Schlemmer created a series of eighteen paintings between April 13 and July 18, 1942, depicting people in interior settings as seen through the window of his own apartment at Döppersberg 24 in Wuppertal. Relatively small in size, all of these paintings were executed in oil

and pencil on cardboard. In most cases, their making can be traced to particular dates and times of day, leaving us with a visual diary of Schlemmer's last wave of aesthetic productivity before his death in April 1943.

In his letters and diary entries of the time, Schlemmer described his window paintings as images reinscribing the thick textures of the visible world and emancipating perception from the mandates of modernist abstraction. To look through his apartment's rear window and capture the sight of people in everyday settings for Schlemmer meant to explore the ordinary as a source of classicist composure and transcendental value—to recover from the existential mess and artistic blockage he had experienced over the past decade. Schlemmer's window paintings were supposed to exhibit and celebrate the visual field in all its diffidence and incommensurability. On May 11, 1942, after having completed the ninth painting, Schlemmer wrote to his friend Julius Bissier: "Today, since I can no longer believe in the blissful abstractions of a Picasso . . . and also no longer have the courage to believe in previous (and immodest) forms of modernism, in a curious way I am beginning to appreciate the world of the visible in all its density and surreal mysticism."[39] And one day later, on May 12, Schlemmer noted in his personal diary: "The window paintings: wonders of the visible, mysticism of optics. At least in its transcendence; that is, one cannot really invent such a thing. Energy source for free composition. Regarding the window paintings: I feel like a hunter who, every night between nine and ten o-clock, goes stalking. And then: only here I am true to myself, in the curious sense that I only paint what I see, Yet how I see it, and most of all, how I paint it—that's what counts as much as the old question: 'What is truth?' Aesthetic truth-natural truth. . . ."[40]

Schlemmer's self-descriptions have led many critics to describe—and disparage—his window paintings as antimodernist, as fueled by the artist's retrograde desire to counteract abstraction and, in a quasi-religious gesture, move through and beyond the grid of mimetic representation. Schlemmer's exploration of the visible and its mysticism, so the argument goes, harks back to premodern idioms of authenticity and natural truth in order to redeem perception from the burdens of the present. Ironically, however, in defining aesthetic modernism solely in terms of anti-mimetic abstraction, arguments such as these not only erase the multiplicity of modernist projects and practices, they also fall prey to a certain kind of antimodernism themselves. For in excluding Schlemmer's window paintings from the normative canon of modernist art, this position fails to account for the many ways that modernism might respond to shifting historical contexts and local situations. Following

Oskar Schlemmer, *Raum mit sitzender Frau in violettem Schatten,* Fensterbild XII (1942), oil over pencil on board, 30.6 × 20.7 cm. Kunstmuseum Basel, Depositum Schlemmer. Courtesy Photo Archive C. Raman Schlemmer, IT-28824 Oggebbio (VB), Italy.

Schlemmer's own lead, the normative conception of modernism as anti-mimetic and abstract in the end forgoes modernism's own impulse to engage with an ever-changing present in ever-new ways, to put formal experimentation in the service of articulating the contingencies of modern experience, including that of Nazi society.

Schlemmer's self-commentary, then, should be viewed with a pinch of salt. In fact, rather than seeing his window paintings as idealist exercises in metaphysics, we should expose their precise historical index, the way that the formal qualities and contradictions of these paintings simultaneously allegorize and work against very specific historical experiences. Schlemmer's paintings at first of course recall Alberti's definition of the window as a tool of perspective and code of realist representation. Once again, the window's geometry here serves as a mechanism in order to provide "a comprehensible form for the complexities of human experience."[41] As apertures in architectural walls, Schlemmer's windows seem to resemble picture plans, themselves interposing the apex and the base of what Alberti would have called the visual pyramid. At the same time, however, Schlemmer also employs the window as a framing device exhibiting the modernist revolt against Alberti's hubris. For rather than displaying space according to one geometric vanishing point, Schlemmer's frames project space as planar and structural and thereby emancipate the visual field from the laws of central perspective. What we see *within* Schlemmer's windows evokes not Alberti's program but rather modernist attempts to disrupt perspective and reveal, through variations of color and tone, the hidden structure behind natural settings. Like the mature works of Paul Cézanne's, Schlemmer's window paintings do not simply try to capture random impressions in all their transitoriness but rather aspire to bring the visual field to some kind of intellectual order. Instead of subjecting vision to the laws of central perspective, Schlemmer's frames—like Cézanne's paintings—create sensations of depth and distance, of shape and solidity, by elaborating different tonal planes and semi-abstract forms. Within the frames of Schlemmer's windows, the articulation of space results from horizontal or vertical intensities and not from idealized, godlike viewpoints.

Schlemmer's window paintings were products of highly constructivist efforts, of planning and technique. Instead of arresting momentary sensations intuitively on cardboard, Schlemmer first drew numerous sketches to calculate spatial relations as well as to map out different planes of color and vision. Notwithstanding their dimensions and seeming casualness, Schlemmer's window paintings were designed as laboratories investigating the legacy of different

modalities of modern visual perception and spatial representation. What these paintings accomplished, however, was not merely to juxtapose the dissimilar programs of Alberti and Cézanne within the space of one and the same frame but also to stage a dialectic of seeing that defied any final synthesis. Far from reconciling Cézanne's modernist disruption with Albertinian perspectivalism, Schlemmer's window frames revealed the effort, technique, denial, and violence it takes in order to conjure the world as ordered and natural. As they emphatically draw the viewer's awareness to the framing of perception and visibility itself, Schlemmer's window paintings stress the extent to which nature must always elude our sight because sight is a social and historical fact. What, in the final analysis, bears responsibility for the beauty and melancholy of Schlemmer's final works is the way in which they show that neither Alberti nor Cézanne got it right; that is to say, whenever we see, think, say, or touch, whenever we depict nature, we have—for better or worse—already entered the realms of mediation, of culture, of representation, of history.

Yet it is only when seen against the backdrop of Hitler's use of windows as sites of political display, charismatic interruption, and godlike visuality that we can fully understand the significance of Schlemmer's 1942 window paintings. For whatever Schlemmer himself believed to be his project, his window paintings do not only negotiate the legacy of different notions of perspective and aesthetic practices of spatial ordering. Instead, their concern is deeply political, slicing through Nazi society's manipulations of people's sensory perception as a means of coordinating all aspects of private and public life and fetishizing the appearance of power. "The fetish," as Laura Mulvey has written in a different context, "necessarily wants history to be overlooked. That is its function." She continues: "The fetish is also a symptom, and as such has a history which may be deciphered."[42] As I have argued in the preceding pages, Hitler's use of window settings was part of a concerted effort to present his body and appearance as a fetish. Whether in Nuremberg or at the Obersalzberg, Hitler's windows denied the labor required to see and to be seen in Nazi mass culture. As they displayed historical experiences as natural facts, Hitler's windows fetishized the Führer's body into an object of desire and consumption, a site of charismatic presence and auratic redemption, a phantasmagoria of the first order. It is in the formal arrangements of Schlemmer's window paintings that we can locate one rare contemporary attempt at questioning how Nazi aesthetics organized attention and managed visuality. Unlike Hitler's use of window settings, Schlemmer's windows foregrounded the mediated character of modern perception. Rather than hitting people over the head with a surplus

of visual signs and sensual attractions, Schlemmer's final paintings contested hegemonic framings of perception and, in so doing, exposed the historical index of seeing, the historicity of perception. Schlemmer's window paintings draw our attention to the work and the process of articulating sight and visibility under the conditions of modern culture; they not only keep us thinking about what is behind the images we see from this era, they also challenge the myth of authenticity so central to Nazi visual culture and media politics. It is in Schlemmer's window paintings that we can locate at least one attempt to do to Nazi visual culture what many visual artists since the 1960s have done to Nazi imagery with historical hindsight and advanced media technology: to produce powerful counter-images to the Nazi orchestration of individual sight and public visibility. Schlemmer's window paintings present the Nazi fetishism of power as a symptom of a history we cannot afford not to decipher.

Postscript

A recent video installation by Marcel Odenbach, entitled *Das große Fenster* (The Big Window, 2001), continues Schlemmer's line of inquiry so as to shed additional light onto the particular modernization of sight during the Nazi period, the grounding of totalitarian power in modern frames of looking. This installation consisted of six widescreen television sets positioned in front of the window panes of perhaps Germany's most spectacular exhibition site: the gallery on top of the Zugspitze, which has magnificent views on Alpine landscapes close to the former site of Hitler's Berghof. All six video screens showed the same short film (duration: 12:19), an assemblage of found fiction and nonfiction footage and footage shot by Odenbach himself. In its main sequences, this video offers breathtaking images of a wintry mountainscape, at times seen through the grid of a horizontal window, at times seen without any further framing device. Every now and then, a hand moves a curtain across the screen in order to block our gaze temporarily and mark the beginning of a new chapter. In addition, Odenbach periodically turns curtain and panorama window themselves into projection screens, displaying moving images that—as we will see in a moment—trouble our impression of pristine landscapes and unadulterated looking. A seventh monitor, situated in the rear of the gallery, plays a second video of equal length called *Die Brille* (The Eyeglasses). Though the images on this second video screen are of much less interest than the exhibit's main attraction, they do serve an important function, namely to simulate the position of the installation's viewer within the parameters of the show itself.

According to Dan Cameron, Odenbach's work since the mid-1970s has been first and foremost dedicated to "uncovering the hidden nature of power: how it is practiced unthinkingly, the way its symbols permeate social behavior, and the degree to which its significance is minimized by those who are its most ardent practitioners."[43] *Das große Fenster* continues this interest, trying to recall not only how the Nazis embraced modern media in order to stage-manage the political but also how Nazi media politics sought to remake the very modalities of modern looking, of modern sensory perception and visual pleasure. The video begins with two different shots of workers shuffling soil and moving construction materials during the renovation period of Hitler's Berghof in the mid-1930s. We cut to a closeup of Hitler. Positioned in front of his refurbished domicile, he allows his gaze to wander slowly across the landscape around him. Next, we cut to what according to classical editing rules must be understood as a subjective point-of-view shot. The camera pans across a majestic mountain panorama as if permitting the viewer to watch the natural surroundings through Hitler's imperial eyes. What follows is the video's brief title sequence, interspersed first by two consecutive shots showing Hitler walking up the stairs to the Berghof and then by a medium shot of Hitler taking possession of the Berghof's interior while turning his gaze silently from right to left. In these first seven shots, Odenbach already lays out for us the major themes and premises of this installation: the relation of physical movement and visual perception; the reciprocal blurring of boundaries between interior and exterior spaces, between the subject and the object of looking; the work it takes to enable visual pleasure and awe-inspiring viewing positions; the mediated nature of what strikes the viewer as the mountain's magnificent immediacy. In this opening sequence, acts of panoramic looking are unmistakably marked as enactments of power. Hitler's gaze in fact is that of a film camera, one that renders movement and power, aesthetic pleasure and authority, form and domination, as mutually exchangeable. Modern techniques of building and representing space here are shown as actively constructing the countryside as a site of wonder and enchantment; they subject human bodies and remodel natural topographies in order to produce nature as image—as a sublime experience of the first rank.

After the end of this opening sequence, we cut to the video's signature shot: the image of snow-covered mountains as seen through the grid of a panorama window. This footage was shot by Odenbach himself, as were the recurring shots showing a hand drawing a curtain across the screen in what is reminiscent of a Punch and Judy puppet show. For the next ten minutes, this window

Marcel Odenbach, *Das große Fenster* (2001). Printed by permission of the artist.

and curtain serve as a projection screen: a site recalling how Nazi visual culture engineered emotions and produced fantasy, how it used moving images to mobilize people's bodies and anaestheticize perception. We see historical footage of Adolf Hitler greeting various guests at his Berghof compound—diplomats, military personnel, movie stars, master architects, civilians, and local children. We behold images of Hitler visiting an art exhibit at the Haus der Deutschen Kunst in Munich. We witness footage of a 1934 parade of S.S. and Labor Force members in Nuremberg as captured in *Triumph of the Will*, a clip from the opening of Leni Riefenstahl's 1938 *Olympia* showing well-trained athletes in classical poses, and a shot of Hans Albers in the role of Baron Münchhausen as he sails on top of a canon ball through the air and waves his hat at the viewer. Then, after another curtain, we cut to aerial shots of ruined German cities at the end of World War II as well as to footage showing British forces, including their commander-in-chief Winston Churchill, as they visit the damaged Berghof and look through what is left of Hitler's erstwhile panorama window. Intermittent sounds accompany these projections: birds chirping, a child's voice praising Hitler's magnanimity, Hitler speaking over the radio in 1933 to commend the Nazis' "national revolution," a brief excerpt from a Hitler speech in which he defines true art and the beautiful as the representation of all that is natural and healthy, the voices of Labor Force members identifying their regional identities, party rally drumrolls, the clattering of dishes and cutlery, and, last but not least, the sounds of at once tragic and commanding symphonic music.

Fredric Jameson has described postmodern visual culture in terms of a paradoxical return of the aesthetic.[44] In so many ways, postmodern art and thought endorses the nearly seamless integration of art, culture, economics, and politics today in order to turn modernism's quest for aesthetic autonomy—certain modernists' pursuit of the innocent eye—into a viable commodity. Under the sign of the postmodern, illusions and nostalgic glimpses of aesthetic autonomy emerge not in opposition to but as an effect of the market and the geopolitical rule of capital. Nothing is more foreign to Marcel Odenbach's *Das große Fenster* than this attempt to reinvent pure vision and older concepts of aesthetic autonomy. What Odenbach's layering of images and perspectives, of sights and sounds, exposes is that there is no such thing as an innocent eye, whether we cast our gaze at natural landscapes or sublime artworks. Visual perception for Odenbach is a historical product, a result of articulation and negotiation. It is dependent on shifting historical and cultural configurations, on competing discursive, technological, and political formations, even if visual regimes such

as that of Nazi modernism deny the aleatory character of human sight and dictate one essential model of vision. In the last shot of *Das große Fenster,* Odenbach allows us to cast a direct glance at his Alpine mountainscape. Neither the curtain nor the curiously disembodied hand, neither projected images nor the window's earlier grid block or distort our gaze any longer. And yet, in light of what we have seen during the previous twelve minutes, and since we are positioned in front of the gallery's own window frame, there is no way not to take the final image on screen for what it is: a product of technological mediation, a "special effect." In drawing our awareness to the frames that make perception possible in the first place, Odenbach opens a window onto visual practices that oppose delusions of aesthetic self-sufficiency and imperial control. Sight might have always already lost its innocence, but it is only when recognizing messiness, multiplicity, and historical mediation as irrevocable conditions for our seeing that we can develop effective counter-images to the dominant organization of sight—counter-images that are centered around nothing less than the idea of individual emancipation, mutual recognition, and scopic reciprocity.

6 | *Fluxus Television*

No medium other than television has been more often discussed and experienced—from its very inception—as a window onto the world. On March 11, 1963, the industrial city of Wuppertal witnessed the opening of a small exhibition that not only explored the metaphorical conception of television as a window but also irrevocably changed the course of postwar German art and its relationship to the ever-expanding arsenal of electronic media. The site of this show was Rolf Jährling's Galerie Parnass, located in a stately *Gründerzeit* mansion on Moltkestraße 67, only a few blocks away from where Oskar Schlemmer had executed his window paintings in 1942. The artist whose objects were on display was a young whirlwind from South Korea, Nam June Paik, whose connection to the transatlantic Fluxus movement of the time placed him in radical opposition to everything classic modernists such as Schlemmer had stood for. Born in Seoul in 1932, Paik had come to West Germany in 1956 to study music and philosophy, but after meeting Karlheinz Stockhausen and John Cage in Darmstadt in the late 1950s, Paik started to complement his investigation of Kant's *Critique of Pure Reason,* Hegel's *Aesthetics,* and Zen Buddhism with textbooks on electronic circuitry, physics, and indeterminacy theory. In the late 1950s and early 1960s, Paik experimented with electronic sounds at the studios of the Cologne radio station WDR (Westdeutscher Rundfunk) and participated in numerous "happenings," which confronted the entire institutional context of how art and culture were practiced during the decade following World War II. Paik's 1963 show at the Galerie Parnass, entitled *Exposition of Music—Electronic Television,* offered the first comprehensive public display

of his artistic concerns and cultural interventions. At the same time, however, the range of installation pieces presented at this exhibition documented Paik's gradual move away from electronically mediated sound manipulation to the exploration of television and video art, the performative alteration of diverse art objects at the hands of the visitor, and the visualization of sound as screen image with the help of interactive electronic relays.

Paik's *Exposition of Music—Electronic Television* has triggered wide-ranging discussions among art historians about the advent of media art during the postwar era and the rise of art environments in which artists and visitors alike could undo the notion of the frame and hence destabilize traditional notions of aesthetic form, closure, and autonomy. John G. Hanhardt summarized these arguments when he wrote in 2000, "*Exposition of Music—Electronic Television* transformed the gallery through an array of installations created to shock the visitor out of complacency, bringing him or her into the material world of altered objects. The visitor was no longer a passive viewer of traditionally coded art objects, such as paintings, framed and installed at eye level on the gallery walls. Rather, the spectator confronted new sights. . . . Moving from room to room, the viewer could engage individual sound pieces and examine the prepared pianos and televisions as materials of temporal destruction and reconstruction."[1] But the costs of this canonization of Paik's show as anti-canonical have been considerable. Among others, it has led to the gradual detachment of Paik's early work with television sets from its immediate historical context. What has faded from view is the rich historical context which in the course of the 1950s and early 1960s defined television watching as the chief form of postwar entertainment, opening unprecedented windows onto the world and bringing new amusements into people's living rooms. Paik's show in Wuppertal bookended what can be considered the formative first decade of television in West Germany. For *Exposition of Music—Electronic Television* opened its door to the public nine years after nationwide television broadcasting had commenced in West Germany, on November 1, 1954; four years after the arrival of magnetic recording had decentered early program structures and their fundamental insistence on present-ness and the instantaneous; and a few weeks before the introduction of West Germany's second nationwide broadcast channel, ZDF (Zweites Deutsches Fernsehen), on April 1, 1963, which was to supplement the first channel, ARD (Arbeitsgemeinschaft der öffentlich-rechtlichen Rundfunkanstalten Deutschlands), and resulted from a protracted battle over the cultural mission, political function, and public responsibility of the new medium in the Adenauer Republic.

Framing Attention

In this chapter, I want to reconstruct some aspects of the historical milieu from which Paik's early work with television emerged. Rather than further canonize Paik's initiatives of 1963, my plan is to recall how Paik's altered objects encouraged the visitor to confront the ambitious metaphor of television as a window onto the world, how Paik's installation pieces addressed and reframed the way in which television around 1960 sought to organize people's sensory perception and attention, and how the groundbreaking exposition commented on the fundamental role of television in redefining existing interfaces between the public and the private, the political and the intimate, in post-fascist and Cold War Germany. The intention of this chapter, in other words, is to understand Paik's 1963 show as a symptomatic act in the Freudian sense.[2] *Exposition of Music—Electronic Television* will not be seen here as causally determined by current developments in West German television culture, nor am I trying to trace how the show may have affected how empirical viewers watched and discussed mainstream programming circa 1963. Instead, what I seek to do in this chapter is to render visible how, in thoroughly contingent ways, unconscious desires and utopian wishes about the new medium and its fenestral qualities attached themselves to Paik's aesthetic strategies and interactive installations—desires and utopias that were not inherently connected to Paik's altered objects but allow us better to understand the cultural and political dynamic within which West German viewers in the late 1950s and early 1960s embraced television as a vehicle of imaginary travel and as a device framing the real.

The Show

Between January 1949 and September 1965, Rolf Jähring's Galerie Parnass served as a quirky counterpoint to the hegemony of abstract modernism in postwar West German culture. It hosted a multitude of different shows, all dedicated—in Jähring's understanding—to undoing current fashions and stylistic programs, to putting on view the unorthodox, subjective, and intensely modern, and, instead of revering recognized artistic signatures and techniques, to exploring uncomfortable aesthetic attitudes, political positions, and cultural alternatives.[3] Presented two years before the gallery's closing, Nam June Paik's *Exposition of Music—Electronic Television* clearly fit Jähring's bill. Paik's installation pieces were scattered across the entire mansion, including its basement and one of its bathrooms. Open for ten days between 7:30 and 9:30 p.m. only, *Exposition of Music—Electronic Television* did not attract large crowds;

N AM **J** UNE **PAIK**

EXPosition of music

ELectronic television

11.–20. März 1963

Tel. 35241

Moltkestraße 67

Wuppertal-Elberfeld

Galerie

Parnass

Kindergarten der »Alten«	How to be satisfied with 70%
Féticism of »idea«	Erinnerung an das 20. Jahrhundert
objets sonores	sonolized room
Instruments for Zen-exercise	Prepared W. C.
Bagatèlles americaines etc.	que sais-je?
Do it your ...	HOMMAGE à Rudolf Augstein
Freigegeben ab 18 Jahre	Synchronisation als ein Prinzip akausaler Verbindungen
Is the TIME without contents possible?	A study of German Idiotology etc.

MANFRED MONTWÉ

PETER BRÖTZMANN

Artistic Collaborators: Thomas Schmitt

Frank Trowbridge

Technic................... Günther Schmitz

M. Zenzen

Poster for Nam June Paik, *Exposition of Music—Electronic Television* (1963). Printed by permission of Manfred Montwé, Bad Wurzach, Germany.

Framing Attention

the nominal cover charge of five German marks was dropped after the first few days due to a lack of interest. But Paik's show, in both the short and the long run, no doubt did to the German and international art world what Jähring had expected it to do, namely to recalibrate the relationship between aesthetic objects and their viewers and defy what had reified modernist impulses into seemingly apolitical bastions of Cold War politics.

Entering Jähring's mansion, the visitor of Paik's show first had to circum-navigate a cow's head suspended from the ceiling such that no one could avoid catching sight of the bloody traces of the animal's recent slaughter.[4] The first hall presented four prepared pianos: one lying on its back and to be played by walking across it; one with keys that could no longer be pressed; and two beefed up with a panoply of optical, acoustical, and tactile devices, enabling the visitors to produce unexpected sounds and observe startling mechanical motions. This first hall opened to the garden room, in which were displayed eleven different television sets, seven of them radically manipulating regular broadcast images through pre-set electronic and magnetic interventions and four inviting the visitor to engage in interactive image production with the help of attached foot pedals, microphones, tape recorders, and radios. The basement displayed all kinds of sonic devices, including the first version of Paik's famous *Schallplatten-Schaschlik,* a stack of turntable records to be played by the visitor with an unfastened pick-up arm; and an assembly of audiotape strips, called *Random Access,* which were glued to the wall and could be turned into sound with a movable magnetic playback head. Upstairs, the visitor could find, among other items, a disjointed window display dummy partly sub-merged in a bathtub; an assemblage of photos and press reports documenting the death of Marilyn Monroe; and *Zen Box,* a wood construction that invited one visitor at a time to sit inside while others banged against the side walls. Finally, in the garden: an installation of diverse objects hanging from a shrub and producing arbitrary sounds (*Zen for Wind*), and a parachute spread out on the lawn with an old sewing machine on top.

Though later celebrated as a watershed event, *Exposition of Music—Electronic Television* generated only very modest public interest and received mixed reviews in the press. In his article for the *Deutsche Zeitung,* John Anthony Thwaites described the show, its visitors, and their different interactive do-ings in great detail. Unfortunately, however, Thwaites misidentified many of the objects on display while enveloping his general lack of understanding in a cloak of sarcasm and ridicule.[5] Siegfried Bonk, in his article on the exposition for the *Kölner Stadt-Anzeiger,* showed more sympathy for Paik's project. For

Nam June Paik, *Exposition of Music—Electronic Television* (1963). Photo: Rolf Jährling. Printed by permission of the Gilbert and Lila Silverman Fluxus Collection, Detroit.

Bonk, *Exposition of Music—Electronic Television* heralded the advent of the twenty-first century amid the relatively provincial atmosphere of industrial Wuppertal: "Spatialization of music, as Paik imagines it, and abstract screen indeterminism, as it is not being imagined by television program directors and practitioners."[6] While in clear disagreement about the objectives and accomplishments of Paik's show, both Thwaites and Bonk managed a certain Eurocentric condescension toward Paik's Korean background. And both reported with bemusement what amounted to the perhaps most spectacular moment of the entire show: the decision of Joseph Beuys to smash one of the displayed pianos into a thousand pieces.

Craig Saper has described the Fluxus movement as it emerged around 1960 as an orchestrated attempt to undo traditional notions of aesthetic authorship and self-realization. Fluxus representatives such as Paik were eager to redefine the aesthetic as a site not simply of arbitrariness and chance but of collaborative experimentation. Instead of producing or reading "works," Fluxus practitioners understood art as a laboratory and interpersonal network: "This

way of working placed creativity and innovation in the hands of a linked or networked community rather than locating it in the mind of a sole genius in the form of a single artist's inspiration."[7] As we shall see, the laboratory setting of Paik's *Exposition of Music—Electronic Television* foreshadowed some of the basic axioms of our own age of networked communications. Principles of modularity and variability, which some scholars have identified as central for understanding the "fractal structure" of computerized interactivity, certainly also informed the way Paik transformed Jährling's exhibition space into a site of nonhierarchical connections, encounters, combinations, and permutations.[8] For now, let it be simply noted that Paik's 1963 show, by refunctionalizing the postwar era's most successful window of imaginary travel, namely television, succeeded in attracting a good number of like-minded artists to come to Wuppertal and link Paik's aesthetic strategies to their own initiatives. Aside from Beuys, the show was visited, for instance, by Wolf Vostell, whose destruction and manipulation of television sets during the YAM and YOU festivals in New York in 1963 and 1964 were ostensibly informed by Paik's own earlier interventions. And in spite of considerable health problems, even George Maciunas—the self-declared czar of Fluxus—did not hesitate to travel to Wuppertal from New York to witness firsthand how Paik's aesthetic laboratory, by reconfiguring television's frame of representation, encouraged visitors to restructure the temporal and spatial coordinates of postwar culture. It is specifically to how Paik's eleven television sets at the Galerie Parnass sought to reframe the postwar framing of attention that we turn our attention.

Culture and Television

In the decade following the first experimental broadcasts between 1950 and 1952, West German television quickly gained the status of a truly mass-cultural medium. In 1963, 35 percent of all households in West Germany had a television set, the total number exceeding 7 million. Having spread rapidly in particular after 1954—the inauguration of West Germany's first statewide channel ARD—television programs of the early 1960s sought to appeal to audiences of diverse social backgrounds as much as they transported urban patterns of consumption to more rural areas. Yet in spite of its mass-cultural prominence, West German television in the early 1960s continued to endorse what had energized its inception a decade earlier: an emphatic cultural mission, a spirit of enlightenment and elevation. As conceived in the first half of the 1950s, the task of West German television was to mobilize culture against multiple

fronts simultaneously: against the commercialism of its American forerunners, against the way modern media had been used by National Socialism, and against the politicization of private and public spheres in East Germany and its Socialist allies. West German television in the early 1960s sharply emphasized its own political and moral responsibilities. Designed neither as a medium to commodify personal attitudes nor as one to manipulate popular opinion, emerging program structures were eager to reflect the fact that televised images and sounds would meet consumers at their most vulnerable sites, namely the intimacy of their homes.

The basic parameters of West German television culture, as they were to inform public broadcast practices at least until the early 1980s, were already envisioned prior to the existence of operative network structures and technological mass access. Television, it was claimed upon the launching of the first experimental regional station on November 27, 1950, fulfilled "one of the oldest wishes of humanity, namely our desire to be at several places at one and at the same time: at once seven-league boot and invisibility cloak."[9] Television, it was said, realized the utopian dreams of unrestricted mobility and voyeuristic invisibility as they had been encoded in ancient myths and popular fairy tales. It allowed people to traverse space speedily, as in the Grimms' famous tale, or to hide one's own appearance under a magic piece of cloth, as the hero of the medieval *Nibelungenlied* does. But in doing so, it was added, the new medium could support unwanted mass-psychological agendas and illiberal initiatives and for this reason should be made answerable to strong public demands and prudent interventions. According to Nord-West Deutscher Rundfunk (NWDR) administrator Emil Dovifat, culturally sophisticated program elements were to serve as antidotes to the peculiarly modern formation of anonymous, irrational, and seducible crowds. Only culture could truly be able to control and contain television's "magical development," that is, translate the medium's mythic powers into stable, bourgeois, and post-fascist structures of publicness.[10]

Due to the cultural zeal of early program directors, program structures in the first years of West German television mostly offered small modules of urbane entertainment presenting audiences with live news or enlightening conversations nightly between 8 and 10 p.m. Endowed with an aura of privacy, early programs featured a series of talking heads debating the latest developments in art, culture, and politics; travelers recounting their exotic adventures; zoologists describing animal behavior; cooks, coaches, and fashion designers dispensing personal advice on how to gratify the viewer's palates, bodies,

and eyes; and scientists spreading knowledge about the latest inventions and discoveries. Similar to the debates about cinema around 1900, early television in West Germany was haunted by wide-ranging anxieties about excess, uncontrolled reception, and the emasculating powers of consumption. The initial pursuit of limited and highly compartmentalized programming was a symptomatic expression of such fears. Short program blocks did not simply result from insufficient resources and capabilities but were considered quite intentional preemptive measures against the excessive use and mind-numbing abuse of the new medium. "We promise," solemnly declared NWDR director Werner Pleister on screen when inaugurating the first official West German broadcast on December 25, 1952, "to do our best to fill this new mysterious window to your apartment, this window onto the world, your television receiver, with what will interest and delight you and beautify your life."[11] As if trying to transplant Friedrich Schiller's eighteenth-century notion of aesthetic education to twentieth-century media culture, Pleister presented television as a tool of communication whose proper use could yield utopian forms of community. Television, in Pleister's view, contained the possibility of connecting people across existing differences and restore spontaneous feelings of mutual understanding and solidarity in each and every viewer. At once looking at and being looked at by the world, television users in Pleister's sense, precisely by taking in the multitude of clearly delimited program units, could reexperience nothing less than humanity's lost sense of totality and plenitude.

Aesthetic education, as facilitated by televised sophistication, was clearly not what Nam June Paik had in mind when displaying his eleven manipulated television sets at the Wuppertal exposition in 1963. On the contrary, one of the goals of this exhibition was to explore how the advent of technologies such as television urged contemporary audiences to rethink older notions of community, aesthetic experience, authenticity, and solidarity. Rather than reproduce mythic powers and utopian energies with the help of modern machines, Paik's ambition in Wuppertal, among others, was to use the television screen to expose the precarious role of traditional meanings and aesthetic sensibilities in the age of electronic mass communication. Consider *Rembrandt TV,* one of the installation pieces located in the exposition's main hall. It consisted of one television set, its face lying flat on the floor, the apparatus's brand name "Rembrandt Automatic" clearly visible on the machine's back casing. Legend has it that Paik had initially rewired the circuitry of this TV as he had some of the other devices on display. While transporting the set from his shop to Jährling's gallery, however, this particular model was damaged, causing Paik simply to

turn it upside-down, hence removing its screen from sight. A product of un-foreseen circumstances, *Rembrandt TV* was thus meant to be encountered in its sheer materiality, as a mere thing among other things, devoid of whatever could make it into a proper art object. Neither window onto the world nor a screen of aesthetic appearance, *Rembrandt TV* seemed to remove semblance and symbolism from the world of art. No author could claim authorship for its peculiar outlook. No visitor could or should mistake this object for a "work" in the emphatic sense, understood here as something that even at its most dis-sonant cannot do without a certain sense of unity, a purposeful relationship between its individual parts and the idea of the whole.[12] And yet, precisely by bringing into play a great painter's name to designate this object, Paik's instal-lation contained clear allusions to the categories of work and authorship. As it staged its own failure to frame and evoke aesthetic experience, *Rembrandt TV* provided a secondary frame exploring the problematic relationship between art and technology in a world of apparatical mediations. Seemingly reluctant to serve as window onto anything, Paik's *Rembrandt TV* asked the visitor to rethink the dominant opposition of organic and apparatical perception when envisioning the artwork of the future.

The emergence of modernist culture and its notions of autonomous art in nineteenth- and early twentieth-century Germany relied heavily on polemical gestures strictly separating the realm of art from that of technology. The *topos* of the split between the technological and the nontechnological served as one of the most powerful founding myths of modernism, even though many artists, poets, and writers were eager to turn the perceptual transformations associated with technological changes in modern life into viable engines of aesthetic cre-ativity and experimentation. Although, as Sara Danius persuasively argues, it might be more accurate to understand modernism as a form of crisis manage-ment, not exterior to but deeply immersed in the modern presence of tech-nologies and machines, its practitioners often actively renounced the historical conditions that brought their work into being in the first place.[13] Eighteenth- and nineteenth-century authors such as Johann Wolfgang Goethe and Julius Langbehn, by celebrating the Dutch Rembrandt as a German genius whose work transcended history and the social, certainly helped pave the way for this antitechnological bias of autonomous art and modernist practice in Germany. In nineteenth-century discourse, Rembrandt represented the mythic origin of art and aesthetic community as defined in radical opposition to the mundane realm of technological progress. The image of Rembrandt embodied every-thing allegedly denied by the age of technological reproduction: emotional

depth, authentic expressiveness, contemplative order. Hailed in particular by Langbehn as an educator of the German people, Rembrandt served as a pawn to decry modern technology as a realm of nonhuman and deterministic instrumentalism and to delineate its soulless territory from that of art, understood as a last repository of meaning, autonomy, and communal coherence.[14]

Paik's *Rembrandt TV* turns Rembrandt's legacy and the antitechnological bias of German modernist culture upside-down, both literally and symbolically. Obscuring the window that is television, Paik's installation challenges not simply the viewing expectations of ordinary television viewers but the way in which modern aesthetic culture was and continued to be constructed as a negative aesthetic—as one renouncing the very technological, institutional, and historical forces that made it possible. Paik's *Rembrandt TV* objects to the survival of genius aesthetics in modern(ist) artistic practice and cultural discourse. Negating the negative, his installation piece reenvisions the realm of aesthetics not as a realm of organic works and authentic expressions but as something concerned with the shifting nature of human sensory perception, with the contingent gratifications, pleasures, and shocks we may derive through our senses from the phenomenal. In this radically expanded aesthetic universe, technological mediation per se is neither good nor bad. Unlike certain pundits of both prewar and postwar modernism in Germany, Paik refuses to equate the modern realm of machines and apparatical reproductions solely with instrumental rationality and the nonhuman. As it mocks artistic authorship and the category of the work, *Rembrandt TV* demurs aestheticizing views of culture as a fail-safe antidote to barbarism, violence, and disenchantment. In its very refusal to provide a beautifying perspective onto the world, *Rembrandt TV* opened a window onto the viewer which, among other things, called into question the culturalist zeal of West German program directors like Werner Pleister. As seen through the hidden screen of *Rembrandt TV,* Pleister's dream of television as a tool of aesthetic education, collective enlightenment, and community building emerged as an ideology ignoring the constitutive dialectic of modernist culture. It grafted nineteenth-century notions of aesthetic autonomy and cultural edification onto the scenes of postautonomous media culture, whereas in Paik's view the true challenge would have been to understand how twentieth-century electronic communication had changed (and kept changing) the parameters according to which we define art, aesthetics, and culture in the first place.

Beauty, Change, Interest

My experimental TV is
not always interesting
but
not always uninteresting
like nature, which is beautiful,
not because it changes b e a u t i f u l l y
but simply because it c h a n g e s. [15]
—Nam June Paik, 1963

Television and Fascism

In a biographical sketch written around 1960, Nam June Paik recalls his life story as one situated at crucial junctures of German history. "1932, July 20," Paik reports, "day of the insurrection against Hitler, I was born in Seoul/Korea as the son of my father and mother." According to the Korean calendar, Paik's sketch continues, his birthday should actually be June 17, the "Day of German Unity," celebrating the uprising of workers in East Berlin against their government in 1953.[16] But Paik is quick to add that he would vastly prefer the July date "because, if the German people had been more forcefully against Hitler, the costly blood against Stalin would have been unnecessary. For that reason both days should be defined as national holidays, and not ONLY June 17, as it is today."[17]

Holidays, Walter Benjamin has written, skirt modern conceptions of time as homogeneous and empty. They operate like historical time-lapse cameras, at once remembering the history of past violence and establishing the present as a time shot through with chips of messianic redemption.[18] In Paik's autobiographical sketch, holidays serve the additional purpose of defining structures of identification and envisioning alternative courses of history. The claims of those who once resisted Hitler's rule remain open. Yet they call on us to imagine different versions of reality and hence emphasize the need to make ethical choices between competing memories and utopian political perspectives. To privilege one day of birth over another, for Paik, is not to substantiate the arbitrary character of his own life story. On the contrary, it is to emphasize how twentieth-century history has sought to contain the fundamental, albeit essentially ambivalent, contingency of modern existence and to resist the modern rationalization of time by reclaiming the power to choose between different temporalities and in this way to articulate counterfactual nodes of meaning and belonging.

Nam June Paik, *Exposition of Music—Electronic Television* (1963). Photo: Rolf Jährling. Printed by permission of the Gilbert and Lila Silverman Fluxus Collection, Detroit.

Paik's autobiographical sketch is a wish biography situating the artist as a resistance fighter against Nazi rule whose life cannot be thought without reference to larger historical developments, even if these developments stand in no causal relationship to the factual trajectory of his existence. Paik employs German historical memory as a window through which to witness his own life as a meaningful one, much as he uses his own life as a magnifying lens to differentiate between conflicting interpretations of the German past in the present. This dis-identification with the Nazi past becomes particularly momentous if we recall that Nazi engineers and politicians actively sought to develop the very technology that would inhabit the core of Paik's artistic practice starting in the early 1960s: television.[19] Surely, even during the heyday of televisual experiments in Nazi Germany around 1936, television never

came close to what it would mean to audiences, program directors, and image makers twenty years later. Contrary to expectation, the medium was actively developed during the 1930s not as a conveyor belt of political propaganda but mostly to prove the technological competence and modernity of Nazi society. But this development was significantly marred, and ultimately halted, by fundamental conflicts about the medium's position between radio and cinema as well as by struggles between government branches over who should control television's future. During the early years of Nazi rule, television was seen as a new tool to network the national community and engineer effective forms of intimacy amid a society of total mobilization. In 1937, television was called an "electric eye," allowing the viewer to stand "silently and inconspicuously" right behind Hitler when reviewing his troops and party members in Nuremberg.[20] But with the exception of a number of broadcast trials during the 1936 Berlin Olympics and the lackadaisical inauguration of a very few experimental television programs prior to the outbreak of World War II, not much came of the Nazis' initial visions of placing this new technology in the service of documenting Nazi modernity, let alone mobilizing the masses for the nation.

And yet, the shadow of how the Nazis sought to seize control over the electrical eye of television were to haunt the medium's future during its formative development between 1952 and 1963. Some of the greatest successes on early West German television were tied to issues of national crisis and postwar identity formation. The coverage of the East Berlin street fights on June 17, 1953, drew unprecedented audiences in the West and became emblematic for how this new medium could fundamentally restructure the political public sphere. A year later, millions of viewers witnessed the televised live broadcast of the 1954 World Cup final, not simply celebrating the German soccer team's triumph over Hungary but embracing television as a means able to rekindle German pride and self-confidence after Hitler. Uneasy about the potential that television could play into the hands of powerful political or economic agendas, the West German Supreme Court soon sought to curb federal plans to inaugurate a second television channel that would at once open the airwaves to greater commercial uses and, by circumventing the broadcasting authority of individual states, transfer unparalleled program control to centralized authorities. Lessons of the Nazi past clearly informed the Supreme Court's final decision of February 28, 1961, against what public opinion simply, if memorably, called "Adenauer television." Rather than endorsing the German chancellor's quest for institutional and political centralization, the Supreme Court decreed West German television to be neither apolitical nor noncommercial but rather

representative of the diverse voices within German society—independent from unbuffered commercial imperatives, ideologically unbiased, and free from any direct political affiliation. The installment of a second West German television channel, ZDF, on April 1, 1963—a week after the closing of Paik's show in Wuppertal—was largely seen as reflecting the Supreme Court's landmark decision, even though this new channel ended up being much more centralized and commercially oriented than the judges had envisioned. And Paik's show itself, with its emphasis on decentered contingency and interactive image manipulation, clearly provided its own commentary on who should have the authority to rule over what could be seen and heard on post-fascist television screens—and whether this new medium, after all the "costly blood" of Nazi nationalism and warfare, should ever again serve as a window of the nation.

Program Dispersal

> Imagine a future where *TV Guide* will be as thick as the Manhattan telephone directory.[21]
>
> —Nam June Paik, 1973

Thresholds and Windows

In the December 1952 issue of the interior design and architectural journal *Die Kunst und das schöne Heim,* Munich architect Ernst Hürlimann was asked to present his ideal living room. Hürlimann's design was of stunningly moderate proportions, indicative of German architects' overall disposition against grandiose gestures and extravagant volumes following World War II. In Hürlimann's house, living and dining room elements share the same space, the southern wall of which is pierced by a regular window and a huge removable balcony opening. What structures the space of Hürlimann's design are three seating areas—a small breakfast table seating two, a round cherry-wood dining table seating five, and a sitting-nook with an expansive lime-green bench, a strawberry-red wing chair, a yellow-ribbed arm chair, and two additional red chairs. Located along the room's walls and corners, these three seating areas create a curious void at the very center of the living room. When relaxing on one of the armchairs, you can enjoy panoramic views through the balcony opening; the arrangement is such that the balcony window extends interior space to the exterior as much as it allows the dweller to entertain illusions of being outside when relishing in the domestic comfort of the living room seat.

Heavy curtains, on the other hand, prevent the intrusion of blinding light or curious gazes when eating breakfast right underneath the second window.

None of this, however, can distract the inhabitant enough from not seeing the room's three nodes of activity as having a rather disjunctive relationship. Whatever we may see outside, within the room our gaze cannot but stumble across the strange emptiness that resides in the middle. And yet, we would be mistaken to understand Hürlimann's living room as incoherent and categorically ruptured. For what ties Hürlimann's space together is not the dwellers' visual perception but rather their anticipated movements between the different areas of activity. Scattered around a vacant space whose purpose is to enable open-ended transitions, Hürlimann's modular interior is primarily designed to appeal to a tactile and fundamentally unsettled sense of perception. What Hürlimann calls the "rhythmic 'correspondence'" between balcony and his three seating areas can be consumed, not through static or pensive acts of looking, but only through ongoing passages from one module to another.[22] The eyes of Hürlimann's ideal users are lodged in fundamentally restless bodies. Unable or unwilling to pause, these bodies traverse the void in the middle as if searching for anything that might carry their minds and gazes away. Neither the window in the breakfast niche nor the panoramic balcony opening seem to provide enough to satisfy their desire for distraction and imaginary escape. Like Rainer Werner Fassbinder's Maria Braun, they cannot find peace and therefore pace around in their own dwelling. Dedicated to individual achievement, they are haunted by memories of the past. Pursuing material gain, they are unable to envision alternative futures. And yearning for redemptive transformation and self-redress, they end up endlessly repeating what they repress or cannot understand in themselves.

Did the advent of television, introduced in West Germany at precisely the moment when Hürlimann presented his ideal living room, succeed in pacifying the nervous and agitated dwellers of the economic miracle? Did it soothe their restless minds and provide their unsettled houses with a renewed sense of order, stability, and visual mastery?

Eleven years after the article on Hürlimann, at a time when television had already invaded more than a third of all West German households, the editorial agenda of *Die Kunst und das schöne Heim* clearly sought to accommodate the ever-increasing presence of the new medium in living rooms. To be sure, rarely do we see actual television sets in many of the journal's illustrations. Following the dominant international trends of the time, the journal mostly alludes to television sets as something hidden behind Danish teak-wood wall

units or media cabinets. As a result, the journal's contributors talk about the new apparatus, but they rarely show it. If we see television sets in their photo essays at all, they tend to occupy the corner of a living room. In fact, in most cases the position of the television set is modeled on the former location of the radio, as if people would solely listen to the machine's sounds and have no desire to watch the images from a frontal perspective. What haunts the journal's pages, in other words, is a certain embarrassment about the new medium. Interior designers, architectural critics, and photo reporters imagine the television set as something else or hide it from view in order to elude the way in which this apparatus had redone (and continues to redo) people's domestic pleasures and living arrangements. And yet, even largely concealed, television sets leave marks of their presence all over the place; most interior designs presented in *Die Kunst und das schöne Heim* around 1963 reveal clear signs of a symptomatic return of the repressed.

Consider Johanna Schmidt-Grohe's February 1963 article about a show house in a row house settlement close to Munich. Designed by Lois Knidlberger, the housing development's task, for Schmidt-Grohe, was to translate the idea of the American suburb into a West German idiom. It therefore had to solve a number of difficult challenges, in particular how to overcome considerable space restrictions, maintain privacy, and preserve a sense of proximity to nature amid a heavily built environment. Knidlberger, for Schmidt-Grohe, solved these particular problems with an ingenious encapsulated patio design. The settlement's many courtyards are not simply added to prefabricated housing plans but rather define the perimeters of individual dwellings in the first place. The vision of the atrium, in other words, preceded the blueprint of the home, each yard constructed such that "one does not necessarily have to participate in the neighbors' outdoor life and can cultivate uninhibited family conversations and sun baths."[23] Instead of asking its dweller to pace between different nodes of domestic activity, Knidlberger's design envisions a more relaxed and stationary inhabitant enjoying the comfort of privacy even within semi-public and exterior settings. His patios incorporate the outdoor world into the home just as much as they promise to bring the interior world outdoors, thereby giving the dweller a fantasy of privatized mobility free of restlessness and physical exertion. You can see, it is emphasized, the trees far beyond and above the walls of your patio as if they were solely there for your private delight. The home as a whole thus becomes a vehicle of transport, a motor of imaginary mobility. It allows people to move their lives to different spaces without sacrificing their sedentary impulses.

Atrium House, 1963. Reprinted from *Die Kunst und das schöne Heim* (February 1963): 282.

This sense of intimacy, inert mobility, and unhampered relaxation extends to the home's interior as well. Like Hürlimann eleven years earlier, Knidlberger emphasizes the functionalist design and modular character of the living room. Due in part to the use of new nonstick and nonslide floor materials, however, Hürlimann's quest for continual physical mobility in Knidlberger's design pertains not to the dwellers themselves but to their furniture: "Instead of a larger couch table we have smaller, lighter side tables. Chairs and benches too are less voluminous; they can be turned without effort and just as the mood takes one toward the court yard, the television set, or the slide projection wall."[24] In the ideal home of 1963, it is no longer the people but the dwelling's objects that are and have to be on the move. Their ongoing repositioning stands in direct, albeit inverted, relationship to the dweller's sense of ease and relaxation. As long as you can easily rearrange the furniture, you can calmly go traveling and consume the world in miniature from within the home. In this way, the home's moving objects at once facilitate and allegorize the dweller's dreamlike separation from the social space around the house. These objects turn the house into a nonspace that reinvents the world as a world framed by the patio door and wall, captured by slides recalling past travels, and put on view by the television screen—a world in which the subject's body and motion no longer serve as a kinesthetic key to reality.

Margaret Morse has argued that in the age of television "oppositions between country and city, nature and culture, sovereign individual and social

subject are neutralized only to be reconstituted within nonspace in a multilay-
ered compromise formation, a Utopian realm of *both/and,* in the midst of *nei-
ther/nor.*"[25] In Knidlberger's show house of 1963, television's *both/and* becomes
the norm of domestic experience. It enables the dweller to live in a permanent
elsewhere without ever leaving the everyday. Though at first sight only one of
its various gadgets of imaginary transport, the television advances to the or-
ganizing metaphor of domestic architecture and interior design in general. To
serve the leisure needs of West Germany's citizens of the early 1960s, Knidl-
berger's Munich row houses themselves turn into televisions. Like television
screens, these dwellings provide intimate diversions that accommodate desires
for both movement and stasis. As if trying to sublate the new medium in the
Hegelian sense of the word *aufheben,* these ideal homes of 1963 offer windows
onto the world that condense spatial relationships, recast public space within
domestic settings, and redefine the real as an effect of technologically medi-
ated frames of distraction. In a curious dialectic move, these houses at once
incorporate and displace television with the intentions of universalizing the
medium, synthesizing all contradictions, and thereby suspending any dialecti-
cal understanding of the world whatsoever.

In an essay written in the immediate aftermath of *Exposition of Music—
Electronic Television,* Nam June Paik explained the show's ambition to dispute
the impulse I just located at the core of Knidlberger's housing design. Instead
of simply displacing history and the real, Paik's exposition wants to show how
experiences of displacement give birth to reality and historical time in the first
place; we should embrace this state of displacement not as a site of sedentary
escape or lament but as an ongoing source of choice and change. According to
Paik, *Exposition of Music—Electronic Television* explores the ecstatic as the nor-
mal condition of individual existence. One meaning of the Greek word *ekstasis*
understands the ecstatic moment as a disruptive flash of divine intervention,
a mystical instance of absolute self-identity and transcendental communion, a
discontinuous halting of mundane time in favor of an exclusive mode of con-
templation and inspiration privileged by artists to draw boundaries between
high art and mass cultural practice. Paik opposes this etymology, recalling
Jean-Paul Sartre's analysis of the ecstatic as the most ordinary condition of the
human mind. Human consciousness and being, for Paik, can never be self-
identical nor in unmediated communion with the divine and transcendental.
We live beside ourselves even in the most ordinary situation. The experience
of ourselves as other is the principle condition of human existence, and it con-
demns all of us—not just the privileged artist—to think and ask questions.

In Paik's Sartrean view, the desire for ecstatic self-identity desires the end of history and hence human free will.

The television sets of *Exposition of Music—Electronic Television,* by contrast, want to promote the non-identical as the basis of historical temporality, as a source of profane illumination rendering visible the aleatory and contingent nature of contemporary space-time. The windows of Paik's television sets empower ecstatic experiences not because they serve as theaters of temporary self-redress and imaginary mobility but on the contrary because they provide threshold spaces where, recalling Baudelaire's understanding of the window, "life lives, life dreams, life suffers."[26] Like Baudelaire's windows, Paik's television sets of 1963 were meant to be holes at once black and luminous. Their purpose was far from suturing contradictory spaces and times into imaginary experiences of wholeness and reconciliation. Defying the utopian *both/and* of conventional televisual practice, Paik's installation rejected the way that contemporary broadcast contents and architectural designs positioned television as a mechanism fusing conflicting desires for stasis and mobility. Unlike Knidlberger's house of the same year, the task of Paik's 1963 television sets was not to synthesize existing contradictions or to obscure the work of displacement but rather to turn the incommensurable into an engine of history and in so doing to exhibit "the dialectical movement of our spirit as a proof of our freedom."[27]

Non-identity

> I AM ALWAYS WHAT I AM NOT and
> I AM ALWAYS NOT WHAT I AM[28]
> —Nam June Paik, 1963

Sex, Abjection, Television

Television, Paik wrote in somewhat ungrammatical English a few years after the Wuppertal show, "is as mass media as sex. Before Kinsey beautiful lady used to whisper to her neighbour, 'My husband plays only one piece on piano . . . and always with one finger. . . .' Kinsey wiped out this frustration and made the heresy to the authodoxy. TV-culture is in the pre-Kinsey stage at this moment. As wife was just a sex machine for her husband (before), public is just the Pavlovian dog for the network (presently)."[29] Public discourse on television during the 1950s and early 1960s, in both West Germany and the

United States, endorsed the new interface as a tool of purifying social space while at the same time worrying about new possibilities of moral pollution and contamination. On the one hand, television offered a window frame that could limit experience and social encounters to the seemingly safe and pre-dictable arena of the familiar living room. Televised images had the power to draw people, in particular teenagers and adolescents, away from the streets.[30] They could divert people from entering sinful places, cleanse messy urban environments, and in this way contain the increasing blurring of social dif-ferences. Tapping on much older myths and utopian visions, commentators and program directors thus did not even hesitate to present television as a new window of opportunity for building "an intellectual neighborhood, purified of social unrest and human misunderstanding."[31] On the other hand, however, television's antiseptic stance was also seen as an agent of new forms of disease and corruption. The television screen not only placed the world in the heart of the living room, but in doing so it also could produce addictive behavior and consummating passivity. Toppling former boundaries between interior and exterior spaces, television was suspected of causing widespread emasculation and in this way undermine parental and paternal authority in the home. As the new machine's Pavlovian dog, viewers would no longer be able to control their intoxication and could not but develop pathological fantasies of omnipo-tent presence and control. As television critic Werner Rings feared in his 1962 treatise *The Fifth Wall,* "Hundreds of Millions of people plunged themselves into this new experience, into this whirlpool of dreamlike lust and desire, with one push of the button, with a mere turning of a switch, to summon men and women, destinies and events, faces and foreign worlds to their screen and hence to come to them."[32]

Whether seen as antiseptic or addictive, the breakthrough of television dur-ing the 1950s triggered public arguments in which—reminiscent of earlier de-bates about cinema—medical metaphors played a key role in explaining the new medium's costs and blessings. Instead of simply alleviating prevalent fears about television in the larger public and the artistic community, it was one of the tasks of Paik's 1963 *Exposition of Music—Electronic Television* to expose the profound complicity between the advocates of electrical purification and the opponents of televisual contamination. For to speak about television in medical terms, for Paik, was to miss how television had fundamentally altered the very terms of how one can speak about the integrity of human bodies and desires in the first place. Public discourse around 1960 devoted itself to the question whether television was healthy or not. In the perspective of Paik,

however, the true question was whether the invention of television had not transformed the entire nature of what constitutes a healthy, sick, desiring, or virtuous body.

The cow's head in the entrance area of Galerie Parnass served as a preview of such coming attractions. Its point was to turn the viewer's attention away from the realm of public language and the existing metaphoricity of health and disease toward the radical materialism of abjection. The abject, in Julia Kristeva's understanding, escapes the symbolic order. Abjection is aligned with the flesh and its dissolution, with viscosity and bodily fluids, with speechless desire and death.[33] Like the cow's head, Paik's Wuppertal television sets presented sites of the abject as well. Their principal meaning was to puncture the symbolic and contest meaning. Things among other things, these television sets were designed to cut across the kind of discourses that considered television an agent of either public cleansing or collective pollution. For the existing arsenal of medical language, according to Paik, necessarily kept television in what he called "the pre-Kinsey stage." Whether it was used to promote or interdict the apparatus, the medical metaphor repressed the medium's full range of possibilities: its ability to interconnect minds, bodies, desires, and visions across space and time. By showcasing the abject, Paik's Wuppertal exhibition hoped to clear the symbolic ground for a more wide-ranging discussion of televisual communication. It established television as an advanced catalyst of sex so as to protect the medium's utopian promises from public containment; for the "infinite potentials of TV, such as: two-way communication, audience participation, 'electronic democracy through instant referendum' (John Cage) . . . is by far ignored or delicately suppressed."[34]

The End of the Couch

On October 11, 1963, Gerhard Richter and Konrad Lueg launched a one-night show at the Berges Furniture Store in Düsseldorf. Entitled *Life with Pop: A Demonstration for Capitalist Realism,* the event made use of the store's entire display area, including several dozen bed rooms, living rooms, kitchens, and nurseries. Richter and Lueg presented themselves as living sculptures in the first exhibition room:

> Lueg sat in a chair mounted on a white plinth, Richter lounged on a couch—also on a white base—reading a detective story. Other elements of the installation included designer magazines, a set of the complete works of Winston Churchill, a television turned to the news and to a special on the

Adenauer era, which had just ended in 1963, assorted coffee cups, glasses and bottles of beer, and in a wardrobe by the door the "official costume of Prof. J. Beuys (hat, yellow shirt, blue trousers, socks, shoes; to which 9 small slips of paper are attached, each marked with a brown cross . . .)."[35]

Unlike many of their American counterparts, German pop artists of the first half of the 1960s appropriated popular forms and consumer culture in order to express their wary attitude toward the materialist longings, packaged desires, and mass-mediated forms of alienation in West German society of the "economic miracle." Having initially grown up under the rule of socialist realism in East Germany, Richter in particular—in spite of his pop endorsement of depthlessness and the surface around 1963—often perceived the West's consumerism and material culture as merely a reverse image of how East German authorities manipulated minds and emotions in the name of historical materialism. In *A Demonstration for Capitalist Realism,* it was not least the function of a television set—located such that it fundamentally unsettled the installation's living room arrangement—to communicate these misgivings. Neither Lueg's armchair nor Richter's sofa allowed for ideal views of the screen image; neither Lueg's nor Richter's gaze could really be directed comfortably at the apparatus. And yet, with its cabinet doors flapped open like wings, its angular position, and its flickering images of Adenauer, the TV clearly dominated the space of the installation—much more so than Lueg's and Richter's rather bored postures or the seating unit's elevated and perpendicular grouping. The installation thus presented television as a vehicle not of mindless distraction or imaginary transport but of uncanny surveillance: a panoptic eye whose electrical gaze has the power to restructure spatial relationships and monitor social behavior.

In his analysis of how television affected living room arrangements during the 1950s, Martin Warnke has argued that the arrival of television sets forced open the tightly integrated grouping of sofas, armchairs, and coffee tables in postwar West German apartments. Though furniture designers were eager to assimilate the machine's exterior outlook to the appearance of other living room fixtures, television sets ended up exploding the relationship between seating elements, thus to some extent reinstating the open and transparent constellation of the eighteenth-century salon. Confronted with the new apparatus's appeal, West German couch elements lost their autonomy and isolation. The machine forced armchairs away from their habitual positions, made coffee tables disappear, and moved entire sofa arrangements out of their protective corners into more central locations. Television sets unfettered the

taut association of living room elements, yet it was not in order to enable new forms of intimate communication between sheltered dwellers but rather to reorganize their privacy in light of the electrical eye's publicness or, conversely, to reorder other spheres of life along the principles of living interaction. Whereas in earlier times the domestic sphere had been able to privatize public services such as the water toilet, the bath, or the concert hall without much difficulty, the advent of television dissolved the boundaries of the domestic sphere from both the inside and the outside—a process of disintegration which, at least in the late 1950s and early 1960s, could still be seen as fundamentally ambiguous and potentially utopian: "The sofa corner, which during the twentieth century has emerged and been successful as a symbol of a secluded and intimate private existence, is bound to be dissolved within the outside world. It is impossible to say whether the world will become more inhabitable in response or whether one of the last counter worlds will thus be exhausted."[36]

Paik's 1963 *Exposition of Music—Electronic Television* was designed to explore this transitional space between pre- and post-electronic forms of privacy, habitability, and surveillance. One of Paik's television sets at this exposition was connected to a microphone. It was prepared in such a way that, by speaking into the microphone, the user could at once produce and witness a virtual firework of light dots on the television screen in real time. Television, for Paik, was clearly not a sedentary activity carried out passively in cushy armchairs and sheltered domestic environments. A closed-circuit installation, the microphone set enabled interactive forms of viewing that positioned human and machine in some kind of reciprocal relationship. Sound here was being transformed into a visual surface, which in turn could impact on the viewer's bodily input. Situating the machine as an organic extension of the body and the body as the machine's annex, Paik's installation thus also challenged what Lueg and Richter in their exhibition of the same year took for granted, namely the understanding of television as an inevitable assault on people's intimacy. Television's most salient feature, for Paik, was to help render visible our innermost desires, needs, and sensibilities. Properly used, this new type of window could become receptive to personal fantasies, emotional intensities, and corporeal motions and thereby liberate us from bourgeois codes of behavior. For Paik, the question in 1963 was not whether television sets might change living room arrangements and graft public demands onto the topographies of private life. Instead, by allowing television both to translate human expressions into different registers of visual figuration and to return the viewer's gaze and voice, Paik presented the world of television as one in which binary oppositions such

as the ones between the private and the public, interiority and exteriority, had become problematic.

Paik's television sets were prosthetic devices. They took on organic qualities and infused the human body with apparatical features. Television could reveal to us our own otherness while bringing to light haunting correspondences between the world of objects and the human sensorium. For this reason, for Paik, the disapproval of television as a tool of domestic alienation and chilling surveillance tended to miss the point. It let older notions of domestic closure and existential authenticity in through the back door, whereas the true challenge would have been to understand how electronic media turn us into universal nomads whose bodies have always already entered into symbiotic relationships with the things around us. Unlike Lueg and Richter, Paik saw television per se neither as reifying illusions of bourgeois seclusion nor as automatically disciplining the private sphere as an increased technique of surveillance. Instead, the *telos* of television, for Paik, was to invalidate the conditions that produced modern notions for privacy as much as public regimes of visual control in the first place. Paik's 1963 world of television was a world of permanent displacement and homelessness in which specters of desire cut through the order of the day.

Art, Technology, and Intentionality

> In usual compositions, we have first the approximate vision of the completed work, (the pre-imaged ideal, or "IDEA" in the sense of Plato). Then, the working process means the torturing endeavor to approach to this ideal "IDEA." But in the experimental TV, the thing is completely revised. Usually I don't, or *cannot* have any pre-imaged VISION before working. First I seek . . . the "WAY," of which I cannot foresee where it leads to. The "WAY," , , , , , that means, to study the circuit, to try various "FEED BACKS," to cut some places and feed the different waves there, to change the phase of waves, etc.[37]
>
> —Nam June Paik, 1963

TV, Communication, and Art

Paik's 1963 interest in television as a medium of sexual encounter and as a closed-circuit screen of electronic "feed backs" might at first either be seen as a masturbatory fantasy of the first rank or, more importantly, as a contradictory approach to modern communication technologies.[38] Paik's sexual metaphor implies a model of communication that favors dissemination—the spilling

and potentially wasteful spreading of seeds—over the Socratic ideal of embodied dialogue. Communication as dissemination does not aim at establishing a reciprocal union between sender and recipient, nor does it necessarily constitute an effective means of transporting contents. A one-way street, it leaves the choice of interpretation entirely to the recipient, including the option of ignorance or non-receptivity. Dissemination recognizes disembodied communication—the temporal and spatial gaps between sender and recipient—not as uncanny and hazardous but on the contrary as a means of freedom and productivity. The willingness or desire to dissipate seeds across various distances implies the recognition of the other as other. Paik's exploration of feedback circuits, on the other hand, is indebted to an understanding of communication as a reciprocal, non-hierarchical, immediate interaction between equal participants, a form of soul-to-soul exchange that bridges the gap between non-identical particulars in real time and embodied space. Feedback communication has no tolerance for personal inaccessibility and protective distance. It wants chasms to be erased and the sheer materiality of communication not to stand in the way of the inspiring transaction of ideas, meanings, and pleasures.

Nam June Paik was certainly not the only artist in West Germany exploring the aesthetic dimensions of television and redefining the concept of art after the advent of electronic media. What makes his work unique in the particular context of German art in the 1960s, however, is that his Wuppertal exposition neither demonized television as an instrument of alienated communication nor celebrated it as a mechanism of mass communication whose anti-dialogical aspects would automatically set right postwar ideologies of domesticity and cultural consumption. Television itself, for Paik, is neither good nor bad. What counts is what you do with it. Rather than opting for a single model of mediation, Paik's work with television hovers between seemingly opposite views of electronic communication as dialogue and as dissemination. Television, in Paik's view, can and should do both at once: scatter ideas, images, and pleasures and also foster a marriage of different minds and explore new zones of intimacy, solidarity, and articulation. Dissemination, for Paik, might indeed—as John Durham Peters has put it—have become our lot in the age of television and constitute a mechanism quite apposite to "the weirdly diverse practices we signifying animals engage in and to our bumbling attempts to meet others with some fairness and kindness."[39] But at the same time, according to Paik, we cannot do without those rare moments of reciprocal dialogue when the window of television allows us to touch directly upon the other's mind and soul. As envisioned circa 1963, Paik's ideal television is a hybrid of

different modes of communication that does not seek to resolve the opposition between dialogue and dissemination.[40] For Paik, to communicate to another through television, including to the strangers in our own selves, is to desire what Hegel's called a "union of union and non-union,"[41] a harmony within diversity, a scenario of mutual recognition that preserves rather than erases the particularity of its individual moments.

It is Paik's dual interest in the dialogical and disseminative possibilities of television as window onto the other that defines the fundamental difference of his work from that of other West German artists who employed television in their artistic projects during the 1960s. Unlike Paik, the work of most of his colleagues in West Germany in this period—including that of his Fluxus brothers in arms Wolf Vostell and Joseph Beuys—initially approached television as a mere symptom of postwar alienation, escapist consumerism, and mind-numbing passivity whose very objecthood needed to be destroyed to clear the way for more interactive forms of exchange. Driven by the dream of communication as a two-way communion of the souls, these artists entertained often highly destructive strategies to attack what was perceived as television's inherently wasteful and oppressive elements. In contrast to Paik's retooling of television circuitry, the most common strategy in West Germany in the early and mid-1960s was simply to destroy or at least blindfold television's proverbial function as a window onto the world. Television, for these artists, was violence by other means, and they saw art's task to fight this violence with any means available. Wolf Vostell's installation *TV Begräbnis* (TV Burial) of 1963, for instance, presented a damaged television set surrounded and hence further disabled by barbed wire, packages of turkey breast, and a music stand. At the YOU happening in New York in 1964, Vostell did not hesitate to set fire to a number of television sets, a gesture that could not but recall the burning of books in Germany a generation earlier. Günther Uecker's installation *TV* of 1963 consisted of a television set placed on a round wood table, both pieces punctured by hundreds of nails whose function was to at once render inoperative and mask the apparatus. Likewise, in an intertextual gesture of 1967, a work entitled *Wrapped Television Set (for Nam June Paik)*, Bulgarian-born artist Christo, well, wrapped a television set in polyethylene material and string—not in order to extend auratic qualities to the machine through strategies of veiling but simply to camouflage the object and obstruct any kind of visual exchange with its screen. Wolf Kahlen's 1969 *TV Spiegel* (TV Mirror) turned the screen of a contemporary TV set into a mirror surface, thus urging the viewer to see him- or herself rather than behold of faraway distrac-

tions. And Jürgen Waller's oil painting *Der Fernseher* (The Television) of the same year showed a male viewer succumbing to physical exhaustion after work in front of a television set, his body having partially assumed the shape of his armchair while images of murder and violence pervade his room, further benumbing his already numb outlook.

For most West German artists working with or addressing the role of television in the 1960s, the machine's window itself embodied power and aggression, whose tyrannical aspects had to be challenged by aesthetic practice. Informed by intellectual traditions that favored the immediacy of communal dialogue over the disseminative functions of mass communication, this early work about television by and large demonized the apparatus as a tool of deception, manipulation, alienation, and social fragmentation. Unlike Paik, whose aim in 1963 was to explore alternative models of televisual pleasure, the early installations of Vostell, Uecker, and Kahlen were intended as anti-television. For them, no good could be discovered in disseminative tools of communication or in electronic windows opening views onto the alterity of self and other. It was only toward the end of the decade and then in the 1970s that Paik's attempt at reorganizing rather than rebuffing television found resonance among West German artists. In particular the work of Vostell, whose installations of the early 1960s are often falsely considered comparable to Paik's own initiatives, now embraced television as a medium to address the role of corporeal experience and social mobility in postwar society and to envision new kinds of mediated pleasures and perceptions. Vostell's 1970 montage *Entwurf für ein Drive-in Museum* (Design for a Drive-In Museum) showed a freeway intersection with two enormous television sets placed at its center with numerous arrows pointing toward their screens. It anticipated his 1981 work *Die Winde* (The Winds), a 1965 Mercedes station wagon equipped with a video camera and twenty-one embedded television monitors to display images while the car was being driven around West Germany.

In these and other drawings and installations, television was no longer simply seen and physically attacked as a demonic eye homogenizing consumers, surveilling minds, and disciplining the senses. Instead, like Paik's prophetic ambitions in Wuppertal in 1963, television was now explored as *the* a priori of both visual perception and artistic practice in a world obsessed with movement, progress, amnesia, and travel. Recalling Paik's earlier explorations, Vostell's work of the late 1960s and 1970s suggested that television was symptomatic of the unsettled state of postwar West German society while acknowledging the ambivalent potentials of televisual communication—potentials whose future

could not be decided by these machines themselves but by people using them in different institutional contexts. As with Paik, Vostell's later work revealed the extent to which postwar anxieties about television reflected not the operations of the machine itself but the legacy of romantic notions of communication as a communion of disembodied souls.

Faraway, So Close!

But then again, does it make sense to call Paik's manipulated television sets at the 1963 exposition "tele-visual" in the first place? If the Greek prefix *tele-* implies "reaching over a distance," if it involves transfers "carried out between two remote points," then shouldn't we understand Paik's Wuppertal machines as zoom lenses defining zones of proximity and immediacy? As anti-television, after all?

Consider one installation piece, which allowed the visitor to produce an instantaneous firework of light dots by depressing a foot-pedal to short-circuit the set's normal electronic operations. Paik's manipulated set situated the user as his or her own program director, cinematographer, editor, and gaffer. Instead of transporting the viewer across distances, this set identified the act of watching television as an experience of closeness, however many feet of circuitry it takes to produce the image on screen. In continuation of a good deal of nineteenth- and twentieth-century writing on the physiology of vision, Paik here explored seeing not simply as an optical activity but one also deeply imbricated with haptic elements. Sight, for Paik, is never autonomous or pure. In order to be both effective and gratifying, it has to be in contact with other modes of sensory perception that help establish subjective relations to the space around us. According to Paik, vision is more than simply embodied: it is an inherently messy affair unthinkable without our sense of touch. Paik's Wuppertal television sets literally seek to bring the visitor's eye in touch with the images on screen. Instead of untying the senses and allowing the faculty of sight to travel across large distances, Paik's installations hope to reintegrate human sensory perception, wed vision to touch, and engineer a viewing subject different from the one favored by public television's regime of sedentary mobility. Paik's fireworks on screen are near-visions not because they experiment with closed-circuit arrangements but mostly because they contest the hygienic separation of different forms of perception that has energized so many modern visions of the interface and their ability to carry us to remote points while never leaving our living rooms or home offices.

Television, Rudolf Arnheim presaged in 1935, "is a relative of the motorcar and airplane: it is a means of cultural transportation. To be sure, it is a mere instrument of transmission, which does not offer new means for the artistic interpretation of reality—as radio and film did. But like the transportation machines, which were a gift of the last century, television changes our attitude to reality: it makes us know the world better and in particular gives us a feeling for the multiplicity of what happens simultaneously in different places."[42] With the introduction of the portable Sony TV8-301 in 1959, leading television manufactures began to translate Arnheim's comparison of television and motorcar into compelling electronic designs. In contrast to dominant trends of the 1950s, television sets were now no longer hidden in rustic wall units or self-effacing media cabinets. Nor would they much longer transfigure their purpose with the help of pompous brand names such as *Rembrandt* and *Rubens*. Instead, what now came into fashion was a new kind of at times playful, at times austere functionalism: sleek forms, open designs, stripped-down ornamentation, cryptic product names. Television sets in the early 1960s increasingly and ever more self-confidently displayed what they were asked to do, namely serve as vehicles of transport. Their shapes referenced the curved and aerodynamic design of automobiles circa 1960, while advertising campaigns presented television sets as participating in the age's passion for space travel—as domestic allies in the attempt to overcome the Sputnik shock. Assertively packaged as transportation machines, television sets in the course of the early 1960s thus progressively lost their former status as a domestic bad object. Technology now no longer was feared as detrimental to domesticity, the screen's outlook no longer experienced as a cold eye staring at what might—or might not—go on in front of it.

The short-lived popularity of portable television designs around 1965 completed this trend, even though—as Lynn Spigel has shown with regard to the American market—it also added yet another dimension: "Rather than incorporating views of the outdoor world into the home, now television promised to bring the interior world outdoors."[43] Portable television sets of the early 1960s embodied the dream of privatizing social mobility and domesticating a world ruptured by political unrest and global polarization. Rather than situating the home as a passive window onto the world, this new generation of television sets promised the viewer an experience of domesticity itself as active and vehicular, as a form of transport allowing people to experience public spaces and natural environments as private topographies. Though much of this remained fantasy, the hype about portable television sets in the 1960s was

a clear sign that television's capacity to "derealize space" had become the order of the day.[44] Whether they mobilized domestic space or domesticated public mobility, the designs of television sets in the early 1960s at once reflected and influenced the age's fascination with movement, progress, and travel as something that could be experienced not in radical opposition to but in symbiotic communication with the materiality of the home.

Paik's television sets of 1963 belonged to a product generation whose physical appearance preceded the 1960's rhetoric of functionalism, portability, and space travel. Their design, even prior to Paik's interventions, was far from ready to emulate the dynamic shape of cars, airplanes, and rocket ships. And yet, by subjecting "live-transmissions of the normal broadcast program" to active user manipulation, Paik's installations in Wuppertal sought to complicate the links between television and vehicular transport established in the 1950s and 1960s.[45] As if trying to disprove Arnheim's prophetic statements of 1935, Paik's foremost ambition was to use the medium in order to achieve a new artistic interpretation of reality. Television, for Paik, was not simply a neutral tool of cultural transportation, it also offered a novel means of engaging the human sensorium, of exploring the linkage of sight and touch, and hence of practicing art in the age of postautonomous culture. As importantly, however, Paik's television sets, precisely by enabling near-vision, were meant to explore what was foreign and remote in the viewer him- or herself. Launching electronic fireworks through physical motion, Paik's users were able to open up image spaces in which bodily innervations could become apparatical discharge and electronic figurations could produce unforeseen corporeal movements. Paik's fireworks made their viewers look inward, explore the multiplicity of their own temporal and spatial coordinates, and find enchanting displacement much closer to home than expected. Machine and body were encouraged here to enter symbiotic relationships whose dynamic could transport the viewer to other places and times far more dramatic than the ones presented on regular broadcast programs. The exposition's task, then, was not to bring us to the other but to unearth the other in us. Its charge was to liberate the energies of non-identity, allowing viewers to traverse the uncanny realms between the human and the machine like subway riders plotting their routes through the modern city's unconscious.

Flow, Crisis, Contemplation

The majority of German intellectuals, addressing the new medium of television in the 1950s and 1960s, by and large reiterated arguments launched against

cinema during the so-called *Kino-Debatte* in the first two decades of the century. Similar to public film exhibition, television was seen as an agent of seduction: a hazard as much to public health as to personal identity. By transforming the world into an image and carrying it to the living room, television—so the argument went—converts autonomous individuals into inactive consumers in whose impoverished imagination voyeuristic pleasures and fantasies of godlike omnipotence would become one and the same. Part of modern serial culture, television—it was feared—erases the boundaries between being and appearance, reality and image. Virtualizing mobility, television—it was repeatedly concluded—undermines the conditions of the possibility of experience. As it takes the "fahren" out of "Er-fahr-ung" (experience), television renders impossible dynamic encounters of world and self.

As early as 1953, Theodor W. Adorno criticized the very form of television as a direct expression of instrumental reason and capitalist reification, eliminating the last residues of mimetic behavior and non-identity in modern society. The window of television, according to Adorno, by capturing the real as a bounded image, mirrors the logic of commodification. Its primary purpose is to entertain fantasies to own the world as personal property. Television thus produces forms of distraction that subject the viewer to improved strategies of discipline and manipulation: "In that television awakens and visually represents what preconceptually slumbers in the viewer, it at the same time prescribes them how to behave."[46] In Adorno's relentless perspective, television's aim of bridging distance and transporting us to remote sights is pure ideology. What television does is not bring people together across distance but dictate a false sense of solidarity and proximity, which only furthers the larger course of alienation.

No less relentless than Adorno, Günther Anders in 1956 spoke of television as a nemesis to human interaction, intersubjectivity, and dialogue.[47] Television turns words into depthless images. It impedes our need to speak and interact and allows us solely to listen, and because spoken dialogue, for Anders, provides the grounds for our identity as humans, television pushes the viewer far down the evolutionary ladder. It infantilizes our minds and enfeebles our emotions. Hostile to the rich texture of spoken language, television enslaves its consumer. It leads to the banalization of public discourse, undermining anyone's ability to articulate ideas, feelings, and agendas. Lacking the critical power of words, television, according to Anders, promotes a society in which not only the reproduction becomes more important than its original, but the original also has to assimilate to its mass-reproduced image to be seen or heard in the first place.

Given German intellectuals' antagonistic response to the popular success of earlier media such as the phonograph and the cinema, their reaction to the breakthrough of television during the 1950s should not really come as a surprise. What does surprise, however, is the extent to which German intellectuals located the detrimental effects of television almost exclusively in its visual modes of address, that is, in how televised images seemed to reify the world into a commodity, deplete the wealth of verbal communication, flatten our understanding of the real, and thus advocate consumerism and spectatorial inactivity. If German intellectuals in the 1950s and the early 1960s rejected television as barbarism, it was mostly because they saw the spread of televised images per se as a corruption of cultural refinement. What they did not address, on the other hand, was how television broadcasts fundamentally restructured people's sense of time and how televised images provided windows on the world that were as much optical as acoustical in nature. Adorno and Anders basically loathed television in the 1950s because it extended commercial cinema to the private living room. Something already bad had thus gotten even worse. In understanding television as cinema by other means, however, they tended to forget that the reorganization of temporal experience was perhaps a much more important effect of television than the inundation of viewers with a flood of images, and that television produced forms of distraction and attention quite unlike those associated with cinematic pleasure.

For doesn't television's specificity lie less in its pervasive proliferation of moving images than its insistence on presentness and its celebration of the instantaneous? Unlike photography and cinematography, both of which were hailed (and feared) as techniques of reversing the flow of time and embalming the past, the medium of television promised not to deal with death and the forgotten but the cataclysms of an eternally changing present. In contradistinction to the photographic image, television has the potential to annihilate memory and history because of its stress on nowness. It promulgates structures of temporality void of resolution: the punctual, contracted time of crisis and catastrophe in which everything seems to happen at once and—unlike narrative cinema—nothing seems to develop. Catastrophe, as Mary Ann Doane has persuasively argued, is the very stuff of television broadcasting. While television in particular during the 1950s profoundly reshaped people's leisure time and helped render natural the rhythms of the social order, its windows on catastrophe and crisis defined states of emergency that authenticated the medium's very regime of representation: "Television's greatest technological prowess is its ability to be there—both on the scene and in your living room

(hence the most catastrophic of technological catastrophes is the loss of signal). The death associated with catastrophe ensures that television is felt as an immediate collision with the real in all its intractability—bodies in crisis, technology gone awry."[48] Catastrophe is both the exception and the norm of how television—prior to the advent of the video machine and its regime of time shifting—reorganized people's attention. Catastrophic time at once promised the spectator referentiality and presence and deferred it indefinitely.

Flow is the principle factum of televisual presentation and experience.[49] Even early West German program schedules around 1960, though restricted to one channel, encouraged the viewer not to watch a specific show but simply to watch television. To speak of flow is to emphasize television's capacity to place dissimilar items within the same frame of experience without organizing them such that they would result in one homogeneous and identifiable meaning. Televisual flow organizes the viewer's time by replacing cinema's clearly timed sequential units with segmented temporal patterns whose function it is to establish a balance between the ease of repetition and the hype of novelty. Markedly different from the teleological makeup of cinematic temporality, television's time is one in which short bursts of attention swiftly interact with reiterative forms such as the series and the serial. Television calls for a much lower level of sustained concentration than narrative cinema. Its stripped-down images are gestural rather than providing compositional detail. As John Ellis argues, "The cinema-looker is a spectator: caught by the projection yet separate from its illusion. The TV-looker is a viewer, casting a lazy eye over proceedings, keeping an eye on events, or as the slightly archaic designation had it, 'looking in.' In psychoanalytic terms, when compared to cinema, TV demonstrates a displacement from the invocatory drive of scopophilia (looking) to the closest related of the invocatory drives, that of hearing. Hence the crucial role of sound in ensuring continuity of attention and producing the utterances of direct address ('I' to 'you')."[50] Devoid of cinema's richness, television images prior to the advent of HDTV urged their viewer to glance rather than gaze at the world on screen. Whereas classical cinema capitalized on the viewer's voyeurism in order to produce forward-moving narratives, early television relied much more on the role of sound to tie disparate elements together and produce an intimate sense of complicity between viewer and apparatus. Part of the success story of televisual modes of representation and address in the 1950s and 1960s was that they implored the user to enjoy the pleasures of listening to images as much as of seeing sounds on screen. Contrary to the assumption of many German intellectuals in the 1950s, the windows of early

television were as acoustical as they were visual; they did not simply extend commercial cinema into the living room, they offered categorically different forms of distraction. Television's sound was a crucial feature in producing the illusion of having the world at our fingertips while seemingly confirming hegemonic divisions of the world between inside and outside, the domestic and the public, the safe and the risky, the mundane and the exceptional. Sound guided the viewer's perception across the disparate segments of the program schedule, ensured and enriched the precarious meaning of low-definition images, solicited consensus and intimacy between viewer and institution, and thus created forms of shaping attention and narrating temporality quite distinct from the dominant modes of cinematic time.

"Many mystics," Nam Jun Paik wrote about his 1963 Wuppertal exposition, "are interested to break out of ONE-TRACK-TIME, ONE-WAY-TIME, in order to REACH OUT for eternity. aa) To stop at the consummated or sterile zero-point is a classical method to reach out for eternity. bb) To perceive the SIMULTANEITY of the parallel flows of many independent movements is another classical way to do it."[51] As much as it sought to translate the viewer's physical motions and sounds into figurative images, *Exposition of Music—Electronic Television* set out to explore and counteract how broadcast television around 1960 increasingly organized the viewer's experience of time and directed his or her attention across disjointed temporal segments. Paik's television sets at the Galerie Parnass stressed the embodied and symbiotic aspects of human looking. They rendered vision not as an abstract and autonomous mechanism but as an aleatory and tactile practice inextricably intertwined with other registers of sensory perception, especially touch. As importantly, however, the images of Paik's television sets were meant synergetically to merge the viewer's corporeal rhythms with the pulse of electronic circuitry. For Paik, sound played an essential role in this endeavor. Acoustical properties were to emancipate the act of watching television from the mundane rule of one-track time. *Kuba TV,* for instance, consisted of a manipulated television set connected to a tape recorder. Whenever the viewer decided to play music on the tape recorder, the television screen would respond with certain visual images. Contrary to the use of sound in dominant cinema, sonic material here shaped the parameters of visual representation. *One Point TV,* on the other hand, was linked to a radio. The screen showed a bright point in its center, the size of which could be controlled with the radio's volume button: the louder visitors played the radio, the larger the image would appear on screen.

As if wanting to reverse Anders's and Adorno's fears about broadcast tele-

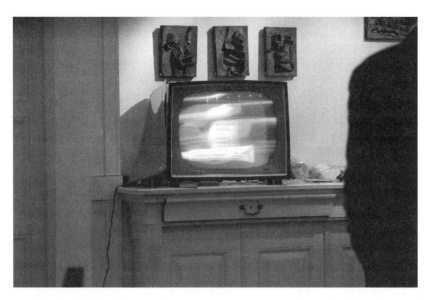

Nam June Paik, *Kuba TV* (1963). Printed by permission of Manfred Montwé, Bad Wurzach, Germany.

vision, sonic feedback structures such as these neither endorsed a droning dominance of the visual over the auditory nor erased the condition of the possibility of individual experience. On the contrary, in exploring sound as one of the most significant dimensions of our dealings with television, Paik hoped to redefine television as a source of experiences whose principal contingency and interdeterminacy could unfetter the subject from bourgeois concepts of the self as a sovereign ruler of his mind and emotions. Paik's sound-images may have been fleeting and devoid of resolution, but their ultimate goal was to exorcize modern concepts of linear time altogether and thus unhinge the dual rule of flow and catastrophe in ordinary broadcast practice. Paik's use of interactive sound undercut any desire for seeing the segmented in preexisting harmony to the iterative. It wanted to lead the user through time beyond it, that is, to beat the temporal dimensions of human existence at their own game. Like nothing that could be seen on West German television screens circa 1963, Paik's Wuppertal exposition envisioned the act of watching television as an activity radically situated in the now of a present whose ever-changing images and sounds would neither simply distract nor overpower the viewer with impressions of death. Television, for Paik, was a technology of physiological sym-

biosis *and* spiritual self-transcendence. In the final analysis, installations such as *Kuba TV* and *One Point TV* taught the visitor to climb television's ladder of sensory address and embodied perception, only finally to cast it away and enter a mystical state of contemplation. Paik's Wuppertal exhibition embraced the new and rich possibilities of electronic mediation to open a window not on inauthenticity, alienation, and catastrophe, as West German intellectuals feared, but on tranquil meditation and liquefied forms of modern subjectivity. Paik's ideal viewer was able to undo the reifying logic of postwar consumer society, a viewer willing to live with inconclusiveness and incompletion—with "75 percent" or even "9 percent"—rather than one fortifying his or her heart by trying to take it home like property.[52]

Modularity/Variability

Paik's Wuppertal show in 1963 was staged well before the advent of the remote control, multi-channel cable, and the video recorder would redefine the parameters of televisual viewership. *Exposition of Music—Electronic Television* explored the aesthetic possibilities of electronic mediation in its nascent state, at a time when the interface of television was still seen as a site of utopian promise and undeveloped opportunity. The act of watching television around 1960, in spite of its domestic arrangements, still bore a communal index. It took place within the coordinates of public time. Everyone watched the same program at the same time. Everyone talked about the same shows at work or school the next day. Though his manipulated television sets sought to enable variability and contingent reception, Paik was clearly not yet in any position to envision how future institutional mandates, economic imperatives, and technological inventions would transform television into a medium of highly individualized drift.

Leo Charney has described the channel-hoppers of later years as viewers eager to track down every moment of pleasure, to escape empty time and not to waste a single minute. To zap channels is to act like a hunter for moments of fulfilled presence. The zapper accelerates the rhythms of commercial distraction in order to outpace the principal structure of modern diversion, namely its oscillation between peaks and valleys of attention and stimulation: "People say watching TV distracts you from leading your real life. But I think it's the other way around. Everyday life is so boring, you're scavenging for whatever moment of pleasure you can find. Life distracts you from television. What we call everyday life is already distracted. . . . TV channel-hopping eliminates the

empty spaces. Movies have all this dead space. So does life. TV does too, but if I get the zapping just right, I can suture them out. . . . It's a game I play with myself, to get as close to this as possible. How fast can I zap away from the dead spots? Can I get away so quickly that I beat the empty moment? Get up there ahead of it?"[53] Charney's channel-hoppers know how to put drift, understood as one of the key structures of modern life, to work. The remote control serves as a tool of redemption: its shears off waste, ruptures the predefined frames of perception, and counteracts the fundamental vacancy of modern secular experience.

Similar to Charney's expert zappers, Paik's viewers of 1963 were intended to explore the philosophical and theological possibilities of watching television. For Paik, the television set opened windows onto self-transcendence as much as it transported the world as image and sound across distance. But we would be mistaken to understand Paik's viewers of 1963, as they manipulated prepared television sets in order to break out of the one-track time proliferated by mundane broadcast structures, as mere forerunners of Charney's skillful channel-hoppers. Paik's viewers were encouraged not to flee from empty time but into it. They zapped right into the dead spots of representation in order to explore new ways of seeing and experience sensuality as a "contact to the world without pedestal."[54] Unlike today's channel-hoppers, Paik's viewers slowed down the pace of televisual images. Their struggle for meaning was a struggle not against waste and vacant time, but for it. Their ultimate challenge was to experience television as something not ever in need of a remote control.

The work of Fluxus artists such as Nam June Paik, it has been argued, neither had a unified message nor showed any formal unity. For Fluxus defined itself not as yet another chapter in the history of aesthetic styles but as a mere mode of communication, as a network of artists ready to join each other's efforts, eager to link up to unscripted aesthetic practices, and principally open to transience, chance, playfulness, and intermedial cross-fertilization. As Dick Higgins writes, "Fluxus was not a movement; it has no stated, consistent programme or manifesto which the work must match, and it did not propose to move art or our awareness of art from point A to point B. The very name, *Fluxus,* suggests change, being in a state of flux."[55] Fluxus's resistance to certified meaning did not even stop short of how to think about the relation of art and society. Though recalling earlier avant-gardes such as interwar Dadaism, the Fluxus project of the early 1960s no longer insisted that radical aesthetic innovation would or could lead to political reform. It considered the bridge between the aesthetic and the political itself as one in permanent flux. To fault

particular Fluxus performances for muddled politics therefore misses the import of the Fluxus project. What made Fluxus political cannot be gleaned from the content of its works, installations, and events themselves but from how this group of artists pursued new structures of aesthetic collaboration beyond conventional notions of artistic authorship. Fluxus events neither aimed at an aestheticization of postwar living conditions nor subjected aesthetic expressions to the cause of explicit political agendas. Instead, by bringing into play the pleasures of indeterminacy, surprise, and networked collaboration, the hope held out by Fluxus was to revolutionize the material conditions of mutual understanding. Fluxus events may have struck contemporary audiences as wildly provocative and irrational. In truth, however, their purpose was to explore the role of the aesthetic in postautonomous culture as a catalyst of communicative reason: a site able to allow for unconstrained forms of expressive action and social integration; a mode of interaction restoring the possibilities of nonidentity and mimetic behavior; and a space of performative self-enactment unsettling what Jürgen Habermas a year before Paik's Wuppertal exposition had famously called postwar capitalism's "refeudalization" of the public sphere.[56]

Fluxus remains important to us today because our own age of computerized telecommunication claims to have realized Fluxus's quest for the open-endedness of networked communication. Similar to the way in which current computer interfaces represent media elements such as sounds, images, and shapes "as collections of discrete samples (pixels, polygons, voxels, characters, scripts)," so did Fluxus exhibitions such as Paik's 1963 *Exposition of Music— Electronic Television* seek to assemble media objects whose modal structure would allow for the articulation of individual elements into larger objects without denying their separate identities.[57] And as the objects and practices of today's digital culture are characterized by endless variability and mutability, so too did Fluxus installations such as *Kuba TV* or *One Point TV* give rise not to identical copies of some original but to many different versions, each authored in part by a human agent and in part by the automatic program of a machine.[58] Yet unlike the aficionados and corporate spokesmen of today's digital culture, Paik did not insist that networked communication per se, in spite of its stress on process, performance, fragmentation, and indeterminacy, would automatically energize social transformation and political reform. Paik wanted his Fluxus exposition to provide electronic interfaces different from the ones defined by West German program directors, broadcast advisory boards, economic imperatives, and state policies as the hegemonic form of television. His aim was to explore the multiplicity of possibilities inherent in television, a uto-

pian richness already largely buried despite the relative youth of the medium. As a result, Paik's television sets of 1963 would allow audiences to recall what they had never seen. They were meant to help "re-member" the utopian promises of television as a window onto the other, as a technology of beholding and listening to the strangeness of ourselves as much as of the world around us. But for Paik, the mere experience of or openness to alterity did not yet vindicate emancipatory politics, just as the formal language of fragmentation, variability, and modality of digital media per se do not yet authorize transformative agendas.

What people would do with the images and sounds witnessed at the Galerie Parnass was not for Paik to decide. His emphasis on indeterminacy precluded the possibility of dictating the viewer's reception and interpretation. If Paik's 1963 *Exposition of Music—Electronic Television* had a message at all, then it was to call attention to the contingent relationship between media and their users, representation and attention, the aesthetic and the political. Paik's prepared television sets sought to reinterpret television in light of its multifarious potentials. They empowered alternatives modalities of looking at the screen to enable networks of viewers to look more closely at this looking. How this would translate into practice outside of the gallery could only remain an open question—a matter in a permanent state of flux.

1 ❚ *The Nation's New Windows*

Throughout most of the Cold War era, Berlin—West and East—served as a display window for highly contested cultural, economic, and political attractions. Large state subsidies transformed the city's western half into a showcase of cultural experimentation and cosmopolitan openness, a vibrating outpost whose function was to demonstrate the superiority of liberal democracy and the free-market economy. The eastern part, by contrast, was transformed into a monument to socialist unity and proletarian solidarity, a self-confident capital to which the workers and peasants from the provinces could proudly look up. On either side of the Wall, Berlin's urban landscape thus provided meanings and values far beyond the city's historical traditions and socioeconomic possibilities. Though it largely relied on external resources to sustain its material status, Cold War Berlin played the role of a national imaginary. Different frontier myths here intermingled with front experiences and forefront avant-garde imageries, situating Berlin as a unique playground of the imagination, a site crisscrossed by competing fantasies, anxieties, political utopias, and historical recollections.

Yet the two Berlins of the Cold War era were places not only to look at but also from which to look out. They functioned as framing devices, shaping attention and defining different viewing positions. Display and supervision, spectacle and panoptic mastery, public exhibitionism and private voyeurism were here often closely related. To climb on special platforms in order to peek at eastern paucity was as much a part of the many visual regimes of pre-1989 Berlin as gazing at eastern television sets broadcasting western entertainment

programs. Public discourse in both German states may have constructed the Wall as an expression of radical separation. In truth, however, the Wall also operated as a kind of inverted interface, as an area of contact between and separation of different templates of temporal and spatial experience. The Wall's concrete surface simultaneously divided and connected, obscured and revealed, estranged and associated. It engaged the mind and inspired imaginary travel while at the same time arresting bodies in their physical locations. Deeply marked by the omnipresence of the Wall, the visual culture of Cold War Berlin became highly charged with political energies and frictions. No matter where you looked or what you looked at, acts of looking negotiated the fragile boundaries of community, alterity, and otherness. No matter what you put on display—in both halves of the city—sight and the framing of visual attention were crucial to competing constructions of political belonging and national identity.

The final chapter of this book investigates the extent to which German unification has transformed this Cold War politics of sight and spatial framing. Berlin public architecture and urban design since the fall of the Wall has been obsessed with endowing the new German capital with symbols of national unity and an "emotionally appealing addition of state representation."[1] Whether we consider the revamping of older government buildings or the construction of the new Chancellery, post-Wall Berlin has become a site where democratic politics and impressive architecture are supposed to go hand in hand again. As importantly, however, the frenzied remaking of the city since 1990 has served the purpose of improving the city's location in the transnational reorganization of capital, of enhancing Berlin's attraction and marketability on a worldwide scale. A negligible economic force prior to 1989, postunification Berlin has been charged to become a global city and hence a window onto the world: a self-assured metropolis coordinating the evermore global flow of moneys, technologies, labor forces, images, sounds, pleasures, and meanings. Yet rather than create a city whose surface simply mimics other first-tier cities such as New York, Los Angeles, Paris, London, or Tokyo, Berlin's city planners have, among other things, endorsed images of locality and historicity in order to increase the city's competitive advantages. In stark contrast to the self-restrained architects of postwar Bonn, Berlin's chief designers have chosen to develop highly choreographed environments that enhance local prestige by gratifying desires for historical continuity, livability, and territorialization.

In September 1999, the newsweekly *Der Spiegel* boasted: "Last year, New

York was promoted as the American 'Capital of the World.' . . . Now, New York is facing a competitor: 'New Berlin.' The allusion is deliberate, for the German capital has everything it needs at its disposal to become for twenty-first–century Europe what New York was for the New World in the old millennium."[2] It is the task of the following pages to show how in the public architecture of "New Berlin," the desire for global recognition and transnational reach coincides with the reinscription of national legacies and subnational identifications. Far from leveling local atmospheres and cultural differences, it is Berlin's drive toward the global that produces locality and historical particularity in the first place. Sir Norman Foster's renovated Reichstag building and—more specifically—the structure's glass cupola shall be the focus of my argument. As I argue, the dome's windows embody everything that makes the new "Berlin Republic" different from both its self-restrained Bonn forerunner and its autocratic East Berlin precursor. Foster's dome is emblematic of German politics since 1989. It symbolizes the new responsibilities of unified Germany in the European context and legitimizes the Berlin Republic's unprecedented engagements in settling international conflicts. As importantly, however, Foster's dome also plays a central role in marketing Berlin as a global city and tourist destination. Enabling spectacular views of the city, the dome offers a choreographed event zone in which people can consume the markers of urban space and national history as attractions of the first rank. Foster's windows invite the visitor to gather awesome sights that reorder historical memory while at the same time tending to blur former differences between the realm of politics and that of pleasure. They frame the city as a crossroads of multiple legacies, histories, and recollections that allow people to be various things at once and construct multiple homes and temporalities within one and the same space.

Foster's dome opens a window on post-Wall Germany that rearticulates the terms according to which postwar public discourse negotiates the relationships between symbolic politics and visual culture, between the stage-managing of political legitimation and the recollection of national history, between the burdens of the past and Germany's political responsibilities in the present. But to understand the many meanings of Foster's dome, I suggest, requires more than solely probing the ruptures and continuities of twentieth-century German history. For Foster's windows also raise basic questions about the recoding of auratic experiences and the monumental in postmodernity; about the virtualization of sentience and historical memory in contemporary cyber-culture; about the readability of architectural styles and the cultural specificity of built space;

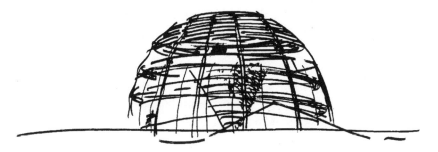

The new cupola of the Reichstag. Norman Foster concept sketch. Printed by permission of Foster and Partners, London.

and, last but not least, about the legacy of modernism in our age of digital reproduction and transnational networking. It is with these issues in mind, I propose, that we must approach the questions of the meaning of Foster's glass dome and of how it reframes the role of seeing in German political culture today. And in our attempt to answer these questions, it should come as no surprise that different cultural, political, and historical lines of reasoning here will produce a picture that is inherently ambivalent and multiple. For what makes Foster's window onto post-Wall Berlin so compelling an intervention is that it elevates the modern logic of polyfocality, of enabling different perspectives within one and the same space of viewing, to the central allegory of unified Germany and its new role in the era of combative nationalisms and post-9/11 cultural reifications.

The Ghosts of Berlin

In response to the manipulation of the visual during the Nazi era, the Bonn Republic had placed a tacit taboo on all conspicuous forms of political symbolism. For this reason, it was no coincidence that the architects of Bonn's government buildings favored function over form, modernist composure over historical reference.[3] While the mothers, fathers, and children of the economic miracle found their symbols of national identity after fascism in the private spheres of economic progress and consumption, Bonn's postwar architects rejected breathtaking public gestures. They created government buildings in the unassuming guise of provincial banks, municipal administration centers, and commercial management compounds. Bonn's architects designed the capital as a non-sensational city in which—to speak cinematically—neither dramatic

pans nor overwhelming long shots could ever cast a spell over the viewer's sensory perception. While they, like many postunification architects, often too relied on the lightness and transparency of glass in order to demonstrate that the Bonn Republic was an open democracy, the majority of political structures, including the old parliament building, refused to provide any awe-inspiring points of view. Glass indicated the modernity and openness of West German politics after Hitler, but it did not provide stunning views and proud vistas of Bonn.

The German *Wende* (reversal) of 1989–90 stimulated many intellectuals and academics to reject Bonn's aesthetics of humility. The iconoclasm of the "Bonn Republic" was suddenly seen as a sign of political and aesthetic provincialism, whereas the capital's move to Berlin seemed to promise new architectural opportunities to celebrate national sovereignty, democratic openness, and international prominence. Approved by the Parliament's council of elders in early 1995, Foster's dome project would have been unthinkable without this new demand for a self-assured political imaginary after 1989. But at the same time, Foster's glass cupola wrestled with legacies much older than German unification. It resuscitated corpses of the past and, in the eyes of some, converted repressed memories into an uncanny fantasy of metropolitan grandeur. Foster's window on Berlin has, to say the least, added yet another specter to what Brian Ladd calls the many "ghosts of Berlin."[4] Neither the new dome's provocation nor its popular success can be fully understood without considering the ways in which Foster's structure—twenty-three meters tall and forty meters wide—reworks Paul Wallot's original design of 1882 and 1889. Though heavily bombed during the final days of World War II and then blasted away entirely in the early 1950s, Wallot's original dome figures as the hidden reference point of Foster's project secretly illuminating the new dome's public meaning and reception. It is therefore with Wallot's dome that we begin our efforts to understand how the new dome's glass windows reframe the location of the past in the present.

Built between 1884 and 1894, Wallot's original Reichstag was intended as a monument to both German national history and the awakening of parliamentary self-confidence in Germany during the second half of the nineteenth century.[5] Wallot combined allusions to the Italian High Renaissance with the then-fashionable neo-Baroque in order to compensate for what he considered the absence of a coherent "national style."[6] He forged an eclectic architectural idiom in which sheer size and historicist surplus were meant to give an impression of democratic dignity and national distinction. Wallot's contemporaries

were far from enthusiastic about the new Reichstag. What is interesting to note, however, is that Wallot's main opponents—Wilhelm II derided Wallot's structure in 1893 as the "summit of tastelessness"[7]—directed their criticism less at the structure's synthetic historicism or monumental gesture than at Wallot's extravagant glass-and-iron dome and its connection to the rest of the building. Wallot's original dome relied on highly advanced principles of structural engineering. According to Wallot's own explanations, the cupola anticipated a utopian future in which the three classical arts of painting, architecture, and sculpture would be harmoniously joined by a fourth sister: the decisively modern art of engineering. Fusing old and new, art and technology into what he understood as a new kind of national *Gesamtkunstwerk,* Wallot embraced industrial construction methods and materials in order to conjure a dreamlike semblance of historical continuity. Though mostly used for transitory purposes such as exhibition halls and railway stations, glass and steel in Wallot's understanding were supposed to endow the Reichstag building with an aura of dignity and permanence. Yet what Wallot himself considered an organic integration of the classical and the modern, the transitory and the timeless, in the eyes of his critics was seen as inorganic and, hence, aesthetically deficient. Conservative critics praised the building's massive stone block design but ridiculed the dome's sobriety. More progressive critics, on the other hand, hailed Wallot's bold use of glass and steel yet at the same time rejected the building's onerous historicism. If no one really liked the building in its entirety, that was mostly because just about all of the critics privileged organic integration over stylistic discontinuity, structural totalization over semantic ambivalence. Whereas Wallot had hoped to reconcile art and modern technology, most critics insisted on the radical alterity of formal and functionalist considerations in architecture. Rather than understand the relation of art and industrial culture as a dialectical one, Wallot's critics on all sides of the debate disparaged the Reichstag building because it seemed to violate proper boundaries of taste and thereby blur any clear separation between traditional aesthetic culture and modern industrial civilization.

Contrary to both Wallot's original intentions and his critics' responses, Foster's new structure unreservedly displays the relation between cupola and building as a disjunctive one. Foster—like Wallot—does not aim at an organic integration of old and new, nor does he—like Wallot's many critics—reject any outward sign of stylistic discontinuity, multiplicity, or ambivalence. The dome's deliberate emphasis on heterogeneity, it might be argued, encodes the many breaks and fissures of German twentieth-century politics. It explodes the

naturalizing view of history as continuous and triumphant that inspired the building's initial historicism and monumentalism. Foster's new Reichstag, one might say, opposes any chauvinistic or revisionist narrative of German history. It envisions a German future neither overshadowed by nor willing to forget the national past. I will come back to the question of whether we can uphold this reading after looking at some of the technical features of Foster's dome and sketching its symptomatic role in the remaking of Berlin after 1989.

Foster's dome is composed of twenty-four steel vaults sustained by seventeen horizontal steel rings. Three thousand square meters of glass cover this steel frame, broken up into seventeen rings of glass panels, which overlap like transparent fish scales. The dome's interior is dominated by a funnel-shaped mirror construction whose main function is to carry diffused daylight into the plenary chamber. This futuristic cone consists of 360 individual mirrors (4.2 x 0.6 meters). With the help of a computer-aided shading contraption, selected areas of mirrored glass can be covered so as to block any direct reflection of sunlight into the chamber below and readjust the building's natural illumination according to seasonal irradiation angles. Additionally, the cone helps control the air quality of the plenary chamber. It channels used air to an opening at the dome's top with the assistance of a ventilator positioned inside the mirror shaft. Two access ramps measuring 230 meters each spiral around the light cone. Staggered by 180 degrees, both ramps connect the roof terrace at the base with the observation platform (200 square meters) close to the apex of the dome. Foster's ramps climb (or descend) at a steady angle of eight degrees without ever meeting each other. The ramps' purpose is primarily touristic, even though some final interventions ruled out the possibility of peeking into the inside of the plenary chamber. Open to the general public, the ascent to the top of Foster's glass dome—according to public relations office of the Bundestag—offers the opportunity to "enjoy an overwhelming panorama of the whole of Berlin," an experience of scopic plenitude unknown in the humble political aesthetic of the Bonn Republic.[8]

Since the early twentieth century, Christine Boyer has argued, architecture has served as a commodity and form of publicity, but now in the triumphant culture of global capital and consumption, "designer skylines and packaged environments have become vital instruments enhancing the prestige and desirability of place."[9] The experience of urban space in the last decades of the twentieth century has been enormously homogenized: a lot of things today look very much the same everywhere. At the same time, however, at the local level, city space has been increasingly fragmented into segregated and self-con-

tained zones of work, leisure, and living. Stylized references to the past here serve to sell the city to consumer tastes, to satisfy diverse demands for lifestyle quality, political presentation, and corporate self-representation. Whereas modernism remained relatively critical about the commodification of architectural forms, the global city of postmodernity fuses corporate interests, political mandates, and cultural entertainments into one single mechanism. Foster's window on Berlin, I argue, is deeply implicated in this homogenization, fragmentation, and commodification of contemporary urban space. It offers a carefully choreographed setting of visual consumption in which numerous historical references simultaneously promote a desire for local space and serve as a global attraction. On the one hand, the building appeals to what Andreas Huyssen has called the memory boom of the postmodern condition. It invites the visitor to recall different historical moments as if such acts of memorization could indeed halt the dissolution of temporal experience in contemporary cyber-culture and uphold a "basic human need to live in extended structures of temporality."[10] A syncretic blend of different images and historical recollections, Foster's Reichstag reworks history into a sign of urban livability and local atmosphere. It recodes the past so as to sign up Berlin for a globalized future. On the other hand, however, the dome also functions as a looking glass enabling the visitor to experience not the building and its various layers of historical substance but the surrounding city as the primary thrill. Foster's ramps take the tourist on an astonishing ride into the city's sky. In stark contrast to the limited possibilities of the iconoclastic Bonn years, the dome thus produces the new German capital as an object of stunning visual pleasure and historical identification. It is to the curious dialectic between looking at and looking out through the dome's windows that we next turn.

The Power of Glass

In Albert Speer's megalomaniacal future vision of Berlin, massive stone structures were meant to provide—even hundreds or thousands of years later—impressions of overwhelming beauty and sublimity. While Goebbels encouraged his subjects to hold out with poise because "in one hundred years' time they will be showing a fine color film of the terrible days we are living through," Speer, in his infamous "Theory of Ruin Value" suggested the use of sturdy construction materials ensuring that even in a state of decay, as ruins, the colossal new buildings of future Germania would "more or less resemble Roman models."[11] It is safe to say that Speer's poetics of monumental disinte-

gration has had little impact on the designers of public architecture for the new Berlin Republic. Contrary to Speer, the architects of Germany's new capital have sought to emphasize the transitory, open, and contingent rather than to encode the course of history as fateful, closed, and inevitable. Instead of Speer's gigantic stone blocks, glass has emerged as one of the Berlin Republic's most privileged construction materials. For the use of glass, one might contend, defies Speer's theory of ruin value. Unlike Speer's monumental stone designs, glass can not assault perception, overwhelm the senses, and deny the private body as an autonomous site of pleasure; nor can it ever decay in an aesthetically pleasing fashion, whether tomorrow or in a hundred years' time. The windows of Foster's dome are consequently understood by many as testimony to the spirit of pluralistic openness of German politics after Hitler and Honecker. In the eyes of most commentators, Foster's use of glass is seen as the most appropriate way of symbolizing the proposition that parliamentary democracies cannot survive without unhampered interaction between citizens and their representatives, without unconstrained transparency and accountability, without a public sphere in which values, orientations, and decision-making processes are in open contestation. By interconnecting interior and exterior spaces, Foster's windows, so the argument goes, signify nothing less than the formal principles of a democratic body politic. The language of glass, according to this logic, is instantly recognizable: it casts Germany's new political identity and unity into an obvious architectural expression.

Does it, though? And if so, how?

The popular equation of glass and democracy raises fundamental issues not only about the relation between architecture and politics but also, on a more basic level, about how public buildings produce meanings in the first place. It therefore is warranted at this point to recall briefly that the view of glass as a catalyst of democratic values and social harmony already played an important part in the programmatic writings and designs of architectural modernism during the early decades of the twentieth century. For the modernist champions of glass architecture, in particular German science-fiction writer Paul Scheerbart and *Werkbund* architect Bruno Taut, glass did not simply *signify* progressive politics or egalitarian ideals; it did not simply *symbolize* modernism's campaign against entrenched traditions or *encode* the advent of a literally "enlightened" civilization. Rather, for architects and ideologues around 1900 glass moved architecture beyond language, metaphor, discourse, and representation. It reformed the body politic and influenced social practice without any mediation of signs and symbols. Thanks to their material qualities, their

paradoxical immateriality, glass buildings could address the inhabitant's sensory perception directly. They overcame the past's obsession with signification and, in so doing, enabled the modern architect to become a social engineer. Far from simply reconfiguring the house—like Le Corbusier—into a viewing apparatus collecting transient views, the glass architects of the early twentieth century sought to define whole buildings as nothing but windows in the hope of gaining unmitigated access to the dweller's soul. In one of Scheerbart's inscriptions for Taut's famous Glass Pavilion of 1914, this conception of glass architecture as practical politics found perhaps its most emblematic expression: "Glass opens up a new age / Brick building only does harm."[12] Interestingly enough, however, neither Scheerbart's nor Taut's programmatic understanding of glass architecture broke as radically with the past as it may have at first suggested. Taut's glass buildings translated theological concepts and sacred traditions into secular forms. They alluded to gothic cathedrals or cultic sites so as to foster communal bonds and elevate architecture to the status of a civil religion. Glass might have offered a radically modern construction material, but it also had the power to recall forgotten pasts and project mythic desires for collective redemption into the future. Nowhere did this metaphysical subtext of glass become clearer than in Taut's publication *Alpine Architecture,* which detailed Taut's fantastic plan to reconstruct the Alps with the help of glass, to radically remake the alterity of nature in the image of sacred iconographies, and thus to promote the architect to a godlike figure who had magical powers over the world.

The modernist use of glass was marked by a curious dialectic between the sacred and the secular, the monumental and the ephemeral. Though glass on the one hand articulated modernism's negative view of the monumental as kitsch, totalitarian, inauthentic, and narcissistic, on the other hand it revealed the extent to which the monumental was a hidden dimension of modernism itself, a product of modernity rather than its radical opponent.[13] Taut and Scheerbart's glass architecture celebrated the transitory and provisional, but precisely in exploring contingency and discontinuity as the central parameters of modern life their designs at the same time communicated a desire for auratic contemplation and monumental profundity. Foster's dome reconfigures the uneasy questions and quixotic desires that propelled the modernist use of glass. Similar to his modernist precursors, Foster's grasp of the profound and the contemplative concurs with a renewed belief in the power of architecture to reform individual attitudes and collective identities. If the modern glass architect aspired to salvage humanity from hatred and disunity, Foster's glass

cupola at first appears to be driven by a vigorous impulse to improve society by means of reorganizing public space. As Jane Kramer has hyperbolically noted of Germans in the *New Yorker,*

> They live in a capital from which the worst of Germany's history was de-
> creed, and now that the government is moving back to that capital they have
> convinced themselves that the right buildings will somehow produce the
> right attitudes in the people inside them. They like the transparency of the
> Reichstag dome—it's the most visited place in the city now—because they
> think it will somehow guarantee that openness and democracy thrive in the
> Reichstag. They think that the right number of stone slabs in a Holocaust
> monument will possess a memory of mass death; that the right balance of
> concrete and glass in a building for their Chancellor will temper authority
> with accountability.[14]

Foster's glass cupola, like Taut and Scheerbart's architecture of illumination, wants to enlighten those who behold it from a distance. It wants to generate political transparency, openness, and unity through the use of specific construction materials. It appeals to the sacred so as to overcome segregation and remake secular politics in terms of a civil religion. The dome conceives of history as project and progress, yet at the same time it expresses a desire to engineer something lasting and auratic amid the decentered topographies of contemporary life.

Yet even though Foster's dome recalls the programmatic use of glass in architectural modernism, it is not difficult to see that his implementation of glass breaks from Taut and Scheerbart's naïve notions of built space as a nonrepresentational sign. Foster's windows might insinuate or even orchestrate transparency and introspection, yet they are meant to do so not by regulating perception and channeling desire directly but rather by presenting themselves as a signifier and code. As seen from afar, Foster's cupola is designed to be read and interpreted, to be decoded and conceptualized. In doing so, the dome's windows draw attention to what Fredric Jameson calls the allegorical character of architecture: the fact that the political content of built space does not reside in its mere form but is instead projected onto space in a process of allegorization, a process depending on contingent contexts as much as unconscious associations.[15] Reclaiming glass as allegory rather than a direct conduit to our emotions, Foster historicizes the utopian program of modernism. His dome uncovers the extent to which Taut's monumental antimonumentalism relied on historically contingent categories and thus recodes the monumental for new purposes. Foster's glass intends to emancipate the monumental from

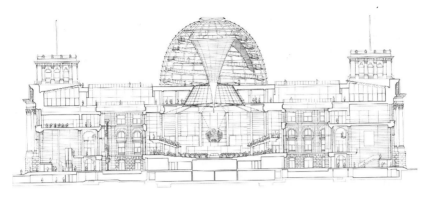

The renovated Reichstag building. Section drawing. Printed by permission of Foster and Partners, London.

being seen as essentially complicit with Hitler's and Speer's megalomaniacal urban projects. The dome's windows suggest the advent of a new language of monumentality that no longer associates desires for the auratic and lasting, for the impressive and the miraculous, with totalitarianism, fascism, and despotic narcissism.

Foster's resurrection of the monumental and auratic echoes wide-ranging efforts in postmodern art and culture to rehabilitate monumentality as a testing ground for reflections on temporality and subjectivity, as an antidote to the dematerialization and displacement of experience in our culture of digital hyper-mediation.[16] Viewed in a more political perspective, however, some of the more precarious ramifications of Foster's project can hardly be denied. First, in symbolically identifying secular politics as a civil religion, Foster's glass might be seen as visualizing democracy as a form of public communion rather than as a recognition of culture, nation, and state as necessarily differential. Though the building's overall structure foregrounds the heterogeneity of form and style, the dome itself invites appropriations that see post-Wall democracy as an altar of unity rather than a site of ongoing contestation. Second, by showcasing the plenary chamber as the foremost symbol of the entire political process, Foster's dome tends to obscure the fact that political deliberation and decision-making take place in lobbies and at back-office telephones or computers rather than in idealized zones of interest-free argumentation.[17] Foster's windows propagate the autonomy of the political without acknowledging that this autonomy has little viability in face of the post-Fordist spreading of decision-making processes over the ever more global, variegated, and accelerated

spaces of transnational capital.[18] And third, in celebrating the astonishing out-look of glass as a historically proven way of symbolizing political transparency and democratic openness, Foster's dome tends to reify the manifold relation-ships between historical signs, architectural styles, and political meanings and thereby, in some sense, replicates the historicist shortcuts of nineteenth-cen-tury political architecture.[19]

In the work of architects in post-Wall Berlin, the fragile material of glass has come to signify all kinds of things. In fact, it means and does so many things at once that it is tempting to argue that it no longer means anything at all. In Helmut Jahn's colossal Sony Center at Potsdamer Platz, glass is supposed to make a "bold corporate statement" enshrining the transnational power of a global media giant.[20] In Hitler's former Reichsbank building and Göring's former Air Force Ministry, innovative glass foyers are meant to break the spell of an oppressive past and endow Germany's relocated Foreign and Finance Ministries with a spirit of civic modesty. And in Jean Nouvel's spectacular design for the Galeries Lafayette on Friedrichstraße, glass provides for a "ka-leidoscope of luxury, status, and fashion," a surreal comedy of visual effects and optical illusions exciting desire for frenzied shopping and extraordinary profit-making.[21] True to Scheerbart's utopian hopes, glass in all its different uses in post-Wall Berlin indeed shows German culture in a different light and transforms dominant notions of history, memory, and identity. But given the highly diverse functions and designations of glass in the Berlin Republic, ico-nological clichés according to which glass enables transparency, transparency signifies pluralistic openness, and pluralistic openness necessarily eliminates hatred, strife, and authoritarianism are stunningly naïve. Like the phantasma-gorias of nineteenth-century industrial culture, Foster's dome is a wishful fan-tasy cast into plastic form. It intermingles the old with the new, memory with anticipation, utopian imagination with primeval past. A dreamt configuration as much as a real one, Foster's glass cupola has given Berlin a new signature building, a skyline marker that attracts national and international interest. Yet like the enigmatic ciphers of our own personal dreams, Foster's reverie is best understood as equivocal and polysemic, a site of discursive ambiguity and multiplicity rather than of straightforward lucidity and illumination.

Dome Strolling

But then again, is Foster's cupola really meant to be seen and read at all? What if we change our point of view and, instead of looking *at* the dome

from afar, look out from its top into the distance, look *away* from it? What if we walk up on the dome's spiraling ramps to consume a breathtaking view of Tierpark, the Brandenburg Gate, Potsdamer Platz, and, as of spring 2005, Peter Eisenman's completed Memorial for the Murdered Jews of Europe? What if we explore Foster's glass dome as a viewing apparatus that allows our gaze to consume post-Wall Berlin from above?

Foster's dome, by asking the visitor to walk, look, and contemplate the city from above, reconstructs modalities of seeing space and mapping urban territories closely associated with the history of nineteenth- and early twentieth-century Berlin. In fact, the dome's windows convert former ways of looking at cityscapes into a viable attraction and heritage value. What you chose to consume here is a historical object and material configuration as much as the pure sense of sight and mobility itself, the way in which one might have looked at cities before digital windows and computer interfaces produced visual experience as a mostly sedentary act of virtual immersion. Think of Bill Gates's infamous vision of future housing, in part realized in the construction of his own home on Lake Washington, as a contrasting model.[22] Gates's residence abounds with electronic screens allowing the inhabitant to access vast image banks and hence conjure appropriate sights and sceneries according to mood and whim. With the proverbial click of the mouse, you can now ask your window to transport you to a Hawaiian beach or to the Louvre, to look at spectacular landscapes or famous artworks scattered across the entire globe—to stay connected and mobile, to switch between interior and exterior views, without moving a single foot. Foster's windows, by contrast, recall older paradigms of looking so as to reproduce a world in which sight resided in clearly demarcated bodies and corporeal movement was essential to produce impressions of temporal continuity and spatial contiguity. Though the many rectangular frames and windows of Foster's dome seem to reference the ubiquity of digital screens and windows of mediations today, the structure's principal aim is to enable us to enjoy the mobile gaze and gain knowledge at the level of the body—and hence pursue modalities of looking free of and parallel to what drives Gates's ambitious vision of future architecture. What Foster's dome tries to do is to reinscribe memories of modern forms of looking not to return us to the past but to supplement the perceptual a prioris of the present and bestow the dome tourist with gratifying experiences of the auratic, the spectacular, and the corporeal.

The logic of Foster's intevention is twofold. On the one hand, the dome brings to mind the famous panoramas of the nineteenth century (see chapter 1). Offering 360-degree views on painted sceneries, panoramas were designed

to transport the viewer to distant realities and thereby accord virtual experiences of spatial and temporal mobility as well as an imaginary sense of visual omnipotence. As Anne Friedberg has noted, the "illusion presented by the panorama was created by a combination of realist technique of perspective and scale with a mode of viewing that placed the spectator in the center of a darkened room surrounded by a scene lit from above."[23] Panoramas did not really mobilize the viewer's body physically, even though some of the most stunning effects relied on the user's circumnavigating activity. What you got instead was the allure of a sweeping, comprehensive view immersing the spectator in temporary elsewheres and elsewhens. In the Berlin *Kaiserpanorama,* which opened in the "Unter den Linden" passage in 1881, this nineteenth-century mechanism of imaginary transport found perhaps its most advanced representative. A stereoscopic peep show designed for multiple viewers, the *Kaiserpanorama* accommodated twenty-five viewers who could view twenty-five different images rotating in two-minute intervals from viewing station to viewing station. Like earlier versions of the panorama, the *Kaiserpanorama* promised a panoptic view of other times and spaces. It provided "virtual spatial and temporal mobility, bringing the country to the town dweller, transporting the past to the present."[24] In addition and in contrast to earlier models, however, this late nineteenth-century gadget also left no doubt about the extent to which visual pleasures had become objects of industrial standardization and capitalist commercialization. While liberating sight from the strictures of place and providing new experiences of virtual mobility, the *Kaiserpanorama* aligned body and machine in ways similar to the relentless rhythms of industrial production.[25] What allowed the gaze to move freely across distant times and spaces was directly linked to how industrial culture reorganized the viewer's attention and sought to rule out commercially unproductive states of drift.

The design of Foster's dome recalls the history of nineteenth-century panoramas, yet it is also meant to emancipate the panorama's sweeping gaze from the hidden frames and industrial connotations of nineteenth-century culture. Instead of transporting the spectator into distant times or spaces, Foster's panorama situates the viewer vis-à-vis the compelling here-and-now of post-Wall Berlin. And instead of aligning body and assembly-line machinery, Foster's windows seem to unchain visual perception from all machinery and enable the viewer's gaze to hover over Berlin like Wim Wenders's angelic cameras in *Wings of Desire* (1987) and *Faraway, So Close!* (1993). What makes Foster's dome, in this sense, a tourist destination is precisely that it seems to restore the utopian aspects of sweeping visuality and surround sight while displacing its

historical implication in scenarios of commodification and industrialization. Foster's windows reconstruct the possibilities of majestic looking by remaking its nineteenth- century institutions. Tourists enjoy most that which seems to defy the logic of tourism and commodification—the essential, unpolluted, organic, primitive, and authentic. And so does the tourist of the new German dome, consuming Foster's dome as a site recuperating the seemingly authentic and nonregulated experience of surround sight independent of how it was shaped by the advent of modern industrial culture in the nineteenth century.

On the other hand, Foster's dome, with its two modestly graded ramps, seems to evoke the visual practices of the Berlin flâneur of the Weimar era, the observing city roamer who drifted through urban spaces in order collect fleeting impressions and consume the transitory markers of modern life. Flâneurs such as Franz Hessel, Walter Benjamin, and Siegfried Kracauer transformed the streets of Berlin into virtual playgrounds of the visual imagination. As Anke Gleber has argued, these urban ramblers replicated film cameras as they tried to redeem visual reality by means of an unprecedented sharpening of their optical awareness.[26] In 1930, British writer Christopher Isherwood summarized the flâneur's visual passions: "I am a camera with its shutter open, quite passive, recording, not thinking."[27] Unlike their contemporaries in the underground, the Berlin flâneurs of the 1920s experienced the modern metropolis as a site of radical fragmentation and physiological shock, as a discontinuous series of punctualized sensations that defied any kind of meaningful totality. Flânerie during the Weimar era indulged in the peculiarly modern demise of reliable and stable points of view. It thrived on physical immersion, decentered perception, distraction, and transitoriness. Prototypically embodying one of the scopic regimes of modern life, Weimar flâneurs such as Hessel or Benjamin found pleasure and aesthetic excitement not beyond but in the very texture of modernity's accelerated temporality and heterogeneous spaces.

Foster's dome, so it might seem, rearticulates the Weimar art of taking a walk for the new Berlin Republic. It is designed for present-day flâneurs who wish to slow down their pace and, in the mode of Hessel, Benjamin, and Isherwood, behold the new capital with their shutters wide open. And yet we do well not to push the analogies between Berlin's amblers of the Weimar era and Foster's contemporary sightseers too far. For Foster's structure, rather than immerse the viewer into the city's discontinuous and fleeting immanence, entertains the contemporary tourist with the pleasure of a highly detached viewing position. Foster's ramps and windows invite the public to gather undisturbed views amid wide-ranging historical transitions. They enable the sightseer to

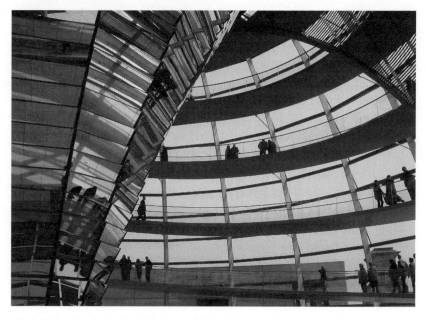

The art of taking a walk. Photo: Lutz Koepnick.

gaze at the city from a distance and thus to supplant troubling experiences of discontinuity with a magnificent prospect of homogeneous space. Rather than replay the Weimar flâneur's sensation of contingency and ocular destabilization, Foster's dome reinscribes the commanding standpoint of a preindustrial traveler safely resting on a mountain top and beholding urban or—even more—natural topographies from a "monarch of all I survey" position, a pose in which aesthetic sentiments, the production of knowledge, and the assumption of authority aspire to become one and the same.[28]

Foster's windows, then, allow us to mimic the visual practices associated with both the nineteenth-century panorama and the modernist flâneur *without* experiencing what characterized these practices as peculiarly modern(ist) activities of sight. Though his cupola showcases spectacular advances in construction technology, Foster wants us to experience vision as something somatically lodged in the observer's moving body. Technology here denies technology, the dome's windows stressing the continuity between the spaces on this and the other side of the glass. There is certainly no need to disparage this as a retrograde attempt to remake the past for the present. On the contrary: in asking the dome visitor to slow down his pace and experience vision as an

active process of embodiment, Foster's ramps and windows provide important counterpoints to how contemporary media and consumer cultures promote the speed of accelerated life styles and of technologies of random access as the exclusive key to being contemporaneous.[29] Unlike the restless dweller of Gates's Lake Washington residence, Foster's visitors are asked not only to decelerate amid the city's hectic rhythms but to acknowledge and enjoy the role of their own bodies in capturing images of the world. Advanced technology here serves the purpose of intensifying rather than obscuring the thick materiality of temporal experience, our physical location in space and time. When viewed from a more narrowly political and German perspective, however, this "revision" of Berlin raises a number of concerns, of which I here address only two.

First, in displaying the new capital as an object of visual consumption, as a totality to be seen from an abstracted, aerial point of view, Foster's cupola tends to erase our memory of the many ruptures and discontinuities that have marked the history of Berlin, not just after Hitler or the building of the Wall but ever since the city's original founding. By inviting visitors to experience a stunning bird's-eye view of the urban landscape, a perspective from which the city can be conceived as a unity, Foster's ramps divert our perception away from the tangible fissures that have remained present in Berlin's urban texture, even today. They shroud the fact that Berlin's most prominent urban tradition is its absence of tradition and continuity.[30] Although dome strollers, as of 2005, will now also lay their eyes on the central Holocaust memorial, Foster's new Reichstag has the potential to depoliticize the uniquely politicized urban landscape of Berlin, a landscape "whose buildings, ruins, and voids groan under the burden of painful memories."[31] Foster's ramps capitalize on nostalgic desires for envisaging Berlin not as an unwieldy site of open wounds, systematic displacements, traumatic projections, or uncanny introversions but as a space of continuity, authenticity, and historical identification. The ramps urge the sightseer to reimagine Berlin's history as uncontested and homogeneous, converting urban history into a theme park in which sweeping visuality systematically rules out the possibility of encountering the past as something incommensurable, unexpected, or painful.[32]

Second, in reframing and displaying Berlin as a valuable property and experiential totality, Foster's windows mask the very logic of urban fragmentation that they seem to advocate. As a highly compelling event-space, Foster's dome, on the one hand, plays an important role in post-Wall marketing narratives that place Berlin's "new city consumer inside an imaginary representational order that multinational capital now determines and provisionally tunes with

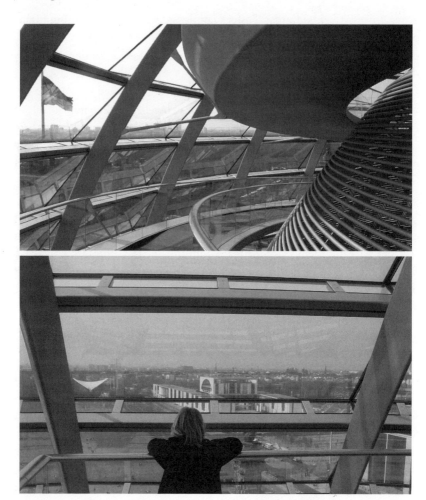

Dome views. Photos: Lutz Koepnick.

the specific distinctions of regional and local tastes."[33] Spectacular design interventions define the new Reichstag as a well-articulated node within the larger urban grid. They produce a self-enclosed space of pleasure that appeals to the discriminating and distinctive tastes of local consumers as much as those of global audiences. On the other hand, however, by elevating the tourist to a detached viewing position above the urban matrix, the dome obscures the city's grid of factual segregation and converts glimpses of meaningful homogeneity into an ideological commodity. Foster's windows promote "a gaze which

sweeps over objects without seeing in them anything other than their objectiveness."[34] They invite the tourist to see the city as mere image, as a unified surface devoid of competing histories and diverse meanings. Though Foster foregrounds the visitor's own bodily role in the act of gaining a view of the city, his windows potentially can turn the city's social space into a fetishized abstraction. They situate the spectator in a state of visual supersaturation that might as well reinforce the global ecstasy of communication today.[35]

The Dead are Dead

Saskia Sassen has suggested distinguishing at least two different, albeit imbricated, dimensions of what qualifies metropolitan districts today as global cities.[36] On the one hand, global cities are catalysts of highly inclusive and diversified consumption. They provide commodities, pleasures, meanings, and ideologies that are no longer bound to the boundaries of national economies and nation-states. Global cities open windows on the world *qua* consumer practice. They allow their dwellers to live in permanent elsewheres and elsewhens while at the same time catering to the consuming glance of transnational audiences, users, and visitors. On the other hand, the global city must be understood as a relatively elitist system whose function is to organize the global flow of goods, moneys, technologies, bodies, and pleasures. Global cities are exclusive sites of power actively involved in deregulating, privatizing, and liberalizing regional economies. They manage the circulation of commodities and thereby articulate the global order for specific regions and territories.

Though it has a lot to offer as a site of transnational production and consumption, post-Wall Berlin still far from qualifies as a city that organizes the flows of the global economy.[37] The city might become at some point an important network managing the "new content industries," that is to say, sectors of the economy centered around the proliferation of cultural goods and the development of multimedia technologies, software, and computer games. But in contrast to the dreams of many post-Wall ideologues, Berlin still lacks the decisive industrial, financial, and technological backbone needed to join first-tier organizational centers such as New York, Los Angeles, London, São Paulo and Bombay. Although post-Wall Berlin has clearly marketed itself as a site of globalized culture and consumption, its economic and political clout at present falls far short of the image of the capital of the new century. What has been widely celebrated as the "New Berlin" is mostly a wish fantasy. It demonstrates the extent to which many decisive political and economic issues after

unification have been posed in Germany as cultural questions—as matters of lifestyle, aesthetic preference, pleasure, and consumer choice. The image of "New Berlin" in this sense feeds directly into neoliberal claims that cultural globalization may profit from, but at the same time can stay independent of or stimulate, economic transnationalism. Inasmuch as it casts global fantasies into plastic expressions, post-Wall Berlin entertains the illusion that in spite of the ever-increasing integration of culture, economy, and politics today, you can create global markets through culture without touching the autonomy of cultural and aesthetic experiences.

The windows of Foster's dome, as I have argued, are integral parts of this post-Wall imaginary. In the absence of any monument memorializing the process of unification itself, Foster's glass is energized by and energizes the dream of post-Wall Berlin as a national hub of global importance. Foster's glass at once revokes and reworks certain historical legacies, including the antitraditional modesty of Bonn architecture, so as to define a new political aesthetic in which global aspirations and national identifications supplement each other. It should therefore come as no surprise that many have compared Foster's intervention to the ways in which Christo, when he veiled the Reichstag in 1995, focused international attention and public debate on Wallot's building. Christo's wrapping served as a strategy to reveal views of history hidden under the building's stolid postwar façade. Systematically blurring the lines between high art and popular culture, *Wrapped Reichstag* neither resulted in a mere Hollywoodization of avant-garde practices nor reproduced, as some critics had feared, the monumentalist orchestration of public life during the Nazi era. On the contrary, to the extent that Christo's project explored the monumental as a temporal process and transitory product, *Wrapped Reichstag* "stood as a monument to a democratic culture rather than a demonstration of state power."[38] In spite of some of the concerns I have expressed in the preceding pages, I think it's safe to argue that Foster's new dome continues the spirit of Christo's intervention in signalling the advent of a new form of constitutional patriotism in post-Wall Germany. Whether we look at the discontinuous integration of glass and building from afar or look out through the staggered windows while walking up the ramps, Foster's dome offers a viewing apparatus whose stress on multiplicity and polyfocality—the simultaneous presence of different symbolizations, memories, and perspectives—makes it impossible to see this building as a monument to stalwart nationalism and exclusionary identity politics. Foster's windows do many things at once. Their recoding of the monumental is fraught with instructive tensions and deliberate contradictions, with ironic

inversions and surprising self-cancellations. It is in endorsing the noncontra-dictory co-presence of different ways of seeing the present and recollecting the past that Foster's dome—like Christo's *Wrapped Reichstag*—goes a long way to showcase a notion of national identity defined no longer in terms of ethnic identity and quasi-timeless tradition but in terms of the contingent in-stitutions, codes, and practices of democratic exchange in an ever more global world.

Some American critics such as Herbert Muschamp have argued that if Ger-many's new capital has a soul at all, then it may be found not amid Berlin's many new glass constructions but in the Holocaust Tower of Libeskind's Jew-ish Museum. It is the bottom of Libeskind's dark shaft—according to Mus-champ—that should be understood as the starting point of all cultural reflec-tion in postwar and post-Wall Germany.[39] "This angular four-sided concrete chamber," adds Martin Filler, "its long, narrow footprint far smaller than the room's ninety-foot height, gives one the sensation of being sunk at the bottom of a mineshaft. There is nothing to grasp onto emotionally here—this is the abject minimalism of existential despair—and even the bracket-like service ladder that climbs one wall commences far above human reach."[40] We may rightly question whether in trying to make historical trauma and despair ex-periential, whether in seeking to graft meaning directly onto the user's body, this tower violates Libeskind's own deconstructive credos.[41] But in conclusion, what is important to note is that Foster's glass dome chooses a strategy funda-mentally different from Libeskind's concrete structure in order to interrogate the burdens of the German past and situate the visitor in the presence. While Foster's windows too invite their users to experience the city at the level of the body, as something that cannot be seen independent from how our body relates to and traverses the visual field, the dome wants to lead us out and be-yond the violence that has overshadowed the entire postwar period. Foster's windows display the new German capital as a site finally able and prepared to reach some sense of normalcy after the horrors of the Holocaust. They frame the city as one eager to move on not in order to forget this past but to explore the heterogeneous temporalities, recollections, and visions that structure the German present after the end of the Cold War and that define Berlin's location in the landscapes of global capitalism today.

Unlike Libeskind's dark tower, then, Foster's luminous dome wants to lead visitors out of the black hole of the Nazi past and return them to the pres-ent—as subjects whose eyes and bodies behold many things at once and whose identities are structured by inconsistency, multiplicity, and polyfocality. If this

dome has one meaning at all, then it is that meaning never comes in the singular, that our present of global shrinkage and universal interconnectivity urges us to live many lives at ones, to take on various perspectives and memories simultaneously and thus situate our minds and bodies in parallel orders of space and time. To think Foster's dome would deny the trauma of the past and showcase the new Berlin as a triumphal presence misses the point. Rather than intensify postmodern amnesia, Foster's window panes can be seen and experienced as paying tribute to the glass splinters of *Kristallnacht*. They make us think about the painful irreversibility of historical violence. We must therefore recognize Libeskind's windowless tower and Foster's dome as two sides of the same coin. We cannot afford not to remember, but in our many efforts to remember we should not think that we can resurrect the dead and thus find some sense of redemption. As Max Horkheimer wrote in 1937 in a famous letter to Walter Benjamin: "Past injustice is done and over. The dead are really dead."[42]

Epilogue

"Berliner Fenster"

For a number of years now, Berlin subway authorities have been successful in distracting passengers from the underground's absence of distractions. Similar to what can be experienced in urban transport systems in other German cities such as Hamburg, Hanover, Leipzig, and Fürth, Berlin subway users today will find almost all of the capital's 1,200 subway cars equipped with several dual television monitors, each mounted under each car's ceiling and spread out across the wagon in reasonable viewing distance. Linked to a wireless system for digital multimedia broadcasting, these monitors—simply called "Berliner Fenster" (Berlin windows)—primarily display the latest news items as edited by the *Berliner Kurier*, with the inevitable interruption of commercials and selected event announcements. The presentation of news follows a highly standardized template. Not only does this template break up all the news that's fit to be displayed into a number of clearly separated groupings such as world events, domestic politics, local issues, the arts, and sports, but it is also designed such that within each of these categories a total of three consecutive items can be presented, whereby bulleted text with alluring headings dominate the left screen and eye-catching images attract the viewer's attention on the right.

Notwithstanding the fact that the system can easily handle the streaming of large amounts of data, so far most of the news has been presented in the form of still images, one screen basically serving as the other screen's visualized soundtrack, as it were. Commercials and event calendars, on the other hand, freely use moving pictures and animated designs across both screens, yet the

intentional absence of sound—chosen not because of technological difficulties but for the sake of passenger comfort—here often produces rather comical side effects and lapses of attention. As theorist of silent film Hugo Münsterberg already knew, whereas we have no problem consuming still images silently, moving images seem to require sound and music to keep spectators alert and prevent their interest from drifting off to something else.[1]

According to the company that has installed and is marketing "Berliner Fenster," since the year 2000, the displays have served the purpose of "shortening the passengers' travel time with the help of a varied program for the capital [*ein abwechslungsreiches Hauptstadt-Programm*]."[2] There is no need to read long statistical surveys in order to realize that this new electronic window indeed captures people's attention. A brief ride on any of the subway lines will do, as we witness the vast majority of eyes—in an effort to look at anything at all and thus escape what in chapter 4 I characterized as the subway's melancholic, introverted and fogged-up gaze—trying to capture a glimpse of the current program. Though most cell phones and handheld computers will remain entirely able to receive data transmissions even in the deepest of Berlin's subway tunnels, it is as if—in our era of compulsive connectivity and instantaneous accessibility—the system's dual monitors offer an umbilical cord enabling passengers to stay in touch with whatever they consider the world outside. To look at the screen is to prevail over what made the Weimar underground a poetic heterotopia of the first order: a (non)place whose dark windows suspended the ordinary perception of space and time above ground. To follow the news on the dual monitors becomes a way not only of reinserting the authority of sight into the underground but also to incorporate the underground's unsettling alterity into the circuits of our information age. No matter how dull and mindless the news, what the screens offer are electronic windows that keep us from delving into our own dullness and fatigue. Rather than veer into dysfunctional drift, we attach our eyes to the monitors' drift in the hopes of staying connected and not stumbling over our own feelings of lack, failure, and disattachment.

Wouldn't it be foolish to resist these windows' lure?

The proliferation of the "Berliner Fenster" during the first years of the twenty-first century has coincided with the ascension of a new word in the German language, namely the term *Zeitfenster* (time window), approximately equivalent to the English *timeframe*.[3] To speak of a "time window" is to identify a clearcut span of action and possibility. It is to define a distinct frame in which certain events are likely to happen, desired activities are expected to

"Berliner Fenster." Photo: Lutz Koepnick.

take place, specific symptoms might come to the surface, or particular treatments show or fail to show anticipated effects. Whenever we speak of time windows we are looking at temporal flows from a distinct vista of interest, singling out certain zones of attention while allowing everything else to recede into the background, to become noise. Though we mostly use this term in sentences anticipating the future, with a certain sense of hypothetical uncertainty, curiosity, and hence anxiety, any definition of a time window results in a severe reduction of temporal contingency and multiplicity. What the term's use indicates is thus not only an acute need to spatialize time, define hierarchies of significance, and make our lives in the expanded present of the digital age meaningful and manageable. What is also seems to suggest is that this survival of meaning and self-maintenance depends on nothing so much as our strategic efforts to eliminate the possibility of chance, coincidence, and surprise. Whether we consider their frames as subsequent, parallel, or overlapping, whenever we perceive the passing of time as an assemblage of time windows, we tend to preclude the unexpected and incommensurable. Similar to the rigid template structuring the presentation of sensational news in the "Berliner Fenster," the notion of a time window presents history as something

that at heart, in spite of all possible novelty and change, is deeply familiar and has no power to unsettle our ordinary existences, that might touch us but—all things told—will never ask us to change our itineraries in view of something we might fail to identify, categorize, and render entirely calculable.

Perhaps, we should consider lucky anyone who has had a chance to witness the occasional crash of the "Berliner Fenster," this window on and of time specially designed for the mobile citizens of our digital present. These breakdowns might be rare, but they do have the potential to upset our daily route through the city. First, the crash results in both displays throughout the entire subway train suddenly turning black, swallowing up whatever text or sight might have caught our attention prior to this particular instant. Next, the image of an all-too-familiar Microsoft error message window pops up in the center of the righthand monitor, a window within the window indicating in bold letters the event of an "Invalid System Time" and, for the eagle-eyed viewer, explaining that the date and time have been entered into the computer according to an incorrect format. Whereas only a moment ago we considered the screens as transparent membranes connecting us to the world outside the underground, now we suddenly find ourselves staring at an opaque window whose only message is that it has no message because its invisible operating system has run into trouble. If prior to the breakdown we considered ourselves in touch with the fast-paced agendas of the real, in this moment of breakdown we unexpectedly feel ourselves being returned to the unyielding and hellish timetables of the underground. For a moment, the system's invalid time format cannot but diffuse our attention and put us beside ourselves. It causes us to stare with puzzled eyes, first at the intransigent electronic window; then at our fellow traveler's puzzled gaze; and finally, perhaps, at our own mystification in the subway car's darkened window pane. Suddenly, we feel strange about our own strangeness, unsettled about the unsettled nature of our daily routines of looking. Suddenly, the window seems to look back at us and what we see through its frame makes us wonder where we have been all along—where we have been coming from, and where we might be going.

To live with electronic interfaces and windows of virtualized transport has become the norm—our destiny. Driven by the mandates of nonstop communication and universal connectivity, we no longer (or only rarely) find room to slow down, halt our ongoing displacement, and question how our own present ever more forcefully expands into, reframes, and gobbles up the rest of the time. In moments such as the breakdown of the "Berliner Fenster," on other hand, we are suddenly reminded of the initial promise of our modern

age and its fenestral cultures of mediation—the promise of contingency, unpredictability, chance, and change. It is in front of the monitor's darkness that we recall Baudelaire's desire for luminous holes in which life can live, dream, and suffer. It is in the presence of the network's collapse that we begin to yearn again for windows able to transport us into the unknown and incommensurable, into a future different from our past and our present.

Bernhard Garbert, "Weiter Reisen" ("Keep traveling" / "Move on"), platform of U2 line at Berlin Alexanderplatz station, May 2003. Printed by permission of the artist. Photo: Lutz Koepnick.

Notes

Introduction Framing Attention

1. Charles Baudelaire, *Prose and Poetry*, trans. Arthur Symons (New York: Albert and Charles Boni, 1926) 63.

2. Baudelaire, *Prose and Poetry* 64.

3. Jay David Bolter and Richard Grusin, *Remediation: Understanding New Media* (Cambridge, MA: MIT Press, 2000) 65.

4. "First of all, on the surface on which I am going to paint, I draw a rectangle of whatever size I want, which I regard as an open window through which the subject to be painted is seen." Leon Battista Alberti, *On Painting and On Sculpture: The Latin Texts of "De Pittura" and "De Statua,"* trans. Cecil Grayson (London: Phaidon, 1972) 55.

5. Svetlana Alpers, *The Art of Describing: Dutch Art in the Seventeenth Century* (Chicago: University of Chicago Press, 1983).

6. W. J. T. Mitchell, *Iconology: Image, Text, Ideology* (Chicago: University of Chicago Press, 1986) 17.

7. Quoted in Lawrence Wright, *Perspective in Perspective* (London: Routledge and Kegan Paul, 1983) 87.

8. Erwin Panofsky, *Perspective as Symbolic Form*, trans. Christopher S. Wood (New York: Zone Books, 1997).

9. Marshall McLuhan, *Understanding Media: The Extensions of Man* (New York: McGraw-Hill, 1964).

10. "Through much of the Western tradition oil paint is treated primarily as an *erasive* medium. What it must first erase is the surface of the picture-plane: visibility of the surface would threaten the coherence of the fundamental technique through which the Western representational image classically works the *trace.*" Norman Bryson, *Vision and Painting: The Logic of the Gaze* (New Haven: Yale University Press, 1983) 92.

11. For more on windows in painting, see among others Lorenz Eitner, "The Open Window and the Storm-Tossed Boat," *Art Bulletin* 37.4 (1955): 281–290. See also Thomas Grochowiak, ed., *Einblicke-Ausblicke: Fensterbilder von der Romantik bis heute* (Recklinghausen: Städtische Kunsthalle Recklinghausen, 1976); Carla Gottlieb, *The Window in Art: From the Window of God to the Vanity of Man* (New

York: Abaris Books, 1981) 287–305; and Suzanne Delehanty, ed., *The Window in Twentieth-Century Art* (Purchase, NY: Neuberger Museum, 1986) 17–28.

12. For more on windows in literary fiction, see Massimo Fusillo, "Metamorphosis at the Window," *Elephant and Castle,* October 26, 2004, http://dinamico .unibg.it/cav/elephantandcastle/.

13. Walter Benjamin, "The Work of Art in the Age of Mechanical Reproduction," *Illuminations: Essays and Reflections,* trans. Harry Zohn, ed. Hannah Arendt (New York: Schocken, 1969) 236.

14. Jonathan Crary, *Techniques of the Observer: On Vision and Modernity in the Nineteenth Century* (Cambridge, MA: MIT Press, 1992) and *Suspensions of Perception: Attention, Spectacle, and Modern Culture* (Cambridge, MA: MIT Press, 1999); Mary Ann Doane, *The Emergence of Cinematic Time: Modernity, Contingency, the Archive* (Cambridge, MA: Harvard University Press, 2002).

15. Doane, *The Emergence of Cinematic Time* 80.

16. Doane, *The Emergence of Cinematic Time* 11. See also T. J. Clark, *Farewell to an Idea: Episodes from a History of Modernism* (New Haven: Yale University Press, 1999) 10–11.

17. Leo Charney, *Empty Moments: Cinema, Modernity, and Drift* (Durham, NC: Duke University Press, 1998) 7.

18. Guy Debord, *The Society of the Spectacle,* trans. Donald Nicholson-Smith (New York: Zone Books, 1994) 24.

19. For such a celebratory account, see for instance Mark Poster, *What's the Matter with the Internet* (Minneapolis: University of Minnesota Press, 2001).

20. Franz Kafka, "The Street Window," *The Complete Stories,* ed. Nahum N. Glatzer (New York: Schocken Books, 1971) 384. Thanks to Jennifer Kapczynski for drawing this passage to my attention.

21. Kafka, "The Street Window" 384.

22. Erwin Panofsky, "Style and Medium in the Motion Pictures," *Film Theory and Criticism: Introductory Readings,* ed. Leo Braudy and Marshall Cohen, 6th ed. (New York: Oxford University Press, 2004) 292.

23. For more on Kafka's obsession with cinema, see Hanns Zischler, *Kafka Goes to the Movies,* trans. Susan H. Gillespie (Chicago: University of Chicago Press, 2003).

24. John Zilcosky, *Kafka's Travels: Exoticism, Colonialism, and the Traffic of Writing* (New York: Palgrave Macmillan, 2003) 153–174; Lutz Koepnick, "Kafka Calling on the Camera Phone," *Journal of Visual Culture* 2.3 (2003): 353–356.

25. Ivan E. Sutherland, "The Ultimate Display," *Proceedings of International Foundation of Information Processing,* ed. Wayne A. Kalenich (Washington, D.C.: Spartan, 1965) II, 506.

26. Gene Youngblood, *Expanded Cinema* (New York: E. P. Dutton, 1970) 189.

27. Thierry Bardini, *Bootstrapping: Douglas Engelbart, Coevolution, and the Origins of Personal Computing* (Stanford: Stanford University Press, 2000) 143.

28. Lev Manovich, *The Language of New Media* (Cambridge, MA: MIT Press, 2001) 97.

29. Alan MacFarlane and Gerry Martin, *Glass: A World History* (Chicago: University of Chicago Press, 2002).

30. Lemony Snicket, *A Series of Unfortunate Events: The Wide Window* (New York: HarperCollins, 2000) 2.

31. Martin Jay, *Downcast Eyes: The Denigration of Vision in Twentieth-Century French Thought* (Berkeley: University of California Press, 1993) 21–148; and Barbara Maria Stafford, *Good Looking: Essays on the Virtues of Images* (Cambridge, MA: MIT Press, 1996) 20–41.

32. Hal Foster, "Preface," *Vision and Visuality,* ed. Hal Foster (Seattle: Bay Press, 1988) ix.

Chapter 1 Menzel's Rear Window

1. Françoise Forster-Hahn, "Adolph Menzel's *Balkonzimmer*: Room Without a View," *Künstlerischer Austausch / Artistic Exchange,* ed. Thomas W. Gaehtgens (Berlin: Akademie Verlag, 1993) II, 750.

2. Michael Fried, *Menzel's Realism: Art and Embodiment in Nineteenth-Century Berlin* (New Haven: Yale University Press, 2002) 42.

3. Leon Battista Alberti, *On Painting and On Sculpture: The Latin Texts of "De Pittura" and "De Statua,"* trans. Cecil Grayson (London: Phaidon, 1972) 67–69.

4. Jonathan Crary, *Techniques of the Observer: On Vision and Modernity in the Nineteenth Century* (Cambridge, MA: MIT Press, 1992).

5. Crary, *Techniques of the Observer* 77.

6. Svetlana Alpers, *The Art of Describing: Dutch Art in the Seventeenth Century* (Chicago: University of Chicago Press, 1983) 53.

7. Alpers, *The Art of Describing* 58.

8. Werner Busch, *Die notwendige Arabeske: Wirklichkeitsaneignung und Stilisierung in der deutschen Kunst des 19. Jahrhunderts* (Berlin: Gebr. Mann Verlag, 1985) 280–304; *Adolph Menzel: Das Balkonzimmer. Ein Werk aus der Alten Nationalgalerie* (Berlin: Gebr. Mann Verlag, 2002) 28–30.

9. László F. Földényi, *Caspar David Friedrich: Die Nachtseite der Malerei,* trans. Hans Skirecki (Munich: Matthes und Seitz, 1993) 58.

10. This influential description comes from Franz Kugler, quoted in Gisold Lammel, *Adolph Menzel: Bildwelt und Bildregie* (Dresden: Verlag der Kunst, 1993) 190.

11. Peter-Klaus Schuster, "Menzel's Modernity," *Adolph Menzel, 1815–1905: Between Romanticism and Impressionism,* ed. Claude Keisch and Marie Ursula Riemann-Reyher (New Haven: Yale University Press, 1996) 138–160.

12. Timm Starl, *Im Prisma des Fortschritts: Zur Fotografie des 19. Jahrhunderts* (Marburg: Jonas Verlag, 1991) 12.

13. Peter Galassi, *Before Photography: Painting and the Invention of Photography* (New York: Museum of Modern Art, 1981) 12.

14. Werner Hofmann, *Die Moderne im Rückspiegel: Hauptwege der Kunstgeschichte* (Munich: C. H. Beck, 1998).

15. Johann Wolfgang von Goethe, *Theory of Colours,* trans. Charles Eastlake (1840; Cambridge, MA: MIT Press, 1970) 17.

16. Crary, *Techniques of the Observer* 69.

17. Maurice Merleau-Ponty, *Signs* (Evanston, IL: Northwestern University Press, 1964) 159. It is also quoted in Terry Eagleton, *After Theory* (New York: Basic Books, 2003) 212; I am greatly indebted to Eagleton's critical phenomenology of death, failure, and nonbeing and his critique of fundamentalist subjectivity.

18. Alexander von Humboldt, *Kosmos: Entwurf einer physischen Weltbeschreibung,* ed. Hanno Beck (Darmstadt: Wissenschaftliche Buchgesellschaft, 1993) 7.2: 79ff.; quoted in Oliver Grau, *Virtual Art: From Illusionism to Immersion,* trans. Gloria Custance (Cambridge, MA: MIT Press, 2003) 69.

19. For more on Gaertner's biography and the making of the panorama, see Irmgard Wirth, *Eduard Gaertner: Der Berliner Architekturmaler* (Frankfurt a. M.: Propyläen Verlag, 1979), in particular pages 33–38.

20. Renzo Dubbini, *Geography of the Gaze: Urban and Rural Vision in Early Modern Europe,* trans. Lydia G. Cochrane (Chicago: University of Chicago Press, 2002) 79–82.

21. Mary Louise Pratt, *Imperial Eyes: Travel Writing and Transculturation* (London: Routledge, 1992) 201–227.

22. Walter Benjamin, "On Some Motifs in Baudelaire," *Illuminations: Essays and Reflections,* trans. Harry Zohn, ed. Hannah Arendt (New York: Schocken, 1969) 173.

23. Theodor W. Adorno, *Kierkegaard: Konstruktion des Ästhetischen* (Frankfurt a. M.: Suhrkamp, 2003) 63.

24. Wilhelm Heinrich Riehl, *Die bürgerliche Gesellschaft,* ed. Peter Steinbach (1851; Frankfurt a. M.: Ullstein, 1976).

25. Jürgen Habermas, *The Structural Transformation of the Public Sphere: An Inquiry into a Category of the Bourgeois Society,* trans. Thomas Burger (Cambridge, MA: MIT Press, 1991) 43–51.

26. Fried, *Menzel's Realism* 96.

27. Jonathan Crary, *Suspension of Perception: Attention, Spectacle, and Modern Culture* (Cambridge, MA: MIT Press, 1999) 74.

Chapter 2 Richard Wagner and the Framing of Modern Empathy

1. Denis Diderot, *Das Theater des Herrn Diderot,* trans. Gotthold Ephraim Lessing (Stuttgart: Reclam, 1986) 340.

2. For an overview, see Erika Fischer-Lichte, *Kurze Geschichte des deutschen Theaters,* 2nd ed. (Tübingen: A. Francke Verlag, 1999) 165–260.

3. Richard Wagner, *Das Kunstwerk der Zukunft* (Leipzig: Otto Wiegand, 1850) 188–189.

4. Beat Wyss, "*Ragnarök* of Illusion: Richard Wagner's 'Mystical Abyss' at Bayreuth," *October* 54 (Fall 1990): 61.

5. Richard Wagner, *Die Meistersinger von Nürnberg: Opera in Three Acts,* trans. Susan Webb (New York: Metropolitan Opera Guild, 1992) 103. Hereafter, page references are given in parentheses.

6. "Nowhere, not even in *Parsifal,* is Wagner's music so artificial as in the appearance of simplicity with which it clothes itself in *Die Meistersinger.*" Carl Dahlhaus, *Richard Wagner's Music Dramas,* trans. Mary Whittall (Cambridge: Cambridge University Press, 1979) 75.

7. Theodor W. Adorno, *In Search of Wagner,* trans. Rodney Livingstone (London: New Left Books, 1981) 85. Interestingly enough, Adorno borrowed this concept from nineteenth-century developments in visual rather than sonic representation. The term *phantasmagoria* was popularized around 1800 as the name for magic-lantern shows in which back projection diverted the viewer from the actual sources of visual delight and thereby mystified the operations that generated pleasurable images in the first place. See Jonathan Crary, *Techniques of the Observer: On Vision and Modernity in the Nineteenth Century* (Cambridge, MA: MIT Press, 1992) 132–133; Terry Castle, "Phantasmagoria: Spectral Technology and the Metaphorics of Modern Reverie," *Critical Inquiry* 15 (Autumn 1988): 26–61.

8. Mary Ann Doane, *The Emergence of Cinematic Time: Modernity, Contingency, the Archive* (Cambridge, MA: Harvard University Press, 2002) 81.

9. Lydia Goehr, *The Quest for Voice: On Music, Politics, and the Limits of Philosophy* (Berkeley: University of California Press, 1998) 48–87.

10. Marc A. Weiner provides an extended analysis of eyes in Wagner as organs guaranteeing the recognition of similarity and difference, in *Richard Wagner and the Anti-Semitic Imagination* (Lincoln: University of Nebraska Press, 1995) 35–102.

11. Richard Wagner, *Prose Works,* trans. William Ashton Ellis (Lincoln: University of Nebraska Press, 1995) I, 91.

12. Lutz Köpnick, *Nothungs Modernität: Wagners* Ring *und die Poesie der Macht im neunzehnten Jahrhundert* (Munich: Wilhelm Fink, 1994) 225–245.

13. My understanding of Wagner's festival as a "simulacrum of ritual sacrifice" is informed by the work of Jacques Attali, for whom music's principal function is to bond people in common rituals and make them forget the general violence that resides behind the appearances of everyday life. See Jacques Attali, *Noise: The Political Economy of Music,* trans. Brian Massumi (Minneapolis: University of Minnesota Press, 1985) 21–45.

14. Goehr, *The Quest for Voice* 71.

15. Friedrich Schiller, "Über naive und sentimentalische Dichtung," *Über das Schöne und die Kunst: Schriften zur Ästhetik* (Munich: Deutscher Taschenbuch Verlag, 1984) 230–308.

16. Crary, *Techniques of the Observer* 19.

17. Robert Vischer, "On the Optical Sense of Form: A Contribution to Aesthetics," *Empathy, Form, and Space: Problems in German Aesthetics, 1873–1893,* ed. and trans. Harry Francis Mallgrave and Eleftherios Ikonomou (Santa Monica, CA: Getty Foundation, 1994) 104; translation adjusted slightly.

18. Heinrich Wölfflin, "Prolegomena to a Psychology of Architecture," *Empathy, Form, and Space* 151.

19. Konrad Fiedler, "Moderner Naturalismus und künstlerische Wahrheit," *Schriften zur Kunst,* ed. Gottfried Boehm (Munich: Wilhelm Fink Verlag, 1991) I, 106.

20. See Fiedler, "Richard Wagner," *Schriften zur Kunst* II, 270–272 and "Briefe aus Bayreuth," *Schriften zur Kunst* II, 325–336.

21. Detta and Michael Petzet, *Die Richard Wagner-Bühne König Ludwigs II.* (Munich: Prestel Verlag, 1970) 167.

22. Petzet and Petzet, *Die Richard Wagner-Bühne König Ludwigs II.* 160.

23. Petzet and Petzet, *Die Richard Wagner-Bühne König Ludwigs II.* 167.

24. Petzet and Petzet, *Die Richard Wagner-Bühne König Ludwigs II.* 167.

25. Martin Jay, *Downcast Eyes: The Denigration of Vision in Twentieth-Century French Thought* (Berkeley: University of California Press, 1993) 122.

26. Sir David Brewster, *The Stereoscope: Its History, Theory, and Construction with Its Application to the Fine Arts and Useful Arts and to Education* (London: John Murray, 1856).

27. Hermann von Helmholtz, "Recent Progress in the Theory of Vision (1868)," *Selected Writings,* ed. Russell Kahl (Middletown, CT: Wesleyan University Press, 1971) 217.

28. Hermann von Helmholtz, "Über das Sehen des Menschen (1855)," *Philosophische Vorträge und Aufsätze,* ed. Herbert Hörz and Siegfried Wollgast (Berlin: Akademie-Verlag, 1971) 75.

29. Crary, *Techniques of the Observer* 125.

30. For a persuasive reading of *Die Meistersinger* in terms of Sigmund Freud's *Civilization and Its Discontents,* see Paul Robinson, *Opera and Ideas: From Mozart to Strauss* (Ithaca: Cornell University Press, 1985) 210–261.

31. Arthur Groos, "Constructing Nuremberg: Typological and Proleptic Communities in *Die Meistersinger,*" *Nineteenth-Century Music* 16.1 (Summer 1992): 27. For more on nineteenth-century political festival culture, see for instance George L. Mosse, *The Nationalization of the Masses: Political Symbolism and Mass Movements in Germany from the Napoleonic Wars through the Third Reich* (Ithaca: Cornell University Press, 1975); and Kirsten Belgum's *Popularizing the Nation: Audience, Representation, and the Production of Identity in* Die Gartenlaube, *1853–1900* (Lincoln: University of Nebraska Press, 1998), ch. 4.

32. Groos, "Constructing Nuremberg" 30.

33. See Jay, *Downcast Eyes* 90–94.

34. Jacques Derrida, *Of Grammatology,* trans. Gayatri Chakravorty Spivak (Baltimore: Johns Hopkins University Press, 1976) 306.

35. Jürgen Habermas, *The Structural Transformation of the Public Sphere: An Inquiry into a Category of Bourgeois Society,* trans. Thomas Burger (Cambridge, MA: MIT Press, 1989).

36. Guy Debord, *The Society of the Spectacle,* trans. Donald Nicholson-Smith (New York: Zone Books, 1994) 22.

37. Wyss, "*Ragnarök* of Illusion" 77–78.

38. Dietrich Mack, *Der Bayreuther Inszenierungsstil* (Munich: Prestel-Verlag, 1976) 27.

39. Walter Benjamin, "The Work of Art in the Age of Mechanical Reproduction," *Illuminations: Essays and Reflections,* trans. Harry Zohn, ed. Hannah Arendt (New York: Schocken, 1969) 247.

40. Andrew Hewitt, *Fascist Modernism: Aesthetics, Politics, and the Avant-Garde* (Stanford: Stanford University Press, 1993) 168–169. For more on Benjamin's critique of the fascist spectacle, see Lutz Koepnick, *Walter Benjamin and the Aesthetics of Power* (Lincoln: University of Nebraska Press, 1999).

41. Peter U. Hohendahl, "Reworking History: Wagner's German Myth of Nuremberg," *Re-Reading Wagner,* ed. Reinhold Grimm and Jost Hermand (Madison: University of Wisconsin Press, 1993) 58.

42. On Wagner's relation to nineteenth-century bourgeois culture, see Egon Voss, "Wagners 'Meistersinger' als Oper des deutschen Bürgertums," in Richard Wagner, *Die Meistersinger von Nürnberg: Texte. Materialien. Kommentare* (Reinbek: Rowohlt, 1981) 9–31. For more on Wagner's understanding of politics as theater, see Köpnick, *Nothungs Modernität* 17–42.

Chapter 3 Early Cinema and the Windows of Empire

1. Hugo Münsterberg, *The Photoplay: A Psychological Study and Other Writings,* ed. Allan Langdale (1916; New York: Routledge, 2002) 68.

2. Münsterberg, *The Photoplay* 60.

3. Münsterberg, *The Photoplay* 61.

4. Münsterberg, *The Photoplay* 103.

5. Martin Loiperdinger, "Kaiser Wilhelm II.: Der erste deutsche Filmstar," *Idole des deutschen Films: Eine Galerie von Schlüsselfiguren,* ed. Thomas Koebner (Munich: Edition Text und Kritik, 1997) 41–53.

6. *Photographisches Wochenblatt,* vol. 20 (1894): 424; reprinted in Deac Rossell, *Faszination der Bewegung: Ottomar Anschütz zwischen Photographie und Kino* (Basel: Stroemfeld/Roter Stern, 2001) 120.

7. *Photographische Correspondenz* 254 (1883): 157.

8. John K. Noyes, "National Identity, Nomadism, and Narration in Gustav Frenssen's *Peter Moor's Journey to Southwest Africa*," *The Imperialist Imagination: German Colonialism and Its Legacy,* ed. Sara Friedrichsmeyer, Sara Lennox, and Susanne Zantop (Ann Arbor: University of Michigan Press, 1998) 98.

9. For studies on German cinema and colonialism, see among others Sabine Hake, "Mapping the Native Body: On Africa and the Colonial Film in the Third Reich," *The Imperialist Imagination* 163–188; Wolfgang Fuhrmann, "Lichtbilder und kinematographische Aufnahmen aus den deutschen Kolonien," *KINtop* 8 (1999): 101–116; Assenka Oksiloff, *Picturing the Primitive: Visual Culture, Ethnography, and Early German Cinema* (New York: Palgrave, 2001); Sabine Lenk, ed., *Grüße aus Viktoria: Film-Ansichten aus der Ferne* (Basel: Stroemfeld / Roter Stern, 2002).

10. For more on Wilhelm II's lifelong obsession with naval politics, see among others Volker R. Berghahn, *Der Tirpitz-Plan: Genesis und Verfall einer innenpolitischen Krisenstrategie unter Wilhelm II.* (Düsseldorf: Droste, 1970); Hans Wilderotter, "'Unsere Zukunft liegt auf dem Wasser': Das Schiff als Metapher und die Flotte als Symbol der Politik des wilhelminischen Kaiserreichs," *Der letzte Kaiser: Wilhelm II. im Exil* (Gütersloh: Bertelsmann Lexikon Verlag, 1991) 55–78; and Christopher Clark, *Kaiser Wilhelm II* (London: Pearsons, 2000) 123–159.

11. For the most compelling attempts to sketch out the emperor's precarious personality structure, see among many others Walther Rathenau, "Der Kaiser," *Schriften und Reden,* ed. Hans Werner Richter (Frankfurt a. M.: Fischer, 1964) 235–272; and John C. G. Röhl, *Kaiser, Hof und Staat: Wilhelm II. und die deutsche Politik* (1987; Munich: C. H. Beck, 2002) 17–34.

12. Wilhelm II, *The Kaiser's Memoirs,* trans. Thomas R. Ybarra (New York: Harper and Brothers, 1922) 235.

13. Shorts and actualities starring Wilhelm II are scattered across various German film archives and museums. An instructive, albeit not unproblematic, compilation of extant material is provided in Peter Schamoni's 1999 essay and documentary feature *Majestät brauchen Sonne: Wilhelm II., der letzte deutsche Kaiser, der erste deutsche Kinostar,* coproduced by the Verenigde Nederlandse Film & Telivisiecompagnie BV, the Independent Netherlands Broadcasting Organisation AVRO, and ZDF (Zweites Deutsches Fernsehen).

14. See, for instance, the 1910 "Pointers on Picture Acting" of the Selig Polyscope Co., reprinted in *KINtop* 7 (1998): 29–36.

15. J. Landau, "Mechanisierte Unsterblichkeit," *Der deutsche Kaiser im Film,* ed. Paul Klebinder (Berlin: Verlag Paul Klebinder, 1912) 20.

16. "Hermelin und Lichtspielkunst," *Der deutsche Kaiser im Film* 12.

17. Anton Kaes, ed., *Kino-Debatte: Texte zum Verhältnis von Literatur und Film 1909–1929* (Tübingen: Niemeyer, 1978) 13.

18. *März* 4.4 (1910): 173–174; reprinted in *Hätte ich das Kino! Die Schriftsteller und der Stummfilm,* ed. Bernhard Zeller (Stuttgart: Ernst Klett Verlag, 1976) 24–26.

19. *Hätte ich das Kino* 26.

20. *Hätte ich das Kino* 26.

21. Henri Bergson, *Le rire: Essai sur la signification du comique* (Paris: F. Alcan, 1900). For a similar reading of Viertel's text, see Klaus Kreimeier, "Die doppelte Verdopplung der Kaiser-Ikone: Berthold Viertel in einem Kino zu Wien, anno 1910," *Kino der Kaiserzeit: Zwischen Tradition und Moderne,* ed. Thomas Elsaesser and Michael Wedel (Munich: Edition Text und Kritik, 2002) 293–302.

22. Albert Hellwig, "Kinematograph und Zeitgeschichte," *Prolog vor dem Film: Nachdenken über ein neues Medium 1909–1914,* ed. Jörg Schweinitz (Leipzig: Reclam, 1992) 105.

23. Rainer Maria Rilke, *The Notebooks of Malte Laurids Brigge,* trans. Stephen Mitchell (New York: Random House, 1982) 4–5.

24. Ludwig Wittgenstein, *Tractatus Logico-philosophicus: Logisch-philosophische Abhandlung* (Frankfurt a. M.: Suhrkamp Verlag, 1959) 115.

25. Carsten Strathausen, *The Look of Things: Poetry and Vision around 1900* (Chapel Hill: University of North Carolina Press, 2003).

26. Hugo Münsterberg, "Why We Go to the Movies," *The Cosmopolitan* 60.1 (December 15, 1915); reprinted in Münsterberg, *The Photoplay* 172.

27. Münsterberg, *The Photoplay* 153–154.

28. Allan Langdale, "Editor's Introduction: S(t)imulation of the Mind: The Film Theory of Hugo Münsterberg," *The Photoplay* 7.

29. Henri Bergson, *Matter and Memory,* trans. N. M. Paul and W. S. Palmer (New York: Zone Books, 1991) 150.

Chapter 4 Underground Visions

1. Peter Galison, *Einstein's Clocks and Poincaré's Maps: Empires of Time* (New York: W. W. Norton, 2003); and Stephen Kern, *The Culture of Time and Space, 1880–1918* (Cambridge, MA: Harvard University Press, 1983).

2. Lynne Kirby, *Parallel Tracks: The Railroad and Silent Cinema* (Durham: Duke University Press, 1997) 45.

3. Wolfgang Schivelbusch, *The Railway Journey: Trains and Travel in the Nineteenth Century,* trans. Anselm Hollon (New York: Urizon Books, 1979) 63.

4. Quoted in Michael Bienert, *Berlin: Wege durch den Text der Stadt* (Stuttgart: Klett-Cotta, 1999) 116–117. Here is the original German version: "Die Träumer in der Untergrundbahn/Haben vernebelten Blick./Sie träumen ihre Zeit, ihr Geschick,/Beidem untertan.//Will keiner von ihnen den anderen sehn,/Will keiner vom anderen hören,/Will keines irgendwie stören./Sie fahren. Und ihre Gedanken gehen,/Gedanken gehen, langsam, im Rund,/Laufen sich nicht die Sohlen wund.//Die Träumer in der Untergrundbahn,/Sie haben weder Klage noch Wahn./Sie haben nicht viel zu erträumen/Unter Grund./Sie werden ihr Ziel nicht versäumen."

5. Michel Foucault, "Of Other Spaces," trans. Jay Miskowiec, *Diacritics* (Spring 1986): 22–27.

6. The following accounts have been consulted in this chapter in order to track the history of the Berlin subway: E. H. J. Boussett, *Die Berliner U-Bahn* (Berlin: Verlag von Wilhelm Ernst und Sohn, 1935); Sabine Bohle-Heintzenberg, *Architektur der Berliner Hoch- und Untergrundbahn. Planungen, Entwürfe, Bauten bis 1930* (Berlin: Verlag Willmuth Arenhövel, 1980); Ulrich Lemke and Uwe Poppel, *Berliner U-Bahn* (Düsseldorf: Alba, 1985); Heinz Knobloch, *Berliner Geisterbahnhöfe* (Berlin: Ch. Links, 1994); Stefan Handke, *Berlin und seine U-Bahn* (Berlin: Marion Hildebrand Verlag, 1994); Jürgen Meyer-Kronthaler, *Berlins U-Bahnhöfe: Die ersten hundert Jahre* (Berlin: Be.Bra Verlag, 1996); Petra Domke and Markus Hoeft, *Tunnel, Gräben, Viadukte: 100 Jahre Baugeschichte der Berliner U-Bahn* (Berlin: Kulturbild Verlag, 1998); and Jürgen Meyer-Kronthaler and Klaus Kurpjuweit, *Berliner U-Bahn: In Fahrt seit hundert Jahren* (Berlin: Be.Bra Verlag, 2001).

7. Viktor Auburtin, "Schranken," *Berliner Tageblatt* (No. 322), July 12, 1922.

8. Plessner is one of the chief witnesses in Helmut Lethen's, *Verhaltenslehre der Kälte: Lebensversuche zwischen den Kriegen* (Frankfurt a. M.: Suhrkamp, 1994), to whose concept of cold conduct the following pages are greatly indebted.

9. Helmuth Plessner, *The Limits of Community: A Critique of Social Radicalism*, trans. Andrew Wallace (Amherst, NY: Humanity Books, 1999) 109.

10. Siegfried Kracauer, "Proletarische Schnellbahn," *Schriften*, ed. Luka Müller Bach (Frankfurt a. M.: Suhrkamp, 1990) V, 179.

11. Kracauer, "Proletarische Schnellbahn" 179–180.

12. Alfred Kerr, "Neu Schönheit!—Bülowstraße?" *Mein Berlin: Schauplätze einer Metropole*, ed. Günther Rühle (Berlin: Aufbau, 2002) 107–109.

13. Quoted in Michael Bienert, *Die eingebildete Metropole: Berlin im Feuilleton der Weimarer Republik* (Stuttgart: Metzler, 1992) 46.

14. Quoted in Bienert, *Die eingebildete Metropole* 45.

15. Bienert reports that train conductors during the 1920s were held to delay the approach to the station at Gleisdreieck in order to enhance the optical effect of leaving the tunnel and reentering the urban surface. Bienert, *Die eingebildete Metropole* 45.

16. Kurt Tucholsky, *Deutschland, Deutschland über alles* (Berlin: Neuer Deutscher Taschenbuchverlag, 1929) 114; trans. Anne Halley (Amherst: University of Massachusetts Press, 1972).

17. Tucholsky, *Deutschland, Deutschland über alles* 115.

18. Tucholsky, *Deutschland, Deutschland über alles* 115.

19. Janet Ward, *Weimar Surfaces: Urban Visual Culture in 1920s Germany* (Berkeley: University of California Press, 2001).

20. Andre Breton, "Manifesto of Surrealism (1924)," *Manifestoes of Surrealism*, trans. Richard Seaver and Helen R. Lane (Ann Arbor: University of Michigan Press, 1972) 22.

21. Breton, "Manifesto of Surrealism" 22.

22. For more on this movement, see for instance Walter von zur Westen, *Reklamekunst* (1903; Bielefeld: Verlag von Velhagen und Klasing, 1914).

23. Ward, *Weimar Surface* 201.

24. See, for example, Wilhelm Schnarrenberger, "Reklame architekturbildend," *Die Form* 3 (1928): 268–271; and "Der umstrittene Weg Berlins zur Lichtstadt. Sammelartikel mit Beiträgen von Gustav Böß, dem Brüdern Luckhardt, Hans Poelzig u.a.," *Berliner Tageblatt*, October 14, 1928.

25. For more on window shopping and the Weimar art of taking a walk, see Anne Friedberg, *Window Shopping: Cinema and the Postmodern* (Berkeley: University of California Press, 1993); and Anke Gleber, *The Art of Taking a Walk: Flanerie, Literature, and Film in Weimar Culture* (Princeton: Princeton University Press, 1999).

26. Franz Kafka, *The Diaries 1910–23*, trans. Joseph Kresh and Martin Greenberg (London: Secker and Warburg, 1976) 888.

27. On the role of traveling in Kafka, see John Zilcosky, *Kafka's Travels: Exoticism, Colonialism, and the Traffic of Writing* (New York: Palgrave Macmillan, 2003).

28. For more on phatic speech acts, see Roman Jakobson, *Language in Literature*, ed. Krystyna Pomorska and Stephen Rudy (Cambridge, MA: Harvard University Press, 1987) 62–94.

29. László Moholy-Nagy, *Painting, Photography, Film,* trans. Janet Seligman (Cambridge, MA: MIT Press, 1969) 122–137.

30. Moholy-Nagy, *Painting, Photography, Film* 32.

31. Moholy-Nagy, *Painting, Photography, Film* 123.

32. Moholy-Nagy, *Painting, Photography, Film* 128.

33. Walter Benjamin, "The Work of Art in the Age of Mechanical Reproduction," *Illuminations: Essays and Reflections,* trans. Harry Zohn, ed. Hannah Arendt (New York: Schocken, 1969) 238.

34. Lev Manovich, *The Language of New Media* (Cambridge, MA: MIT Press, 2001) 325.

35. Sigmund Freud, "The Uncanny," *The Standard Edition of the Complete Psychological Works of Sigmund Freud,* ed. and trans. James Strachey (London: Hogarth Press, 1962) XVII, 248.

36. For contemporary responses to the square's and station's innovative modernization, see Ulf Dietrich, "Der Alexanderplatz in Berlin," *Der Städtebau* 24 (1929); Martin Wagner, "Das Formproblem eines Weltstadtplatzes," *Das Neue Berlin* 1 (1929): 33–38; and Paul Westheim, "Umgestaltung des Alexanderplatzes," *Die Bauwelt* 20 (1929): 312–316.

37. Alfred Döblin, *Berlin Alexanderplatz. Die Geschichte vom Franz Biberkopf* (Frankfurt a. M.: Suhrkamp, 1980) 179.

38. Bertolt Brecht, *Die Gedichte von Bertolt Brecht in einem Band* (Frankfurt a.M.: Suhrkamp, 1981) 674.

39. Brecht, *Gedichte* 674.

Chapter 5 Windows 33/45

1. Albert Speer, *Inside the Third Reich,* trans. Richard and Clara Winston (New York: MacMillan, 1970) 34.

2. Speer, *Inside the Third Reich* 34.

3. I have discussed this issue at length in *Walter Benjamin and the Aesthetics of Power* (Lincoln: University of Nebraska Press, 1999).

4. Steve Neale, "*Triumph of the Will*: Notes on Documentary and Spectacle," *Screen* 20.1 (1979): 69–70.

5. Neale, "Notes on Documentary and Spectacle" 76.

6. Claudia Schmöller, *Hitlers Gesicht: Eine physiognomische Biographie* (Munich: C. H. Beck, 2000) 50–54.

7. Heinrich Hoffmann, *Hitler Was My Friend,* trans. R. H. Stevens (London: Burke, 1955) 42.

8. Reprinted in Schmöller, *Hitlers Gesicht* 47.

9. Rudolf Herz, *Hoffmann & Hitler: Fotografie als Medium des Führer-Mythos* (Munich: Klinkhardt & Biermann, 1994); Ian Kershaw, *The "Hitler Myth": Image and Reality in the Third Reich* (Oxford: Oxford University Press, 1987). On the "drummer" years, see Kershaw, *Hitler: 1889–1936: Hubris* (New York: W. W. Norton, 2000) 167–220.

10. Max Weber, *Economy and Society: An Outline of Interpretative Sociology,* trans. Ephraim Fischoff and Hans Gerth, ed. Guenther Roth and Claus Wittich (New York: Bedminster Press, 1968).

11. Susan Sontag, *On Photography* (New York: Farrar Straus and Giroux, 1977) 105–106.

12. Alan Williams, "Historical and Theoretical Issues in the Coming of Recorded Sound to the Cinema," *Sound Theory Sound Practice,* ed. Rick Altman (New York: Routledge, 1992) 128.

13. Mary Ann Doane, "The Voice in the Cinema: The Articulation of Body and Space," in *Film Sound: Theory and Practice,* ed. Elisabeth Weis and John Belton (New York: Columbia University Press, 1985) 162.

14. Alan Williams, "Is Sound Recording Like a Language?" *Yale French Studies* 60 (1980): 51–66.

15. I have analyzed this in further detail in *The Dark Mirror: German Cinema between Hitler and Hollywood* (Berkeley: University of California Press, 2002) 23–49.

16. Jay Bolter and Richard Grusin, *Remediation: Understanding New Media* (Cambridge, MA: MIT Press, 1999).

17. Simonetta Falasca-Zamponi, *Fascist Spectacle: The Aesthetics of Power in Mussolini's Italy* (Berkeley: University of California Press, 1997) 86.

18. Giovanni Spagnoletti, "'Gott gibt uns das Brot—Er bereitet es uns und verteidigt es': Bild und Mythos Mussolinis im Film," *Führerbilder: Hitler, Musso-*

lini, Roosevelt, Stalin in Fotografie und Film, ed. Martin Loiperdinger, Rudolf Herz and Ulrich Pohl (Munich: Piper, 1995) 125.

19. For critical examinations of Nazi experiments with television, see Heiko Zeutschner, *Die braune Mattscheibe: Fernsehen im Nationalsozialismus* (Hamburg: Rotbuch, 1995); Erwin Reiss, *"Wir senden Frohsinn": Fernsehen unterm Faschismus* (Berlin: Elefanten, 1979); and Siegfried Zielinski, *Audiovisionen: Kino und Fernsehen als Zwischenspiele in der Geschichte* (Reinbek: Rowohlt, 1989) 98–174.

20. Ernst Hartwig Kantorowicz, *The King's Two Bodies: A Study in Medieval Political Theology* (Princeton: Princeton University Press, 1957).

21. Rudolf Herz, "Vom Medienstar zum propagandistischen Problemfall: Zu den Hitlerbildern Heinrich Hoffmanns," *Führerbilder* 52.

22. Richard Dyer, *Stars* (London: British Film Institute, 1979) 23.

23. Eric Rentschler, *The Ministry of Illusion: Nazi Cinema and Its Afterlife* (Cambridge, MA: Harvard University Press, 1996).

24. See, for instance, Fritz Hippler, *Betrachtungen zum Filmschaffen* (Berlin: Hesse, 1942) 102–107. On the uneasy but nonetheless effective relationships between stars and Nazi film theorists, see Andrea Winkler, *Starkult als Propagandamittel? Studien zum Unterhaltungsfilm im Dritten Reich* (Munich: Ölschläger, 1992).

25. Falasca-Zamponi, *Fascist Spectacle* 121.

26. Andrea Weiss, *Vampires and Violets: Lesbians in Film* (New York: Penguin Books, 1993) 28.

27. Kershaw, *Hitler* 363.

28. Walter Benjamin, "The Work of Art in the Age of Mechanical Reproduction," *Illuminations: Essays and Reflections,* trans. Harry Zohn, ed. Hannah Arendt (New York: Schocken, 1969) 220–221.

29. Theodor W. Adorno, "On Popular Music," *On Record: Rock, Pop, and the Written Word,* ed. Simon Frith and Andrew Goodwin (London: Routledge, 1990) 308.

30. Jeffrey Schnapp, *Staging Fascism: 18 BL and the Theater of Masses for Masses* (Stanford: Stanford University Press, 1996) 2.

31. Falasca-Zamponi, *Fascist Spectacle* 12.

32. Heinrich Hoffmann, *Hitler wie ihn keiner kennt: 100 Bilddokumente aus dem Leben des Führers* (Berlin: Zeitgeschichte-Verlag, 1941) xi.

33. For a comprehensive history of Hitler's Berghof, see Ferdinand Schaffing, Ernst Baumann, and Heinrich Hoffmann, *Der Obersalzberg: Brennpunkt der Zeitgeschichte* (Munich: Langen Müller, 1985).

34. Speer, *Inside the Third Reich* 86.

35. Le Corbusier, *Précisions sur un état présent de l'architecture et de l'urbanism* (Paris: Vincent, 1930) 132.

36. Beatriz Colomina, *Privacy and Publicity: Modern Architecture as Mass Media* (Cambridge, MA: MIT Press, 1994) 312.

37. Umberto Eco, "Ur-Fascism," *New York Review of Books,* June 22, 1995: 13.

38. For more on the definition of fascism as a form of palingenetic ultranationalism propagating a phoenixlike rebirth of nation, spirit, and culture, see Roger Griffin, *The Nature of Fascism* (New York: St. Martin's Press, 1991).

39. Reinhold Hohl, ed., *Oskar Schlemmer. Die Fensterbilder. 20 Farbtafeln und 19 Vorstudien* (Frankfurt a. M.: Insel Verlag, 1988) 27.

40. Andreas Hüneke, ed., *Oskar Schlemmer. Idealist der Form. Briefe, Tagebücher, Schriften, 1912–1943* (Leipzig: Reclam-Verlag, 1989) 339.

41. Suzanne Delehanty, *The Window in Twentieth-Century Art* (Neuberger Museum, State University of New York at Purchase, 1986) 17.

42. Laura Mulvey, "A Phantasmagoria of the Female Body: The Work of Cindy Sherman," *New Left Review* 188 (July–August 1991): 150.

43. Dan Cameron, "Power Play: Marcel Odenbach's Layered Histories," *Marcel Odenbach,* ed. Dan Cameron (New York: New Museum of Contemporary Art, 1998) 15.

44. Fredric Jameson, "Transformations of the Image in Postmodernity," *The Cultural Turn: Selected Writings on the Postmodern, 1983–1998* (London: Verso, 1998) 93–135; see also Jameson, *A Singular Modernity: Essay on the Ontology of the Present* (London: Verso, 2003).

Chapter 6 Fluxus Television

1. John G. Hanhardt, *The Worlds of Nam June Paik* (New York: The Guggenheim Museum, 2000) 34–35.

2. For more on the Freudian notion of the symptomatic act, see for instance Slavoj Žižek, *The Fright of Real Tears: Krzystof Kieślowski between Theory and Post-Theory* (London: British Film Institute, 2001) 100–101.

3. *Crossroads Parnass: International Avant-Garde at Galerie Parnass, Wuppertal 1949–1965* (London: Goethe Institute, 1982) 8.

4. For the most detailed description of the expositions and its individual objects, see Tomas Schmitt, "exposition of music," *Nam June Paik: Werke 1946–1976: Musik—Fluxus—Video,* ed. Wulf Herzogenrath (Cologne: Kölnischer Kunstverein, 1976) 67–73. A few days into the exhibition, the gory sight of the cow's head had to be removed from the show upon request of the local health authorities.

5. John Anthony Thwaites, "Der Philosoph und die Katze: Nam June Paik in der Galerie Parnass in Wuppertal," *Deutsche Zeitung,* April 9, 1963: 10.

6. Siegfried Bonk, "Über dem Eingang ein blutiger Ochsenkopf: Nam June Paik in der Galerie 'Parnass,'" *Kölner Stadt-Anzeiger,* March 16, 1963.

7. Craig Saper, "Fluxus as Laboratory," *The Fluxus Reader,* ed. Ken Friedman (Chichester, England: Academy Editions, 1999) 139.

8. Lev Manovich, *The Language of New Media* (Cambridge, MA: MIT Press, 2001) 30.

9. Anonymous, "Eine neue Großmacht im Entstehen," *Fernseh-Informationen,* vol. 1 (1950): 1.

10. Quoted in Knut Hickethier, *Geschichte des deutschen Fernsehens* (Stuttgart: J. B. Metzler, 1998) 71.

11. Quoted in Hickethier, *Geschichte des deutschen Fernsehens* 76.

12. Theodor W. Adorno, *Ästhetische Theorie* (Frankfurt a. M.: Suhrkamp, 1970) 235.

13. See Sara Danius, *The Senses of Modernism: Technology, Perception, and Aesthetics* (Ithaca, NY: Cornell University Press, 2002).

14. Julius Langbehn, *Rembrandt als Erzieher: Von einem Deutschen* (Leipzig, 1890).

15. Nam June Paik, "Afterlude to the EXPOSITION of EXPERIMENTAL TELEVISION," *Medien Kunst Aktion: Die 6oer und 7oer Jahre in Deutschkland,* ed. Rudolf Frieling and Dieter Daniels (Vienna: Springer, 1997) 46.

16. This date lost its status as a national holiday after German reunification in 1990.

17. Quoted in Herzogenrath, *Nam June Paik* 13–14.

18. Walter Benjamin, "Theses on the Philosophy of History," *Illuminations: Essays and Reflections,* trans. Harry Zohn, ed. Hannah Arendt (New York: Schocken, 1969) 253–264.

19. See chapter 5.

20. *Nationalsozialistische Rundfunkkorrespondenz,* August 11, 1937; quoted in Hickethier, *Geschichte des deutschen Fernsehens* 39.

21. Nam June Paik, quote from *Global Groove* (1973), videotape by Nam June Paik; the video's text was printed in *Electronic Arts Intermix: Video,* ed. Lori Zippay (New York: Electronic Arts Intermix, 1991) 157.

22. "Ein Wohnzimmer," *Die Kunst und das schöne Heim* 51.3 (December 1952): 102.

23. Johanna Schmidt-Grohe, "Atriumhaus inmitten einer Großwohnanlage," *Die Kunst und das schöne Heim* 61.5 (February 1963): 283.

24. Schmidt-Grohe, "Atriumhaus inmitten einer Grosswohnanlage" 283.

25. Margaret Morse, "An Ontology of Everyday Distraction: The Freeway, the Mall, and Television," *The Logics of Television: Essays in Cultural Criticism,* ed. Patricia Mellencamp (Bloomington: Indiana University Press, 1990) 199.

26. Charles Baudelaire, *Prose and Poetry,* trans. Arthur Symons (New York: Albert and Charles Boni, 1926) 63.

27. Nam June Paik, "Nachspiel zur Ausstellung 'Exposition of Music—Electronic Television' (Wuppertal 1963)," *Nam June Paik: Werke 1946–1976: Musik—Fluxus—Video,* ed. Wulf Herzogenrath (Cologne: Kölnischer Kunstverein, 1976) 90.

28. Paik, "Nachspiel" 90.

29. Nam June Paik, "Projects for Electronic Televisions and Aphorism," *Medien Kunst Aktion* 78.

30. For more about fears about teenager riots due to the spreading of mass-cultural distractions during the 1950s, see Uta G. Poiger, *Jazz, Rock, and Rebels: Cold War Politics and American Culture in a Divided Germany* (Berkeley: University of California Press, 2000) 71–105.

31. Lynn Spigel, *Welcome to the Dreamhouse: Popular Media and Postwar Suburbs* (Durham, NC: Duke University Press, 2001) 36.

32. Werner Rings, *Die 5. Wand: Das Fernsehen* (Vienna: Econ-Verlag, 1962) 16.

33. Julia Kristeva, "Approaching Abjection," *Powers of Horror: An Essay on Abjection* (New York: Columbia University Press, 1982) 3.

34. Paik, "Projects for Electronic Televisions and Aphorism" 78.

35. Robert Storr, *Gerhard Richter: Forty Years of Painting* (New York: Museum of Modern Art, 2002) 33.

36. Martin Warnke, "Zur Situation der Couchecke," *Stichworte zur 'Geistigen Situation der Zeit,'* ed. Jürgen Habermas (Frankfurt a. M.: Suhrkamp, 1979) II, 687.

37. Paik, "Nachspiel" 88.

38. The following discussion of different models of communication has been shaped by John Durham Peters, *Speaking into the Air: A History of the Idea of Communication* (Chicago: University of Chicago Press, 1999).

39. Peters, *Speaking into the Air* 62.

40. For more on the fundamental hybridity of television consumption, in particular during the 1950s, see Spigel, *Welcome to the Dreamhouse* 87–96.

41. G. W. F. Hegel, "Fragment of a System," *Early Theological Writings,* trans. T. M. Knox (Philadelphia: University of Pennsylvania Press, 1988) 312.; quoted in Peters, *Speaking into the Air* 112.

42. Rudolf Arnheim, "A Forecast of Television," *Film as Art* (Berkeley: University of California Press, 1957) 194.

43. Spigel, *Welcome to the Dreamhouse* 71.

44. Morse, "An Ontology of Everyday Distraction" 195.

45. Paik, "Nachspiel" 89.

46. Theodor W. Adorno, "Prolog zum Fernsehen," *Eingriffe: Neun kritische Modelle* (Frankfurt a. M.: Suhrkamp, 1963) 77.

47. Günther Anders, *Die Antiquiertheit des Menschen: Über die Seele im Zeitalter der zweiten industriellen Revolution* (Munich: C. H. Beck, 1956) 97–212.

48. Mary Ann Doane, "Information, Crisis, Catastrophe," *The Logics of Television: Essays in Cultural Criticism,* ed. Patricia Mellencamp (Bloomington: Indiana University Press, 1990) 238.

49. Raymond Williams's reflections on flow in *Television: Technology and Cultural Form* (New York: Schocken, 1975) mark the beginning of this line of analysis.

50. John Ellis, *Visible Fictions: Cinema, Television, Video* (London: Routledge and Kegan Paul, 1982) 143.

51. Paik, "Nachspiel" 89.

52. Paik, "Nachspiel" 92.

53. Leo Charney, *Empty Moments: Cinema, Modernity, and Drift* (Durham, NC: Duke University Press, 1998)

54. Paik, "Nachspiel" 73.

55. Dick Higgins, "Fluxus: Theory and Reception," *The Fluxus Reader* 221.

56. Jürgen Habermas, *The Structural Transformation of the Public Sphere: An Inquiry into a Category of the Bourgeois Society,* trans. Thomas Burger (Cambridge, MA: MIT Press, 1991) 181–235.

57. Manovich, *The Language of New Media* 30.

58. William J. Mitchell, *The Reconfigured Eye: Visual Truth in the Post-Photographic Era* (Cambridge, MA: MIT Press, 1994); Peter Lunenfeld, ed., *The Digital Dialectic: New Essays on New Media* (Cambridge, MA: MIT Press, 1997); Vivian Sobchack, ed., *Meta-Morphing: Visual Transformation and the Culture of Quick-Change* (Minneapolis: University of Minnesota Press, 2000); Christiane Paul, *Digital Art* (London: Thames and Hudson, 2003); Sean Cubitt, *The Cinema Effect* (Cambridge, MA: MIT Press, 2004).

Chapter 7 The Nation's New Windows

1. Jörg-Dieter Ganger, "Staatsrepräsentation," *Staatsrepräsentation,* ed. Jörg-Dieter Ganger and Justin Stagl (Berlin: Dietrich Reimer, 1992) 16.

2. *Der Spiegel* 36, September 6, 1999: 3.

3. See, for instance, Heinrich Klotz, "Ikonologie einer Hauptstadt—Bonner Staatsarchitektur," *Politische Architektur in Europa vom Mittelalter bis heute—Repräsentation und Gemeinschaft* (Cologne: DuMont, 1984) 399–416; Mathias Schreiber, "Selbstdarstellung der Bundesrepublik Deutschland: Repräsentation des Staates in Bauten und Gedenkstätten," *Staatsrepräsentation* 191–203.

4. Brian Ladd, *The Ghosts of Berlin: Confronting German History in the Urban Landscape* (Chicago: University of Chicago Press, 1997).

5. For a comprehensive overview of the building's history, see Michael S. Cullen, *Der deutsche Reichstag: Geschichte eines Parlaments* (Berlin: Argon, 1992).

6. Quoted in Rudolf Speth, "Der Reichstag als politisches Kollektivsymbol: Anmerkungen zum deutschen Nationalmythos," *Kunst, Symbolik und Politik: Die Reichstagsverhüllung als Denkanstoß* (Leverkusen: Leske und Budrich, 1995) 275.

7. Quoted in Michael S. Cullen, "Dem deutschen Volke: Das Reichstagsgebäude in Berlin," *Architektur und Demokratie: Bauen für die Politik von der amerikanischen Revolution bis zur Gegenwart* (Stuttgart: Hatje Verlag, 1992) 144.

8. See www.bundestag.de/blickpkt/arch_bpk/rtg_12.htm. Accessed September 13, 1999.

9. M. Christine Boyer, *The City of Collective Memory: Its Historical Imagery and Architectural Entertainments* (Cambridge, MA: MIT Press, 1994) 5.

10. Andreas Huyssen, *Twilight Memory: Marking Time in a Culture of Amnesia*

(New York: Routledge, 1995) 9; see also, by the same author, *Present Pasts: Urban Palimpsests and the Politics of Memory* (Stanford: Stanford University Press, 2003).

11. Goebbels quotation from Karlheinz Schmeer, *Die Regie des öffentlichen Lebens im Dritten Reich* (Munich: Pohl, 1956) 168. Albert Speer, *Inside the Third Reich,* trans. by Richard and Clara Winston (New York: Macmillan, 1970) 56.

12. Dennis Sharp, ed., *Glass Architecture by Paul Scheerbart. Alpine Architecture by Bruno Taut,* trans. James and Shirley Palmer (New York: Praeger, 1972) 14.

13. Andreas Huyssen, "Monumental Seduction," *New German Critique* 69 (Fall 1996): 181–200.

14. Jane Kramer, "Living with Berlin," *The New Yorker,* July 5, 1999: 54

15. Fredric Jameson, "Is Space Political?" *Rethinking Architecture,* ed. Neil Leach (London: Routledge, 1997) 255–269.

16. See my *Walter Benjamin and the Aesthetics of Power* (Lincoln: University of Nebraska Press, 1999), ch. 8.

17. Klaus von Beyme, *Die Kunst der Macht und die Gegenmacht der Kunst: Studien zum Spannungsverhältnis von Kunst und Politik* (Frankfurt a. M.: Suhrkamp, 1998) 338–339.

18. David Harvey, *The Condition of Postmodernity: An Enquiry into the Origins of Cultural Change* (Oxford: Basil Blackwell, 1989).

19. Winfried Nerdinger, "Politische Architektur: Betrachtungen zu einem problematischen Begriff," *Architektur und Demokratie* 21–22.

20. Kramer, "Living with Berlin" 61.

21. Herbert Muschamp, "Once Again, a City Rewards the Walker," *New York Times,* April 11, 1999, sec. 2: 36.

22. Bill Gates, with Nathan Myhrvold and Peter Rinearson, *The Road Ahead* (New York: Viking, 1995) 205–226.

23. Anne Friedberg, *Window Shopping: Cinema and the Postmodern* (Berkeley: University of California Press, 1993) 21. For more on the history of panoramas, see also Stephan Oettermann, *The Panorama: History of a Mass Medium,* trans. Deborah Lucas Schneider (New York: Zone Books, 1997); and Oliver Grau, *Virtual Art: From Illusionism to Immersion,* trans. Gloria Custance (Cambridge, MA: MIT Press, 2003) 90–139.

24. Friedberg, *Window Shopping* 22.

25. Jonathan Crary, *Suspensions of Perception: Attention, Spectacle, and Modern Culture* (Cambridge, MA: MIT Press, 1999) 138.

26. Anke Gleber, *The Art of Taking a Walk: Flanerie, Literature, and Film in Weimar Culture* (Princeton: Princeton University Press, 1998).

27. Christopher Isherwood, "A Berlin Diary," *The Berlin Stories* (New York: New Directions, 1963) 1.

28. The use of the quotation is inspired by Mary Louise Pratt, *Imperial Eyes: Travel Writing and Transculturation* (London: Routledge, 1992) 201–227. On the unity of aesthetics, knowledge, and authority, see David Spurr, *The Rhetoric of Em-*

pire: Colonial Discourse in Journalism, Travel Writing, and Imperial Administration (Durham: Duke University Press, 1993) 16.

29. For mounting discontent with the contemporary cult of speed and connectivity, see among many others Milan Kundera, *Slowness*, trans. Linda Asher (New York: Perennial, 1997); Carl Honoré, *In Praise of Slowness: How a Worldwide Movement Is Challenging the Cult of Speed* (San Francisco: HarperCollins, 2004); Harald Weinrich, *Knappe Zeit: Kunst und Ökonomie des befristeten Lebens* (Munich: C. H. Beck, 2004); and Wendy Wasserstein, *Sloth* (Oxford: Oxford University Press, 2005).

30. Peter Reichel, "Berlin nach 1945—eine Erinnerungslandschaft zwischen Gedächtnisverlust und Gedächtnisinszenierung," *Architektur als politische Kultur: Philosophica Practica* (Berlin: Dietrich Reimer, 1996) 273–296.

31. Ladd, *The Ghosts of Berlin* 3.

32. For more on the negotiation of past and present in contemporary Berlin urban planning, see among others Rolf Goebel, "Berlin's Architectural Citations: Reconstruction, Simulation, and the Problem of Historical Authenticity," *PMLA* 118.5 (October 2003): 1268–1289.

33. M. Christine Boyer, "The Great Frame-Up: Fantastic Appearances in Contemporary Spatial Politics," *Spatial Practices: Critical Explorations in Social/Spatial Theory*, ed. Helen Ligget and David C. Perry (Thousand Oaks, CA: Sage Publications, 1995) 88.

34. Mike Gane, *Baudrillard's Bestiary* (London: Routledge, 1991) 101.

35. For more on the link between aesthetic and anaesthetic architecture, see Neil Leach, *The Anaesthetics of Architecture* (Cambridge, MA: MIT Press, 1999).

36. See Saskia Sassen, *The Global City* (Princeton: Princeton University Press, 1991); and Sassen, "Ausgrabungen in der 'Global City,'" in *Berlin: Global City oder Konkursmasse? Eine Zwischenbilanz zehn Jahre nach dem Mauerfall*, ed. Albert Scharrenberg (Berlin: Dietz, 2000) 14–26.

37. For similar assessments, see the various contributions to Scharrenberg, ed., *Berlin: Global City oder Konkursmasse?*; and Stefan Krätke and Renate Borst, *Berlin: Metropole zwischen Boom und Krise* (Leverkusen: Leske und Budrich, 2000).

38. Huyssen, "Monumental Seduction" 187. See also Lutz Koepnick, "Rethinking the Spectacle: History, Visual Culture, and German Unification," *Wendezeiten, Zeitenwenden: Positionsbestimmungen zur deutschsprachigen Literatur 1945–1995*, ed. Robert Weninger and Brigitte Rossbacher (Tübingen: Stauffenburg, 1997) 151–170.

39. Muschamp, "Once Again, a City Rewards the Walker," 36.

40. Martin Filler, "Berlin: The Lost Opportunity," *New York Review of Books*, November 1, 2001: 30.

41. After writing about the Jewish Museum's new installations, Amos Elon for instance rightly points out: "The trouble with such installations is that the nearer they come to simulating reality, the greater the danger of their becoming kitsch. The same is true of Libeskind's 'Holocaust Tower.' This too is very high, an an-

gular-shaped rounded space with a small opening at the top through which a dim light emerges. The trick here is that as you enter, a heavy door slams shut behind. You may be alone—usually you are not—and perhaps you are slightly cold (there is no central heating in this room). But otherwise you are the same museum visitor who entered the tower and you may even be glad to have escaped the crowds outside; but you have been informed by the architect that this is what the victims may have felt as they were deported and found themselves in a concentration camp. 'Inside here we are cut off from every-day life. We can hear sounds and see light but we cannot reach the outside world. So it was for those confined before and during the deportation.'" Elon, "A German Requiem," *New York Review of Books,* November 15, 2001: 43. On some of the more problematic aspects of Libeskind's museum and of our ways of "reading" architectural sites of memory, see also Lutz Koepnick, "Forget Berlin," *German Quarterly* 74.4 (Fall 2001): 343–354; and Rolf Goebel, "Forget Hermeneutics? A Response to Lutz Koepnick." *German Quarterly* 75.2 (Spring 2002): 197–200.

42. Walter Benjamin, *Gesammelte Schriften,* ed. Rolf Tiedemann (Frankfurt a. M.: Suhrkamp, 1982) V, 588–589.

Epilogue "Berliner Fenster"

1. Hugo Münsterberg, *The Photoplay: A Psychological Study and Other Writings,* ed. Allan Langdale (1916; New York: Routledge, 2002) 145.

2. See *www.berliner-fenster.de.*

3. Special thanks to Doerte Bischoff for making me think about the relationship between these two terms.

Index

Index